Vinnie Ream

Vinnie Ream

AN AMERICAN SCULPTOR

Edward S. Cooper

Published in 2004 by
Academy Chicago Publishers
363 West Erie Street
Chicago, Illinois 60610

Printed in Canada.

Library of Congress Cataloging-in-Publication Data

Cooper, Edward S., 1939–
 Vinnie Ream : an American sculptor / Edward S. Cooper.
 p. cm.
Includes bibliographical references and index.
 ISBN 0-89733-505-8 (hardcover)
 1. Ream, Vinnie, 1847-1914. 2. Sculptors--United States--Biography.
I. Ream, Vinnie, 1847-1914. II. Title.

 NB237.R38A4 2004
 730'.92--dc22

 2003022106

For Jordan, Dylan, Zachary, and Casey

Acknowledgments

This book could not have been written without the understanding of my wife who tolerated the countless hours spent in libraries across the country. I am indebted to Seymour Skolnick and Daniel Rossiter who, on many occasions, when I became overwhelmed by the task, insisted I complete the work. All the effort would not have seen the light of day were it not for Anita Miller who had the courage to publish an unknown author.

With gratitude for help from Marjorie Zapruder of the Smithsonian American Art Museum; Dr Bernice S. Reid, National President of the National League of American Pen Women; Chris Montgomery of the State Historical Society of Missouri; Lulen Walker of Georgetown University; Gordon Field, Reference Librarian at the Glenview Public Library, Glenview, Illinois; and Scott Roller and Paul Bourcier at the Wisconsin Historical Society.

CONTENTS

INTRODUCTION

VINNIE REAM IS remembered, if at all, as a sort of infant prodigy who accomplished a remarkable feat at the age of fifteen and faded gradually into genteel obscurity. She herself has been presented rather simplistically by her biographers as a beautiful and gifted phenomenon whose characteristics included an almost angelic temperament.

But both Vinnie Ream and her story were much more complicated, and much more interesting, than that. Her story is entwined with the Civil War, with political maneuvers over Reconstruction and impeachment and, of course, with attitudes toward women in nineteenth century America. And she herself was unquestionably beautiful and certainly gifted, but her temperament was far from angelic. If she had not been tough and determined almost to the point of ruthlessness, she would never have become the phenomenon she undoubtedly was.

Fortunately, Vinnie Ream saved most of the letters she received, and Edward Cooper has been able to glean from them much information about her life and times, and many insights into her character. Vinnie Ream herself reconstructed her story: perhaps feeling, with some justification, that her achievements were being continually belittled, she expended some effort to create the illusion that she had won her two important commissions—statues of Lincoln and Admiral Farragut—in stringent competitions. As early as 1871, the *Evening Journal* (24 Jan), reported that in 1866 Vinnie had been awarded the commission for her Lincoln statue over "eight famed and experienced competitors." Eight years later in 1879, the *Daily Advertiser*

(24 Feb) said that she had been chosen by Congress over "eight competing sculptors."

In 1897, the November *Midland Monthly* reported that Vinnie had won over "nineteen sculptors [who had] submitted clay models to the Committee of Award. The examination was conducted by sealed envelopes." By 1900 the competitors had grown to twenty, according to the 15 January *Washington Post*, although in 1904, *Washington Life* (27 Feb) reduced the number once more to nineteen. In 1907 the *Des Moines Register* (22 Sept) put the number of competitors as "over twenty," adding that Mrs Lincoln was one of the committee who chose the sculptor and that she pointed to Vinnie's model and said, "That is my husband."

In 1909, an article by Vinnie appeared in both *La Follette's Magazine* (13 Feb) and in the *Christian Science Monitor* (31 Mar) in which she said, "All the great sculptors of the country competed [for the Lincoln commission]. I thought they would laugh at me." In 1913, in the *Evening Star* (7 Dec), her story changed once again. The government, she said, "gave" her a commission "to make a statue" and she decided upon Lincoln, whereupon the "committee in charge of the affair approached Lincoln," who of course agreed.

Her biographer Glenn Sherwood quotes Vinnie on this subject: "When Congress . . . appropriated money to erect a marble statue of the martyred President in the capitol, it never occurred to me, in my youth and inexperience, to compete for that great honor; but I was induced to place my likeness of him before the committee having the matter under consideration and, together with many artists—competitors for the work—I was called before the Committee . . . remembering the appearance before that stern committee as a terrible ordeal before unmerciful judges . . . Judge then of my surprise and delight when I learned . . . I had produced the most faithful likeness of him, they had awarded the commission to me." (p. 352).

None of these statements is true. As Edward Cooper explains, Vinnie, who had executed a bust of Lincoln, decided, on the president's death, that she should be the sculptor to do the statue that would inevitably be commissioned, and she had enough political connections and was able to pull enough strings to get Congress to agree with her, despite the vociferous objections of powerful men like Senator Charles Sumner. There was no competition of any kind, and Vinnie was not "called before" any "stern committee" of judges. In addition, Mrs Lincoln certainly never praised her work, but tried hard to stop her from carrying out the commission.

As to the Farragut commission, Sherwood comments that "Vinnie didn't appear to do anything in the form of 'lobbying' that wasn't also being done by her competitors." He calls this competition a "cut-throat and frustrating experience for the participants." (p. 353).

In point of fact, Vinnie did more than lobby: she had a stacked committee of three judges: Farragut's widow, Vinnie's lover General Sherman and Secretary of the Interior George Robeson. Vinnie already had a devoted friend in Virginia Farragut, who was grateful to her for suggesting the memorial in the first place. There were several highly respected sculptors competing for this award, but to Secretary Robeson's intense annoyance, Vinnie's two friends awarded her the commission, as they had intended to do from the outset. The experience was undoubtedly frustrating for the other competitors, but it was not "cut-throat."

It is obvious from all this that there has been a need for an unbiased biography of Vinnie Ream, whose true story is compelling enough without fabrications. Here is a young woman from an unremarkable Midwestern family, who becomes a famous sculptor without rigorous professional training, at a time of intense gender discrimination. Her reluctance to enter into professional competitions was based on the undeniable fact that

women were not allowed to win these competitions. Her sto-
ries about winning over eight or twenty or countless competi-
tors reflect an understandable basic insecurity and a sad desire
to be accepted as an exceptional contestant.

Vinnie Ream was an amazing and complex character who
fascinated powerful men not only because she was beautiful
and knew very well how to use that beauty, but because of the
strength of her personality and her very real intelligence. I be-
lieve that Edward Cooper has brought her life and times into
long-delayed focus.

Anita Miller
November, 2003

1

WASHINGTON

She would make a magnificent coquette if she chose to do so.

—*James Rollins*

IN APRIL, 1861, when President Lincoln, in response to the attack on Fort Sumter, issued a call for troops, the city of Washington began to be transformed from a relatively sleepy backwater to a hub of feverish activity. Barricades went up around the Capitol and other public buildings, trenches were dug on the grounds and in a few weeks the city was inundated with Federal troops. The New York Seventh Regiment, the first to arrive, received a tumultuous reception: cheering crowds lined the streets, balconies, windows and rooftops to watch the Seventh's triumphal procession down Pennsylvania Avenue to the White House, where the president stood on the sidewalk to salute them.

After that, the arrival of soldiers became an everyday occurrence: the Fifth and Eighth Regiments from Massachusetts, the Seventy-First and the Twelfth from New York, and a force from Rhode Island. Encampments soon ringed the hills around the city and armed guards, dress parades and the sounds of regimental music were everywhere.[1] Civilians, too, flocked to the capital: speculators, contractors and people seeking wartime appointments.

Among the latter, arriving from Arkansas, were Robert L. Ream, his wife Lavinia and two daughters, 16-year-old Mary and 14-year-old Vinnie. Lavinia McDonald had married Robert in Canton, Ohio, when she was eighteen. A son, Robert Jr., 23, stayed behind in Arkansas. The elder Ream, who was born in Center County, Pennsylvania, in 1809, had lived in Canton

until he moved to Wisconsin, where he set up an inn in Madison in 1838. Becoming involved in local politics, he was elected Register of Deeds for Dane County, was named County Commissioners Clerk, and in 1839 was appointed by Governor Henry Dodge to the Territorial Treasurer's office. In 1848 he was elected Chief Clerk of the Wisconsin House of Representatives.

Possibly because he saw no real future in it, he gave up Wisconsin politics and went to work for the government as a surveyor in Kansas, Nebraska, Iowa and Missouri, as well as in Wisconsin, drawing the earliest maps of these territories. In 1859 he was appointed Clerk to the Surveyor General of Kansas. But at that time Kansas was torn over the question of whether it should be admitted to the Union as a free or a slave state. Because Robert Ream supported the free state position, he was dismissed from his post and moved his family to Fort Smith, Arkansas, where the Reams remained until the outbreak of the Civil War. In Washington, with his map-making experience the elder Ream had no difficulty in being hired to work in the cartography section of the War Department.[2]

Since expenses were high in the wartime capital, Ream needed to augment his salary. He turned to an old friend, James S. Rollins, the newly elected representative from Missouri, to find jobs for Mary and Vinnie. Rollins, 49, had practiced law in Columbia, had served in both the state house and senate and had been instrumental in establishing the University of Missouri in 1839. Ream had settled in Missouri when it became necessary to establish a base so that his three children could be educated, and that was how he had become friendly with Rollins.

Vinnie's early school years had been spent at the St Joseph Female Academy. When the Academy principal, James K. Rogers, a firm believer in states rights and an advocate of secession, was appointed principal of Christian College, the female counterpart of the state university, Vinnie and Mary transferred there. Rogers was impressed by Vinnie's lively intellectual curiosity

and her obvious talents.[3] According to the school *Chronicles*, she "gave evidence of the varied gifts with which nature, in rare cases, sees fit to endow certain favored ones of her children." She was recording secretary of her class and often gave musical performances and "elocution" recitations at school programs.[4]

Rollins and the Reams had not met for over a year and the reunion was a pleasant one, filled with recollections of the girls' schooldays in Columbia. Rollins teased Vinnie, asking whether she was as strong-willed as ever, always insisting on getting her own way. He recalled that when she was at Christian College, she had wanted to attend a weekend party off the school grounds, something that was strictly forbidden. But Vinnie had drafted a petition to James Rogers, signed by her entire class, asking that she be exempted from the rule.[5] Rollins was obviously taken with Vinnie, and from this point on was to play an important role in her life, introducing her to sculpture, seeing that she met the right people, offering her guidance and support during dark days. Vinnie had a faculty for catching the fancy of older men. She was not classically beautiful, being barely five feet tall and too thin by nineteenth-century standards. But her eyes—flashing, sparkling, misty by turns—and her luxuriant mass of chestnut curls, combined with her romantic nature and independent spirit, were to capture male hearts and imaginations for the next twenty years.

Because the manpower shortage had opened the Civil Service to women, Rollins was able to find a job for Mary in the land office and one for Vinnie in the post office at $600 a year. Robert Ream had gotten his government jobs through patronage, and the ease with which Rollins found employment for the girls was not lost upon Vinnie: she was impressed by the power of political influence. Family finances were so much improved by the girls' Civil Service jobs and by the extra $150 a year Vinnie brought in singing at the E Street Baptist Church, that she was able to afford private lessons in music, French and German.[6]

Life in the capital at the beginning of the war was exciting
to young girls: horse-drawn artillery sped along the avenues at
all hours of the day and night; uniformed couriers dashed from
building to building delivering their urgent messages; the shops
were filled with handsome officers on leave, and reporters and
military attachés from all over Europe were arriving daily. For
the first several months, the war was glamorous, with parades
and parties, and no bloodshed. The war party, led by Horace
Greeley's *New York Tribune* and others, began the cry, "On to
Richmond!" In response to this pressure, Federal troops marched
out and met the Confederates at Bull Run on July 21, 1861.

On the morning of July 22, in a steady, sullen rain, the troops
began to return to Washington, not as they had left, in smartly
marching units, but at first slowly, in twos and threes, bewil-
dered, in muddy, bloodstained uniforms. As the day wore on,
larger units limped into the city, followed by baggage wagons
carrying the wounded and dying to the hospitals. Disorganized
regiments, followed by stray horses, wandered about the streets;
hungry, exhausted men fell asleep in the unremitting rain on the
pavements, in the parks. They had been routed at Bull Run, but
there were 10,000 men in the army who had fought little or not
at all, and they, along with other reinforcements, were able to
hold the bridges over the Potomac River. The Confederates had
taken losses too, and did not intend to try to take Washington,
although that would not be apparent for several days.

The electric excitement of the previous months gave way
suddenly to the harsh reality of men with limbs shot off, scream-
ing in agony as they were carried from the wagons to the make-
shift hospitals. Newspapers printed propaganda about Confed-
erate brutality, reporting that the rebels "cut off the heads of
men on the field, and absolutely kicked them from one to an-
other [and] bayoneted many of our men who lay wounded on
the field of battle . . ."[7] Panic spread among the populace in
Washington, but was allayed when it was learned that the Union
units had regrouped and were dug in on the Virginia side of the

Potomac. People brought out food and drink for the exhausted men when the Commissary Corps became overtaxed. Slowly, order was restored. Soldiers were told where their units were reforming, and Washington settled down to the long struggle ahead.[8]

The nation was torn apart, and some families, too, were split by differing loyalties. Robert Ream was decidedly pro-Union, but his son Robert considered himself a son of Arkansas and refused to accompany his family to Washington. James Rogers, Vinnie's teacher at Christian College, wrote her: "I am glad to hear that even in the Federal Capitol [*sic*] there are hearts that still in these dark days beat true to the cause of the now down-trodden and oppressed South. I have no heart to join in this mad attempt to preserve the integrity of the Nation by over-throwing the Constitution. It is because I am unwilling to join in so desperate and inhuman a game as this, that I am called a *Secessionist*, a *rebel*, a *traitor*, etc., etc."[9] Rogers assumed that Vinnie sympathized with the South, and she did, until blood began to flow, when her sympathies gravitated to the North. She had no strong political commitments.

Arkansas withdrew from the Union on May 6 and young Robert Ream answered the Confederacy's call to arms. When the family did not hear from him, Vinnie, relying as always on connections, asked for help from J. E. Powell, a friend of General John Charles Frémont. Powell responded immediately that he would go to the general and inquire about Robert from Confederate prisoners.[10] These inquiries were fruitless. Vinnie and her mother asked Powell to apply to General Frémont for a pass through Union lines to look for Robert, since at this early point in the war, civilians had been moving freely across both Union and Confederate lines. Soon both sides began to search men crossing the lines; this led to the use of women couriers.

Powell wrote Vinnie, "I have done all I can to gain permission for your mother to pass our lines. I have used all my influence among the army officers, all to no purpose. The only an-

swer is a most decided *no*. Troops are now moving against the confederates from several points. It would be exceedingly difficult for your mother to follow or penetrate to the confederates added to which an occurrence happened here last night that has caused great suspicion to fall on *all ladies now going South*. As for yourself, you must not attempt under any circumstances to go. The enterprise is too full of toil and hardship, and the country is infested with bands of dissolute men scarcely above the grade of savages who prey on either side. General Frémont's pass cannot be obtained and you must not go without. He says no one shall leave St Louis to go south."[11]

In early March, 1862, word reached Washington of the Union victory at Pea Ridge—also called Sugar Creek—under General Samuel Curtis. This was a notable battle in some ways: it was one of the few times that the Confederate regiments, bolstered by Indian troops, heavily outnumbered the Federals, and in a war that produced many eccentric generals, this battle included General Albert Pike, one of the oddest, and one who was to play an important part in Vinnie's life.

Immediately upon receiving news of the victory, Vinnie wrote General Curtis: "Pardon me for thus troubling you, but I must leave nothing undone that can give me any information concerning my only, and dearly loved, brother Robert L. Ream—a young man about twenty-four years of age who joined the Southern army at Little Rock, Ark. We have not heard from him since last June, and then heard that he had joined Woodruff's Artillery, and went to Ft Smith, and from there into southwest Mo. under Ben McCullough. If our information is correct, he was in the Battle of Wilson's Creek and he was very probably in the Battle of Sugar Creek where you were recently victorious. Our anxiety is such that I presume to write this, thinking you can tell me if any such person has come to your knowledge either as a prisoner, wounded or killed. If you will be kind enough to do this, Gen. Curtis, God will reward you for your goodness. I know how much you have to engage your attention, yet trust

to your generosity to forgive us for troubling you. I beg of you, and if you will kindly see by your list of prisoners, or give us any information, a Mother's prayers and a sister's gratitude will be forever yours."[12]

The general responded to this heartfelt plea, ordered a review of the prisoners lists and informed Vinnie that there was no mention of Robert.[13] Vinnie persisted in her inquiries: she was always an opportunist, claiming whatever allegiance would benefit her at the moment. Now despite her Union sympathies, she put on a Rebel hat when she wrote to a family friend in Columbia, who responded, "I cannot expect you to speak as fully, under your restraints, as you feel, and was only gratified at your assurance of continued faith in the cause. Our town has none of that good old family quiet it wore when you were here, but is garrisoned by 'Merrill's Horse,' a federal regiment, the detention of which in our midst must certainly be on account of its inefficient character. Certainly they are not leaving good soldiers to harass and insult good people . . ."[14] Unfortunately there was no news of her brother. But Robert Ream had in fact not been captured at Pea Ridge, but had performed so well that he had been made a first lieutenant in Company H, 1st battalion of the Arkansas Cavalry.[15]

In addition to her job at the post office, Vinnie worked as a clerk in James Rollins's office, where she learned about special-interest lobbying, about the way bills moved from conception to passage through compromise and coalitions. She was a keen observer and had many willing teachers. Most congressmen came to Washington without their families; they were self-important but often lonely and vulnerable. Vinnie was an attractive listener.

She was an expert manipulator, but she did not lack compassion, and often volunteered to sing for the wounded at the Lincoln General Hospital. Her repertoire including "Il Bacio," "What Are the Wild Waves Saying?," "Departed Days," "Annie Laurie" and "Santa Lucia." In addition to visiting the sick, she wrote to men in both Union and Confederate prison camps, prisoners

of all ranks from Confederate General M. Jeff Thompson at Johnson Island, Ohio, to a Union private in Raleigh, North Carolina, and received grateful letters in return. She attempted to alleviate their pervasive despair with cheerful assurances of their future reunion with wives and sweethearts.[16] Throughout her life, her somewhat ruthless ambition was tempered by strains of affection and genuine friendship.

As time passed, Washington took on the aura of a huge military compound. More than 160 gambling houses sprang up, as did at least an equal number of brothels, both ranging from the opulent to the seedy. The *Washington Evening Star* estimated that there were approximately 5000 prostitutes in the capital, including street walkers. And there were twenty-one hospitals receiving a constant stream of ambulances filled with the sick and wounded. Night and day the streets were filled with the sounds of galloping cavalry, marching men, bugles, carts and wagons and the cursing of muleteers.[17]

One day in 1863, James Rollins invited Vinnie to go with him to the studio of Clark Mills, where he was sitting for a bust. Mills was at that time the most eminent sculptor living in the U.S., having in 1852 executed the country's first equestrian statue, *Andrew Jackson,* placed in Lafayette Park across from the White House, a work that so impressed Congress that they awarded Mills $6,500 more than the original $32,000 contract fee. In addition to his studio, Mills had built a foundry where his work and the work of other sculptors were cast. Vinnie found herself fascinated not only by the sight of models in various stages of completion, but by Mills's skill in shaping the clay to create the Rollins bust. But her feeling of respect did not prevent her from blurting out, rather to her own surprise, "I could do that!"[18]

Both men were amused by her presumption. But Mills himself was self-taught and had executed his *Andrew Jackson* without ever having seen Jackson himself or, indeed, any equestrian

statue. He gave Vinnie some clay, told her to copy the head of an Indian chief, and went on with Rollins's sitting. When this was done for the day, they went to see how Vinnie was doing. Rollins said later that both he and Mills were astonished at the medallion in profile that she had produced. Mills was in fact so impressed that he offered on the spot to take Vinnie on as a student-assistant if she could arrange her schedule at the post office. This was not a problem: General George W. McClellan, the assistant postmaster, had hired Vinnie as a favor to Rollins, and had grown fond of her.[19]

Mills's foundry provided an excellent training ground. There Vinnie was able to study Mills's techniques and also meet sculptors who were bringing their work to the foundry for casting and who easily found time to give this charming novice instruction and advice. Vinnie was fortunate, too, to be living in Washington, a virtual treasury of statuary and painting in the streets, the public buildings and the art galleries. There was, for instance, Horatio Greenough's *Washington*, unveiled in 1841, depicting the first president as Zeus, seated on a throne ornamented with Roman chariots, naked to the waist, his left arm holding a Roman sword and his right arm pointing upward, his sandaled feet protruding from a cloth draped about his hips and legs. This work was widely ridiculed by some, but was praised by the powerful Senator Charles Sumner of Massachusetts, considered an expert in the arts. Congress soon awarded Greenough a commission for *The Rescue,* the subject of which was a pioneer defending his family from attack by Indians. The original contract for the latter was $24,000, but when he completed it, Greenough applied for, and was granted, an additional $8000. *The Rescue* was placed in the east stairwell of the Capitol.

There was also the work of Thomas Crawford, whose *Armed Freedom* stood above the dome of the Capitol. Crawford also designed the bronze doors and pediment statues for the Senate wing, but Vinnie felt a particular affinity for *Armed Freedom* because the statue, of a gowned woman carrying sword and

shield, had been cast at Mills's foundry in 1862. Then there were paintings: the *Embarkation of the Pilgrims* by Robert Weir, who taught drawing at West Point, had recently been damaged when falling scaffolding in the Capitol rotunda cut a five-foot gash in the canvas and smashed the frame. Weir came to Washington and set up a workshop in the Capitol where he cleaned and repaired the painting. Constantino Brumidi's frescoes ornamented the canopy of the rotunda.

The most popular statue of the period in both Europe and America was *The Greek Slave* by Hiram Powers, whose statues of Benjamin Franklin and Thomas Jefferson stood in the Capitol. *The Greek Slave* was on exhibit in Washington in 1863 in an alcove of the mansion owned by William Wilson Corcoran, the financier and philanthropist whose collection was to form the nucleus of Washington's Corcoran Gallery of Art in 1897. Powers was so respected and admired that the *Greek Slave* was open to viewing by women, even though it was a nude.[20]

Vinnie was not intimidated by the fact that Horatio Greenough, Thomas Crawford, Robert Weir and Hiram Powers had all studied and worked in Italy. Clark Mills had learned his craft in America and that was good enough for her. Like him, she preferred realism to classicism. She was not likely to forget that both Greenough and Mills had received additional compensation from Congress when their works were completed, and she undoubtedly understood that to have a friend like Charles Sumner in Congress was essential to a sculptor's future. What she never learned to accept was that every work of art would be subjected to intense criticism from one quarter or another.

Vinnie volunteered much of her time to the war effort, spending months sewing shoulder straps and epaulets on uniforms, and working for the Ladies Great National Sanitary Fair to be held in Washington on January 15, 1864. A circular announcing the fair called upon the public to "respond by their ready

assistance in providing for the wants and suffering of the brave defenders of the Union." Gaining entrée to the circle of congressional wives and other prominent people supporting the fair, she was put in charge of collecting writing materials for the troops, and had a card printed for distribution:

Vinnie Ream
In charge of the Post Office
GRAND SANITARY FAIR
Contributions of Stationery and Unsealed Letters
gratefully received by her at No 325 North B street
Capitol Hill, Washington D.C.[21]

The fair was a huge success and supplies poured in, along with money that was used to purchase food, bandages, morphine, opium, chloroform, scissors and forceps.

Vinnie was meeting more and more of the "right people," enjoying sculpting and finding life in Washington exciting and lively. But she could hardly ignore the horrors of the war; the carnage of a battle's aftermath could be seen in the photographs in the Washington studios of Mathew Brady and Alexander Gardner. And there were letters like the one she received from Ward 2, Seminary Hospital, Georgetown, dated June 7, 1864:

Dear Vinnie,
At last my time has come. On the 28th inst. at Annons Church, Va. we had one of the most desperate cavalry battles I ever saw. Our Regt. was ordered to change position and I was sent back to see that the ranks were closed up. As I sat on my horse, in good range of enemy artillery, a shell carried away my left-foot, and upon examination it was found that the bone was so badly shattered that amputation had to be performed about midway betwixt the ankle and knee.[22]

Vinnie was approaching her seventeenth birthday in the summer of 1864 and she had to be thinking about her future. Her mother, Lavinia McDonald Ream, had married at eighteen, and had raised three children while following her husband across the western frontier, from Wisconsin to Missouri to Kansas and then to Arkansas. She was an educated woman, but she made few independent judgments, and undoubtedly never considered a career of her own. She had her hands full as mother and housekeeper, and then too, the husband of a working woman was generally condemned as a poor provider. This was the case no matter how high up the social and financial ladder one went. But Vinnie did not envision a life for herself filled only with parties, shopping and travel.

In Washington at the post office, and in Rollins's office, she had seen a world she respected. True, that was a man's world, but she had also seen women organizing the Grand Sanitary Commission, drafting bylaws, setting up committees, building a distribution network and delivering enormous quantities of supplies to the military. She was quite aware that once the war ended, this female activity would probably no longer be socially acceptable. She wanted a career that would give her financial independence, and she wanted to be famous: to be recognized, to be mentioned in the newspapers, to be known and admired by the public.

A career as a teacher or a governess was certainly open to her, but what those jobs offered was neither fame nor fortune, but the probability of spinsterhood, a prospect that Vinnie found repellent. Nor was she attracted to the women's movement. Elizabeth Cady Stanton and Susan B. Anthony were certainly famous, they seemed able to raise funds, and Stanton at least was married, but influential men considered these women "shrill" and openly criticized them. Vinnie had no desire to imperil her soft feminine appeal.

Only one group of women seemed to embody Vinnie's ambitions. These were the sculptors Harriet Hosmer, Emma Steb-

bins, Edmonia Lewis and Louisa Lander. According to the *New York Times,* Hosmer's income was estimated "to be $15,000 per year, all of which she chisels from the original rocks."[23] The press was fascinated with Hosmer's unconventional life: her youth spent roaming the fields around Watertown, Massachusetts like a "young fawn," and the freedom allowed her by her doting father. Her "manly" qualities were dwelt on: swimming, horseback riding, marksmanship, her male clothing and her close friendships with women. Her skill as a sculptor was much admired; the papers gave periodic progress reports on her work on the colossal statue of Thomas Hart Benton for which she had received a commission from the city of St Louis.[24]

Much attention was also paid to Emma Stebbins's work-in-progress *Angel of the Waters,* destined for New York's Central Park, and her bronze statue of Horace Mann, to be displayed at the State House in Boston. Notice was more subtly taken of her liaison with the celebrated actress Charlotte Cushman. Edmonia Lewis, the daughter of a black man and a Chippewa Indian, had received praise for her bust of Colonel Robert Shaw, a hero who had died leading black soldiers into battle. A few years earlier, accused of poisoning two classmates at Oberlin College, she had been attacked and beaten by a vigilante mob. She was acquitted of attempted murder after apparently proving in court that she had spiked her classmates' drinks with an aphrodisiac, not a poison. Then there was Louisa Lander, who had inspired Nathaniel Hawthorne's free-spirited women artists in *The Marble Faun,* and for whom the U.S. ambassador to Russia had sat in St Petersburg. Lander received more publicity when the ship carrying her statue of Virginia Dare, the first child born in America, foundered and sank off the coast of Spain.[25]

Vinnie was fascinated by the work, the rewards, and the independence of these women. She was not disturbed by gossip about them; she noticed that men appeared to judge them differently from the way they judged the feminists, seeming to feel an admiration for them that bordered on sexual desire. What

did disturb Vinnie was that all these women were living in Rome or Florence, where they could find quality marble, experienced cutters, access to wide markets, and where they could escape the stultifying American puritan tradition.[26]

Women had been barred from the American Academy of Fine Arts, and from the Pennsylvania Academy of the Fine Arts, founded in 1802 and 1805, respectively. But Anna Peale was allowed to exhibit at the Pennsylvania Academy in 1811, and moved to Washington where she painted portraits of James Madison and Andrew Jackson. Ominously, she gave up painting when she married in 1841. Her sister Sarah exhibited at the Academy for the first time in 1818, and embarked on a distinguished career, producing portraits of Thomas Hart Benton, Daniel Webster and the Marquis de Lafayette.[27]

But these women could not have succeeded without male help. The Peale sisters, barred from schools, were taught by their father James and their uncle Charles Wilson Peale. Sarah Hope Harvey was taught by her husband, John Trumbull, the famed painter of scenes from American history. Sarah Goodridge was given private lessons by Gilbert Stuart, enabling her to support herself by commissions for miniatures. Maria Martin was hired by John James Audubon to paint backgrounds for his portraits of birds. It was not until 1811 that women, in groups segregated from men, were allowed even to view antique casts of nudes at the Pennsylvania Academy, and it would be another thirty years before women students were admitted to the Academy. When women were finally allowed to attend anatomy lectures, they were forbidden to work from live nude models. It was not until the late sixties that a nude woman could pose for the female class, and it was 1877 before a male nude was allowed.[28]

Women sculptors had a more difficult time than painters. Working with heavy mallets and chiseling marble was not a seemly feminine activity, to say nothing of molding clay into representations of male genitalia. There were colonial women

tombstone cutters and wood-carvers, but the only successful
sculptor was Patience Lovell Wright, who had turned to model-
ing busts in wax when she was widowed at forty-four and be-
came the sole support of her four children. She created a suc-
cessful traveling exhibit of waxwork portraits of famous people.
After a disastrous fire, she decided in 1772 to relocate to Lon-
don where, with Benjamin Franklin's help, she created an exhi-
bition of popular figures including George III, William Pitt and
Franklin himself. Her exhibit preceded Madame Tussaud's by
thirty years.[29]

In many of the American colonies, women owned property,
voted, entered into contracts, served on juries and held minor
offices. But attitudes changed over the course of the nineteenth
century. As *Godey's Lady's Book* put it, "The station of woman
as the companion of free, independent and civilized and Chris-
tian man is the most important she can sustain on earth—the
most honorable, useful and happy." And *The Family Monitor
and Domestic Guide* declared, "So far as cleverness, learning
and knowledge are conducive to woman's moral excellence, they
are therefore desirable, and no further."[30] "However pure a lady
may be who assumes this position," Vinnie was told by a pomp-
ous young man, "the popular prejudice is so strong on the ob-
ject that they will be subjected to remark and even suspicion."[31]
It was no wonder that Hosmer, Lewis and others had chosen to
work in Italy. Only Anne Whitney was a sculptor with whom
Vinnie could identify.

In 1864, at forty-three, Whitney was becoming famous. She
had exhibited a bust of a child at the National Academy of
Design and currently had a life-sized *Lady Godiva* and a colos-
sal *Africa* on display in Boston. Whitney was of necessity self-
taught, although she had received some help from William Rim-
mer, who had produced a giant head of St Stephen and *The
Dying Gladiator*. But Vinnie could not know that in three years
Anne Whitney, too, would move to Rome.

It was true that the flight to Italy had been initiated fifteen years earlier, not by women, but by Horatio Greenough, Hiram Powers and Thomas Crawford. Men were allowed to attend art schools in America, but there was a dearth of competent teachers, of great sculpture for study and inspiration, and of powerful patrons to subsidize and encourage young artists. Men like Powers, who had worked in a Cincinnati waxworks museum and Crawford, who had been a furniture carver, felt compelled to work in Italy. And these expatriates, along with native Europeans, supplied most sculpture that was commissioned by Americans.[32]

Vinnie, at the age of seventeen, refused to be discouraged by this situation. She believed she had a special talent and that she could become a famous sculptor in Washington. Once again, she turned for help to James Rollins, who agreed to formulate a petition—"An Analysis of the Character and Virtues of Miss V.R."—to get patronage for her. His argument for her qualifications would certainly not now be considered politically correct, but contained some insights into her character:

[Miss Ream] is admirably proportioned, indicating in her whole physical conformation great endurance and at the same time much refinement and elegance of character. Her mind is not only quick and sprightly but very strong. She has a taste for the beautiful and sublime in art. She understands men and things well, and for the management of human nature she has few to excel her of her age. On this account she would make a most capital wife for a politician. She has good taste, she seldom does anything calculated to offend. She would make a magnificent coquette if she chose to do so. She has a keen perception of the beautiful, a quick sense of the ridiculous. In her extended association with men she has learned to be somewhat deceitful, which is not natural to her. Her moral instincts are remarkably good; she

despises anything that is low and mean and selfish. Though naturally affectionate she is not a lady whose sympathies and affections are likely to be concentrated upon one person. She has a strong will based upon the earnest conviction that her opinions are right; it is difficult to persuade her to depart from any line of action that she has determined to pursue. She thinks she is very smart, and it is so, for she is so.[33]

The petition was officially approved by Provost Marshall General R. B. Van Valkenberg, but the Inspector General, not surprisingly, returned it to Rollins with an irritated note: "Such unqualified recommendations cannot be approved at the Headquarters. The within named is a woman far above the generality of her sex, but not an angel."[34] This was certainly true. The petition had little effect, and Vinnie decided to attempt something more dramatic.

During the summer, President Lincoln and his family stayed at the Soldiers Home, north of the city, and traveled every day on horseback or by carriage to the White House. Vinnie often saw him coming down Pennsylvania Avenue with his cavalry escort, and became fascinated with his rugged appearance. She wanted him to sit for her. He had, after all, allowed Leonard Volk to take his life mask, and Francis Carpenter had set up a studio in the White House to paint the first reading of the Emancipation Proclamation. If the president sat for her, her reputation would be made. Three of her new political connections agreed to approach the president for her.

Senators James Nesmith and Reverdy Johnson, along with Representative James Moorhead (both Nesmith and Moorhead were to sit for Vinnie) called on Lincoln, who said he did not want to pose, adding that he could "not imagine why anyone would want to make a likeness of such a homely man." As the men rose to leave, Nesmith, a Democrat from Oregon, remarked, "This will be a disappointment to the young artist who selected

you as her subject. She is a little Western girl, born in Wisconsin. She's poor and has talent, and we intend to encourage her in this work, in which we feel she will excel, by giving her an order for a bust in marble . . ."

Lincoln cut him off. "She's poor, is she?" he asked. "Oh, well, that's nothing against her. Why don't you bring that girl up here? I'll sit for my bust."[35]

Vinnie came for a half-hour session with the president on most days when he was in the White House. She recalled that there was little conversation at these times. Lincoln would roam around the office, apparently lost in thought, or slouch at his desk with bowed head. Vinnie, ever romantic, speculated that "he was, during these moments, following in his mind some such thing as the operation of the army of Grant about Richmond, appraising the horrible sacrifices that every day brought upon the people of his nation, feeling that all deaths that wisdom and forethought might prevent would and should be laid at his door. He was hearing the cries of suffering that were coming from the prisons and the sons, lost like his own."[36]

Often he would stand by the window and look out upon the White House lawn. He told Vinnie that he used to watch his son Willie play there every afternoon and added that Vinnie reminded him of Willie, who had died two years before. Tears would sometimes stream down his face as he talked about his lost son. Vinnie said later that Lincoln, known for his frontier humor, "never told a funny story to me. He rarely smiled."[37] Her enduring impression of Lincoln was one of profound sorrow.

The only personal request she made of him was that he sign a copy she had made of the Emancipation Proclamation. He signed it and had Secretary of State William Seward sign as well. The president gave orders that he was not to be disturbed during the sittings and Vinnie could recall their being interrupted only twice. The first visitor was a woman of middle age. She was the mother of a boy who had worn the gray and who had

been captured and was in old Capitol prison. To visit her boy, she needed a pass with the president's signature. He listened "graciously" to her story, Vinnie remembered, wrote out a pass himself and apologized for the boy's situation. On the second occasion, a young pretty woman came in, blushing and stammering over her request. The president anticipated her and granted her wish, saying afterward that he could tell from her blushes that she wanted to visit her sweetheart.[38]

It seems surprising that Lincoln would take time to sit for Vinnie: the presidential election of November, 1864 was approaching, and the question of postwar policy toward the South had been added to the worries of the war. Lincoln considered secession to be impossible under the Constitution and was therefore willing to accept new governments in states where at least ten percent of the 1860 electorate would swear allegiance to the United States and its laws, including the Emancipation Proclamation. Tennessee, Arkansas, Louisiana and the new Commonwealth of West Virginia had complied with these conditions, formed new state governments and elected congressmen. These men were never seated.

Andrew Johnson became Lincoln's vice-presidential candidate on the new Union party slate. The Democrats' candidate was General George B. McClellan, and it seemed at first that Lincoln was in trouble, but Federal performance in the war improved under Grant, and in September when Sherman captured Atlanta, Lincoln's victory was assured. McClellan resigned from the army on election day.

2
THE LINCOLN STATUE

I am bound to express my opinion that this candidate is not competent to produce the work you propose to order. You might as well place her on the staff of General Grant or put General Grant aside and place her on horseback in his stead.

—Senator Charles Sumner

THE LINCOLN BUST DID indeed bring Vinnie into the limelight, as she had hoped. Once it was known that Lincoln was sitting for her, she was commissioned to do busts or medallions of Senator James Nesmith of Oregon, Representatives James Moorhead of Pennsylvania and Green Clay Smith of Kentucky, and of course James Rollins, as well as Provost Marshall R. B. Van Valkenberg, who had endorsed Rollins's petition for Vinnie. In addition she began to include noted sculptors among her connections. If she had not met them personally, she wrote them, asking for their help and enclosing photographs of her work. Evidently she struck the right note, because almost all of them replied to her. After she met Horatio Stone at Mills's studio, he sent her a volume of his poetry, and she thanked him in a letter like those she sent to artists H. K. Brown, James Wilson MacDonald and William Barbee:

"Your kind words of encouragement to me will not be forgotten, for my heart is sensitive to kindness, and no generous word, or look, is forgotten. I feel that you are my friend. You

looked down into my eyes in that way, and if an interest and regard can spring up and bud in the chilling storms and frozen winds of a terrible wartime like this, surely it will expand and blossom beneath the warm and glorious sunlight of peace."[1]

The Lincoln bust was nearing completion: just a few more sittings were scheduled when the president left Washington on March 23, 1865, to meet General Grant at City Point to discuss postwar plans and possible surrender terms. Lincoln returned on the evening of April 9. Within days, Robert E. Lee had surrendered to Grant and Sherman was about to negotiate terms of the final Confederate capitulation. On Friday, April 14, the president, who had been busy, but happier than Vinnie had ever seen him, went to Ford's Theatre to see *Our American Cousin*, starring Laura Keene.

Vinnie was home alone that evening. Around midnight, as her parents were entering the house, someone hurrying past called out that Lincoln had been shot. Vinnie was stricken, and later described some of her emotions during the five months the president had sat for her: "Throughout all this time the personality of Lincoln was gradually sinking deeper and deeper into my soul. I was modeling the man in clay, but he was being engraven still more deeply upon my heart . . . A big, strong man broken by grief is always a tragic thing to see, but never was there a grief equal to Lincoln's . . . [He] would have a far-away dreamy look and his eyes would light up and his whole face would be illuminated . . ."[2] Her sorrow was certainly not lessened by the thought that her great career opportunity might now be lost.

The first service for the assassinated president was held on Tuesday in the East Room of the White House, where the casket was set upon a fifteen-foot-high catafalque. Among the pallbearers were five men who were to play an important part in Vinnie's life: Senators Richard Yates, Benjamin Wade and John Conness, General Grant and Admiral David Farragut. Yates and Conness were to attempt in every way to gain Senate support

for Vinnie, and she was to sculpt a statue of Admiral Farragut. Benjamin Wade, at first a friend, was to become an implacable enemy, as were General Grant and his wife Julia.

At two in the afternoon on Wednesday, the casket was moved from the East Room to a black-canopied hearse to be taken to the Capitol. As the procession started, minute-guns from the surrounding forts were fired, and church and firebells tolled. First behind the hearse came the 22nd U.S. Colored Infantry division, then regiments of white infantry and artillery and cavalry, then Navy, Marine and Army officers on foot. The family carriage followed, with the guard of honor. Mrs Lincoln became too overwrought to attend the services. President Andrew Johnson's carriage was flanked by a strong cavalry guard with drawn sabers. More carriages brought members of the diplomatic corps, the Cabinet and both houses of Congress. Hobbling behind were disabled veterans. The casket was placed on a catafalque in the rotunda of the Capitol, where thousands of people filed past to pay their last respects. On Friday, April 21, the casket was borne by train on a long slow route through Philadelphia, New York, Chicago, to Springfield, Illinois.[3]

The war had ended; a two-day parade of the armies in Washington was planned prior to their mustering-out. By the 22nd of May, the city was crowded to bursting: hotels turned away thousands of people. The weather was magnificent: the rains of the previous week had damped down dust in the streets and the air was cool and fragrant. At dawn on the 23rd, the 100,000 men who had assembled southwest of the city began to cross Long Bridge into Washington to mass in the streets and empty lots around the Capitol. At nine o'clock in the morning, General George Gordon Meade began leading the Army of the Potomac up Pennsylvania Avenue toward the reviewing stands which had been erected in front of the White House for government officials and diplomats. While the enthusiastic crowd cheered and threw flowers and wreaths, General Wesley Merritt's

cavalry went by, followed by General George Armstrong Custer and his Third Cavalry Division. Custer was wearing a bright red necktie over a dark blue blouse with a star-studded collar, buckskin breeches, black jackboots, white gauntlets and a broad-brimmed hat. He attracted considerable attention, and when a young girl broke into the parade to throw him a wreath, his horse bolted and carried him at full gallop to the reviewing stand, where he reined it in and saluted the new president and General Grant.

The parade of the Army of the Potomac went on for the next five hours that day. The next day, the 24th, the Armies of Tennessee and Georgia passed in review, with General William Tecumseh Sherman at their head. Nearly six feet tall, thin and muscular, with sand-red hair, cropped beard and penetrating brown eyes, he had earned the deep, unending hatred of Georgians and North and South Carolinians by his "March to the Sea" during which his soldiers had foraged off the land for supplies, leaving devastated farms and burning buildings in their wake. Each of Sherman's divisions was followed by a baggage train, small herds of goats and pack mules loaded with game-cocks, hams and other provisions. The thousands of freed slaves who had followed Sherman were represented by small groups of black women leading their children behind the baggage trains.

Sherman tipped his hat and bowed repeatedly before the reviewing stands. And when he reached Seventeenth Street, he dismounted and walked back to the stands to watch the remainder of the parade, as all commanding officers had been instructed to do.[4] The lives of President Johnson, Generals Grant, Sherman and Custer were all to intersect with Vinnie's.

Despite whatever foreboding she might have had, Vinnie's career did not end with Lincoln's assassination. Her friends stood by her, and in short order Senators John Sherman of Ohio, Richard Yates of Illinois and Representative Daniel W. Voorhees of Indiana were sitting for her. She also received some publicity:

mention of the young Washington sculptor appeared in the *Albany Register*, the *Little Rock News*, the *Mobile Register* and the *Cincinnati Gazette*. Some editors ran photographs of her work. Vinnie did her part. She wrote letters soliciting commissions: some were simply straightforward requests for work, but others elicited questionable responses. One John W. Wallace replied to Vinnie, "I am desirous to see you, and knowing [*sic*] what those 'unutterable things in Vinnie's dictionary' are I partly divine my child, but have confidence in your caution and discretion. If I ever get to Washington I want you to take my bust. Will you?"[5]

On June 20, 1865, Vinnie's sister Mary married Perry Fuller, a wealthy businessman from Kansas who held a post in the Bureau of Indian Affairs and owned a house in the capital. Fuller, who was rumored to have made his money cheating Indians in land deals, had many influential friends. Lincoln had been a frequent guest in his home long before becoming president. James Rollins was a friend of Fuller's, as was Thomas Ewing, whose father had adopted William Tecumseh Sherman after the death of Sherman's father. The two boys had grown up together in Lancaster, Ohio. Ewing, a lawyer, had served as Major General of Volunteers during the Civil War and was now beginning a practice in Washington. Shortly before Mary Ream and Perry Fuller were married, Ewing began his most notable trial: the defense of Dr Samuel Mudd, charged with conspiracy in Lincoln's murder. It was a hopeless defense: on June 29, 1865, Dr Mudd was found guilty and sentenced to life in prison.[6]

Shortly after the assassination, Lincoln Memorial Committees sprang up in almost every major city. Money for statues and other memorials was being raised from the public, and contracts were to be awarded under differing conditions. It did not take Vinnie long to recover from the shock of the president's death and move to take advantage of this national spirit. She had no intention of waiting until these local committees sent out a call for models. The Federal government, she knew, must eventually commission a statue of Lincoln; she might as well

apply before anyone else did. Rollins had created a petition for her that emphasized her good character. Now she needed a petition bolstering her claim to public patronage, so that she could apply to Congress for a commission for a Lincoln memorial.

She and her friends drafted a petition in which the signers took "great pleasure in endorsing her claims upon public patronage." They listed the busts, medallions and statuettes she had already completed, saying, "As Americans, we feel a national pride in Miss Ream, and a desire to aid her in the development of her unquestionable genius. Fitly sustained, we feel every confidence that she will excel in her profession, and, with age and experience, rank her name with those who have already won high places in America's temple of Art."[7]

The Thirty-Eighth Congress had adjourned a month before Lincoln's assassination. When the Thirty-Ninth Congress took their seats on December 4, 1865, Vinnie had the petition ready. She knew that an appropriations bill for a statue had to start in the House Committee on Public Buildings and Grounds. She made sure that she met the chairman of that committee, fifty-year-old John H. Rice of Maine, who was serving his third term in the House. Rice found her charming and gladly endorsed her petition. Vinnie asked for a little more than just his signature: she told him she would be eternally grateful if he could authorize her use of a small space for a temporary studio somewhere in the Capitol. This would make it possible for other congressmen to view her work and appreciate Rice's excellent taste as a mentor. Rice was happy to order Room A in the Capitol basement to be set aside for Vinnie's use.[8]

With that accomplished, Vinnie worked to gather more signatures for her petition by going through congressional offices, buttonholing members in corridors and holding meetings in Rollins's office and her studio. She told these politicians about her childhood in the fields of Wisconsin and Missouri; her schooldays in Missouri from the age of ten; her learning to play the guitar from an itinerant salesman; her hard work in the

post office while she studied with Clark Mills; her sittings with Lincoln; her longing to prove herself and the gratitude she would feel to those who helped her. Each man was assured that his signature would give the most credibility to the petition.

Most men could not resist this bold, flirtatious, pretty little girl with her impressive aspirations. She got signatures from President Andrew Johnson, Secretary of the Interior Orville Browning, Attorney General Henry Stanberry, Generals Ulysses Grant and George Custer, Speaker of the House Schuyler Colfax, and 108 of the 211 House members, including Thaddeus Stevens of Pennsylvania. Thirty of the fifty-three senators signed, among them Richard Yates, James McDougall, John Sherman, Edgar Cowan and James Nesmith. These men, Republican and Democrat, represented the full political spectrum of their parties. Vinnie's teacher Clark Mills signed, along with his two sons, Theodore and Fisk, and two other sculptors, H. K. Brown and Robert Ayton.

It was now mid-May; Congress would adjourn no later than the end of July. Since a majority of congressmen and senators had signed her petition, Vinnie decided to implement it. On May 31, 1866, she submitted a proposal to Chairman Rice: "Feeling assured that it would meet with the expectations of the American people to have a marble, life-sized figure of Abraham Lincoln placed by Congress in the National Capitol, I respectfully solicit the influence of your Committee in favoring me an order for the same, and submit my model bust of Mr Lincoln, as a specimen of my work."[9]

Now she and Rice set to work to get this proposal turned into legislation, framing the bill, setting what they thought was a reasonable price for the work and planning their response to the opposition that would inevitably arise in both Houses. Rice said that there would be a crush of business in the next two months, so it would be best to wait and approach the legislators at the last moment. This would give Vinnie time to line up more support and make sure that those already committed did not waver.

Vinnie began to send medallions and flowers to selected congressmen. Their response was typified by J. F. Driggs, who wrote, "I have received a beautiful bouquet of flowers which you say are from your own garden and which you hope will remind me of my little friend. I thank you for this present and assure you that it not only reminds me of the giver but of the fact that I was once young and full of hope and aspirations like yourself."[10]

Having no intention of relying on these little gifts alone, she enlisted her friends to persuade reluctant members to give her their vote. Thomas Ewing wrote her that Senator B. Gratz Brown of Missouri opposed her bill, but that he was working to change Brown's mind "by claiming your genius for Missouri" and by bringing him to visit her "tomorrow evening, when you will readily complete the conquest."[11] James Rollins, now retired from Congress, wrote to Green Clay Smith, "I ask you to be her friend, take hold of her case, and push a resolution through the House for her benefit. You can do it."[12]

Daniel Voorhees told Vinnie that he was bringing New Jersey Representative William Newell to see her: "His influence is all powerful and I have enlisted him for the campaign in your favor."[13] At this time Voorhees, a Democrat, was a controversial figure. He had served two terms in the House and had apparently been reelected a third time, taking his seat on March 4, 1865. The election, however, was contested. The House Credentials Committee voted to seat Voorhees, but the Radical Republican Thaddeus Stevens, who objected to Voorhees because of Voorhees' strong support for President Johnson's Southern policies, was powerful enough to force Voorhees to give up his seat, which he did, on February 23, 1866. Vinnie was able to attract men with differing political convictions: at the same time that Voorhees and Stevens were battling over the president's policies and Voorhees' credentials, both were helping her.

James Rollins wrote Voorhees a sympathetic letter, reminding him that he was young and could afford to bide his time,

and criticizing Thaddeus Stevens's Reconstruction policies. The last paragraph of this long letter is interesting: "Tell Vinnie that she's a sweet little rascal. Kiss her for me, if not for yourself. Our mutual fondness for her (if nothing else) will always assure our steady and warm friendship for each other."[14]

On July 11, Senator James Lane of Kansas committed suicide, and Edmund G. Ross was appointed to take his place. Ross, a small, nervous and very ambitious man, who was destined to play a part in the impeachment of Andrew Johnson, was an old friend of Robert Ream's. When he came to Washington he rented rooms at the Ream house, giving Vinnie the cachet of a senator as a tenant. It was not difficult to persuade Ross to become the thirty-first senator to sign her petition.[15]

On July 26, 1866, John Rice addressed the House: "I ask unanimous consent to report from the Committee on Public Buildings and Grounds a joint resolution authorizing the Secretary of the Interior to contract with Miss Vinnie Ream for a life size model and statue of the late President, Abraham Lincoln, to be executed by her at a price not exceeding $10,000, one half payable on the completion of the model in plaster, and the remaining half on the completion of the statue in marble to his acceptance." Amasa Cobb of Wisconsin rose to object. A woman, he said, especially one as young as Vinnie, was not qualified to execute this statue. Rice demanded a vote. The resolution passed, fifty-seven to seven.[16] Vinnie was ecstatic. She was halfway toward her goal.

Now the action moved to the Senate, where John Conness had agreed to introduce Vinnie's bill. Vinnie had chosen him because he had been a friend of President Lincoln, was knowledgeable about art, and was an erudite debater. Born in Ireland in 1821, Conness had been elected to the Senate from California in 1863 as a Democrat, but had switched to the Republican Party. Now, while Vinnie watched the proceedings from the gallery, he waited until various revenue bills were debated before he asked the Senate to consider her contract.

Charles Sumner of Massachusetts now rose. Since he was considered an expert on the arts, having traveled extensively in Europe for nearly three years—from December 1837 to May, 1840—Vinnie had particularly wanted his signature on her petition. But Sumner, once described as "least susceptible to the charms of women," considered Vinnie too inexperienced for this commission and his opinion was shared by his good friend Mary Todd Lincoln. He had flatly refused to sign the petition or even to visit her studio. He was a formidable figure who had been elected to the Senate from Massachusetts in 1851 by a Democratic-Free Soil coalition. In May of 1856, he had made an aggressively Abolitionist speech specifically attacking a South Carolina Senator who was not present. Two days later the Senator's nephew assaulted Sumner in the Senate chamber, beating him so badly with a cane that it took him three years to recover. He was reelected anyway, as a Republican, and his seat remained vacant until he resumed it in December, 1859.[17]

Sumner, a big man, six feet four inches tall, and an accomplished orator with a strong, melodious voice, now rose to insist that Vinnie's resolution be debated. Henry Lane, a Republican appointee from Indiana, moved to postpone consideration of the resolution so that some pension bills could be taken up instead. "I think it quite as important," he said, "to provide for the widows and orphans of our dead heroes as it is to provide for a statue of President Lincoln."

Conness replied that there was "time enough to pass those bills," and asked for a vote on Vinnie's resolution.

Sumner said, "I am for pensions for those who have suffered for our country. Let us go forward and do justice to them before we undertake to appropriate ten thousand dollars for a statue."

Lyman Trumbull, Republican from Illinois who had held his seat for eleven years, now entered the fray. He liked Vinnie, whom he had met through James Rollins, but he had refused to sign her

petition on principle. "The senator from Massachusetts threatens to lay aside the pension bills by making speeches on the subject," Trumbull said. "The question is, will the senator from Massachusetts allow us to take a vote on this resolution? If he had done so, it would have been disposed of long ago; but the senator from Massachusetts threatens that he will make speeches—for what? To delay the soldier from getting his pension."

Sumner protested this remark and Trumbull responded, "Then let the senator forbear and let us act. Vote down the proposition, if you choose. We could have voted a dozen times while these senators have been appealing to the Senate not to delay the soldiers' claim in order to press this matter."

George Edmunds, Republican of Vermont, promptly asked for a vote on which of the two measures should be considered first, and the pension bill won, 19 to 18. As business in the chamber went on, Vinnie left the gallery to line up support. Four senators who had signed her petition—Richard Yates of Illinois, Henry Anthony of Rhode Island, James McDougall of California and Benjamin Wade of Ohio—had been absent when the role was called; she wanted assurance that they would be on the floor when her resolution was taken up again.

In the corridor she encountered Benjamin Wade, president pro tem of the Senate and, like Charles Sumner, a strong, respected Radical Republican. Wade told her he would reintroduce her bill as soon as the pension questions were resolved, and that he was sure the votes were there. Vinnie returned to the gallery and Wade, true to his word, asked that her resolution be brought forward. Sumner rose again to say that he hoped that the resolution would not be discussed. This brought protests from several senators.

"Senators say, 'Oh, let us vote,'" Sumner said. "The question is about giving away ten thousand dollars."

"Taking it up is not giving money away, I hope," Conness said.

"The question is, I say, about giving away ten thousand dollars," Sumner insisted. "That is the proposition involved in this joint resolution."

"For a statue," Conness said.

Sumner responded, "The Senator says 'for a statue'—for an impossible statue, I say; one which cannot be made. However, I am not going to say anything on its merits now; that will come up another time if the resolution is taken up. I ask the yeas and nays on the question of taking up."

The yeas and nays were ordered. Richard Yates, Henry Anthony and James McDougall had returned to the chamber, and they were joined in the yea vote by Charles Buckalew of Pennsylvania, James Guthrie of Kentucky, Reverdy Johnson of Maryland and Henry Wilson of Massachusetts. The final vote for consideration passed, 26 to 8. Now the real debate was to begin.

"If," Charles Sumner said, "there was any assurance that the work in question could be worthy of so large a sum, if there was any reason to imagine that the favorite who is to be the beneficiary under this resolution, was really competent to execute such a work, still, at this time and under circumstances by which we are surrounded, I might well object to its passage simply on grounds of economy. But sir, there is another aspect of this question to which you will pardon me if I allude.

"I enter upon it with great reluctance. I am unwilling to utter a word that would bear hard on anyone, least of all upon a youthful artist where sex imposes reserve, if not on her part, at least on mine; but when a proposition like this is brought forward, I am bound to meet it frankly.

"I am bound to express my opinion that this candidate is not competent to produce the work which you propose to order. You might as well place her on the staff of General Grant, or put General Grant aside and place her on horseback in his stead. She cannot do it. Surely this edifice, so beautiful and interesting, should not be opened to the experiments of untried

talent. Only the finished artists should be invited to its orna-
mentation."

Sumner then went into a long disquisition on all art in and
around the Capitol, much of it produced by foreign artists. Wash-
ington, he said, surrounded by "an amphitheater of hill, with the
Potomac at its feet . . . resembles the capitol in Rome, surrounded
by the Alban hills, with the Tiber at its feet." Then he walked the
Senate through the Capitol rooms, beginning with Charles Wil-
son Peale's portrait of George Washington in the Vice President's
office, then to the "spacious rotunda, where are four pictures by
John Trumbull, truly historic in character . . ." He touched on
Luigi Persico's *Columbus*; on the bronze doors by Randolph
Rogers forged in Munich; on Thomas Crawford's *Armed Free-
dom* above the dome of the Capitol. He completed his survey
with what he considered "the choicest" work of all in the Capi-
tol: Ary Scheffer's portrait of Lafayette in the Hall of the House.

This was an impressive oration, eloquent and erudite, and
of course deeply painful to Vinnie. "If you wish to bestow char-
ity or a gift," Sumner concluded, "do it openly, without pre-
tense of any patronage of art or homage to a deceased presi-
dent. This I can deal with. But when you propose to pay this
large sum for a work of art to be placed in the Capitol in memory
of the illustrious dead, I am obliged to consider the character of
the artist you select."

James Nesmith, who had introduced Vinnie to President Lin-
coln, responded to Sumner. "The first objection the senator from
Massachusetts presented to this appropriation was on the grounds
of economy. Sir, it is the first time I ever knew that senator seized
with the costiveness of economy." He paused as laughter rippled
through the floor and the gallery. "The senator from Massachu-
setts has pandered so long to European aristocracy that he can-
not speak of anything that originates in America with common
respect. Why is he constantly referring us to Europe? If this young
lady and the works she has produced had been brought to us by
some nearsighted, frog-eating Frenchman with a pair of green

spectacles on his nose, the senator would have said she was deserving of commendation. If she could have spoken three or four languages that nobody else could have understood, or perhaps that neither she nor the senator could understand, he would vote fifty thousand dollars." After even more appreciative laughter, he went on. "I say then there is nothing in the objection on the score of economy. This young lady deserves to be encouraged. I venture to say that the works she had already produced, which are on exhibition in the Capitol, and particularly the bust of Mr Lincoln, are unequaled."

Then it was James McDougall's turn to defend Vinnie. He was a Democrat from California who had practiced law in Illinois, serving two years as attorney general of that state from 1842 to 1844, and he had been a friend of Lincoln's. "I dislike much the term 'charity' that is used by the senator from Massachusetts," McDougall said. "It is a word of offense to the person who is the subject of our business. This is not charity. The great senator did himself but little credit, in my opinion, when he arraigned this poor girl before this great forum and denounced this measure as an act of charity. This young lady is undoubtedly a lady of marked genius; and she has proved, so far as the bust is concerned, that she has produced the best likeness of Lincoln of any person that has attempted it. I have the right to say so, because I was perhaps better acquainted with Mr Lincoln in his lifetime than any gentleman on this floor."

Richard Yates, the junior senator from Illinois, was Vinnie's next champion. Unlike many of the politicians who had signed her petition at least partially because they thought she was a deserving American artist, Yates acted simply because he was infatuated with her—a feeling she did not reciprocate, although she did not hesitate to use him. "I am here," he gushed, "to say that I shall vote for this proposition with the most delightful pleasure." He took a moment to point out that he knew Lincoln as well as any member of the Senate: "I remember his features well and I think the artist has given an exact likeness of

Mr Lincoln. When I consider that she is a young artist, that she is an American artist, and that she has displayed remarkable genius, I almost feel that the senator from Massachusetts is a barbarian of the highest order in attacking this young lady."

Amid the amused response to this sally, Senator McDougall rose to support Yates who, he said, "was quite as conversant with the late president, if not more so, than myself, and is as good a judge of perfection of the work done by this young lady artist."

This goodwill balloon was punctured by the next speaker, Jacob Merritt Howard of Michigan, who had drawn up the platform of the first Republican Party convention and christened that party in 1854. His feelings toward Vinnie could be anticipated by the knowledge that he had drawn the substitute Senate bill ensuring the application of the Fourteenth Amendment to males only. "I know, perhaps, as much of the ability of the young lady to whom it is proposed to give this job as most of the members of this body," he began. "I have met her frequently, as other members of this body have done, and surely she has shown no lack of that peculiar talent known commonly as 'lobbying,' in pressing forward her enterprise and bringing it to the attention of senators.

"I have seen her models of Mr Lincoln; I have seen and examined the one, especially, to which reference is most frequently had, and although I do not pretend to be a connoisseur in this kind of art, I am prepared to say that I never was satisfied with that model. To me, it is monotonous and without meaning and without spirit. I expect, I confess, having in view the youth and inexperience of Miss Ream, and I will go further and say—having in view her sex—I shall expect a complete failure in the execution of this work. I would as soon think of a lady writing the *Iliad* of Homer; I should as soon think of placing at the head of an army a woman for the conduct of a great campaign."

This last remark was too much for Edgar Cowan, Republican from Pennsylvania, who knew Vinnie only in passing and didn't much care for her work. He did know history, however,

and he sprang to the defense of women. "They have done both," he said.

"It has not been their general history," Howard said.

Senator McDougall entered the fray. "They have done it," he said.

"No, sir," Howard cried. "I would as soon expect from the pen of a woman the *Paradise Lost* or any other great work of genius which has honored our race."

McDougall persisted. "Did you ever read the *Fragments* of Sappho?"

Howard said that he had read the *Fragments* of Sappho, but "that certainly did not prove that Sappho was capable of writing Homer's *Iliad*."

"She exceeds Homer in many respects," McDougall said.

"In many respects," Howard agreed. "In erotic expression she certainly exceeds Homer. Whether the proposed work in the present case would have similar merit, I cannot say. Let us employ a [Hiram] Powers, let us employ somebody from whom we have a right to expect a complete and creditable execution of a statue of Lincoln."

Jacob Howard's view of female abilities was not a radical one. Vassar, the first real women's college, had opened only the year before. It was not until 1860 that New York State had granted women joint guardianship of children, the right to sue and be sued, to own their own wages and property. Before that time, a married woman could not inherit in her own name, although a single woman could. But most of this New York Married Woman's Property Act was repealed by the state legislature in 1862. And it must be remembered that during the debate over the Fourteenth Amendment, the same Senate that was debating Vinnie's award roundly defeated every attempt to change the word "male" to "person."

Vinnie witnessed this humiliating argument, knowing that even her supporters did not really believe in female equality. But still she was content to leave that Cause to the Cady Stantons

and Susan Anthonys of the world. She knew it was a man's world and she wanted to play the game better than men. She was determined to have her share now. She did not mind being called a lobbyist, but she certainly objected to Howard saying her work was monotonous.

George Edmunds, Republican of Vermont, who had asked for a vote on consideration of the order of the pension bill and Vinnie's resolution, now took the floor, complaining that the resolution required payment of $5000 to Vinnie before there was any official approval of the plaster model. Edmunds asked that the resolution be amended to require approval by the Secretary of the Interior. Conness argued against this; it smacked, he said, of bargaining in the marketplace.

If Congress were to enter into a business transaction with Miss Ream, Edmunds said, then Congress had a right to set acceptance terms. Trumbull disagreed. "I trust," he said, "that the amendment will not be adopted. I do not presume that it is the intention of Congress—certainly it is not mine—to require her to go on and make this statue and run the hazard of being paid or not. I think it would be a mockery to pass a resolution of that kind."

"Sir," Edmunds said, "the issue is fairly presented, whether it is the intention of this Congress to pay five thousand dollars for this mere experiment or whether this artist is willing to take the risk upon her side of completing the model to the satisfaction of the Secretary of the Interior in order to entitle her to the compensation for it. I therefore insist upon the amendment which I have offered."

Benjamin Wade of Ohio called for a vote, but Conness ignored him, and referred to a resolution commissioning a painting by William Powell to be placed at the head of a Capitol staircase. Wade responded rudely, "We don't care anything about Powell now."

At this point, Charles Sumner once more weighed in. "A statue is one of the highest forms of art," he observed. "There have

been very few artists competent to make a statue. Conversing, as I often have, with sculptors, I remember how they always dwell upon the difficulty of such a work. It is no small labor to set a man on his legs, with proper drapery and accessories. Not many have been able to do it, and all these have had in advance experience in art. This candidate is notoriously without it. There is no reason to suppose she can succeed. Voltaire was in the habit of exclaiming that 'a woman cannot produce a tragedy.' In the present case, you ought to take every reasonable precaution."

This was once more too much for Edgar Cowan, the Pennsylvania Republican who had defended women's abilities to write great prose and lead battles. "I have come to the conclusion," he said, "to vote for this resolution, and I have also come to the conclusion that this young lady, whoever she may be, is unquestionably a person of great genius; it may not be exactly in the line of sculpture, but certainly she is that in agitation. She is occupying the talents of all the senators, and has shaken this chamber to its very center. Certainly it is no ordinary girl who can do this. I must confess," he went on, to the amusement of his audience, "I do not know much about statuary myself. Modern statuary, I think, would be about as well made by the tailor and the shoemaker, all except the head, as by anybody else. How it is proposed to have this statue of Mr Lincoln I am not advised. Whether it is to be draped with a Roman toga, or with a white jacket and black coat and blue pantaloons, I do not know."

"Perhaps with a cannonball in his hand," Benjamin Wade offered, prolonging the general merriment. "Perhaps so," Cowan said. "She had not made a very handsome bust of Mr Lincoln, but that was not her fault; it was Mr Lincoln's, because he was not a very handsome man."

When the laughter had died down, he proceeded in a more solemn vein. "He was a great and good man, but she could not be expected to make an Adonis of him. Mr Lincoln was a man

of the saddest face on earth. If it be true that she caught that particular expression, that is the highest evidence of her genius."

James Doolittle, a Wisconsin Republican who had switched from the Democratic Party, said he thought the resolution should be passed, but that it should include Senator George Edmund's amendment to require the approval of the Secretary of the Interior. This comment caused a general outcry from the senators: "No amendment! Let's vote!"

Howard and Sumner called for a vote, and the amendment was defeated 22 to 7. Next, the joint resolution was called to a vote and passed 23 to 9, with 18 senators absent, a majority of whom were pledged to Vinnie. She had won a significant victory. Four of the nine votes against her came from men who had signed her petition, but had evidently been swayed by Sumner's arguments: these were Edwin Morgan, William Sprague, Peter Van Winkle and Waitman Willey. The other five votes against her were cast by George Edmunds, Jacob Howard, Henry Lane, Samuel Kirkwood and Charles Sumner.[18]

On August 30, 1866, Vinnie met with Secretary of the Interior James Harlan and signed her contract, marking the first time that the government had contracted with a woman for a life-sized statue. On an ironic note, when Charles Sumner and Samuel Kirkwood, a radical Republican from Iowa, were to be honored posthumously by statues—Sumner died in 1874 and Kirkwood in 1894—Vinnie executed the statue of Kirkwood, which now stands in Statuary Hall in the Capitol. An anonymous competition was held for the statue of Sumner, and Anne Whitney's entry won. When the jury learned that the winner was a woman, the commission was given to Thomas Ball.[19]

3

LOBBYING AND CONTROVERSY

*Washington lobbying has evidently not improved the
young lady very greatly.*

—*Mary Todd Lincoln*

VINNIE'S CONTRACT WITH Secretary Harlan provided for two payments of $5000—the first when the plaster model was finished and the second and final payment on the completion of the statue in marble. Now that she had this commission, Vinnie wanted improvements made to the basement studio that John Rice, chairman of the House Committee on Public Buildings, had secured for her. Rice was smitten with Vinnie, who treated him somewhat cavalierly, reducing him to sending her little pleading notes:

"I despair of having a personal interview and must once more address you by letter. You will remember the circumstances we had some time ago in relation to attending a ball together. I told you that if one could be found that was not objectionable I would claim the pleasure of your company. I send you a card of invitation to one which I deem of such character as you may attend with propriety."[1]

Rice quickly complied with all Vinnie's requests, providing carpentry work, furniture, plants and even goldfish for her studio. Vinnie also ordered a specially cast and forged revolving steel plate, 197 pounds of bar iron and miscellaneous hardware, all of which cost the government $73.41.[2] The studio was a small, domed, almost circular room with of course a fireplace,

and one large window shaded by an American flag. Hanging on the walls were a series of portrait medallions Vinnie had done of James Nesmith, James Moorhead, Thaddeus Stevens and Provost Marshall R. B. Van Valkenberg, now minister to Japan. Along the curved wall was a row of pedestals holding statuettes and busts in varying stages of completion. In the center of the room Vinnie had placed a harp, two tables—one for the goldfish and another for flowers—a music box, birdcages and the revolving plate for the *Lincoln*.

As was to be expected, newspapermen enjoyed visiting this basement room. "Her studio is crammed with every conceivable thing," reported the *Philadelphia Inquirer*, "including two Confederate generals and a lady, all of whom are advising her as to the head upon which she is hard at work. People are coming and going all the time, a thousand interruptions; how is it possible for her to work?"[3]

Indeed, Vinnie's studio soon became a gathering place for congressmen and other prominent people. It provided neutral ground where generals from both sides could meet and discuss their battles, where Radical Republicans could socialize with Southern Democrats, and where cliques could meet to formulate plans. Vinnie welcomed everyone, regardless of political affiliation, although she made sure to be doubly charming to celebrated personages.

About a month after the awarding of the commission, Rollins wrote to Mary Todd Lincoln, introducing Vinnie and requesting her cooperation on the young sculptor's project.[4] Vinnie wrote as well, to ask Mrs Lincoln's opinion about details of the statue. It is possible that Mrs Lincoln did not know that Vinnie had sculpted Lincoln's bust; the president may not have told her, because she had a tendency to jealous tantrums, flying into a rage when she learned that Lincoln had visited an army camp where General Charles Griffin's wife was the only woman, and on another occasion when she thought the wife of General Edward Ord was riding alongside the president.[5] In any case,

she chose to consider Vinnie a kind of interloper when she replied to her on September 10, 1866, a note in which the punctuation was not the only oddity:

Miss Vinnie Ream,
 Your letter has been received and I hasten to return an early reply. I shall be unable to comply with your request and you will allow me to say you are undertaking a very sacred work, one of great responsibility, which artists of world-wide renown would shrink from, as incapable of the great task. Every man, woman and child in our land felt as if they knew my beloved and illustrious husband, even if they had seen him but once. In your case, your home, was far removed from ours: in Washington, even if you resided there, during the late President's administration. With his life of toil, he had no opportunities and far less inclination, to cultivate the acquaintance of any save those who were compelled to be with him daily in saving our great Nation from the hands of its enemies.
 As every friend my husband knew, was familiar to me, and as your name, was not on the list, consequently you could not have become familiar with the expression of his face, which was so variable, even to those and especially myself, who had passed almost a life time in studying its changes. The photographs that abound in the country have never done justice to my dear husband, yet I will admit, if you, had even, been introduced to him, in the gaping crowd, the kind & beautiful expression of his countenance would never have been forgotten.
 That happiness was mine for long years of greater felicity, than is usually allotted to frail humanity and his expression was so changing, yet always so kind and almost heavenly—that with my heart then as now, filled

with unutterable love for him who so truly and fervently
returned it—I cannot fix my distressed mind on any par-
ticular look, hence the difficulty of the task, for you, a
stranger to this great, good, & Christ-like man.

Praying that you may have success,

I remain

Truly,

Mary Todd Lincoln[6]

That same day Mrs Lincoln wrote to her friend Charles
Sumner: "My dear Mr Sumner, I was forcibly reminded of you
& your remarks in the Senate by receiving a note from Miss
Vinnie Ream on the subject of her proposed statue of the late
President. Washington lobbying has evidently not improved the
young lady very greatly. Nothing but a mortifying failure can
be anticipated, which will be a severe trial to the nation, and
the world, and the country will never cease to regret that your
admonitions were disregarded."[7]

Sumner replied that he had done his best during the debate
in Congress, and that he had plans to ensure that Vinnie would
never be paid and that the statue would never be placed in the
Capitol.[8]

Although she would certainly have liked Mrs Lincoln's co-
operation, Vinnie had no intention of being intimidated by the
widow. She had decided to produce a realistic portrayal of Lin-
coln wearing the suit he had worn to the theater on the night of
the assassination. Since she knew that Mrs Lincoln had given
the clothes to Alphonse Donn, a White House guard, she asked
her friends to write to Lincoln's son Robert to see if he would
help her obtain the suit. Mrs Lincoln read these letters and on
March 18, 1866, wrote Alphonse Donn that she did not want
the clothes given to "a Miss Vinnie Ream, an unknown person,
who by much forwardness and unladylike persistence, obtained
from Congress permission to execute a statue of my husband,
the late President. From her inexperience, I judge she will be

unable to do this, in a faithful manner. Let me hear from you on this subject when you receive this letter—and show the letter to no one—only burn it."

Vinnie's friends responded by pressuring Donn directly. In desperation the guard wrote to Mrs Lincoln for help, and the harried widow backed off, writing Donn, "I write you in haste, merely to say—that you can act as you please in this matter. This Miss Ream, is an entire stranger to me and mine—and I expect very inexperienced in her work, but I trust very sincerely, she may succeed."[9] Donn lent the clothes to Vinnie, and she copied them for the statue.

The award of the contract to Vinnie did not go unnoticed by the press, which seemed evenly split between those who applauded the support of a young artist and those who decried what they perceived as an action prompted by infatuation with an ambitious coquette. After a round of negative and positive editorials praising or attacking Vinnie, the papers began to attack each other. Vinnie's friends added to the furor by writing to the newspapers to defend her and themselves. But it was friends of Mrs Lincoln and of other artists who attacked Vinnie most harshly. Jane Grey Swisshelm, an influential newspaper columnist and Mary Lincoln's lifelong friend, initiated what was to be a long and bitter feud with Vinnie, by writing an open letter to most leading newspapers:

> Miss Minnie [sic] Ream, who received the $10,000 for a Lincoln statue, is a young girl of about twenty who has been studying her art for a few months, never made a statue, has some plaster busts on exhibition, including her own, minus clothing to the waist, has a pretty face, long dark curls and plenty of them, wears a jockey hat and a good deal of jewelry, sees members at their lodgings or in the reception room at the Capitol, urges her claims fluently and confidently, sits in the galleries in a conspicuous position and in her most bewitching dress,

while those claims are being discussed on the floor, and
nods and smiles as a member rises and delivers his opin-
ion on the merits of the case with the air of a man sitting
for his picture, and so carries the day over Powers, Craw-
ford and Hosmer, and who not?"[10]

Vinnie was particularly incensed by Swisshelm's assertion
that the bare-breasted female bust in her studio was a self-por-
trait. Such brazen exhibitionism would never have been toler-
ated by the public or the politicians on whom she was depen-
dent. The bust was in fact *Violet*, an idealized figure bearing no
resemblance to the artist. Happily for Vinnie, Swisshelm's com-
ments were attributed to malice. Vinnie was far more disturbed
by attacks on her by Sara Jane Clarke Lippincott, a respected
journalist who wrote under the name of Grace Greenwood.
 Before her marriage to Leander Lippincott in 1853, Sara
Jane Clarke had contributed articles to the *Atlantic Monthly*,
Harper's New Monthly and other prominent journals, and had
served on the staff of *Godey's Lady's Book* from 1849 to 1850.
On a tour of Europe from 1852 to 1853 she sent travel sketches
and interviews to the *National Era* and the *Saturday Evening
Post*. President Lincoln himself had praised her for her work
during the Civil War, lecturing, raising funds and visiting the
troops.[11]
 Vinnie did not usually respond openly to criticism, but she
complained publicly about Grace Greenwood who, she said,
"upbraided my patrons and called me a child, asking Congress
to pay for my school bills but take me away from sculpture,
adding that if any work was to be done out, it should be given
to that Roman matron, Mrs Ames, and Mrs Ames is Grace
Greenwood's sister."[12] This was Sarah Fisher Ames, the first
woman sculptor to settle in Rome. She had been born in Lewes,
Delaware, was married to the painter Joseph Alexander Ames,
and did portrait busts, the best known of which is one of Abra-
ham Lincoln.[13]

The *Chicago Tribune* carried the articles by Greenwood and Swisshelm and attacked Vinnie in editorials, prompting Vinnie's friends to rally to her defense. Henry Guerdon, editor of the *New Republic*, promised to "correct the erroneous impression created by the [*Tribune's*] dastardly slander."[14] Representative Daniel Voorhees wrote a blistering response to a series of negative articles in the *New York World*, prompting the *World's* editor Manton Marble to apologize on February 19, 1867 for his paper having "been made the instrument of gross injustice to a woman," and to promise to correct the abuse in subsequent issues.

The Springfield Illinois *Daily State Journal* took Whitelaw Reid, editor of the *New York Tribune* to task for showing "his own want of appreciation and want of sense by endeavoring to create a popular prejudice against" Vinnie.[15] The *Liberty* [Missouri] *Tribune* attacked Jane Grey Swisshelm in an article nastily headed "A Homely Woman's Opinion of a Pretty One."[16]

This war of words continued for months, making Vinnie the latest *cause celèbre*, and it resulted in a strong bond between Vinnie and radical Republican Representative Thaddeus Stevens of Pennsylvania. Vinnie recalled that Stevens came to her studio one day to tell her about a conversation he had just had with a Mrs Ann S. Stephens.

Mrs Stephens, Stevens said, had begun to complain about Vinnie, and the congressman had asked her, "What is she doing ill?"

"Decorating with flowers," came the response, "wearing long hair, attracting the men and thereby lobbying."

"Well," Stevens told her, "it seems to me that you are around here lobbying a good deal, Mrs Stephens, if talking to a congressman is lobbying."

Mrs Stephens protested that no girl could "keep chaste and pure with three hundred wretched men around her," to which Stevens retorted, "Well, out of all the three hundred, there has never been an effort to do as much harm to Miss Ream as one

woman can make." He had then, Vinnie said, taken "up his crutch, hobbled over to see me, befriended me immediately and boldly."[17]

Something in Vinnie's flaunting of convention and her resulting notoriety perhaps struck a responsive chord in Stevens. He himself had defied convention by living for twenty years with his housekeeper Lydia Smith, a mulatto woman who had moved in with him after her husband's death. Stevens was periodically attacked in the press for living "in open adultery with a mulatto woman whom he seduced from her husband." The congressman was fiercely devoted to the equality of the races and, although not a patron of the arts, sympathized with young artists and helped to establish an art school in Philadelphia.

Whatever the reason, he enjoyed Vinnie's company and agreed to sit for her. He was in his mid-seventies when they met, was lame and wore an ill-fitting wig, but no one dared to laugh at him, because he was chairman of the powerful House Ways and Means Committee, and the possessor of an acerbic tongue. Anyone who crossed Stevens could find himself ridiculed on the House floor, as for instance when he ended a speech by saying, "I now yield to Mr B. who will make a few feeble remarks."[18]

Vinnie and Stevens had felt an instant affinity. When he became too ill to manage the steps to her studio, Vinnie took up her tools and her clay and went to his house to work—this in an age when it was not acceptable for unescorted reputable ladies to behave in this way. Later, when the Radicals were seeking to punish Vinnie, it was Stevens who was to champion her cause and save her *Lincoln* from destruction.[19]

Vinnie was nineteen years old and a focus of national attention. In addition to Stevens, she was doing busts of Senators John Sherman, Reverdy Johnson and Richard Yates, Speaker of the House Schuyler Colfax, Representative Francis Preston Blair, and Horace Greeley. General Grant was a frequent visitor, and as he was clearly the man of the hour, she executed a statuette

of him.[20] But Vinnie's appeal to prominent middle-aged men, based on flattery, coquetry and an air of helplessness, failed her with Greeley and Grant. In Greeley's case, she made the mistake of modeling his bust too literally: with his round face, spectacles and fringe of white whiskers, he resembled an owl, and Vinnie sculpted what she saw. Greeley considered the bust a caricature and was so angry that the *New York Tribune* did not print a favorable review of her work until after his death. The problem with Grant, however, was not with the general, but with his wife.

Vinnie did not often establish friendships with women. Her enemies included not only Mary Todd Lincoln, Jane Swisshelm and Grace Greenwood, but Julia Dent Grant as well. Years later, when Mrs Grant was introduced to Enid Yandell, a young sculptor, at the Chicago World's Columbian Exposition, she asked, "A sculptor! You cut marble?"

When Enid Yandell replied that she did indeed cut marble, Mrs Grant replied, "I met one before. She was a great deal about the general. I don't approve of woman sculptors." She went on to volunteer her belief that "every woman is better off at home taking care of husband and children. The battle with the world hardens a woman and makes her unwomanly." Asked, "And if one has no husband?" she replied, "Get one!"[21]

The fact that this conversation took place twenty-five years after Grant visited Vinnie in her studio, is an indication of the level of Mrs Grant's animosity toward the young artist. Her disapproval carried a high price. While Grant was president, he rejected every petition presented to him that favored Vinnie or her family.

Vinnie, possibly distracted by the innumerable irons she had in the fire, did not see the circular soliciting entries for the Paris Exposition until the January 31, 1867, deadline had passed. But she felt she could not lose this chance to establish an international reputation. Her bust of Lincoln would, she thought,

be the key to gaining acceptance to the Exposition through the influence of Lyman Trumbull and Richard Yates, senators from Illinois, Lincoln's home state. She knew that she could not manipulate the moderate Republican Trumbull; her scrapbook contains evidence of her respect for him. Described by a popular historian as a self-possessed man "of innate dignity,"[22] Trumbull had refused to sign Vinnie's petition, but had defended her on the Senate floor out of conviction. Vinnie and Trumbull would remain friends for life precisely because she did not attempt to exploit that friendship.

Richard Yates was a different story. He had signed her petition and spoken for her during the Senate debate. He came frequently to her studio, trying to spend time alone with her, and wrote to her when he was out of town in Chicago or Boston, and even when he was on vacation with his family in Florida. He was clearly infatuated with Vinnie, so she pinned her hopes for the Paris Exposition on him, although she did not even like him. He had joined the Congressional Temperance Society early in 1866, but he had a drinking problem that he could not overcome. His letters to his "dearest wife" express the drunkard's remorse: "You have been very kind and good to me and under the influence of liquor I have treated you with an unkindness for which I can only ask your forgiveness."[23]

Vinnie considered Yates a nuisance, but now she sculpted a medallion of him and told him she thought the medallion should be submitted along with the Lincoln bust to the Exposition. Yates responded promptly by writing to James H. Bowen of the Exposition that Vinnie was sending her work and that the Lincoln bust should be placed in the fair's Illinois department. Many eminent men, he told Bowen, were Vinnie's friends. In a second letter, he wrote bluntly, "As a friend of mine, I desire to solicit your earnest personal attention in giving prominence to the exhibition of her specimens and in securing special and favorable notices in correspondence and in the final Report of the Fair."[24]

Bowen yielded to this pressure, telling Yates to forward Vinnie's work.[25] But in the official report on American art at the fair, there is no mention of Vinnie. The report contains complaints: American sculpture was scattered throughout the Champs de Mars, and the judging was heavily weighted toward the French. Of the twenty-five members of the jury on paintings and drawings, twelve were French, and eight of these were painters competing for prizes. Four of the eight grand medals were awarded to French jury members, and France won twenty-three of the thirty-six prizes for sculpture. The works mentioned in the report were Harriet Hosmer's *Sleeping Fawn*; J. Q. A. Ward's *Indian Dog and Hunter*; Launt Thompson's *Napoleon*; statuettes by John Rogers, and "some clever medallions" by "Miss Foley, a promising Vermont artist."[26]

In addition to the Exposition fiasco, Vinnie was still smarting over Charles Sumner's remarks about her in the Senate chamber. She thought that if the senator came to her studio, she could win him over. The only way she could think to get him there was to execute a bust of him that would win critical acclaim; surely then he would be willing to come to the studio to see it. The obvious problem was how to sculpt the bust when there was no way to get Sumner to sit for her. Yates brought her a stereoscopic picture of Sumner, but she did not find it properly three-dimensional. Then she concocted a harebrained scheme: Yates would order a copy of Martin Milmore's bust of Sumner so that she could work from it. But when Yates told her that he had ordered the bust sent to her studio, she was livid.[27] If Sumner were to discover that she was copying a bust, he would make sure that her reputation was destroyed. Fortunately, she came to her senses and dropped the idea.

Almost immediately after securing the contract, Vinnie had begun to think about taking her *Lincoln* model to Italy to be cast in marble, even though the model was at least two years

away from completion. She asked Senator Edmund Ross, her father's tenant, to contact T. Bigelow Lawrence, the Consul General in Florence, to get cost estimates. After a month, Lawrence replied: "As you can readily understand, sculptors of the highest rank charge in proportion to their reputation for works executed in their studios, although it is seldom even in one of his own productions, that a sculptor touches the marble, *his* work being finished upon the completion of the model, & the execution in marble being entirely a mechanical process. Mr Powers' charge for executing the statue you describe is 800 pounds stg. in gold, while that of one or two other artists is 600 pounds."

A better bid, Lawrence felt, came from a banking firm that also contracted work to the marble cutters at Carrara. Their offer included "the best quality white marble for *320 pounds stg in gold*, they undertaking to pack the same and deliver it free of all excise on board ship at Leghorn." This sounded good, but Lawrence added, "They make this proposition upon the understanding that there is no unusual projection in the statue such as an elevated or extended arm, which could require a much larger block of marble and necessitate an increase in their estimates."[28] The right arm of Vinnie's *Lincoln* was slightly extended. That put paid to that offer.

But Vinnie believed in planning ahead. Although she was certainly not a shrinking violet, she could not see herself undertaking a European journey alone, even two years in the future. She would need her parents with her to protect her reputation and possibly even provide companionship if nothing else turned up. Money would certainly be a stumbling block, but she thought of a way around that: her father could be appointed to a consular position in Italy. She believed she had enough contacts to generate letters and petitions on his behalf. She began by posing for a photograph in her studio, sitting apparently asleep in an easy chair, her head with its luxuriant curls delicately turned

against her left shoulder, surrounded by her medallions, statuettes, busts and allegorical works. This would demonstrate her accomplishments and her devotion to her art.

Her next move was to begin the network pressure. Representatives James Rollins and John Rice wrote to Secretary of State William Seward on Robert Ream's behalf, and Representative James G. Blaine of Maine produced the following petition to President Johnson, signed by Senators Ross, Yates, and Trumbull, along with Thaddeus Stevens and seventy-five other congressmen, Radical and moderate alike:

> We take pleasure in earnestly recommending Mr Robert L. Ream for appointment in Southern Europe.
>
> Both on account of Mr Ream, who is an industrious, highly cultivated and accomplished gentleman, thoroughly acquainted with the French and German languages, and who would do his country credit as a representative abroad, and on account of his daughter, we trust you will act favorably in this matter.
>
> Miss Vinnie Ream had evinced so much genius for this beautiful art of Sculpture that we have intrusted her with an order for a statue of Abraham Lincoln, and knowing that you too, must feel a national pride in her success, as one of America's own daughters, we trust that you will co-operate with us in encouraging and developing this native talent. In other countries, the Governments foster, and draw forth, the genius of their children. Let us also take them by the hand.
>
> As is most natural for one so young the child dreads to be separated from her family and is extremely anxious for them to accompany and remain with her, while she pursues her studies. We sympathize with her in this, and earnestly hope you may feel an interest in her and consider favorably our request.[29]

The next step was to choose someone to present this petition to President Johnson. Vinnie's choice was Francis Preston Blair of Missouri, a Democrat with pro-Southern sympathies similar to Andrew Johnson's. Although a slaveholder, he had been a Union general in the Civil War. Blair met with Johnson, and immediately wrote Vinnie: "I went in person to deliver your roll of Congressional patrons to the President. I let him understand that it was an appeal of both Houses. That Mr Seward had given you encouragement that the appointment would not be withheld. Now you must have some of your Congressional friends follow this up."[30]

Vinnie wasted no time. Representative Daniel Voorhees gave her a letter of introduction to the president and suggested she get a second letter from a congressman friendly to Johnson. Vinnie chose Samuel Marshall, Democrat from Illinois, who provided her with the requested document on July 24, 1867, addressed to "His Excellency the President" and noting that "This will be presented to your Excellency by Miss Vinnie Ream in whose behalf I spoke to you some time ago." After describing Robert Ream's character in exalted terms, Marshall wrote, "The patronage of a great government can never be more usefully and honorably employed than when aiding a struggling child of genius." Vinnie's future artistic contributions would, Johnson was assured, "add additional lustre" to his administration. The letter concluded with a recommendation that Ream be posted to Europe.[31]

Samuel Marshall's personal letters to Vinnie employed a somewhat different tone. "It would give me inexpressible happiness," he wrote from his desk in the House, "to be permitted to steal you away to some quiet lovely spot blessed with sunshine, birds and flowers and there to nurse you, talk to you, read to and with you, and devote my whole soul and life to you. . . . My darling idol! These halls seem to me inexpressibly dark and gloomy this morning. It would be happiness to visit your studio to be blessed with the light of your eyes. . . ."[32]

Vinnie did have a private meeting with President Johnson, although all this activity was premature, because her Lincoln model was far from finished. This meeting was to have unpleasant consequences. In any case, Vinnie had become adept at winning admirers so that she could use them; often she would then avoid these men until she needed them again, or drop them altogether if they lost power. She had put her relationship with Chairman John Rice of Maine on ice after he furnished her studio, ignoring his written pleas for a "personal and private interview" with her and his promises to be "generous and unselfish" toward her. But she found it necessary to use him again on March 2, 1867, when he wrote Secretary Seward supporting her father's diplomatic appointment. March 3 was Rice's last day in Congress and, except for a few brief notes over the years, he disappeared from Vinnie's life.[33]

Vinnie was coldly calculating in her dealings with men like Rice, Samuel Marshall and Richard Yates; she apparently had little respect for them. But, whatever her original motives, she was able to establish lifelong friendships with Senators Edmund Ross, James Rollins, Lyman Trumbull and Representatives Daniel Voorhees and Thaddeus Stevens. Later she would maintain strong friendships with Ezra Cornell, founder of Cornell University; the American genre painter George Caleb Bingham; General Sherman and at least one woman, Elizabeth Bacon Custer.

When the fortieth Congress took their seats on March 4, 1867, the ranks of Vinnie's supporters were thinned by the retirement of John Rice and the loss in the Senate of James Nesmith and James McDougall; but Representative James Moorhead, who, along with Nesmith and McDougall, had first presented Vinnie's case to Lincoln, returned, as did James Blaine, Samuel Marshall and Thaddeus Stevens in the House and John Sherman and Lyman Trumbull in the Senate.

In early January, 1868, Vinnie received a letter from Simon Mills of the Wisconsin State Historical Society informing her

that the society was petitioning the legislature to authorize funds for statues of two ex-governors, Henry Dodge and James Doty, to be placed in Statuary Hall in the U.S. Capitol. Simon Mills was a friend of Robert Ream and had signed Rollins's petition for the Lincoln statue. Now he urged Vinnie to act quickly; she might, he said, win the commission without a competition.[34]

Vinnie did not need to be told this twice. She immediately mounted a blitzkrieg campaign: over the next five weeks appeals from U.S. congressmen on her behalf flooded the offices of Wisconsin Governor Lucius Fairchild, Lt. Governor Wyman Spooner and the state legislators. Representative George Julian of Indiana wrote Governor Fairchild: "Miss Vinnie Ream, a most worthy and gifted little girl who is a native of your state, & is regarded here on all hands as a very fine artist, hopes your legislature will give her the work which it will have to commit to someone under the resolution of the congress. I earnestly hope she will not be disappointed. I am sure that if your people and Legislature knew & appreciated her as we do here & have seen the evidence of her genius, her perfect devotion to her art, & the real worth & beauty of her character they would have no hesitation whatever in doing what she asks from her native state."[35]

Julian's letter was typical of these appeals, which called Vinnie a great sculptor, a friend of many congressmen, and a child of the state of Wisconsin, and each of which closed by saying that the writer would consider it a personal favor if Vinnie were granted the contract. Benjamin Wade, John Rice, Edmund Ross, Richard Yates and Daniel Voorhees were among those who wrote these letters, most of which were given to Vinnie for vetting before they were mailed, a fact that may account for their similar tone. Vinnie herself was a prolific letter writer and loaded the post between Washington and Madison with her personal appeals.[36] It is noteworthy that congressmen and senators spent time writing letters for Vinnie at a moment when the legislature and the executive were engaged in a bitter struggle over the

government's Reconstruction policies in the South, and impeachment of the president was imminent. Benjamin Wade himself, as president pro tempore of the Senate, was poised to succeed Andrew Johnson.

Two weeks after his first letter, Simon Mills wrote Vinnie that Governor Fairchild wanted her to come to Madison bearing a letter from Thaddeus Stevens addressed to the radical Republican speaker of the Wisconsin house, and that it might also be a good idea for her to bring a letter from Daniel Voorhees for the moderate legislators. Mills warned her, "Present indications are that this session will be unusually short, and I think you had better come early in February."[37]

She crated a few busts and arrived in Madison on February, 15, 1868—nine days before the U.S. House was to pass a Resolution of Impeachment against the president. She registered at the Vilas House and began to go from office to office, pleading, flirting, cajoling, handing out letters of endorsement and talking about her strong connection with the state of Wisconsin. Her father had come there in 1837, had held state offices and was appointed Territorial Treasurer; she had, she pointed out, been born in her father's log hotel on September 25, 1847, eight months before Wisconsin became a state. She reminisced about growing up in Madison, collecting tall grasses and wildflowers and playing with Indian children, at a time when the population of the capital numbered only six hundred souls.

Although she had attended St Joseph Female Academy and Christian College in Columbia, Missouri, she was, she assured everyone, a true daughter of Wisconsin, and it was the duty of the legislature to see that Wisconsin filled the niches set aside for it in the U.S. Capitol. In the Historical Room of the Wisconsin Capitol she set up a small studio where she exhibited the busts she had brought from Washington and where legislators and other visitors crowded around to watch her mold medallions of famous Wisconsin citizens.

It was ironic that Vinnie should be striving to win a contract for statues of Henry Dodge and James Doty. These men were political enemies, and Robert Ream had been caught in the struggle between them. Ream had been appointed Territorial Treasurer by Henry Dodge, then Democratic governor of the territory, while James Doty was the delegate to the U.S. Congress. When the two came into conflict over control of funds to complete the Capitol building at Madison, Ream threw his support to Dodge. In May, 1841, when James Doty was appointed governor to succeed Dodge, he promptly named James Morrison to be Territorial Treasurer, claiming that Ream had forfeited his post by neglecting to post the required bond. Ream refused to surrender his books and funds, holding tenaciously to his office until his term expired in December. On February 2, 1842, an investigating committee determined that Robert Ream had in fact posted the necessary bond and had been the legal treasurer.

On February 25, 1868, Andrew Johnson was impeached. Vinnie found this news unsettling; she was afraid the political upheaval might disturb her tenuous relationships with Radical and Democratic supporters. But she continued her singleminded pursuit of the Wisconsin commission, and on Friday, February 28, managed to have a resolution introduced in the state senate calling for her to execute the two statues at a cost of $10,000 apiece. A heated debate ensued on the wisdom of spending money on statues instead of paying down Wisconsin's heavy war debt, and the resolution failed.

That night Vinnie and her senatorial friends drafted a substitute resolution authorizing the governor to contract with Vinnie whenever he felt the state could afford the expenditure. Saturday was a better day for Vinnie; she watched from the gallery as her resolution passed, 19 to 11. But the real test came on Monday when the Assembly considered the resolution. Vinnie did not think she had the votes, but she was surprised that she lost by such a large margin: 64 to 22. Even the motion to recon-

sider was tabled. She did not want to leave Wisconsin empty-handed. The best her friends could do for her was to introduce this new resolution on Tuesday:

"That the State of Wisconsin had just cause to be proud of the eminent skill as an artist of Miss Vinnie Ream, a native of this State, and that, in the opinion of this Legislature, whenever the financial condition of our State shall warrant the filling of the two niches assigned to Wisconsin in the National Capitol, with the statues of her illustrious dead, the claim of Miss Ream to the contract for the execution of the work should be considered paramount for that of any competitor, not a native of our State, who may seek to obtain it."[38]

This resolution passed both houses easily, but it was not what Vinnie wanted. Since it presented an "opinion," it was not binding on future sessions of the legislature, and it did not rule out a competition. However, she had to accept the fact that it was the best she could get. She went back to Vilas House and settled her account: $140.10, including $110.10 for 18 and 3/4 days board, $10.00 for twenty-one fires, $5.50 for laundry, $5.50 for damage to a carpet, $4.00 for livery charges, fifty cents for a dinner sent to the Capitol and miscellaneous.[39] She left Madison that day, and three days later, on March 6, 1868, Governor Fairchild signed her resolution. But all this effort proved to be an exercise in futility: Vinnie never sculpted statues of Doty and Dodge, and neither did anybody else. It would be almost thirty years before Wisconsin commissioned a first statue for its two niches: *Marquette* by Gaetano Trentanova; the second, Jo Davidson's *La Follette,* was completed in 1929.

She was cheered during her time in Madison by a letter from Senator Edmund Ross telling her that he had been conducting tours of her studio in her absence and that visitors "all were much pleased with what they saw, especially the model for the statue of Mr Lincoln, which has been uniformly pronounced by all who had known Mr Lincoln, to be the most perfect likeness of that great man they had ever seen." Even better, Ross wrote

that "Several orders have been left for your Violet and other ideal pieces, which they expect to be filled as soon as possible."[40]

Vinnie had suffered several defeats in the nineteen months since she won the Lincoln commission, but now at least she seemed to be beginning to make money as a sculptor.

4

IMPEACHMENT

He is in your power and you choose to destroy him.
　　　　　　　　　　—General Daniel E. Sickles

ANDREW JOHNSON WAS sworn in as president of the United States on April 15, 1865, the day after Abraham Lincoln was assassinated. Although he was a Democrat from Tennessee, had in fact been governor of Tennessee, Johnson had remained in the Senate throughout the war and the radical Republicans had faith in him because of his fervent rejection of secession that made him a fugitive in his own state. He came from a humble background—he had been a tailor and had not learned to read and write until he was in his twenties—and intensely disliked the wealthy Southern plantation owners, whom he had been known to call "traitors." But his sympathies for poor farmers and other underprivileged citizens did not extend to blacks, against whom he nursed a strong antipathy.

Once in office, Johnson appeared to reflect the attitudes Lincoln had expressed in his Second Inaugural Address ("With malice toward none, and charity for all . . . let us . . . bind up the nation's wounds . . ."), attitudes that were anathema to the Radicals. And in fact Johnson's biographer believes that his president let slip a real opportunity to reform Southern racial practices.[1] In early May, 1865, Johnson recognized the four Southern states to which Lincoln had offered restoration to the Union

if they swore allegiance to the United States and agreed to obey all its laws, including the Emancipation Proclamation. Johnson went on from there to grant amnesty to citizens of the remaining rebel states, which he ordered to write new constitutions that would abolish slavery, but without granting Negro suffrage. Radical Republicans—men like Thaddeus Stevens, Benjamin Wade and Charles Sumner—were quickly disillusioned about Johnson's dedication to the reconstruction of a new South. They managed to pass the Civil Rights Act of April 9, 1866, over his veto.

Congress could pass laws but had no effective means of enforcing them. The provisional governors Johnson appointed for the conquered territories were, with some notable exceptions, lackluster men whose actions were a pleasant surprise to supporters of the Confederacy, who had been prepared to accept Washington policies, including black suffrage. Now, as Johnson issued wholesale pardons to former Confederates who had faced disenfranchisement, white Southerners were relieved to see that the president did not intend to interfere with their control of postwar society. The Radicals in Congress wanted the Army to carry out policies that were opposed by the Commander in Chief.

The situation came to a boil as the result of the Tenure of Office Act, passed on March 2, 1867, which required that all officials appointed with the consent of the Senate remain in office until a successor was approved. Without Senate approval, Cabinet officers could not be removed during the term of the president who had appointed them. To further prevent Johnson from directing Army policy, Congress required that all orders to Army commanders be approved by General Grant. On February 21, 1868, Johnson decided to test the Tenure of Office Act by removing Secretary of War Edwin M. Stanton from office. It was not clear whether the act would apply to Stanton, since he had been appointed by Lincoln.

After Johnson failed to convince first General Grant and then General Sherman to take on the Secretary of War position, the president turned to General Lorenzo Thomas. But the Radicals convinced Stanton to barricade himself in his office, having decided they now had sufficient ammunition to initiate impeachment proceedings. At the same time that Benjamin Wade and George Julian and others were writing endorsements for Vinnie in Wisconsin, they were planning to rid the country of the president. Eleven articles of impeachment were drawn up against him, nine of which dealt with Stanton's removal or with alleged attempts by Johnson to circumvent Grant's authority.[2]

On February 25, 1868, Johnson was impeached. The next day Thaddeus Stevens went to the Senate chamber, despite his deathly pallor and his inability to stand without support. The *New York World*'s description reflected the considerable animus against him: "A wig of black gave by contrast an added and horrid ghastliness to the yellow face—but there was no face, it was an anatomy merely—these were not so much eyes as snakes that glittered in the deep pit-holes; the voice was as hollow and sepulchral as if already issued from the tomb. Full of malignant passions, and even now the prey of the grave, he must carry in himself the worst fate he dare imprecate upon his enemies. Quivering with passion and exultation, this vindictive despot of the despotic majority tottered forward from his place, and shaking a finger above his head, defied the Senate to find any verdict but the verdict of guilty."[3]

Benjamin Wade received the articles of impeachment from the House, and promised fast action. Wade, who had been elected to the Senate in 1856 and reelected in 1863, was president pro tempore of that body and would become president if Johnson was forced to step down. Stevens had not been satisfied with the strength of the original ten articles and had added the eleventh, which accused Johnson of denying the constitutionality of the Congress. Originally, the Senate was to vote on

each article in numerical order, but the Radicals changed the rules so that Stevens' eleventh article would be voted on first.

Although Vinnie, her family and Edmund Ross spent most of the night of March 4, 1868, discussing the political situation, she went to the Capitol and opened her studio the next morning. Almost immediately, the room was filled with congressmen wanting to know every detail of her trip to Wisconsin. At noon, as she visited congressional offices to thank those who had not come to her studio, Chief Justice Salmon P. Chase was in the Senate chamber administering the oath in which each senator swore to "do impartial justice according to the Constitution and the laws." As Wade was sworn in, objections were raised because of his position as a potential successor to Johnson, but these were overridden, and Wade became a member of the jury. The trial was set for March 13.[4]

Over the next eight days, tension was high. Radical and moderate Republicans and Democrats came to her studio and maintained an air of civility. But Vinnie heard enough to know this was a façade. The newspapers reported what senators had dined together and what social events each had attended. The Radicals hired detectives to follow suspected Johnson supporters. There were twelve Democrats and forty-two Republicans in the Senate, and the president could be convicted by six votes more than the required two-thirds. The newspapers offered estimates of the outcome based on information as flimsy as the sight of two senators stopping to chat.[5]

The Chief Justice presided over the trial. Johnson's defense was led by Attorney General Henry Stanberry, who had resigned to defend the president, former Supreme Court Justice Benjamin Curtis and New York lawyers William Grosbeck and William Everts. This was a more impressive group than Thaddeus Stevens, Benjamin Butler and Ohio Congressman John Bingham, the House prosecutors.[6]

Vinnie had obtained a coveted ticket to the opening day's proceedings. The Capitol was crammed with people, each of whom had to show his ticket to three different guards, which made entering the galleries a protracted process. Still, well before noon the spectator, press and diplomatic galleries were packed, with everyone dressed to the nines—more like opening night at an elegant theatre than the beginning of a trial. Reporters were ready to describe not only important political details, but what wives of important personages were wearing, not neglecting Kate Chase Sprague's Etruscan earrings. Mrs Sprague was the daughter of the Chief Justice and the wife of Rhode Island Senator William Sprague. Vinnie did not go unnoticed, by the *Philadelphia Inquirer* at least: "Vinnie Ream, the little sculptress, wore a wave of flat ringlets down her back, reaching below her waist. She is a dark-eyed, nervous, spirituelle little girl, and had admirers in numbers buzzing around her, of course."[7]

At one o'clock the Chief Justice assumed the chair and the clerk said, "Andrew Johnson, President of the United States! Appear and answer the Articles of Impeachment exhibited against you by the House of Representatives of the United States." Henry Stanberry, a tall man with a commanding presence, rose and read the president's acknowledgment of the charges, after which he requested forty days in which to prepare a defense. John Bingham, who had come late to the Radical persuasion but now accepted it wholeheartedly, insisted that the trial proceed immediately. Wrangling over this point went on for an hour and in the end the defense was granted ten days for preparation.[8]

Vinnie, who had friends and supporters on both sides, remained strictly neutral, and at first even the most partisan of them accepted this. During recesses in the trial, Stevens, who was now carried everywhere in a chair by two boys, continued to sit for her. His blue eyes had sunk deep into their sockets and

his skin looked like yellowed parchment. But he maintained his sense of humor. He was overheard asking his chair carriers, "What am I to do when you boys are dead?"[9] Because he was too weak to hold a pen, his secretary had to write his letter to Vinnie praising the statuette. Senator John Sherman also found time during the ten-day trial break to visit her studio often. At one point he sent her a note complaining that he had gone there several times to pay her for his bust, but she was always out.[10]

When the trial resumed on March 23, it entered a dull phase and the reporters spent more time describing ladies in the gallery and commenting on the weather. Evidently attendance was down. On March 25, the *New York Herald* reported, "The impeachment entertainment was well attended today. . . . There was a smaller show of beautiful faces than on yesterday." The *New York Times* on April 9 observed that "although this was one of the fairest of many fair days of late, the attendance in the galleries was about the same as yesterday, leaving room for at least two hundred more people." The ladies, the *Times* went on, would scan "the newcomers and their toilets, particularly here and there a new bonnet. . . ." By April, enthusiasm for the impeachment had waned. The Republicans had won several elections in the South and Johnson had let it be known through his attorney William M. Evarts, that he intended to stop trying to obstruct the Republicans' Southern policy. In addition, or possibly because of this, a group of moderate influential Republicans began to express the opinion that a conviction of Johnson would damage the separation of powers, and to express doubts as well about a Benjamin Wade presidency.[11]

At the beginning of April, Albert Pike, whose sympathies lay completely with the South and who had made clear his dislike of Radical policies, decided to leave Washington for a while, and embark on a speaking tour that would culminate in a speech to the Masonic Supreme Council in Charleston. He left Vinnie his itinerary and they corresponded throughout his tour. "Shall I be a comfort to you?" she asked, sent him new photographs of her-

self, and promised to set his poetry to music. In mid-April Pike wrote, "I have become discontented with your photographs. The face they show me is not yours. The eyes full of thought, with their curious, questioning, wistful loving look, are not there."[12]

Under ordinary circumstances letters like this from Vinnie would simply reflect her usual willingness to use the men who surrounded her, men of charm, intelligence, wealth and power. She had thrust herself into a man's world and had to employ whatever methods she could to survive in it. But her feeling for Albert Pike was different from her feeling toward all the others.

Pike, who had been born in Boston on December 29, 1809, was an autodidact who had taught school in New England, trapped beaver in New Mexico and made his fortune in Arkansas with his ownership of a small newspaper and a law practice devoted to negotiating treaties for land payments between the Government and Indian tribes. His appetite for food and for women became legendary, and after he became a Mason in 1850, stories circulated that he indulged in sexual orgies while conducting satanic rites.

In April, 1866, Pike was granted a pardon for his activities as a Confederate general during the war, although many people believed he was responsible for atrocities at Pea Ridge, where he led a regiment of Indians he had recruited. After he was pardoned, he moved to Washington, set up his law practice and edited a Democratic newspaper, *The Patriot*. It was common knowledge that Pike was involved in the organization of the Ku Klux Klan.

Possibly Pike had known the Reams during their days in Arkansas. In any case, in 1866 he and Vinnie began a relationship that was to last for twenty-five years. What attracted her to him is a puzzle. Her connection to him could only hurt her with the Radical legislators she relied upon for commissions and other help. When she went to his rooms so that he could sit for his bust, she was endangering her reputation in a way that did not happen when she went to the home of the powerful and

respected Thaddeus Stevens. In addition, at that time Vinnie was only twenty, and Pike was fifty-nine years old and weighed close to 300 pounds. Nevertheless, he fascinated her, perhaps playing the role of Svengali to her Trilby. He inducted her into Masonry, conferring all sorts of degrees upon her in secret ceremonies. He himself had had a meteoric rise in the order, which he dominated for thirty years.

On May 6, Vinnie went to hear closing arguments in the impeachment trial. As Bingham concluded the case for the prosecution, the galleries became unruly and refused to heed Chase's calls for order. When in frustration he directed the galleries to be cleared, the shouting, hissing and foot-stamping continued, while some senators asked Chase to withdraw his order, and others demanded that the agitators be arrested. Finally, the police entered the scene: Vinnie and the elegantly dressed ladies and their attendants were required to leave their gallery, and Chase added the reporters in the press gallery to his list of evictees. The Senate then adjourned to deliberate the verdict.

Almost immediately Senator William Fessenden announced that he could not vote to convict on the evidence that had been presented. There were now six Republicans against conviction, and only one more Republican defector was needed to save the president. Enormous pressure was brought by the Radicals on Edmund G. Ross, the junior senator from Kansas. Telegrams poured in on the nervous little man from his constituents, demanding a vote to convict. Samuel Pomeroy, the senior senator from Kansas, warned Ross that a vote for acquittal would cause the party to repudiate him and would mean the end of his career. Reporters began to track his every move.[13]

Benjamin Butler received a letter from C. C. Warner in New York saying that Ross "is owned by Perry Fuller who bought his election and has since used him as an agent in pushing his frauds through the Indian Bureau and Quartermasters Department. He aspires to be Commissioner of Internal Revenue. He

has the promise of the nomination if impeachment fails. . . . Being a democrat and a thief he can get the nomination from no other administration than the present one, hence Ross the present tool and prospective partner does not favor a change. Further Ross though a man of family is at present infatuated to the extent of foolishness with Miss Vinnie Ream, Fuller's sister-in-law. . . ."[14]

Vinnie's brother-in-law Perry Fuller was in fact an open supporter of Andrew Johnson and a successful businessman who had contributed to Ross's campaign. Butler sent Ross a copy of Warner's letter, hoping it would intimidate Ross into voting for conviction. If that was not enough, Butler let Ross know "there was a bushel of money to be had."[15] Ross, fearing for Vinnie's reputation, showed her the letter, which now embroiled her in the impeachment struggle.

Vinnie had never attempted to control the political conversations in her studio. She did not see that she would be affected, no matter who met there or for what purpose. That had been the case in the past, but now the future of the presidency was at stake. Now it was remembered that Senators Ross, Trumbull, Thomas Ewing and others had been habituées of Vinnie's studio, that she had met with Johnson to lobby for her father's appointment as consul, that Ross had conducted tours of her studio and helped to sell her statues, and that she was a close friend of Albert Pike, the Southern sympathizer.

More than that, Ross lived at her house: a weak man subject to the admitted power of her charming personality. For the first time in her life, Vinnie was the recipient of hostile pressure. Samuel Pomeroy threatened her with a charge of conspiracy. George Julian went to her studio to warn her that powerful men were playing for high stakes, and that her reputation was being ruined because of her association with the Johnson factions. Julian, who had hopes of being appointed Secretary of the Interior in a Wade administration, reminded her that he

was her friend and that he had sent glowing endorsements of her work to the Wisconsin legislature. He demanded to know why she was trying to convince Ross to vote for acquittal. When she protested that she had taken no position on the issue, he lost his temper, insisted that she had better use her influence on the side of conviction or pay the consequences, and stormed out of the studio.[16]

Vinnie was understandably distraught. If Ross voted to acquit the president, she believed that she would be ruined; Julian, Pomeroy and Butler would see to that. They had destroyed careers before, of powerful men, and she was powerless. She knew that she could easily sway Ross, but she did not feel that she should do that, and she resolved not to attempt to influence him in any way. She was virtually alone in that decision: Radicals reminded Ross incessantly that he had a duty to convict, and Democrats and defecting Republicans harassed him to vote for acquittal. Reporters and detectives dogged his steps. On May 14, when he had dinner with Pomeroy, hopes for conviction rose, but they plummeted later that night when he met with Trumbull in Van Winkle's rooms.[17]

The night before the vote, Ross had dinner with Pomeroy, who pressured him strongly. Ross told him that the eleventh article was the one that made the most sense. This cheered the prosecutors, but when later that night Ross was seen in a downtown restaurant with Van Winkle and John Henderson, their hopes drooped again.[18] After that, Ross went home. Around 11:30, Thomas Ewing called; Vinnie opened the door to him and showed him to Ross's room. Ewing wanted to know what response Ross had made to a telegram from Kansas, signed "D. R. Anthony and 1000 Others," demanding a vote for conviction. Ross said that he had written out a reply but was afraid to go alone at that hour to the telegraph office, because he had received death threats. He wanted to live to cast his vote the next morning, come what may.

Ewing went with Ross to the office where Ross dispatched his telegram: "I do not recognize your right to demand that I shall vote either for or against conviction. I have taken an oath to do impartial justice according to the Constitution & laws & trust that I shall have the courage & the honesty to vote according to the dictates of my best judgement & for the highest good of the country."[19]

In the few hours left before the vote, the prosecutors made one last attempt to wring a commitment from Ross. Edwin Stanton, who would lose his position as Secretary of War if Johnson was acquitted, sent General Daniel E. Sickles, a New York Democrat, to visit Ross. Sickles had served in the House from 1857 to 1861, when Lincoln authorized him to form a Union brigade. He fought in many battles, and lost a leg at Gettysburg. In 1867 he became military governor of the Carolinas, where he suspended some of the more flagrant of the "Black Codes" enacted to prevent freedmen from equal access to the courts and property ownership, among other things. Sickles insisted that the law should apply equally to all inhabitants of South Carolina.[20] This objection to the codes of the antebellum South did not sit well with Andrew Johnson, who relieved Sickles of the governorship. Sickles' relationship with Stanton went back at least to 1859 when Stanton had successfully defended Sickles who had been on trial for murder for having fatally shot Philip Barton Key—the son of Francis Scott Key—because Key had been having an affair with Sickles' wife.[21]

Sickles did not believe that Ross was going to vote for acquittal, but he agreed to go and see him that night anyway. He took a cab and got to the Ream house in Capitol Hill about midnight—the area was remote, he said later, with unlighted, unpaved streets, and "so little frequented that [the] driver lost his way." Vinnie, he said, came to the door, but did not invite him in, and when he asked for Ross, said he was not in, and was unresponsive when he asked to come in and wait for him.

Finally, Sickles, who had seen a light in Ross's window and knew he was there, pushed his way in, and Vinnie asked him to wait in the parlor.

He sat in a comfortable chair and Vinnie perched on the piano stool. She responded to his attempts at conversation only in monosyllables, seemed distressed, and finally, according to Sickles, burst into tears, saying she knew he had come to save Ross, and she wished she could help him. At four o'clock in the morning, Sickles rose to depart, and asked Vinnie once more to let him see Ross.

"No, no," she said. "I dare not. I dare not. It would do no good."

"Then," Sickles said, "he has bound himself for acquittal."

Vinnie replied that he was going to support the president.

"He is in your power," Sickles recorded he said to her, "and you choose to destroy him."

He bade her good night and returned to his hired carriage.[22] Ross had instructed Vinnie that he was not "to be interrupted by callers who were not known to be my personal friends." It is surprising that Vinnie would tell Sickles that Ross intended to support the president, since Ross had told Ewing that evening that "no living person will know what my verdict will be until he hears it from my lips at my desk."[23]

5

THE VOTE

I will prove that a distinguished Republican member of this House had a conversation with Miss Ream and threatened that if she did not use her influence with Senator Ross to secure the conviction of the President it would be the worse for her.
—*Representative George W. Morgan*

MAY, 1868, WAS A cold month and the 16th dawned clear and crisp. In the Senate Chamber, newsmen asked each senator who entered what they had heard about Ross. On the floor Daniel Sickles spread the story of his meeting with Vinnie.

That morning at 10:30, Edmund Ross, having just finished having breakfast with Vinnie's brother-in-law Perry Fuller, found Samuel Pomeroy waiting for him at the door to the Senate Chamber. Pomeroy warned him that a vote for acquittal would not only mean political suicide, but would open Ross to an investigation of a charge of bribery, and that Vinnie would also pay a price. Benjamin Butler and John Bingham, Pomeroy said, were vindictive men who were capable of any sort of retaliation if their wishes were thwarted. When Pomeroy left him, John Thayer of Nebraska drew Ross into a corner and earnestly pleaded with him to do his duty to his country, his state and his party. When Ross finally reached the floor, he was immediately surrounded by senators and representatives and Sickles began

to lecture him with emphatic gestures. Ross listened silently before retreating to his chair.

Long before noon, the galleries were packed and even the usually empty diplomatic box was overflowing. Thousands of people lined the corridors or filled the grounds outside the Capitol and small groups gathered in the streets. Vinnie, in the gallery, watched infirm senators arrive. John Howard walked in slowly, leaning on the arm of a friend, a heavy shawl thrown round his shoulders. He was a shadow of the man who less than two years before had thundered on the Senate floor that Vinnie's model was "monotonous" and that no woman was capable of writing the *Iliad* or leading an army. James Grimes entered carried by four men in an invalid's chair where he remained seated. While Howard had come to vote for conviction, Grimes was there to acquit.

Roscoe Conkling of New York, handsome, six-foot-three, with a flowing blond beard, famous for his dramatic oratory, was a member of the Joint Committee on Reconstruction. Pale from a recent severe illness, he entered the chamber determined to vote to convict even if he died in the process.

As the city bells rang twelve noon, the Chief Justice, in his black robes, rose and admonished the galleries that there must be absolute silence and complete order and any person making a disturbance would be removed immediately. The clerk began to read Article Eleven, accusing the president of declaring that the 39th Congress was not a Congress authorized to exercise legislative power under the Constitution. Republican John B. Henderson of Missouri left his seat and bent over Ross to whisper in his ear.

Thaddeus Stevens sat impassively listening to his article being read. Each day was painful for him, he knew he had only a short time to live, but he was determined to see Johnson turned out of office. The clerk read: ". . . as the case may require, do demand that the said Andrew Johnson may be put to answer the high crimes and misdemeanors in office herein charged

against him, and that such proceedings, examinations, trials and judgements may be thereupon had and given as may be agreeable to law and justice."

When the clerk finished, the Chief Justice called, "Mr Senator Anthony. How say you, is Andrew Johnson, President of the United States, guilty or not guilty of a high misdemeanor as charged in the article?"

A loud and clear "Guilty!" was Henry Anthony's reply.

The role call continued alphabetically. Alexander Ramsay of Minnesota voted "Guilty!" and Ross would be next. The Democrats—James Bayard of Delaware, Charles Buckalew of Pennsylvania, Garrett Davis of Kentucky, James Dixon of Connecticut, James Doolittle of Wisconsin, Reverdy Johnson of Maryland, Thomas McCreery of Kentucky, Daniel Norton and David Patterson of Minnesota—had voted for acquittal. Three Democrats not yet called—William Saulsbury of Delaware, George Vickers of Maryland and Waitman Willey of West Virginia—had pledged to vote for acquittal.

Four Republicans—William Fessenden of Maine, Joseph Fowler of Tennessee, James Grimes of Iowa and John Henderson of Missouri—had voted for acquittal, and two Republicans not yet called—Lyman Trumbull of Illinois and Peter Van Winkle of West Virginia—had pledged for acquittal. That made eighteen, and nineteen votes were needed for acquittal. It was Ross, then, who would cast the fateful vote, and all eyes were on him as Chase asked, "Mr Senator Ross. How say you, is Andrew Johnson, President of the United States, guilty or not guilty of a high misdemeanor, as charged in this article?"

Ross stood and absently tore a scrap of paper into tiny pieces as he responded nervously, "Not guilty." A murmur of protest was heard throughout the chamber. The remaining votes would not change the outcome. Andrew Johnson was acquitted 35 to 19, one vote short of the two-thirds needed to convict. Benjamin Wade—who had signed Rollins's petition for Vinnie, had reintroduced the bill to give her the Lincoln award and had

written endorsements for her attempt at the Wisconsin com-
mission—would not become president. He had voted, refusing
to disqualify himself.[1]

That evening the atmosphere in the Ream household was
strained. Vinnie was apprehensive about the effect this vote
would have on her future, and everyone thought that Ross's
political career was over. Ross wrote later that at the moment
of voting "it is something more than a simile to say that I al-
most literally looked down into my open grave. Friends, posi-
tion, fortune, everything that makes life desirable to an ambi-
tious man, were about to be swept away by the breath of my
mouth, perhaps forever."[2] He may have believed this at the time,
but it was certainly a dramatic overstatement.

On May 27, Ross rose in the Senate to defend his vote,
saying that he had intended to support impeachment until a
few days before the vote was taken, that he had expressed that
intention, but had changed his mind because he had decided,
on further consideration, that impeachment was wrong. " I have
been no summer soldier, no sunshine patriot," he said. "I was
baptized in politics in the old Abolition party of '44, when but
seven thousand then in the United States dared to say they were
the friends of the slave, and bore my share of the whips and
scorn. I led a colony to Kansas in 1858 and there struggled,
with success, to check the spread of slavery. I entered the ranks
of the Union army as a private soldier, and carried the flag until
slavery was destroyed. I have never labored or fought for plun-
der. My hands have no dishonorable stain on them."[3]

The Radical press did not accept this, and Ross was accused
of having sworn to vote for conviction the night before but
changed his mind when "acquittal slept with him overnight."[4]
This was of course an open attack upon Vinnie as well. Despite
all this considerable hullabaloo, the Republicans who voted for
acquittal were not, as legend has had it, "seven martyrs" who
were read out of the party. At the Republican National Conven-

tion held in Chicago on May 19 and 20, Radicals did try to get the delegates to formally repudiate the seven, but this attempt was a notable failure. All seven—Fessenden, Grimes, Trumbull, Fowler, Henderson, Van Winkle and Ross—campaigned for Grant that fall. The election occupied everyone's energies. When Congress met again, all seven retained their committee assignments: Trumbull, Fessenden and Grimes remained powerful and respected, Ross himself, Foner says, tried to cash in on the president's gratitude by securing "lucrative patronage posts" for several of his friends.[5] But these attempts were rejected by Congress.

There is no question that immediately after the vote, the Radicals attempted to retaliate against the seven. *The Philadelphia Inquirer* reported on May 19, 1868, that when a Republican Senatorial caucus was called for the purpose of "selecting a nominee for Secretary of the Senate . . . [a]mong those who came in were Messrs. Trumbull, Ross, Fowler and Henderson, which caused considerable comment in a quiet way, and on the appearance of Mr Van Winkle, an adjournment to next Monday was at once moved and carried. Senators Wade, Thayer, Stewart and a large number of others, refuse to sit in a party caucus any more with any of the seven who voted 'not guilty;' but there are so many who will not join them that until the new Senators from the South are admitted they will not be able to depose Messrs. Trumbull, Fessenden, Henderson, Grimes and Ross from their respective committees." As we have noted, these men were not deposed.

After the vote, Thaddeus Stevens was carried from the Senate Chamber to the House floor, where he persuaded the members to give the impeachment managers extraordinary powers to look into bribery charges like those leveled against Ross by C. C. Warner. Benjamin Butler was put in charge of the investigation, along with John Bingham. Butler discovered that Charles Wooley, a gambler, had bet heavily on acquittal, and that would be a reason for him to buy votes. When Wooley refused to ap-

pear before Butler's committee, he was arrested and held in a committee room. Then it was decided that he should be held in Room A and Room B. Room A was Vinnie's studio.

John Bingham rose in the House to demand that "rooms A and B, opposite the room of the Solicitor of the Court of Claims in the Capitol, be and are hereby assigned as a guard room and office of the Capitol police, and are for that purpose placed under the charge of the Sergeant-at-Arms of the House, with power to fit the same up for the purpose specified." There were no rooms available "at present," he said, "in which to detain persons ordered into the custody of the Sergeant-at-Arms." The room was needed, he explained, "so that a witness may be detained beyond the power of possibility of any person, by trick or circumspection, to defeat the administration of justice."[6]

Vinnie's friends of course protested. Benjamin Butler's response to these protests was, "Let her and everybody else who visits her there be cleared out, and if the statue of Mr Lincoln is spoilt in doing so I shall be glad of it."[7] There were arguments but, late at night, the resolution was passed. On May 28, Nathaniel G. Ordway, House Sergeant-at-Arms, presented Vinnie with a copy of the resolution ordering her to move at once.[8]

Vinnie was frightened, realizing that Pomeroy's and Julian's threats were real. She told everyone who flocked to her studio and later to her house, about the incident with Julian a few weeks earlier. Democrats George Morgan of Ohio and James Brooks of New York were not particularly good friends of Vinnie's, but they assured her that their colleagues, after mature reflection, would rescind the order. On the 29th, they led a spirited debate on the floor but were continually rebuffed by Bingham and Butler, who claimed that the center of the action was not Vinnie, but Wooley. Morgan, irritated, resolved to throw caution to the winds and go after Julian. He had nothing to lose: his election had been successfully contested and he would have to give up his seat in a few days.

He rose to say that the action against Vinnie was "unmanly,

ungenerous and discreditable." He regretted, he said, having to mention a fact that concerned "an honorable gentleman on this floor" who was fortunately there to defend himself if his name was asked for. Vinnie was being singled out because Ross was a friend of her family, he said, and went on to describe Julian's visit to the studio in which he told Vinnie, "You ought to use your influence in favor of his conviction," and "if she did not it would be the worse for her, or words to that effect." The members demanded the man's name, or at least the name of the state he represented. When Morgan replied the man was from Indiana, each member from that state rose in turn to ask if Morgan was referring to him. Morgan replied that he was not. Finally Julian was forced to rise and attempt to explain his actions.

Some members of the House had told him, he said, that Miss Ream was believed to be using her influence to secure Ross's vote for acquittal, and it was "suggested to me, inasmuch as I was acquainted with her, that I should state the matter to her, as the rumor was calculated to injure her in the estimation of the public and of members of Congress. I stated that I did not believe the story, but that as I knew her, I would mention it to her for the purpose of giving her an opportunity to make such statement as she might see fit under the circumstances. I did so and did it jocularly. . . ."

Vinnie, who was present in the gallery, knew quite well that Julian had not been "jocular," but cold and threatening. She had always liked Julian, who was one of the few congressman who believed in a greater measure of equality for women, including voting rights. He had never treated her with condescension, and they should have been friends. He was an idealist, an abolitionist, a man who hated corruption, but he had been caught up in the heat of the impeachment and now she saw him on the floor of the House lying about their meeting. "I made no threats," he said, "in any shape or form. On the contrary, I accepted her statement at the time as true, and felt no longer any interest in the controversy." Vinnie, he said, had told him

that Ross was going to convict, and Ross the next day confirmed that to him. "So far as any statements purporting to come from Vinnie Ream or anybody else are concerned, in conflict with what I now state, I brand them as deliberate and intentional falsehoods."

Morgan responded that he was ready to prove before a "properly constituted" committee that he had spoken the truth, and that Julian's memory seemed "to be at fault."[9]

Both men were very angry, but the eviction order stood. Vinnie was angry—Julian had called her a liar—but her main concern was that moving her partially completed plaster model of Lincoln could risk nearly two years' labor. She believed she would be allowed to leave it in place once the members understood the full import of their order to vacate the studio. That evening she met with Samuel Marshall, who a year earlier had given her a letter of introduction to President Johnson recommending that her father be posted to Europe. Now Marshall agreed to help her again, and the two of them drafted a letter to the sergeant-at-arms and worked it into a resolution along with a personal appeal from Vinnie. The next day the clerk began to read the resolution, but was interrupted by the Radicals. Marshall asked that the reading continue since the question was a privileged one. The Speaker stated emphatically that the question was not privileged. Marshall lost his composure and began to argue with the Speaker, telling him that since he had not heard the resolution, he could not rule fairly.

The Speaker responded that the resolution required unanimous consent and since a member had objected, the resolution could not be read. Marshall insisted that it was a privileged resolution and could be read. The Speaker said forcefully and clearly, "The Chair has decided otherwise." Marshall then asked to have the resolution printed in the *Congressional Globe*, but an objection was raised to this request as well.[10] Butler and Bingham were determined that Vinnie and her model should vacate the premises. The next day, a Sunday, Vinnie and Marshall met

again. Marshall was certainly able to write inane love letters to Vinnie, but he had badly bungled the resolution affair, having chosen a time when there were angry impeachers on the floor and the Speaker was not friendly. Marshall agreed with Vinnie that they should turn to George Morgan.

On Monday, Morgan rose in the House to ask that Vinnie's resolution be read. The clerk read the preamble to the resolution and then began to read Vinnie's personal appeal. Almost two years earlier Amasa Cobb had said on the floor of the House that Vinnie was not capable of executing a statue and no contract should be given her. Now he sprang to his feet and objected to her studio being returned to her. Morgan had made sure that a sympathetic person was in the chair, and the chair now ruled that Morgan had the right to incorporate anything in his resolution that he felt was germane to it. The clerk was allowed to go on reading Vinnie's letter.

"Dear sir," she wrote, "I am in receipt of your note directing you to take possession of a room now occupied by me as a studio. I would very cheerfully vacate the room at once, were it possible to do so; but it would simply be to destroy the statue of Mr Lincoln, and that I cannot believe the gentlemen of the House desire after having watched its progress with great interest and seemed pleased with the progress of my work. It would be impossible to move it without destroying the labor of the past year, and subjecting me to very great expense and delay. When the order for this work was given me a room was also given me in which to mold the statue. I submit to the gentlemen of the House whether this treatment is fair and just, or at all consistent with that kindness and generosity which have heretofore been uniformly extended to me by members of both Houses of Congress. Respectfully, Vinnie Ream."

Amasa Cobb immediately moved that the resolution be laid on the table, and Morgan then called for a vote on it. Vinnie lost 61 to 47. As would be expected, Julian voted against law. Butler was absent, but had declared that Vinnie would never be

paid for her statue as long as he was on the Appropriations Committee. Thaddeus Stevens, on the other hand, voted for her; he found the whole affair petty, but feelings were running so high that even he could not control the Radicals. In any case, the fight was over.[11]

Vinnie went straight from the House gallery to Stevens's office to thank him for his support and to mention her worries about the statue and about Butler's hostile comments. Stevens, tired and weak, said he was not able to have the order rescinded because Vinnie had stirred so much hatred. But he told her not to worry about Butler, whom a year earlier Stevens had called a "false alarm" and a "humbug." She must, he said, move her personal possessions out of the studio, but under no circumstances should she move the model: he could still prevail upon a sufficient number of members to allow the model to remain. He suggested that she collect letters of opinion on removal of the model from leading sculptors, and promised that when the time was right he would personally see that the studio was restored to her.

Vinnie followed this advice immediately, writing to solicit opinions from Johnson Mundy, James Wilson MacDonald and H. K. Brown. Mundy's response was representative; it was impossible, he wrote, to remove "so large a model successfully to any other place. I am much surprised to hear of a proposition being entertained by the House to remove the model, as it is barely within the range of possibility to succeed in moving such a mass of soft clay without entirely destroying the figure."[12]

James Wilson MacDonald went further: removal of the model, he wrote, would be "a palpable violation of the Contract made by Congress with you."[13] Vinnie, who hoped that these letters would circulate through the Congress, did not want to irritate members by the suggestion of a lawsuit. She deleted all reference to breach of contract from MacDonald's letter before she gave the letters to Stevens.

Once again Vinnie became an object of discussion in the

press. On May 30, the *New York Times* accused John Bingham
of leading a "paltry piece of petty persecution." On that day
the *Chicago Tribune* indulged in a bit of ridicule at Vinnie's
expense: ". . . being young, handsome, vivacious, and the happy
possessor of a magnificent bust—in marble, could Congress do
less than vote thousands—We have no doubt that there are hun-
dreds of ladies who can exhibit as fine a bust as Miss Vinnie
Ream—."

The next day the *New York Times* commented that Bing-
ham was taking vengeance on "little Vinnie Ream, the gifted
artist," and expressed the hope that "he may live long enough
to be ashamed of it." That same day, May 31, the *New York
World* ran a front-page article headlined, "How Beaten Impeach-
ers Make War on Women."

The *New York Tribune*, owned by Horace Greeley, who
was apparently still angry about Vinnie's bust of him, attacked
her: "This young woman, who is spoken of as a helpless girl
had shown herself abundantly able to look out for her own
interest, by the most persistent, unwearied, and successful lob-
bying in Washington for a whole winter for the procuring of
this commission. She lobbied as only a woman can; and every
Senator and Representative in Washington knows, by fearful
experience, the terrible force of what has come to be known as
'hen power.'"[14]

On June 1, the *Philadelphia Inquirer* reported: "A force of
laborers are at work fitting up rooms for Wooley, and Miss
Ream has moved all her property except a partially-formed clay
model for a statue of Abraham Lincoln, which she is going to
leave in the room in which Wooley is to be confined. Workmen
are putting up iron bars at the windows to prevent any escape
from the room. It will be fitted up nicely but plainly, and will be
ready for occupancy by the middle of the week." The *Philadel-
phia Evening Post* on that day commented that Bingham and
Butler were motivated by more than a desire to incarcerate
Wooley: "Another reason was that they might eject Miss Vin-

nie Ream who was supposed to be a friend of Senator Ross."
On June 19 the *Liberty* [Missouri] *Tribune* headlined an ar-
ticle: "Beauty and the Beast—Butler and Bingham Versus a Child
of Art."

Vinnie's enemies began to circulate the rumor that she had
not really modeled the head of Lincoln but had used one done
by Fisk Mills, the son of her teacher Clark Mills, and that Fisk
Mills had accused her of this. Mills went immediately to see
Vinnie and wrote a statement calling the rumor "a base false-
hood started doubtless for the purpose of injuring her. I here-
with declare that it is her own work, and I deny the statements
that I have reported otherwise."[15] Vinnie had a congressional
page deliver a copy of Fisk Mills' letter to Thaddeus Stevens
along with a note requesting a meeting as soon as possible.
Stevens, in ill health and involved in his legislative duties, was
also in the midst of an investigation into the "not guilty" ver-
dict. But the page returned shortly with her note, on the bottom
of which Stevens had scrawled, "Come at any time."[16] Stevens
had been impressed by the job Vinnie had done on his own
bust, showing every crease and imperfection, and capturing in
his face, with its thin lips and aquiline nose, not only his stern-
ness but his strength of character. In the heat of the impeach-
ment proceedings, he had found time to write to her, "I desire
to express my gratification at the genius and skill which you
have shown in the execution of my statuette . . ."[17]

Vinnie went at once to Stevens and explained that the ru-
mor may have started because the head of her *Lincoln* was in
plaster and not in clay as was the rest of the statue. But she
assured him that the plaster head was a faithful copy of the
model he had often seen and that the committee had seen be-
fore they had awarded her the contract. The head had been put
into plaster to avoid damaging it from the daily moistening that
the clay model required. The head, she said, was painted the
color of the rest of the model, not to hide the fact that it was
plaster, but for aesthetic reasons. Stevens told her to calm down,

to make sure her explanation was printed up, and promised that he would see to it that the Fisk Mills letter would circulate widely through Congress and the press.[18]

On June 11, Wooley was brought before the committee. Nothing much came out of his four-hour grilling, and it was obvious that the investigation had run out of steam. Things were beginning to cool down when, less than one month after the acquittal, Andrew Johnson nominated Vinnie's brother-in-law Perry Fuller for the post of Commissioner of Internal Revenue. This certainly supported C. C. Warner's contention that Fuller had bought Ross's vote, and as should have been expected, a storm of protest erupted. The *Chicago Tribune* ran a series of articles intended to show that Fuller was cheating the Indians through shady contracts he had obtained for his wholesale houses by bribing officials in the Indian Bureau. The *New York Tribune* reported that Ross had called personally on Johnson and requested Fuller's nomination. The Senate Finance Committee that had received the nomination consisted of seven members, five of whom had voted for Johnson's conviction. On June 27 the committee reported against confirmation and in executive session the full Senate rejected Fuller.[19]

After a few weeks the storm abated. Wooley had been released from custody, and on July 20, 1868, Stevens introduced a resolution in the House requesting that since the room used by Vinnie as a studio was no longer needed to detain Wooley, she be allowed to return for a year so that she could complete the Lincoln statue. Stevens was willing to accept actions from Vinnie that would have evoked his wrath if others had behaved in that way. Stevens, for instance, hated and tried to suppress the Masons: he attempted to restrict their sitting as judges and serving on juries and denounced the Masonic order as "a secret, oath bound, murderous institution that endangers the continuance of Republican government."[20] Vinnie's association with Pike and Masonry was well known: Pike was a Grand Sovereign Commander and Vinnie was an eighth degree Mason. But

Stevens was willing to overlook this, and not because he had
softened his attitudes as his health deteriorated. He believed
wholeheartedly that Johnson was in league with the worst ele-
ments of the Confederacy, and had proposed splitting Texas
into six separate states so that twelve Republican senators could
vote to convict the president. But he had feelings of fatherly
affection for Vinnie.

Now, in less than one month before his death, Stevens
struggled to his feet to make a last personal appeal for her. "Some
time ago," he said, "when we had a rebel recusant witness, he
occupied a room which had but two windows in it; and it was
thought by our polite Sergeant-at Arms that he had not sufficient
light to read his literature throughout the day. Hence a resolution
was passed by which we took away the room occupied by a girl
who for two years had been at work upon the statue of Mr Lin-
coln which we intrusted to her. To remove the statue as it is now
it is agreed on all hands would destroy it. I hope the House will
allow her to finish it where it is. If I had the preparing of the
lodgings for Mr Wooley, I would have thrust him into 'the black
hole' rather than turn this lady out of her studio."[21] A vote was
called and Stevens's resolution passed easily.

A discussion was begun of other resolutions when the chair
interrupted the proceedings to say, "The Chair will call atten-
tion to the fact that the resolution just passed continues Miss
Vinnie Ream in the use of her studio for one year, when the
jurisdiction of this House only extends until fourth March next,
about eight months." He looked up at Vinnie in the gallery and
added, "The Chair has made this statement so the lady should
not be surprised."[22]

Vinnie wrote Stevens, "I am at a loss how sufficiently to
thank you for your great and constant kindness and interest in
my behalf, which has just been crowned with success by the
restoration of my room. But for you the result so important to
me could not have been. All I can do in return will be to renew
my work with increased zeal and devotion—its interest enhanced

by the protection which you have afforded it. May your life, so full of usefulness to your country and humanity be full of happiness. This is the earnest prayer of your faithful little friend."[23] The man whom the *New York World* called "full of malignant passions"[24] had a heart capable of great tenderness.

Three weeks later, on August 11, Thaddeus Stevens was dead. Word spread rapidly through the city, and crowds of people, Vinnie and Charles Sumner among them, came to see him laid out in his black suit in the front room of his house. On the 13th, his body was placed in a rosewood coffin with heavy silver trim, covered with fine black cloth and lined with white satin. Just before noon, a company of Zouaves arrived to take possession of the closed coffin under a chain of white roses, and led a procession slowly along B Street to New Jersey Avenue, and then to the east portico of the Capitol. The Rotunda was kept open all night and a guard of honor of twenty-five Zouaves remained with the coffin. Streams of visitors, black and white, poured into the Capitol until past midnight. Hundreds of lights burned in the great dome of the Rotunda.

Lincoln was the first to lie in state in the Rotunda; Stevens was the second. Next morning, the body was carried to the depot in a hearse drawn by four white horses. The route was lined with people and a large crowd assembled at the depot. The train's engine was hung with flags draped in mourning. Stevens had chosen a cemetery in Lancaster, Pennsylvania, because it did not contain a provision in its charter that excluded people of color.

Most of the Northern press lamented Stevens' passing, but that was not the case in the South. The *New Orleans Bee* called him "this malignant old man"; to the *Richmond Whig* he was "the very incarnation of sectional prejudice. But," it granted, "he was an outspoken enemy without Butler's roguery and unspeakable nastiness." Foreign newspapers carried extensive obituaries, of which the *London Morning Telegraph*'s summing-up was typical, calling him "neither good nor bad, wise nor

generous. But in his time, he did signal service, and with all his faults, merits the famous phrase, 'that was a man.'"[25]

6

PREPARATIONS

Why, child! You are a working girl, getting your bread by your hands! If you do not help yourself and us, how can any woman help you?

—*Elizabeth Cady Stanton*

VINNIE SPENT SEVERAL weeks turning Room A back into a studio. The bars were removed from the windows, and she brought back her harp, busts, medallions, statuettes, goldfish, doves and all her other clutter. She expected to work without interruption because Congress had just adjourned and, since it was an election year, most members had gone home to campaign. She wanted the Lincoln model to be finished by the time the Fortieth Congress reconvened in early December, 1868, even though the House had given her permission to use the studio until March 4 of the next year.

She worked diligently, but there were distractions. Since the end of the war three years earlier, Washington social life was undergoing a series of changes. Before the war the city had been dominated by a Southern elite who confined their entertaining to an exclusive list. But the conflict had brought new people to the capital, from the Northeast and the Midwest, many of them military men, and they were involved in plans for postwar reconstruction and Western expansion. A building boom had begun after years of neglect. New people brought new money,

and social life was vigorous in a way it had never been before: there were elegant dinners, receptions and garden parties.[1]

Parties given by lobbyists rounded out the social calendar. The theaters were crowded, there were conventions, and Vinnie's studio became an almost mandatory stop on any tour of Washington. To gain entrance all that was needed was to paste one's card or sign one's name in her receiving book. Businessmen from Ohio signed their names beneath that of senators like John Sherman, and handed the pen to men of the stature of General Custer.[2] Despite all these distractions Vinnie worked hard for the rest of the year, on the Lincoln, and on trying to acquire commissions and enhance her reputation. James Rollins, Samuel Marshall and a host of her other friends were enlisted to write letters asking for help. One approach was to tell a influential person that Vinnie was working on a bust of someone he knew and that his advice would be of great help to her. On occasion her friends would make direct appeals for a sitting to help a struggling artist, and after she made an inexpensive clay bust or medallion, Vinnie would suggest that it be transferred into marble.

Sometimes she would give away copies of her work in the hope that the gift would lead to a commission. Occasionally this worked, but often it resulted only in a polite letter like one from Missouri Governor Thomas Fletcher thanking her for a bust of Thaddeus Stevens: "The Missouri Senate visited it in a body today and were all delighted to know it is the work of a fair and talented daughter of Missouri."[3] Vinnie claimed that state as well as Wisconsin as her home, depending on the situation.

She began a campaign to interest Ezra Cornell in buying her work for his university, by having Thomas Rooker of the *New York Tribune* contact him. Cornell wrote Vinnie that Rooker had told him about "some conversation you and he had respecting a group of statuary for Cornell university, and [he] requested that I should answer it. In doing so I must inform you

that my designs are not sufficiently developed that I know yet what I want. It appears to me that some representation of labor might be created that would impress the students at the University with the dignity and manhood of self reliant effort. At present I am not prepared to give an order."[4] This was the start of an association with Cornell that was to last for years, result in several contracts and—most importantly—establish a real friendship.

The third session of the Fortieth Congress convened on December 3, 1868. Despite many distractions, Vinnie had managed, since she was allowed to return to her studio, to complete the *Lincoln*. Now her studio was crowded from morning to night with admirers and friends with whom she discussed strategies for approval of the model and the introduction of an appropriations bill for payment of the first $5000. She knew, of course, what procedures to follow, but she also knew that these politicians were flattered by her requests for help. It was decided that even though the approval of Orville Browning, the newly appointed Secretary of the Interior, was not needed, it would be wise to invite him to inspect the model. Thomas Ewing promised to draft a letter to the Secretary from Vinnie. It was generally agreed that the House would not present a problem, and Lot Morrill and Lyman Trumbull promised to lead the defense in the Senate if Charles Sumner and Jacob Howard spoke against the appropriation. Everyone promised to be ready by the end of January.[5]

But there were distractions. In January, the National Convention on Woman's Rights held a three-day meeting in Washington. Among the attendees were Elizabeth Cady Stanton, Susan Anthony, Lucretia Mott, Annie Kingsbury and Clara Barton; male supporters included Senator Samuel Pomeroy and Parker Pilsbury, editor of the *Anti-Slavery Standard*. The Woman's Rights supporters had been angered by the introduction of the Fourteenth Amendment with its restriction of suffrage to male citizens, and Stanton and Anthony fought hard to

change it. But Congress, determined to ensure immediately the rights of the freedmen, did not want the issue bogged down in controversy over woman suffrage. The attitude of congressmen toward women had not changed since 1866 when there had been not only the debate over Vinnie's contract, but, more significantly, a debate over Senator Edgar Cowan's attempt to include women in the suffrage bill for the District of Columbia.

Senator George Williams argued on the floor, "The woman who undertakes to put her sex in an adversary position to man, who undertakes by the use of some independent political power to contend and fight against man, displays a spirit which would, if able, convert all the now harmonious elements of society into a state of war, and make every home a hell on earth." Senator Frederick Frelinghuysen said of women: "Their mission is at home, by their blandishments and their love to assuage the passions of men. . . . It will be a sorry day for this country when those vestal fires of love and piety are put out."

Cowan's amendment was rejected thirty-seven to nine.

Anthony and Stanton demanded immediate woman suffrage and were willing to break with the Radical Republicans, while others in their Rights group believed that any hope for suffrage rested with the Radicals.

There was dissension in the ranks from the moment Senator Pomeroy opened the convention on January 19, 1869. In the opening prayer, Rev Dr Gray said that woman had come from the rib of man; Mott and Stanton objected to this assertion of inequality. There were arguments over educational requirements for suffrage, and Stanton complained that African and Chinese men had been granted the vote, while women had not.[6]

Before the opening session Elizabeth Cady Stanton paid a call on Vinnie; the first woman who had been able to get a contract from Congress for a life-sized statue would be a valuable voice for the Cause. A reporter for the *Missouri Democrat* was present at the meeting where, after some small talk, Mrs

Stanton produced a petition and said, "Child, we wish your name here."

"Mrs Stanton," Vinnie said, "I will not sign this. I don't wish publicity—" hardly the truth—"and I am not of your thinking on this question."

"It enters into your interests," Mrs Stanton said. "It concerns the recognition of women and woman's labor under the Government."

"I am not a woman's rights advocate, ma'am."

"Why, child! You are a working girl, getting your bread by your hands! If you do not help yourself and us, how can Woman help you?"

"Mrs Stanton," Vinnie said, airing old grievances, "no help has any woman given me here. From Grace Greenwood to Mrs Swisshelm, they have all sought to strike me down. Mrs [Lucia Gilbert] Calhoun writes to the [New York] *Tribune* that she has not seen any of my work, but that she knows it is bad. Mrs Clemmer Ames—All of them can find no larger occupation than attacking a poor little girl, and their venom—I never offended one of them—has extended to personally canvassing against me. No, Madam! I will be befriended by gentlemen only, for whilst I never got any justice from a woman, I was never treated meanly by man!"

"I know Mrs Swisshelm," Mrs Stanton said, probably taken aback by this outpouring of resentment. "She is a friend of mine and prominent in this movement."

"I forbear to enumerate," Vinnie said, "though I will not say they did not wound me to the heart, the many malignant, vulgar and unproved things she wrote against me and published. Then they were sent to me and to my friends. They aimed higher than my profession—at my character and life. Mrs Stanton, the men have more heart for my sex than the women. Their jealousy is at least as large as emulation. Repelled by wrongs, in the way I have stated, I was compelled to learn the generosity of men, and I do not regret the lesson."[7]

It had been more than two years since Jane Swisshelm had
accused Vinnie of displaying a bare-bosomed plaster cast of
herself in her studio, and since Grace Greenwood had advised
Congress to pay Vinnie's school bills, but not to award her a
contract for a sculpture. Vinnie did not easily forgive a slight.
She was certainly not averse to publicity, and her relationship
with Albert Pike showed that she was not afraid to associate
herself with an unpopular person, at least. She believed that she
should have the vote and, as a resident of Washington, would
have liked passage of Cowan's amendment. If she had joined
the women's movement, she would have earned more publicity.
But she certainly could not have afforded to alienate her friends
in the Congress and jeopardize future commissions. In addi-
tion, she wanted to be respected as a sculptor, and not as a
female sculptor. She wanted to compete with the best, and be-
lieved that aligning herself with militant women would dimin-
ish her achievements. It was not surprising that Elizabeth Cady
Stanton left her studio with the petition unsigned.

Mrs Swisshelm read the account of the meeting and fired off
a letter to the *Missouri Democrat* saying that when Vinnie "placed
herself in the position of a public pensioner she may not plead
privacy to shield her designs and character from the scrutiny of
the public whose money she pockets." Vinnie, she wrote, had
"openly plac[ed] herself beyond the pale of woman's sympathy,"
and spoke of "some lonely Congressman who wishes to win a
smile from Miss Vinnie by voting her another subsidy."[8]

As he had promised he would, Thomas Ewing completed
the draft letter to Secretary of the Interior Orville Browning
and on January 27, 1869, Vinnie officially informed the Secre-
tary that she had completed the plaster model and invited him
to inspect it. On the 30th, Browning visited the studio and wrote
at once to Benjamin Wade, President Pro Tempore of the Sen-
ate, recommending that "Congress make an appropriation of
five thousand dollars to enable the Secretary of the Interior to
pay the installment now due to Miss Ream under her contract."[9]

On March 1, two days before the Congress adjourned, William Kelsey of New York proposed an amendment to a House appropriations bill instructing Secretary Browning to pay Vinnie the $5000. Benjamin Butler no longer had the power to sway the vote, and the amendment was quickly adopted. The next day Lot Morrill introduced the amendment in the Senate. Charles Sumner was the first to rise to his feet. He asked Morrill how much had been paid for the statue. When Morrill replied that nothing had been paid, Sumner asked how much more was owed. He knew quite well that another $5000 was due when the statue was put into marble. He had pledged that Vinnie would never be paid and that the statue would never stand in the Capitol, but he had been outmaneuvered when the contract was originally approved, and now that the Senate had a contractual obligation, he was forced to take a different tack. He asked whether the Senate could obtain a release by paying Vinnie $5000 on condition that the remainder of the contract be terminated.

This, he said, was the wisest course, since he was sure that the Senate would not want that statue placed in the Capitol. Morrill, annoyed, responded that if Sumner wanted to make a new contract arrangement, he had better see Vinnie about it. Sumner hesitated, and Jacob Howard attempted to help him by asking whether the contract perhaps contained a condition requiring approval of someone before payment was made. Vinnie and her friends had anticipated this question in their strategy meetings two months earlier: Morrill replied that the Secretary of the Interior had examined the work and recommended the payment. Howard said that he was dissatisfied with the model, that it was a failure, that the country would be unhappy with it and "I think we had better let the matter stand open until the Secretary of the Interior shall have time to examine thoroughly the statue when it shall be completed."

Morrill reminded him that the Secretary had in fact examined it and had recommended the payment. Howard asked to hear the letter from Browning. Morrill, who had twice told

Howard that the model had been approved, pointedly said that he trusted the senator would pay attention as the letter was read. On January 30, 1869, Browning had written that he had inspected the completed model and that it bore "a faithful resemblance to the original and is highly creditable to the skill of the artist" and he recommended that the Congress make an appropriation to enable him to pay the installment due under the contract.

Howard, hardly a graceful loser, said, "It appears from the contract itself that we are absolutely bound to pay the five thousand dollars whatever may be the quality of this model." Trumbull took the floor to respond that he and those intimately acquainted with Lincoln thought that Vinnie's model was a great success. Sumner was forced to concede that the $5000 had to be paid. But he looked around the chamber and asked if anyone could "suggest whether we cannot in some way get a release for the second five thousand, because it is to no purpose; the statue will never be placed in this Capitol."

At this point Senator James Nye of the Nevada Territory rose to confront Sumner. Nye had been elected in 1864 and had not taken part in the debate in July 1866 when Vinnie was awarded the Lincoln contract, but he had voted in her favor. He knew that Sumner had never visited Vinnie's studio; he asked Sumner if he had seen the model, and Sumner had to admit that he had not seen it. But, he said, he had heard about it.

"Why did you not go and see it?" Nye asked him. "It is right here in the Capitol. I insist that when the thing is here on exhibition, the honorable Senator has no right to criticize it unless he has seen it."

"I criticize it on what I have heard and read about it," Sumner replied. "From the beginning, in advance, I criticized it."

Nye agreed that that was true.

"The Senator says that is true," Sumner said, attempting to get off the defensive. "I know it is true, and I am sure the Senate will regret this appropriation. The French have a saying that it

is bad to throw money out of a window. That vote of Congress was like throwing money out a window. I wish we could get it back."

This exchange did not win Sumner any votes. The amendment was easily adopted and after almost three years of work, Vinnie was to receive the first $5000.[10]

When the Forty-First Congress convened that March, Samuel Marshall, Godlove Orth, Benjamin Butler, John Bingham and James Brooks had retained their House seats. George Morgan, who had aired George Julian's threats against Vinnie, had to give up his contested seat. In the Senate, Charles Sumner was beginning his fourth term. Benjamin Wade was gone; he had lost the nomination in the primary. Reverdy Johnson resigned his seat to become ambassador to England.

The best news for Vinnie was that her friend Daniel Voorhees, now forty-one years old, was back as representative from Indiana, three years after being unseated by Thaddeus Stevens. It had not been an easy campaign: Voorhees had written her, "The race is a desperate one and you may prepare to hear that I am beaten. . . ."[11] He and Vinnie had carried on a steady correspondence during his time out of office and had met several times when he was in Washington on business. They shared a mutual trust and admiration that would last throughout their lives, agreeing on everything except Vinnie's relationship with Albert Pike.

Pike had all but given up his law practice and was devoting most of his time to Freemasonry in general and to the Scottish Rite in particular, which he had revised to suit his philosophical bent, while attacking any form of Masonry that differed from his. He traveled extensively on behalf of the brotherhood, refusing to accept expense reimbursement from the Supreme Council. He was obsessed with Vinnie and his letters to her from hotel rooms while he was on these speaking tours reflect that obsession, which was certainly sexual. "While looking long into your eyes," he wrote, "you seemed suddenly to be transfigured

into an angel. Your whole face seemed to change, and to be-come luminous, your eyes to become deeper and full of light. Darling, I see you now, at work in your studio as distinctly and perfectly as if I were there. It seems to me that I can still feel your kisses on my lips. Have you any lingering memories of mine?"[12]

He dedicated poetry to her as well. The first lines of one poem, "Ma Triste Cherie," give the flavor:

> Your wondrous eyes look sadly into mine,
> Look anxiously and eagerly into mine,
> Look like a sorrowing angel's into mine,
> Until mine ache and fill with bitter tears.[13]

About this time he began to complain that she was writing less often, and that her letters were shorter and lacked warmth. Vinnie was in fact extremely busy, and she was under pressure, from men she respected, to break off the relationship with Pike. One day when Voorhees entered her studio to find her writing to Pike, he seized the paper from her, threw it into the fire, and harangued her about what he considered a ridiculous associa-tion with an old reprobate. Voorhees could talk to her like that with impunity. He had a son only a few years younger than Vinnie, and he behaved protectively toward her. Vinnie admired and respected Voorhees; she did not want him to know it, but she was stubbornly determined to maintain her relationship with Pike.[14]

Now that she had the $5000, she decided to take the model to Italy to have it cast into marble, and revived the idea of hav-ing her father appointed to a consulate there. Anxious to mend fences with Grant and his wife, she wrote the president asking for the appointment; the letter was amended by Trumbull and Marshall and personally delivered by Marshall. When Grant did not reply, James Rollins appealed to Secretary of State Hamil-

ton Fish: "Commending to you, Rob. L. Ream as an applicant for a consulate in Europe. From an intimate acquaintance with him of many years, I can cordially recommend him as a gentleman of great personal worth, and unblemished integrity."[15] Ewing appealed separately. When both requests failed, Vinnie decided to try a petition to Grant from the Senate, and her friends obliged, delivering the final version on April 2, 1869:

> We have the honor to present for appointment to a consulate in Italy, Mr Robt. L. Ream of Washington City and to ask for him your favorable consideration. We ask for him a salaried consulate either at Rome or Florence or as near to one of these cities as possible. Mr Ream is a gentleman of education and of good business capacity and habits. He speaks German and French, is a man of excellent moral character and we believe is well qualified to discharge the duties of any of these positions to the entire satisfaction of the Government.[16]

The twenty-five senators who signed the petition represented a cross section of the Republican Party with disparate views and from various sections of the country. Sumner, Wade and Howard did not sign, but it is worth noting that many of the men who did sign had at one time blamed Vinnie for Johnson's acquittal. In any case, Grant did not respond to the petition and Robert Ream received no consular appointment.[17]

Most American artists took their work to Italy where marble and labor were high quality and relatively inexpensive. However, J. Wilson MacDonald and several other sculptors urged Vinnie to remain in America and have the model transferred into Vermont marble. But she had her heart set on going to Europe because of the quality, and also because she wanted to visit the works of the masters. She began to prepare with her customary energy. Henry Kirke Brown provided her with de-

tailed instructions for packing the model, including the size of boards and brackets.[18]

It was necessary to watch her expenditures, since all she had was the $5000, so she asked her friends if they knew a sculptor in Rome who would be willing to share his studio with her. Edward Clark, the Capitol architect, knew that Truman Bartlett, a prominent teacher and art historian, maintained a studio in Rome, although he was currently working in Paris. Clark wrote to Bartlett, who agreed not only to let Vinnie use his studio but also to subcontract work to her, since he had a five-year backlog.

Lyman Trumbull, anticipating that Vinnie would be gone for a considerable time, wrote her, "I shall not forget you, nor cease to interest myself in your welfare and success."[19] He enclosed a letter of introduction to G. P. A. Healy in Rome. Healy was much sought after as a portrait painter: among those who sat for him were John Quincy Adams, King Louis Philippe of France, Daniel Webster and Henry Longfellow. James Rollins obtained a letter from Secretary of State Fish addressed to all diplomatic personnel in Europe telling them to aid Vinnie in every way. She had letters too from her pastor Byron Sunderland to his clerical friends in Europe. When Charles Van Buren turned down Grant's offer of the position of General Counsel in Florence, it went to James Lorimar Graham. As a favor to Vinnie, Van Buren wrote to Graham asking him to get cost estimates of labor and material for the *Lincoln*.

But Vinnie felt that her most important letter of introduction was one to Hiram Powers in Florence from William Corcoran of the Corcoran Gallery: "I take pleasure in introducing Miss Vinnie Ream, a young artist from the west. I beg you will give her the aid of your counsel in furtherance of the work she goes abroad to accomplish for the Govt."[20] Powers was the most famous American sculptor, his reputation resting primarily on the *Greek Slave*, a work he had completed in the 1840s. Vinnie

looked forward to meeting Powers, who, her critics contended, should have been awarded the Lincoln contract.

As a last important action before she left, Vinnie gave her doves to Albert Pike to care for until her return.

7

The Grand Tour

*Poor little thing I said to myself, how tired she must
have been. But you know what Richard said to Queen
Anne, "'Twas your beauty made me do it."*

—*General John Frémont*

Vinnie planned an eighteen-month stay in Europe, starting
with a few days of sightseeing in London, followed by fifteen
weeks of study, work and socializing in Paris. After that she
intended to remain in Rome supervising the transference of her
model into marble. She made arrangements for the statue to be
brought to Georgetown on June 4, 1869, on board a steamer
bound first for New York and then direct to Italy. After seeing
the *Lincoln* safely under way, Vinnie and her parents, with Al-
bert Pike and Samuel Marshall as escorts, set off to New York
to board their own ship. They spent the night in a Jersey City
hotel, where Pike pledged his love, and she reaffirmed hers. But
then she spent some time alone with Marshall. This so incensed
Pike that the next day he refused to board the tug with them to
New York. "I had longed to see you alone," he wrote her later,
"if only for five short minutes. I had begged you to see me alone.
But you saw and talked privately with another, went away with
him into another room, and remained some time. Marshall loves
you but does not worship you as I do."[1]

Vinnie and her parents sailed on June 9 for Liverpool on
board the *Java*.[2] She spent her few days in London sightseeing

and going to concerts with embassy personnel and important American expatriots. By late June, the Reams were in Paris where they took rooms in the rue St Honoré. Vinnie visited Truman Bartlett in his studio and discussed her plans to study drawing and Italian, and her desire to get better accommodation and open a studio in Paris. She thought it was too early to commit herself to taking over Bartlett's studio in Rome, but he was charmed by her, took her on a tour of the city, and helped her to get apartments in Place Clichy. He also took her to the studio of Léon Bonnat, famous for his religious and historical paintings. Bonnat promised to give her drawing lessons and critique her work. She engaged an Italian tutor, but gave up after a few lessons; she had no ear for languages. She did pursue her drawing studies, arranging for a man and a woman to pose for her, but despite Bonnat's encouragement she did not progress beyond competent craftsmanship.[3]

Her letter of introduction to General John Charles Frémont resulted in a successful meeting. They reminisced over the war years when Vinnie had tried to get his permission to pass through Union lines to look for her brother Robert. The war was a sensitive subject with Frémont, who had had a chequered military career. Lincoln had removed him from command because of policy differences and he regained no stature during the remainder of the war. But he had been the first presidential candidate of the Republican Party in 1856 and had run on a third party ticket in 1864. His situation now in 1869, as an officer of the Memphis, El Paso and Pacific Railroad, was not a good one. Bonds for the railroad were being sold on the French market and the company was being accused of misrepresentation. He was in Paris attempting to rally investor confidence. But he found time to visit Vinnie every day. He wrote her, "I looked at the time I left you yesterday. Poor little thing, I said to myself, how tired she must have been. From nine to eleven, from eleven to two, & from two to—? But you know what Richard said to Queen Anne: 'Twas your beauty made me do it."[4] General

Frémont's wife, Jessie Benton Frémont, was also charmed by Vinnie, who began work in Paris on a medallion of the general and a bust of Mrs Frémont.[5]

Also while she was in Paris, Vinnie carried on a voluminous correspondence with her friends in Washington. Edmund Ross, Richard Yates, Lyman Trumbull, Daniel Voorhees, Samuel Marshall and many, many others flooded her with letters asking for every detail of her journey and informing her about what was going on the Capitol. She tried to respond to all of them every Friday, and that seemed to satisfy everyone except Pike, whose loved one was thousands of miles away and whose emotions consequently alternated between ecstasy and agony. We have only his letters, and not Vinnie's. It is highly doubtful that he would destroy them; probably they were destroyed when his papers were turned over to the Supreme Council of the House of the Temple in Washington.

A year earlier Pike had purchased a small house that he called "our cottage." Vinnie occasionally spent the night there in an upstairs bedroom. When she left for Europe, Pike painted the walls of that room a lilac color and the ceiling a brilliant greenish-yellow, and hung a grouping of three photographs of her and two passionate framed poems on the wall. He often slept in the room, and wrote her that he was extremely happy to be "every day and every night in the house where you were the angel." Vinnie responded with some heat that she did not object to his sleeping in the room or hanging the pictures there, but she did not want anyone to see the poems. She demanded that they be removed at once.

On July 27, 1869, Pike told her that his favorite child, Isadore, had died, leaving him heartbroken. "Nobody," he wrote, "was so dear to me as Isadore, and nobody loved me as she did." Now he had only his other children, Luther, Lillian and Yvonne. Vinnie assured Pike that she too was with him, and this cheered him immensely. He wrote her often about her doves: "I have bought an ornate cage for the doves, and shall

love them because they are yours." And later: "The doves are in their glory and pride of paternity and maternity. The father is wonderfully fine, his feathers smooth and glossy, his appetite good, and his paternal pride inordinate. In their big cage, they are out of the reach of felonious cats, and if not sickness or accident prevents, you will find ready for you on your return, a generation or two of descendants."

He regretted her relationships with congressmen. "The villains who govern the country," he wrote, "seem to have lost all reverence for God, all regard for oaths, all sense of decency, and even the little honor that prevails among common rogues and thieves. I am very, very sorry that you cannot help coming before the miserable scoundrels as a supplicant for favor." He understood, he said, why she would not like these men to see the poems, but there was no likelihood of any of them visiting the cottage. "Mr Ross goes in three or four days to visit his wife and children in Kansas" and Voorhees had burned Vinnie's letters so their friendship was surely at an end. If anyone did see the poems, Pike wrote, they would never "imagine that there is any reality in the poems."

But Vinnie remained adamant: the poems must go: juggling relations with that many men was difficult enough without tempting Providence. Pike refused to remove them from the frames: instead he inserted two innocuous poems over them, telling her, "I shall know what is under the mask all the same."[6] This settled the matter.

It was now nearly the end of September, and Vinnie could not point to any accomplishments. She had not increased her drawing skills in her work with Bonnat; she could manage only a few words of Italian and was not much more proficient in French. Her journals show that while she went to view works of sculpture in France, she looked at them as a tourist and not as an artist. After visiting Versailles, she wrote, "The most extensive sculptures in France. Crowds of people. Wandered

through the gardens. I took a glass of wine and cake." The only work she had done besides the Frémont sculptures was a bust of the American consul James Meredith Read. With time running out, she threw herself into her work.

In mid-September, she went with Frémont to visit the priest Charles Loyson, called Père Hyacinthe, in Passy. At that time he was the best-known preacher in France. He wore a coarse robe, was barefoot and had shaved his head. His room had no carpet and only the simplest furnishing. At first he said he did not think the rules of his order would allow him to sit for Vinnie, but the next day he wrote to tell her that it would be allowed. He was not a man to accept rules passively: he opposed the doctrine of papal infallibility, and in 1871 he was to leave the Church and marry. In 1878 he founded the Gallican Church in Paris which in 1893 merged with the Jansenists of Utrecht.

Vinnie's journal entries from September 29 through October 5 reflect the pace she set in those last days in Paris.

Sept. 29—Wednesday & worked on medallions all day. Madame M. called in the evening, also General Frémont just returned to Paris. Received letter from Père Hyacinthe setting tomorrow at four for the visit.

Sept. 30—Thursday—Mr Bartlett came before breakfast. After, I went calling.

When we returned found Mr Ryan here and went with him to call on Gustave Doré.

Found him at home and very agreeable. He was pleased to sit for me. Arranged the sitting at his studio at one tomorrow. Then Mr Ryan and I called upon Father Hyacinthe. Had a most delightful visit. His sisters were there and very kind. Then Mrs Bartlett, Mr M. and Mr Ryan stayed to dinner. After dinner Mr Bauer and Chas Renaud called and also Mr Washburn who brought me three letters.

October 1st—I roughed up the bust of Gustave Doré.
Worked until four in the morning. Went at one for a
sitting and remained until four in the afternoon. His
mother called while I was there and greeted me in the
sweetest and most affectionate way. I played and sang
for him and he showed me his pictures and made him-
self most agreeable. Then I called upon Dr Loud.

October 2—Went to Dorés again and worked for four
hours on his bust. His mother called at eleven and took
tea with us. Chas Renaud sent Ma a beautiful basket of
fruit.

Oct 3—Sunday—Went with Mr Bauer to St Denis. Had
a delightful ride. Went to Dorés and remained four hours.
Doré called in the evening.

Oct 4—Mrs Frémont and daughter called. She remained
to sit for her bust. Remained three hours. She and Gen-
eral stayed to lunch. After seven the General called again
and I went with him to see Mrs Frémont. Took bust
along and worked all evening. While Mrs Frémont was
sitting today the beautiful sketch of Judith came to me
as a present from Gustave Doré with his photograph
enclosed in a beautiful note. Mrs Frémont responded
for me in French.

Oct. 5—Mrs Frémont, Miss Lillie and Frank Frémont
called. I took at their request casts of their hands. I went
at three to Dorés. Found him waiting for me.
 In the evening Mr Ryan and Chas Renaud called.[7]

It was time to leave Paris, which was pleasant and exciting
but more expensive than she had expected. She could not resist
shopping, and had visited the Evard Harp Manufactory, where
the lowest price for a harp was $600, with a seven-dollar extra
charge for strings. After thinking about it for several weeks,

Vinnie bought the harp. She recorded in her journal: "$8 for a worsted dress, nearly three dollars for a striped balmoral, $30 for tools, some tolerably good gloves for 15 cents a pair." She records also the purchase of two French flags, two large shells, two brushes and three antique vases. Nervous about money, she asked Frémont to check the rail cost direct from Paris to Rome, as opposed to the cost to Rome with stops in Munich and Florence. The difference was only eight dollars, and Frémont was able to provide an apartment in Munich, so Vinnie chose the latter route, planning to spend six days in the German city.

On October 7, 1869, she rose early, made a mold of Mrs Frémont's bust and packed her other unfinished work. After dinner, John Frémont came by, saw to the baggage and took the Reams to the station. Although it was less than 500 miles from Paris to Munich, they had to change trains six times and did not arrive in Munich until late on the 8th. She noted, "My thoughts are full of great designs, full of gratitude for the goodness of those left behind."

The next morning she went to the school run by the famed portrait painter Friedrich Kaulbach. She was a complete stranger, had no reputation and was to be in Munich only six days, but she believed that if she could talk to any man for an hour—whether a famous French illustrator or an American senator—he would agree to sit for her. And Kaulbach was no exception. Over the next four days he took Vinnie to visit several artists' studios, along with museums, exhibitions, horse races and concerts. On the 13th her journal reads, "Went to Prof Kaulbach. Had a long sitting, took wine with him. In the evening drove out through Maximillian Street across the Iser. Left for Florence at 10.10."

She arrived in Florence on the 15th, and sent her card and letter of introduction to Consul General James Lorimer Graham. He came to her hotel bearing a large bouquet of flowers. The next days were spent in sightseeing, and on the 17th Graham took the Reams to the station in his private carriage. On

the morning of October 18, 1869, she woke as the train was pulling into the station at Rome. "Looking up," she wrote, "I saw the great dome white and dim in the distance, illuminated by the morning sun. I shall never forget the impression it made upon me." The first few days were spent at the American Hotel before arrangements were made for permanent rooms at 5 Del Marroniti.[8]

Vinnie went to the studio promised to her by Truman Bartlett and was annoyed to find it occupied. She telegraphed him in Paris and he replied that he had asked her several times whether she wanted it and she had not said she did, so he had lent it to another friend.[9] She was forced to spend the next week searching for a studio and finally settled on one at 45 Via de San Basilie in the center of the American artists' colony.

Early in the nineteenth century, American male sculptors had chosen to work in Italy, where they could live cheaply and find marble and skilled artisans at reasonable prices. By the middle of the century, American women sculptors began to join them. It was the actress Charlotte Cushman who convinced Harriet Hosmer, Edmonia Lewis, Anne Whitney and Emma Stebbins that they should set up studios in Rome. Edmonia Lewis had just won praise for her *Forever Free* and *Hagar in the Wilderness*. Anne Whitney, an ardent feminist, was in her late forties when Vinnie came to Rome; she had not started sculpting until she was in her thirties and then only because her pending marriage had been cancelled because of a streak of insanity in her fiancé's family. One day, Whitney's *Samuel Adams* was to stand in the Capitol with Vinnie's *Lincoln*.

Emma Stebbins, older than Whitney, was Charlotte Cushman's lover. The two shared an apartment and went everywhere together. Vinnie may well have found this relationship incomprehensible at the least, but she admired Stebbins's *Angel of the Waters* fountain in Central Park. The artist's brother was head of the Central Park Commission, but Vinnie, with her own heavy reliance on influential connections, would certainly

not denigrate Stebbins's achievement on that account. Edmonia Lewis, however, had a brooding spirit that was anathema to Vinnie.

Henry James called these women "that strange sisterhood of American 'lady sculptors' who at one time settled upon the seven hills of Rome in a white, mormorean flock." Vinnie, he said, "was 'a gifted child' (speaking by the civil register as well as by nature) who shook saucy curls in the lobbies of the Capitol and exhorted from susceptible senators commissions for national monuments."[10]

Vinnie was prepared to dislike Harriet Hosmer, then fifty years old, because Grace Greenwood had insisted that Hosmer should have had Vinnie's commissions. Then, too, Hosmer's work differed basically from Vinnie's: Hosmer never portrayed her subjects in modern dress; even her *Thomas Hart Benton* wears a toga. When that statue of the Missouri politician was unveiled in St Louis, J. Wilson MacDonald had written to Vinnie that it was "the worst thing I ever saw. Nothing could be further from the likeness, drapery and character of the great senator. No body can say who this thing of Miss Hosmer's is intended for. The truth is that she is a fraud and is no representative of American art abroad; and as for genius or talent she, in my opinion, has neither. . . . We all have too much at stake to permit such trickery as has been played by old daddy Powers and the lady I have named."[11]

Vinnie disliked MacDonald, although he had been helpful: he had advised her not to move her statue when she was evicted from her studio, and he had provided her with letters of introduction and told her how to pack the model for shipment to Rome. He praised her work, telling her, "I have always felt that you had the genius, courage, and enthusiasm to succeed and the fact of your being in the Eternal City with a commission from your countrymen is in itself what many older artists have sought in vain. You are therefore successful." He never missed an opportunity to denigrate older artists, telling Vinnie they

were "the fading phantoms of an old theology."[12] Vinnie was careful not to alienate him in case she needed his help in the future, and also to lessen the prospect of his criticizing her behind her back as he was doing to Hosmer.

It cost her only a few letters to keep him on friendly terms. When he won a commission for an equestrian statue of General Nathaniel Lyons, she wrote to congratulate him. Whatever he thought of Hosmer, Vinnie could never argue with success. Hosmer had sold thirty copies of her *Puck*, and *Zenobia in Chains* won her international acclaim. The Brownings asked her to make a bronze cast of their hands. Among her friends were actors, writers, other artists and European royalty. When they finally met, Vinnie found appealing many things about Harriet Hosmer—her success, her freedom and independence. This is not to say that Vinnie did not feel a touch of jealousy. In her journal, she recorded every detail of her visits to Hosmer:

At nine went by invitation to take tea with Miss Harriet Hosmer. Had boiled chicken, tea, cake, strawberries and cream. She wore a black skirt and white tucked thick waist, locket and black velvet ribbon and blue ribbon in her hair, diamond ring. No carpet in salon. Empty jardinieres, rich lamps, two bookcases, small fireplace, globe lamps, copy of "Aurora", crimson and gilt chairs, three lounging sofas, one little bouquet not fresh. Carpet on dining room floor, fine sideboards, plates hung down the walls, antique ware, I suppose, two rows. In the hall many plaster sketches. She said her father was full of fun always and there were only two things that they were agreed upon. One was that she would never marry and the other was that gray was a better color for a house than white. She was on the stage twice, as a gypsy with Charlotte Cushman playing 'Meg Merrills.' Said if she ever left Rome, it would be to go to England to live.

As always, Vinnie was more comfortable with men than with women. Among the artists, G. P. A. Healy, Randolph Rogers and William Wetmore Story were her closest friends. Healy's studio was in the same building as hers; Story and Rogers had studios not far away. Story preferred Vinnie to Charlotte Cushman, whom he found too masculine, and Hosmer, who, he said was "very wilful and too independent by half, and is mixed up with a set whom I do not like."[13] Soon after they met, Healy asked to paint Vinnie's portrait and she of course consented. The artist she most wanted to meet was Hiram Powers, whose studio was in Florence. There is no mention of him in her journals or in the interviews she gave later in life, so it is doubtful that she ever met him. Powers brutally attacked both Vinnie's work and her character after she returned to America.

When Vinnie found a studio, she had her *Lincoln* moved there from the storage depot, and bought carpets, pictures and furniture. In a letter home, she described the studio:

> The model for the Lincoln Statue, the bust of Gustave Doré, and the likeness of Father Hyacinthe, seem to attract a good deal of attention. I have also in my studio a bust of Mrs Genl Frémont which I made in Paris, and a likeness of the great German painter Kaulbach, which I modelled in his studio in Munich. I have a very large photograph of Mr Lincoln, surrounded by a wreath of Roman cypress, and a large American Flag, (bless it!) festooned over it, and I have two French flags crossed over the Doré bust, and the picture he presented to me. I have found kind friends on every side who keep my rooms supplied with a profusion of exquisite flowers, and very frequently on star light nights like these, we are awakened by a sweet Italian serenade.[14]

One evening when William Story was in her studio, they discussed the way the lines flowed in the *Lincoln*, and whether

the drapery concealed too much of the body. Story suggested alterations to improve the effect, and Vinnie followed his suggestions. Except for her brief studies with León Bonnat in Paris, she had had no formal training after she left Clark Mills' studio. She tried to improve her work through informal discussions with artists and by careful examination of masterpieces. Almost no male artist refused to explain procedures to Vinnie or to give her helpful suggestions.

She quickly became involved in Roman social life. She was invited to a concert given by Franz Liszt at the convent where he was living, and her description of that experience shows that the exercise of her charm was not limited to male artists and politicians.

She sat, she said later, in "a chair almost immediately back of the piano at Liszt's right hand. The wonderful magician swept his slender hands over the keys, fascinating all who heard, and with tremulous vibrations touched some tender chords with such a spell that I was deeply affected. The tears which I could not repress rose to my eyes, and being so near, and fearful of making the slightest interruption, I dared not raise my hand to brush them away. The great artist felt the spell he was exercising over me. He noticed my emotion, and playing softly with his left hand, he reached his right hand over and laid it for an instant tenderly on mine. We needed no introduction. We understood each other, and when he finished playing and all rushed to congratulate him and thank him, I waited silently by to try and speak, but he offered me his arm, and as we promenaded with the rest down the old convent's halls, he said, 'You need not speak. I understand you and you understand me,' and during all my stay in Rome this great master was a constant visitor at my studio, and my warm and devoted friend. . . ."[15]

She carefully chronicled in her journal her social conquests:

February 17th—Liszt made a long and delightful visit to the studio. The Duchesse de Collonna [sic], Baroness

Stine and several titled ladies. I went at half past five to
the convent to see Liszt at his invitation. Found the room
full of Bishops and others. Liszt played for us. I wept
again. . . .

February 19th—Liszt came at eleven and made another
long and delightful visit. Mr D. there also. We all took
wine together. Liszt made me drink out of his glass. At
half past two we went to the Carnival.

To view the Roman Carnival, Liszt invited her to his town
apartment overlooking the Corso. Other property owners there
had erected temporary balconies about five feet above the street
and competed to provide the most impressive decorations. The
street provided a brilliant spectacle: the balconies were covered
with streamers and banners, and flags of every description flew
from windows, doorways and rooftops. The street was already
crowded with people when Vinnie and Liszt entered the bal-
cony which he had draped in scarlet with gold hangings, so that
it resembled a first-class opera box.

A Roman senator, robed in his richest costume, formally
inaugurated the festivities by proceeding down the Corso in his
magnificent carriage, surrounded by his brilliantly clad offic-
ers. He was preceded by bands and troops carrying the richly
embroidered colors to be given to the victors in the upcoming
races, and followed by a number of handsome carriages. It was
a brilliant cortege and as it passed, Vinnie had a clear view of
the senator and his little page covered with velvet, lace and gold.

Behind the carriages came the revelers, most of them dressed
as clowns, but some men were dressed as women and some
women as men. There were bands of minstrels in comic clothes
and dignified courtiers in velvet and gold lace. As they passed,
they pelted Vinnie and Liszt with confetti, paper bonbons and
flowers. For protection from these, Liszt had given Vinnie a
fine wire mask fastened to a wooden stick. In return, the ob-
servers on the balconies started a furious war of paper missiles.

At the end of the first hour, Vinnie began to wonder how these festivities could go on for eight days.

She saw an elderly American gentleman trying to make his way down the Corso, dressed in a silk top hat and black broadcloth suit. He immediately became the unwilling target of a barrage of confetti and paper missiles. His loud angry protests and curses—which Vinnie could clearly hear—simply stimulated the masqueraders to fresh outrages. The last Vinnie saw of him he was being carried struggling down the Corso preceded by drums and fifes, his silk hat gone, his black suit covered in white flour.

This mad frolic continued until six o'clock, when a loud boom of cannon from the Castel Sant' Angelo signalled the hour for the races to begin. A troop of dragoons attempted to clear the street but the dense crowd kept closing in on them. Then the riderless horses let loose in the Piazza del Popolo came charging down the Corso draped in embroidered covers and trappings that sparkled and flashed in the sunlight. Under their ornamented covers was a barbed ball that continually goaded the horses to a full gallop. This torture ended only after the mile run when the horses were stopped by a bright canvas barricade blocking the street.

Each day's celebration ended with these races, but on the last day the festivities went on far into the night, when everyone held a lighted candle and tried to keep it burning while at the same time attempting to extinguish the candles of everyone else within reach. The air was filled with laughter, shrieks and a babble of talk from the enormous throng. Vinnie remembered a lady on a nearby balcony holding aloft a trembling taper in her jeweled hand, her wide sleeve exposing her bare arm, her face animated as she concentrated on keeping her tiny flame alive while the shouting crowd below tried unsuccessfully to destroy it.[16]

8
Hard Work and Long Hours

There was a certain deep note about all that her heart uttered. She had a mind of many colours. And there was the very devil of a rush and Forward! March! about her, always in a hurry.

—*Georg Morris Cohen Brandes*

SOON AFTER ARRIVING in Rome, Vinnie hired an agent to search for a suitable piece of marble for her statue. She was fascinated by the Mamorata marble yards where she went to learn about the selection process:

Very early in the morning and late in the evening, I have been here and when it is raining fearfully because it is considered by the judges of marble to be the best time to see the defects and the discolorations. Here you will see a piece with a great streak of color crossing one corner of the block and yet perhaps the highest price is asked for it. Those of experience will tell you that the dark streaks are a guarantee that the portions beneath them are spotless. Go to the marble yard with an Italian sculptor like [Guiseppe] Rosetti and he will immediately call for a martello and hack off a piece. No matter how fine and white and beautiful it may be, if it is soft and crumbly he will throw it down. Around us were many blocks

of marble, the rarest with the most coarse. Yet in these unshaped blocks there was food for the imagination without end. Delicate and graceful vines twine themselves around these sleeping statues and the grasses wave their graceful heads over this precious material. I have a great weakness for these graceful grasses. I gathered them in the fields of Wisconsin when I was a child, in the wild woods of Kansas, in the marshes of Arkansas, in the meadows of England, on the sunny hills of France and now at Marmorata. I love to come and often linger too long.[1]

By early March she had found a piece of marble that she felt pure enough for her *Lincoln,* and arranged for the inspection and documentation needed to ship the model from Rome to Carrara. The Papal Government required certification for statues leaving Rome, to make sure that these were not antiquities being stolen.[2] In her journal for March 11, 1870, she wrote, "The statue is packed and sent to the depot. A lonely day for me." Now in six or seven months the statue would be in marble, and it would be time to return to America. But she had a great deal of work to do and she began to refuse invitations: "Mr Hartwell invited me to go to Tivoli but I felt as if I could not leave my work so felt obliged to decline." "Mr Ehrenberg invited me to go in the morning to hear the grand music but I declined. I feel as if I must work now and accomplish much in the little time I am to remain."

She made a list of the small projects she wished to complete in the next several weeks: "Group for match piece-pediment . . . Group of Mississippi . . . Dignity of Labor . . . Bell flowers from Carrara . . . Camellia and flowers from Liszt . . . Mrs Frémont's and daughter's hands . . . Mr Rice's medallion . . . Finish Mrs F's bust in plaster . . . Finish the Liszt bust . . . Woman kneeling with cross . . . Masonic figure . . . Finish Paris medallions."

This was Vinnie's most artistically productive period. Ever since the Congressional debates when James McDougall and Jacob Howard had argued over the quality of the *Fragments of Sappho*, Vinnie had been planning a work depicting an ideal woman. She had begun to make sketches in Paris and now in Rome she started to model *Sappho*. She was working also on *Spirit of Carnival*, inspired by the Lenten festivities, and a tribute to her birthplace called *The West*. Then there was a statue she called *Miriam*, and various busts and medallions of prominent people she had met.

She seemed to thrive on long hours of hard work. As she completed projects, she added others, like *Highland Mary* and a medallion of the American consul James Meredith Read. The list never seemed to shorten. But after a month of uninterrupted work, day and night, she began once more to accept invitations. Interspersed with entries detailing work until three in the morning, are listed names of callers and descriptions of visits to the Tarpeian Rock, the Roman Baths, the Palace of the Caesars, St Peter's and myriad exhibitions and Roman festivals. She still had time for less intellectual pursuits, noting, "Went with Mr Ehrenberg to the German Casino. Danced until three this morning."[3]

She did not neglect the Rome-based press, making sure that she obtained introductions to Ripley and Huntington of the *New York Tribune*, Daniels of the *New York Herald* and Ureford of the *London Art Journal*.[4] They, along with Pietro Reignoldi of the prestigious *Il Buonarroti*, became frequent visitors to her studio. Favorable notices began to appear: "She has justly perceived how a monumental statue of President Lincoln should be represented . . . Lincoln is represented [*sic*] serious, calm, melancholy, standing erect, dressed in the costumes of the times, yet rendered artistically by the combination of folds, naturally formed by the movement of the person . . . A brilliant career in art attends Miss Vinnie Ream, who, so young, has produced the great work we have described." An American correspondent wrote from Rome

dated May 4, 1870: "Miss Ream's beauty has prejudiced many against her . . . She hopes to have the statue completed in January next. She will accompany it to America February next, and present it to Congress before it adjourns. . . ."[5]

Vinnie pasted these articles in her scrapbook and sent copies, along with her weekly letters, to Daniel Voorhees, Lyman Trumbull and—mindful of the possible Wisconsin commission— to Matthew Carpenter, the newly elected senator from that state. She asked these men to distribute copies of the articles to the American press. They did this and sent her a continuous stream of news and gossip. Thomas Ewing, after informing her that he was moving to Lancaster, Ohio, to the homestead where he had grown up with William Tecumseh Sherman, asked her, "[H]ow many lovers have you, & who are they, & their rank, whether Duke, Doge or Grandee, and are you still so hard hearted as to refuse to love anybody." Lyman Trumbull wrote that "Mr Ross has shaved off his beard, & it has so changed his appearance you would scarcely know him. He is feeling well, & tells me his prospects for reelection to the Senate are very good."[6]

Among the reporters in Rome, Daniels seemed most enamored with Vinnie and, since he was writing for an American audience, she spent a lot of time with him. He went with her to the marble yards, admired her sketches, gave her French lessons and read his articles to her before he sent them off to New York. The question of money came up with him. Although Vinnie was making a little money from medallions, she did not have time to complete any large commissions. She was receiving small amounts periodically from Ewing and others in Washington, but she needed $2000 to pay for the marble. Daniels had been renting rooms from her for about four weeks when she asked him to lend her the $2000. He refused. She noted in her journal, "Quarreled with Mr D—furiously. He did not remain." She did not like to quarrel with anyone—particularly with a journalist—but she liked being refused even less.

James Hopkins and Robert Patrick, two American bankers, were on an extended tour of Europe, using Rome as their base. Whenever they were in that city, they took Vinnie to concerts, churches and festivals. Patrick was so taken with her that he wrote her regularly on his tour, addressing her as "my little pirate." He obviously did not take this sobriquet seriously, because when Vinnie, clearly showing signs of desperation, asked him and Hopkins for the $2000 loan, they both refused. Once more, there was "a terrible quarrel," and for several days Vinnie refused to see either man. They apparently found this insupportable, because they offered to co-sign any loan she could arrange. She was thus able to borrow the $2000 from Drexel, Harjes & Co. in Rome, at 6 percent interest, with Hopkins' and Patrick's guarantee. She assigned the remaining $5000 due her from the U.S. Government to secure the money.[7]

About this time she made some notes for a novel in which the heroine, Leslie, meets "a young American banker who was going on a pilgrimage to Malta, but stopping in Rome, could not leave the fair Leslie."[8]

Now that she had the money, she chose marble cutters Franklin Torry in Carrara to transfer the Lincoln, and noted in her journal:

> May 21, 1870, Left Rome for Carrara. Answered Miss Hosmer's letter. May 22, arrived at Leghorn. May 23rd, The Consul, Mr [J. T.] Howard called, also Mr Torry. May 24th, Left Leghorn at five o'clock. Quite astonished at the large hotel bill for so short a time. May 25th, Arrived at Massa at noon. Left at seven for Carrara. May 26th, Mr Torry came to hotel. Mr Doyle called with Mr Torry's agent. We went down to see the model at Mr Torry's studio. Then we called upon Mrs Doyle who had nice lemonade ready. Fine views from her window of the quarries of Carrara. Mr Torry's agent called

at five. Went up to the quarries. Hard walk. Returned at
nine. Beautiful singing in the streets by bands of boys.

May 27, Mr Torry came early. Finished contracts. Re-
turned to Leghorn. Reached there at ten and went to
Washington Hotel. May 28, Mr Torry called. I went
down to his office and signed a letter of credit of $2000
over to him. Gave me his receipt. Told me I could draw
interest, 200 francs. He went with us to the depot. Kind
man. Pleasant ride home. Arrived at Rome at ten.

Vinnie wanted to model Pope Pius IX, but an audience could
not be arranged. A second best was a meeting with Cardinal
Giocomo Antonelli, the Papal Secretary of State. On June 25,
1870, she appeared at the Vatican where the Cardinal, ignoring
the Masonic pin on her dress, agreed to sit for her for a bust.
Her journal records her impressions:

July 1st—Cardinal Antonelli paid a long visit to my stu-
dio of two hours. His carriage and servants in gorgeous
livery attracted the attention of all persons around the
studio. He drank wine with us. He wore a short suit,
stockings and knee-buckles. Red watered silk Cardinal's
cap on his head. Decorations simple.
 Fine eyes—hair tinged with gray.

July 5th—Cardinal Antonelli at the house. Long visit.
First visit to house. Sat for his bust. Sent me yesterday
three pictures. Brought me two large ones. He has a thin
wiry frame, a stoop to the shoulder and a most gracious
manner. A thin form and a kind and interesting expres-
sion.
 Speaks French beautifully but broken English. He
looks and acts the Cardinal.
 He seems like a man who is conscious of his great
abilities. The first intellect of the Roman Church and

government. Rich and powerful, with artistic taste and superior intelligence, he sees from his window at the Vatican a world which he sways.

The Cardinal invited Vinnie to his private apartments at the Vatican. She spent, she wrote, "four hours there delightfully" while the Cardinal explained the "rare and beautiful works of art which crowd his rooms." She had visited, she noted, "private and public museums in England, France and Germany, and I gazed in wonder at their great magnificence, but I have never seen anything to compare with the costly, priceless gems and jewels, and rare objects of art, arranged and grouped and crowded into the apartments of Cardinal Antonelli. He told me that he had been collecting and concentrating these treasures ever since he was a young man. He brought me a splendid likeness of himself, in which he is seated in his room at the Vatican, with the dome of St Peter's seen through the open window behind him." As a souvenir, he gave Vinnie a medallion locket, a stone cameo head of Christ set in Etruscan gold and Roman enamel.

She and G. P. A. Healy were establishing a firm relationship and she went regularly to his studio to sit for her portrait. He painted her in a white embroidered square-necked peasant blouse with long, full sleeves. Her headdress is a folded white cloth, the gift of Cardinal Antonelli, and triple drop pearl earrings. In the evening, she sat beside Healy as he cleaned his brushes and pallet, and told her about portraits he had done, and about difficulties and triumphs in his life. He attended mass every morning at St Isadora, and Vinnie often went with him to copy the inscriptions from the tombs and monuments.

In July she traveled to Carrara to inspect progress on her statue:

The roads were dusty, and so many oxen teams laden with marble moving constantly, the road winding among

green fields, and beside huge and stately rows of Lombardy poplars, was beautiful indeed, and overlooked by vine covered hills, with cozy villas. Behind us lay the marble hills of Carrara. Before us lay the sea, in all its dim and vague mysteriousness. As the sea breeze swept up the valley, and the refreshing evening drew near, the imagination could hardly picture a more enchanting scene. The uncarved statues that lie sleeping in these picturesque mountains have an influence over the mind. Around us is a wilderness of marble blocks, some so huge that we wonder that they could have been brought here by a wagon. We have a curiosity to see those wagons and here around us are many, with the great white oxen. Three or four or five pair are hitched together. We watched them move the heavy blocks. When the oxen are required to pull, what a beating they do receive. Of all the creatures that work and drudge the white great-horned oxen of Carrara are treated with greatest cruelty.

There is a noticeable difference between these notes and the ones Vinnie had made in France. In Rome she was no longer a tourist, but a student. On her way back from Carrara to Rome, she stopped at Pisa, where she was fascinated by the sculptures of Nicola Pisano, silver work by Michelangelo, mosaics by Giovanni Cimabue, and paintings by Andrea del Sarto. She carefully recorded details of these works: their size, color, composition, setting and lighting, and made copious notes on how alabaster is found and boiled to simulate marble and on the size and color of pieces useful to sculptors. At night she rewrote her notes, interweaving them with observations on Italian life.

In the summer, she noted, the men worked stripped to the waist, while the women wore dark woolen skirts with heavy corsets of cotton-covered damask, worsted shawls over their shoulders and their heads covered with kerchiefs. She commented on all the skills she encountered, from workmen mak-

ing specially designed crates to hold statuary, to women doing fine embroidery. "The white silk was stretched over a square frame," she wrote of the latter "and then [using] a finely engraved landscape as a model, she was copying it in the embroidery so that by the greatest scrutiny one could not detect the difference." Never, Vinnie wrote, in any industrial exhibition in America, England, Paris, Munich or Rome—"the Goblein [sic] tapestries"—had she seen anything to compare to this. "I would sooner undertake to make ten statues than such a piece."[9]

At the end of the summer, the Carrara marble workers completed the *Lincoln*, and Vinnie arranged to have it sent to Leghorn for passage to Washington. At the same time, word spread that because of reverses in the Franco-Prussian War, the French garrison was going to evacuate the city; they could no longer be spared to protect the Pope's claim to it. This left the city open to royal troops who had already declared Rome the capital of the Kingdom of Italy. On September 20, 1870, after a five-hour bombardment, royal troops entered the city, and Pius IX and Cardinal Antonelli retired to the Vatican. Vinnie had fled the city several days earlier for Vienna.

There she met John Jay, the American consul, and did a bust of him. His family considered it a strong likeness, especially in profile, but they disliked it in general. Jay gave Vinnie his daughter's comment: "Father, the principal fault is your own. You have grown too stout. Robust health is not favorable for classic features."[10] They wanted Vinnie to narrow the full face, especially the chin, and to create a sterner mouth and a longer, more slender neck, and to remove some wrinkles. But as she had with Horace Greeley, Vinnie refused to make these changes. Again her dedication to realism left a client unhappy.

When the situation in Rome stabilized, Vinnie returned to the city by train to make final preparations for her journey home to Washington. On the train, carrying her guitar, she took her seat next to a handsome young man and initiated a conversation by asking him, in Italian, if he knew the time. His answer

indicated that he was not Italian; he introduced himself as Georg Morris Cohen Brandes, a 28-year-old Dane who was on a tour of the Continent. Vinnie told him that she hardly knew twenty words in Italian, that although she had been living in Rome for two years, she spoke only English.

At Monte Rotondo, passengers had to leave the train because the bridge had been blown up by Papal forces in an attempt to prevent Royal troops from entering Rome. Vinnie and Brandes had to travel together over bad roads to reach another train waiting on the other side of the destroyed bridge. Brandes wrote later, "Thus I drove for the first time over the Roman Campagna, by moonlight, with two brown eyes gazing into mine. I felt as though I had met one of Sir Walter Scott's heroines. . . ."[11]

Immediately on reaching the city, Vinnie began to finish and crate her work; she was eager to get home. Fifteen or twenty people called every day, and she could turn no one away. Brandes was one of her daily visitors. He watched her work on Antonelli's bust and then went with her to Healy's studio where her portrait was being given finishing touches. Every day she and Brandes went for long walks through the city and through art galleries. Brandes noted that Vinnie seemed ignorant of affairs outside her field of endeavor and spoke with passion only about sculpting. As she had told him, she knew only English and was amused by hoary jokes. She knew only English and American writers; Brandes tried to interest her in European literature. For her part, Vinnie found Brandes undiplomatic: she pointed out that within one week of arrival in Rome, he had offended most of the local Danes by harping on the inferiority of Danish newspapers. She suggested he take her behavior as a model and let people express themselves freely without contradicting them, showing kindness even to those who were hostile.

One day Brandes, coming to take her to the Casino Borghese, found her weeping uncontrollably. She was beside herself

with grief because one of her doves had disappeared during the night. This reminded Brandes of a poem by Catullus describing a girl sorrowing for a dead sparrow. He tried to console her and they went to the gardens of the Villa Borghese where they talked for hours about their pleasure in each other's company with, as Brandes recalled, "no erotic element about it." Then they returned to the studio where he watched her work by candlelight until three o'clock in the morning.

That same evening an Italian who kept a small hotel and sometimes translated letters for Vinnie came to the studio. Brandes, sitting silently by, found it impressive, if surprising, that she treated the man with respectful friendliness. Vinnie whispered to Brandes, "Talk nicely to him as you would to a gentleman, for that he is; he knows four languages splendidly; he is a talented man. Take no notice of his plain dress. We Americans do not regard the position, but the man, and he does honor to his position."[12]

On October 23, Brandes and Vinnie arranged to attend a celebration in honor of one of Italy's fallen heroes, but Vinnie was held up by her usual twenty visitors and by the time they reached their destination, the festival was over. Vinnie convinced Brandes to go with her to the American chapel instead, because she felt like singing. They heard the sermon and the reading of the Ten Commandments and Vinnie sang the hymns and, Brandes remembered, "really did sing them very well." When they left the chapel, she took Brandes' arm and said, "That minister was the most stupid donkey I have ever heard in my life." She objected to the minister's remarks on forgiveness, saying, "What am I benefited if ever so many heavenly beings say to me, 'I pretend you have not done it,' if I know that I have." Brandes asked her why, if she felt that way, she went so often to church. Her answer was: "Because it is nice to sing."[13]

In the last week in October, from the street outside her studio, Brandes and Vinnie watched the evening sky flame with

the Northern Lights. He teased Vinnie that he had wasted a good deal of time with her, and Vinnie replied gravely, "People do not waste time with their friends." Brandes asked her what he had got from her, and her answer was: "Inspiration." That night Brandes wrote in his journal:

Vinnie Ream leaves tomorrow morning; I said goodbye to her this evening.

A door opens, and a door closes, and people never meet again on this earth, never again, never—and human language has never been able to discover any distinction between goodbye for an hour, and goodbye forever. People sit and chat, smile and jest. Then you get up, and the story is finished. Over! Over!

And that is the end of all stories, says Anderson. Those great brown eyes, the firm eyebrows, the ringleted mass of chestnut brown hair and the fresh mouth, the quick little figure, now commanding, now deprecating, is to me a kind of inspiration.

I have never been in love with Vinnie. . . . But I love her as a friend, as a mind akin to my own. There are thoughts of our brains and strings of our hearts, which always beat in unison. Finally, she has shown me again the spectacle of a human being entirely happy, and good because happy, a soul without a trace of bitterness, an intellect whose work is not a labour. She was vain, she was certainly that. But again like a child, delighted at verses in her honour in American papers, pleased at homage and marks of distinction, but far more ambitious than vain of personal advantages. She laughed when we read in the papers of Vinnie Ream, that in spite of the ill-fame creative lady artists enjoy, far from being a monster with green eyes, she ventured to be beautiful.

She was a good girl. There was a certain deep note about all that her heart uttered.

> She had a mind of many colours. And there was the
> very devil of a rush and Forward! March! about her,
> always in a hurry.[14]

She left Rome the next morning and she and Brandes never met again. Thirty years later, when he was established as one of Europe's foremost literary critics, he wrote his memoirs and devoted nine pages to his seventeen days with Vinnie.

The Unveiling

It would be foolish to pronounce the statue a real work of art. The test of time will determine that. But that it is a contribution of real value to the portraiture of its subject cannot be doubted.

—New York Times

IT WAS LIKE THE RETURN of a conquering hero. Generals, congressmen, Cabinet members and journalists came to welcome Vinnie home, to hear about her journeys, her adventures, the people she had met, but primarily to be with her after an absence of eighteen months. They found her more beautiful than ever, but also more self-assured and sophisticated. She told and retold her stories to her admirers, sometimes in small groups, sometimes individually. Her only negative experience was her voyage home, when she spent several terrifying days in her cabin because of stormy seas. Crosby Noyes, editor of the *Washington Evening Star*, was so taken with her description of the Roman Carnival that he asked her to write an article about it— that appeared under her byline in two front-page columns.[1] She unpacked *Sappho*, *Spirit of Carnival*, *The West* and other pieces and exhibited them to rave reviews. But despite strong interest, she left the *Lincoln* in its crate.

The news she heard from her visitors was not good. Edmund Ross, Lyman Trumbull and Daniel Voorhees expressed despair over corruption in the Grant administration, which

Grant seemed unwilling to clean up. Even Vinnie's old nemesis George Julian had become fed up and broken with the administration, denouncing the greed of the railroad lobby. Charles Sumner broke with the president over his San Domingo policy.

Edmund Ross was defeated in the November elections and was forced to relinquish his seat in March. Vinnie liked Ross and maintained her friendship with him, something she did not do with other defeated congressmen. William Fessenden was dead and James Grimes had resigned. John Henderson, Joseph Fowler and Peter Van Winkle were retired. Of the seven Republicans who had voted to acquit President Johnson, only Lyman Trumbull was left. He was a serious moderate, a Constitutional scholar, deeply upset over the corruption in his party. Vinnie admired his logical mind and dignified deportment and was unhappy to learn that he was considering retirement when his term expired in two years.

The only good news for Vinnie was that Daniel Voorhees had won reelection. Before she left for Europe, Voorhees had cautioned her about her relationship with Albert Pike; now on her return he told her again that this affair should be terminated. Whether out of respect for Voorhees or because she had grown more sophisticated, she did cut back considerably on her correspondence with Pike. She wrote most often to Voorhees who, unlike Trumbull, felt that his presence in Congress could make a difference. He rose daily in the House to speak against the course Reconstruction was taking, and to attack the president. "You tender General Grant the sword," he said on the floor, "and tell him to wield it upon his countrymen in any direction he chooses, strike whenever his passions, his hates, his ambitions, or his interests dictate, and upon such causes or provocations as to him alone may appear sufficient. Do you wish to establish lawless tyranny in this land?"[2]

Vinnie did not understand why Voorhees, Trumbull and Ross were so upset. She could feel passionate about art and about

personal insults, but her emotion did not extend to politics. She was disturbed only that her friends were disturbed, and she tried to amuse them, to take their minds off their problems. They were delighted that she was home and vowed to do everything in their power to make the debut of *Lincoln* a success. They told her to contact Columbus Delano, Grant's Secretary of the Interior. The contract specifically required that the finished statue be approved before the final $5000 was paid.[3]

Vinnie did not look forward to her meeting with Delano, who had contested the election of her friend George Morgan of Ohio and taken his House seat. Morgan had defended her by exposing George Julian's threats against her, and she felt there was poetic justice in the fact that Morgan had been reelected in November while Julian had lost his seat. Despite her reservations about Delano, however, her interview with him was successful; he promised to inspect the statue as soon as it could be moved to the Capitol, and even offered unlimited help with the eventual public unveiling.

The crate was moved into the Capitol rotunda where Vinnie and her family gathered with Delano, many congressmen and reporters. The workmen dismantled the crate and the large figure, tightly wrapped in cloth, was revealed. Vinnie was noticeably nervous, described by Noyes as "pale and anxious, and rendered more childlike in appearance by her petite form and Dora-like curls."[4] She knew that H. K. Brown's statue of Lincoln had recently been unmercifully criticized. She knew too that most of the people in the Rotunda had been personally acquainted with Lincoln, and were not going to judge the statue on artistic grounds alone but on its faithfulness to the subject.

As the cloth was slowly raised, the deeply chiseled words on the base—ABRAHAM LINCOLN—appeared, then the body and finally the head of the martyred president. For a moment, but what must have seemed to Vinnie like an eternity, everyone stared at the statue. Then they began to applaud—everyone except

Delano, who walked over to Vinnie, took her hands in his, and smiled. She knew she had succeeded. People began to mill around the statue, examining it from all angles.[5]

Lincoln was modeled with his right foot a little forward of his left; the right knee slightly bent. A long circular cloak covers the right shoulder and arm, falling off the left arm, held partially under the forearm and caught up by the left hand. The head is bent forward a little as if he looks at the person to whom he is offering the Emancipation Proclamation in his right hand. The expression is rather sorrowful. Vinnie stood off to one side, her eyes filled with tears, as she was warmly congratulated. She knew that her friends in Washington had accepted the work and she did not have to worry about Delano's reaction. But it was what the reporters would write that would influence the country's opinion. She did her best to charm them, but she could not tell what they were thinking.

The next morning a war of words exploded on the front pages and in the editorial columns of the nation's newspapers. The negative comments were negative indeed. "Art is a great thing," wrote the *Philadelphia Evening Telegraph*, "it deserves encouragement; and public money may often be worthily bestowed upon its best products; but as there are at least ten thousand American girls who, under equally favorable circumstances, would become the peers of Vinnie Ream in the business of moulding statuary, we see no good reason for singling her out for the special honors and special rewards she has received. If the Capitol is to be adorned by statuary, let it be procured from the masters of the art, and not from pupils educated at public expense."

The *New York World* reviewed the unveiling under the headline, "Vinnie Ream Congratulated on the Whiteness of her Bust."

The article in Horace Greeley's *New York Tribune* began with a discussion of a rumor that Vinnie would be given a contract to do a statue of one of two of the nation's greatest war heroes, Admiral Farragut or General Thomas, both of whom had re-

cently died. David Glasgow Farragut, who had died August 14, 1870, had won fame for his capture of New Orleans and his victory at Mobile Bay. George Henry Thomas, who died March 28, 1870, had commanded the Army of the Cumberland during Sherman's march to the sea, where he earned the soubriquet "The Rock of Chickamauga" for his stand at the Battle of Chickamauga. The *Tribune* commented, "It seems time to call a halt! Are there not sane men enough left in Congress to stop this folly? This country is not without sculptors of recognized genius and established fame. To say nothing of Powers and others now abroad. It was discreditable that a work demanding the best inspiration of our first master, should have been given, not to Quincy Ward, or Launt Thompson, but to a young girl whose best known productions were repulsive libels upon the eminent men whose features she undertook to produce."[6] It was obvious that Greeley was still angry about the bust Vinnie had done of him.

The women critics weighed in as well. Mary Clemmer Ames in the *Independent* called Vinnie a "fraud" and the statue an "abortion."[7] Grace Greenwood's *Tabitha Tatler* articles attacked Vinnie's taste in clothes, her lobbying and her attempts to charm congressmen. Lucia Gilbert Calhoun's criticism was intemperate enough to prompt an editorial: "The secret of Mrs Calhoun's savage attack upon the little artist is accounted for by the fact that Mr Sumner opposed the appropriation for Miss Ream, and has never countenanced or encouraged her efforts. The Tribune thinks as Mr Sumner thinks; and Mrs Calhoun gives audible voice to Greeley and the Massachusetts Senator."

Mrs Calhoun was castigated by another newspaper for what it termed "slurs" prompted by Vinnie's receiving "the Senatorial commission for the statue of Lincoln when [Sarah Fisher] Ames, an older woman, wanted it." The *Daily Gazette* advised Mrs Ames to stop endorsing "the libels concerning Vinnie Ream's personal appearance and actions." Crosby Noyes of the *Washington Evening Star* commented: "The Mrs Calhoun clique of the *New York Tri-*

bune may be expected to howl pretty lively. The idea that government should presume to set up a work of art which has not received the approval of Mr Tweed's esthetical kingdom will prove to be too much for their tender sensibilities."[8]

Most newspapers printed a letter from J. G. Kellogg of which the *Philadelphia Telegraph* said, "the opinion of so competent an authority as the distinguished painter Kellogg, who has both a European and American reputation, will be read with interest" and quoted Kellogg: "'The features of Mr Lincoln are admirably rendered. The head and features are forcibly yet truthfully modelled, the hair boldly managed in flowing mass, as by the skill of experience; and the expression of sadness, mingled with benevolence, is touchingly portrayed, well conceived, and appropriate to the expression and meaning of the statue.'"[9]

The *New York Times* delivered a balanced assessment. "No statue of Lincoln—and there are several—has met with general favor, and some of them, notably the one in Union Square, New York, have been favorite subjects of ridicule. And Miss Ream's statue will undoubtedly receive more or less adverse criticism. It is a conscientious, painstaking, loving effort of a young woman, not devoid of artistic perception, and even genius, to present Mr Lincoln as he actually appeared, and in the dress he habitually wore. So if Miss Ream has not evoked from the marble a figure of striking beauty, so that she has fashioned truthfully the President, certainly it is not she who is at fault. It would be foolish to pronounce the statue a real work of art. The test of time will determine that. But that it is a contribution of real value to the portraiture of its subject cannot be doubted. The giving of a commission of such importance to a young lady of only two years experience in the study of art was possibly deserving of censure. But there will be few now found to express regret, or who will not be, indeed, glad. Not all the attempts of our Government to encourage and aid artists have found so worthy a return."[10]

Three days after the unveiling, Secretary Delano sent Congress a letter saying he accepted the statue and recommending

the appropriation of the final $5000 payment. Vinnie met with Delano to plan the formal public acceptance and presentation of the statue to the nation. Vinnie wanted an evening gala with music and speeches and the attendance of all Washington dignitaries, particularly President Grant.[11] But before these plans could be put into effect, Vinnie's brother-in-law Perry Fuller died suddenly on January 11, 1871.

Fuller had been a wealthy man, owning a three-story wholesale house in Lawrence, Kansas, that did $600,000 a year in business, and operating branch stores in New Mexico and the Indian Territory. He owned a home on K Street in Washington. But something seemed to have happened to his business arrangements after Congress refused his appointment to the Internal Revenue Service. Thomas Ewing, who periodically sent Vinnie small sums of money, now sent her a check to give to her sister Mary, "if," he wrote, "you think her pride will not be offended. Otherwise keep it for yourself."[12]

After the funeral, Vinnie turned her attention again to the public unveiling, set for January 25, 1871. Trumbull thought that Richard Yates should be the main speaker, because he was from Illinois and had known Lincoln well. Yates was still attending temperance meetings, and Trumbull said he was "in good condition. He would do the thing handsomely, if himself, which I think he would be, if he undertook it."[13] But Vinnie was not impressed with Yates's attendance at temperance meetings. She was afraid that he would be drunk at the unveiling, and she felt his acceptance of the statue would be inappropriate considering that he had spoken harshly against a pension for Mary Todd Lincoln. She did, however, want someone from Illinois, so Trumbull arranged for her to meet with Justin Morrill and John Beatty, chairmen of the Committees of Public Buildings and Grounds for the Senate and House, respectively. They worked together to develop a guest list, set the order of speakers and chose 7:30 in the evening as the time for the ceremony. Circulars were distributed to ensure a good turnout.[14]

Just before the public unveiling, Vinnie received the letter from G. P. A. Healy that she had been eagerly awaiting, announcing that he had finished her portrait and sent it to Leghorn to be shipped to her. "As I promised you," he wrote, "I took your portrait to Antonelli but was told he was not well, nor would they take my note to him, saying he was too ill. Of all those nice people I met at your house the only one who called in time to see your picture was the young Dane."[15] This must have brought back vivid memories of October evenings watching the Northern Lights with Georg Brandes.

Vinnie arrived at the Capitol on the 25th to find the steps filled with people waiting to gain admission. She wore a black velvet robe with an overdress of white poplin, and a white velvet hat with a single ostrich plume. Her hair was pulled back into a simple knot held by a small golden dagger. In the Senate Chamber were President Grant, General Sherman, Admiral David Porter and senators, Cabinet members and ambassadors. She was twenty-three years old and these prominent men had gathered for her. She moved easily around the chamber, chatting and accepting congratulations.

At a quarter after seven, it was time to move to the rotunda, brilliantly illuminated with gas jets and hung with huge flags, and take their seats in the stands that had been erected around the flag-covered statue. At 7:30 the doors were opened and the crowd surged in. After the Marine Band played, Justin Morrill gave the introductory remarks. Then Supreme Court Justice David Davis stepped up and removed the flag from the *Lincoln*. There was a burst of applause, followed by a loud hum of conversation.

Trumbull called for order and talked about Vinnie's life, about how Congress had awarded her the contract and about her trip to Europe, and the appropriate choice of marble to immortalize Abraham Lincoln. Speeches in praise of Lincoln, periodically interrupted by applause, especially at mentions of Grant and Sherman, were given by Representatives Shelby

Cullom of Illinois and Nathaniel Banks of Massachusetts and
Senator James Patterson of New Hampshire. The remarks ended
with thanks and congratulations to Vinnie. James Brooks of
New York said, "We have no Pantheon, no Vatican, no West-
minster Abbey wherein to entomb our illustrious men or to erect
statues to their honor. Yet the time is coming—nay, in part,
come—when this rotunda and the surrounding halls and grounds
will be filled with pictures, statuary, and other monuments of
the world's memorable men. But in the work here we are un-
veiling is the double memorial of not only a chief magistrate in
the prime of life foully shot down, but the memorial of a woman's
handiwork . . . we now see the equal rights of woman, if not
with the ballot, with the chisel and artistic instruments to per-
petuate the human form divine."

Closing remarks were delivered by Matthew Carpenter of
Wisconsin, who had been elected to the Senate just before Vin-
nie left for Europe. Vinnie wanted all congressmen to be her
friends, but she wanted Carpenter especially, because he could
be of assistance in the matter of the statues of Henry Dodge and
James Doty that Wisconsin was considering. She had written to
him from Europe, hoping that news she sent would be passed
on by him to the Wisconsin legislature, and she had singled him
out to speak at the unveiling, believing that he would show
appreciation for this opportunity for national exposure. Car-
penter began by thanking Congress for giving the contract to a
Wisconsin native, and he thanked Vinnie for not presenting Lin-
coln as a Roman god as Greenough had done with George
Washington. In conclusion, he asked Vinnie to step forward.
She smiled and bowed to the applause of the crowd, which
moved in around her, led by General Sherman.[16] There was to
be gossip in the future about the relationship between Vinnie
and Sherman.

It was a perfect evening, although there were some people
who had not come. Vinnie had wanted Thomas Rooker of the
New York Tribune to be there so that she could work on him to

end the bad notices she was getting, and also to restart her campaign to interest Ezra Cornell in her work, but Rooker could not attend because his presence was required elsewhere.[17] Thomas Ewing received his invitation too late, and declined, saying "I care little for such occasions and would rather have your good company all to myself."[18] James Wilson MacDonald also received his invitation too late. She had invited him even though she disliked him, because she wanted to charm him so that he would not savage her *Lincoln* as he had Harriet Hosmer's statue of Thomas Hart Benton.[19] Vinnie sent a telegram to James Rollins, but he too was committed to speaking engagements.

General Custer wrote, "My Dear Vinnie: I hope you have not judged me harshly because of my silence. . . . I am so tied down by business engagements that I have found it impractical to absent myself from New York. I cannot tell you how disappointed I am not to be present at the unveiling of your statue."[20] Albert Pike, although he surely wanted to see Vinnie in her moment of triumph, nevertheless declined to attend, saying he would not "meet men who have no name for me but Rebel." He was also "sure it would not serve you, with them, for you to welcome me before them as a friend."[21]

The next few days were filled with entertaining at home, accepting still more congratulations, accompanying interested persons to the Capitol to see the statue, and reading newspaper reviews. Most papers carried small factual reports following their more in-depth assessments of the unveiling, but the *New York Tribune* ran a series of attacks on Vinnie's work and on Vinnie herself. In the January 26, 1871, issue: "We expected a failure, but did not dream it would be so bad. Now let Mr Delano board it up again, and when the members have forgotten what it looked like they will vote money to the indefatigable young lobbyist for statues of Farragut and Thomas."

Anti-*Tribune* papers rose to her defense. The *New York Telegram* inquired, "What has Miss Vinnie Ream done to the free love women who write editorials for the Tribune that they

should abuse her? The criticism of Mrs Calhoun's savage attack upon the little artist is accounted for by the fact that Mr Sumner opposed the appropriation for Miss Ream, and has never countenanced or encouraged her efforts."[22]

The *Tribune* responded on the 31st with a long article that began with the statement that the paper had been reserved and charitable, "but since these injudicious advocates refuse to be grateful for silence, let them listen to a word or two spoken in sober sadness. When the fair enslaver of the Senate had gotten her order, she lobbied for a studio and got that. She devised a jaunty coquettish costume and played at modelling. At last she completed a formless thing she called her model. But she knew she could no more make a statue without some man's help than she could make the living model of a Bambino. So she sailed for Italy with her clay image and a few photographs. She gave these to the skillied statuaries, and while they were cutting the marble Miss Vinnie went about in very picturesque and polite company. Before long another effort will be made of voting this young lady money enough to hire a statue made in Italy."

The *Daily Chronicle* pointed out that that a model by one of the *Tribune's* prized artists, J. Quincy Ward, currently being transferred into marble in Italy, was one-third the size of the *Lincoln*, and asked, "Will the Tribune assert that he is less competent?"[23]

Vinnie was deeply hurt by these *Tribune* attacks not only on her talents but on her integrity. Harriet Hosmer fired off a letter to Horace Greeley that was reprinted by most leading newspapers, saying that she had firsthand knowledge that the *Tribune's* allegation that Vinnie had "flitted about Rome receiving the attentions of Cardinals and other dignitaries" was a lie. Further, Miss Hosmer suggested that Vinnie sue the paper for libel for saying that she had not done the work herself. "I knew Miss Ream personally when in Rome, and I lift up my voice in her defense. I believe her to be a conscientious and hardworking artist, and as much entitled to the credit of her work as any artist I know."[24]

But the *Tribune* continued its onslaught, with a reporter writing that he had been "informed of the great secret of Miss Vinnie Ream's success as a sculptress. It appears that she is a Mason, or a Masoness, as you please. She belongs to a Female Lodge, which has some sort of connection with Male Lodges. . . . However, Miss V. Ream has taken eight degrees in something or other and is very high in the mysteries. This accounts for the elegance, beauty, and generally fine mason-work of the Lincoln statue." The *Tribune* did not hesitate to praise her as being "unusually attractive," using this against her by adding that "[her] bright eyes and brown curls . . . undoubtedly aided her in her first public work." Her appearance was a favorite newspaper topic. One reporter commented that "her eyes are very black, large and expressive, her forehead broad and high, with finely shaped nose and a firm, almost obstinate mouth. She is the possessor of the finest head of hair of any lady in Washington."[25]

Vinnie's studio was also an object of interest to the press. Since she could no longer work in the Capitol and had little money, she took over the ground floor of her parents' house. Its "soft curtains of crimson red," rhapsodized one enchanted writer, "veil the windows through which the light falls with a lifelike glow upon the busts of statesmen and poets arranged around the room, giving the cold features such a semblance of life that one is startled, almost imagines himself in the presence of the great and gifted who have come back once more to honor this child of genius." Reporters did not fail to describe the artist herself with her "petite . . . figure," her "large black eyes and abundant hair . . . She is about twenty-three years old but in fact looks like a child. She wears in her studio a short dress, a blue blouse, and a small turban on her head, not unlike that seen in the portrait of Raphael."[26]

Once again, a visit to Vinnie's studio became an important part of any complete tour of Washington places of interest.

10
Finances and Fairs

*Pardon me for my free method of writing, for I have
almost fancied that I was writing to one of my own
daughters.*

—*Ezra Cornell*

Shortly after the unveiling, Daniel Voorhees came to Vinnie's
house to discuss ways to ensure that the House and Senate would
honor Secretary Delano's request for the $5000 payment.
Voorhees knew that Vinnie was in debt and that her sister Mary
was dependent upon her since Perry Fuller had died leaving his
business affairs in a tangle. Robert Ream had gotten back his
job in the cartography department, but his salary was low. When
Vinnie told Voorhees about the $2000 loan from Drexel and
Harjes, he told her she had acted responsibly by arranging the
loan, but chastised her for using strangers as co-signers.

Vinnie had no head for money management, but she told
Voorhees that she had learned two valuable lessons from Clark
Mills: one was that a sculptor should always strive for realism,
and the other was that a sculptor should always strive for extra
appropriations. She knew that the Congressional contract for
Mills's *Jackson* was set at $32,000, but an extra $6,500 was
voted because of unforeseen expenses. She believed she was in
the same situation and asked Voorhees if she could ask Con-
gress for extra money. He promised to look into the matter, and
the next night returned with her pastor Dr Byron Sunderland

and Crosby Noyes of the *Washington Evening Star*. Sunderland, who had done extensive research into payment for various works commissioned by Congress, told Vinnie that the contract for Horatio Greenough's *Rescue*, originally set at $24,000, had been increased by Congressional appropriation to $32,000, and his *Washington* had gone from $28,000 to $51,000. Luigi Persico's *Columbus* contract had been increased from $24,000 to $32,000.

Dr Sunderland emphasized that when these appropriations were made, the dollar was worth twice as much as it was at present. After some discussion about what Congress would accept, Vinnie decided to ask for an additional $5000. Voorhees went along with that, but told her, "You had better address all your attention to the stupid senators. Members of the House are far the most sensible."[1] Noyes pledged editorial support for her request and said he would print Dr Sunderland's findings. But after some discussion, it was decided that these findings should not be published in the *Star* because everyone knew that Vinnie and Noyes were friends. It was agreed also that it would be wise to let the appropriation stand at the original $5000 and then call for an amendment once the bill reached the floor. Everyone agreed too with Voorhees that the House would not present a problem, but that the Senate vote, with Charles Sumner and Jacob Howard there, would be in doubt. So it would be best to choose a time when they were absent. Voorhees suggested that Vinnie and Rollins meet with as many senators as possible before the resolution reached the floor.[2]

Over the next month, she met continuously with congressmen, telling them about her unexpected costs, that she did not stint in her selection of the purest marble, that she had worked for years to capture the essence of Lincoln, that their support would help to offset the dreadful press attacks upon her, and that she could hardly express the gratitude she would feel if they voted her the additional money. If Richard Yates felt slighted by the speaking arrangements at the unveiling, he did not show

it, because he pledged his support and his vote. Nathaniel Banks, who had spoken at the unveiling, agreed to introduce the amendment. William Kelsey of New York who two years earlier had proposed the amendment to pay Vinnie the first $5000, was now against the amendment on the grounds that it violated the contract and therefore violated the law. But William Lawrence of Ohio, Julius Hotchkiss of Connecticut and John Peters of Maine remained pledged to her.

On February 24, 1871, at the last session of the Forty-First Congress, when last-minute appropriations bills were being reviewed, the clerk read, "To pay Vinnie Ream the amount due on the contract for making the marble statue of Abraham Lincoln, $5000." Nathaniel Banks rose to "amend the paragraph just read so that it will read as follows: To pay Vinnie Ream for making the statue of Abraham Lincoln, $10,000; which, in addition to the sum of $5000 already paid, shall be in full of all claim for work."

Banks' amendment was supported by Julius Hotchkiss, who said, "I shall vote very cheerfully for this proposition. I am no judge of the merits of this work, but the example of this young girl is worth more to American women than $15,000. I advocated the passage of the original appropriation with this young lady, and now that I see such a war of the press upon this child, when I see the envy that is excited in the breasts of others who might better follow her example, I want the Congress to reward her for this work. She is entitled to far more than we have given her or than is asked for her. I hope that this has not been asked by her, but that the proposition has arisen from a sense of justice to her."

Banks' reply to this certainly skirted the truth: he was proposing the amendment, he said, of his own volition. Hotchkiss said he was glad to hear it and he only wished the sum were larger. Several other congressmen announced that they had prepared similar amendments, but that Banks had obtained the honor. Then Benjamin Butler, who had vowed in March, 1869,

that Vinnie would never be paid for the Lincoln statue, rose to argue against the amendment. He had read, he said, all the speeches given at the unveiling, and he agreed "to a great deal said about her looking over the prairies and over the lakes, and all that sort of thing . . . to all the 'spread eagle,' all the 'Fourth of July,' all the 'American brag and boast' of that hilarious occasion." He accepted it all, "but still I am not willing to pay more than was agreed." If, he said, her bargain entailed any loss, "let her come here and tell how much."

Banks asked, "You would have her come here begging for it?"

Butler said that he did not want "any begging about it. I wish to ask attention to the facts whether she has not made more than any of her sisters in the Republic during the same time? Beside, she had the honor of the endorsement of Congress, and she had the profit of studying her art in Italy. I know that bright eyes, blooming cheeks, and red lips go a great ways here." This comment sparked considerable laughter on the floor and in the gallery.

"This young lady has given five years to this work," Banks replied. "Her situation has been such that she had to take her family with her. She could not go, like other artists, to Rome alone. She comes home with charges she cannot meet even by the increased appropriation." He then read a statement by Dr Sunderland from the *Chronicle*: "'Her family depends on her mainly for support. I have recently seen them in deep affliction. That youth which most young ladies are able to give to leisure and indulgence she gives to weariness and sorrow.'"

When an attempt was made to amend the amendment, the floor erupted with cries of "Vote! Vote!" The question was taken, and it was decided in favor of Vinnie by 78 to 70. Ninety-two congressmen were absent or abstained. This was a closer vote than Vinnie's partisans had expected, but the first step had been taken toward the additional $5000.

On March 3, the amended appropriation was presented to the Senate. Zachariah Chandler of Michigan, Roscoe Conkling

of New York and George Edmunds of Vermont tried to have the appropriation reduced to the original $5000. Defending Vinnie's appropriation were Lyman Trumbull of Illinois and Samuel Pomeroy of Kansas. Pomeroy had threatened Vinnie with a conspiracy charge during the impeachment furor, but after it was over they had become friends, and Pomeroy believed that she was entitled to the extra money. Charles Sumner and Jacob Howard were absent when the vote was taken: 38 for Vinnie and 14 against. Her lobbying had been successful.[3]

March 3 was Edmund Ross's last day in the Senate. It was a sad day for Vinnie; he had been her friend for the past five years, and it would be fourteen years before they met again. He returned to Kansas and bought a newspaper in Coffeyville. He was an experienced newspaperman, having started with the *Milwaukee Sentinel*, been the publisher of the *Topeka Tribune* and the founder of the *Kansas State Record*. But there was still a good deal of animus against him in Kansas for his role in Johnson's acquittal, so his enterprise failed. Like the other Republican senators who had voted for Johnson's acquittal, Ross was disillusioned with the party, and became a Democrat, after which he enjoyed a long respected political career. Grover Cleveland, two months into his term as president, appointed Ross governor of the New Mexico Territory where he served a four-year term. He studied law, established a successful practice, was appointed Secretary of the Bureau of Immigration and wrote a book about the impeachment.[4]

March 3 was the last day too for Richard Yates. It was Yates who had given Grant his commission in 1861 when no one else would do it. Now, upon leaving the Senate, he applied to Grant for a patronage position, but Grant refused most of his requests and offered him only a minor appointment as a commissioner inspecting a land subsidy railroad. Yates died at the age of fifty-five only thirty months after leaving office.[5]

The day after receiving Congressional approval for the appropriation, Vinnie was subjected to another negative press

barrage, spearheaded by Greeley's *Tribune*, which commented: "General Banks led the House into voting a gratuity of $5000 to a young lady. It is easy for men of deficient moral sense to give money away and so hard to resist the voice and eyes of a young woman. We cannot prevent the House from voting money, but we beg that the recipient shall make no more dismal images to affront persons of taste and culture."[6]

Crosby Noyes led the defense in the *Washington Evening Star*: "The House did a very proper thing by adding $5000 to the amount appropriated to pay Miss Vinnie Ream for her statue of Lincoln. This was only fitting recognition of the merits of her work; the sum voted should have been at least $10,000. The Ream statue is now before the public; and if it cannot stand the ignorant and malicious abuse of the Tribune women it deserves to fail."[7]

Women were indeed vindictive. Mary Clemmer Ames did not dislike the statue, but commented, "If you ask me if I think a refined and sensitive woman would willingly have photographs of herself in theatrical attire, with photographs of private personal gifts bestowed upon her, hawked about the street and in the corridors of the Capitol, I say, most emphatically, No. But then your irritation at Miss Ream's taste has no right to irritate you against her statue. Besides, it is charitable to remember the curse of the want of money, and that the pressing need of it may have urged Miss Ream to this 'trick of the trade', which, certainly, one would think would be a sacrifice of her feeling as a lady." She could not resist adding, "As for the Ream statue of Lincoln, . . . the first glance at it is the most satisfactory that you will ever have. It will never look so well again. In this statue of Mr Lincoln we have his rude outward image, unilluminated by one mental or spiritual characteristic. It is mechanical, material, opaque."[8]

It was obvious to Vinnie that this kind of criticism could hurt her attempts to gain lucrative commissions. She received good notices in the Washington papers, where she knew the

editors and reporters, but hostile notices were appearing out-
side Washington and in influential New York newspapers in
particular, and she decided to mount a sort of public relations
campaign to win those papers over. She intended to use the
$10,000 government check to open a studio in New York to
give her work greater prestige and to enable her to charm the
press there.

She received the check and almost at the same time a letter
from Drexel, Harjes and Company reminding her that payment
for her loan was overdue: "We enclose a copy of this contract
signed by yourself and Messrs. Hopkins and Patrick by which
you will see that you are to pay us two thousand dollars in gold
on April 1st 1871 with interest at 6% per annum. We solicit
your early attention to this matter in order that we may know
whether we are to receive reimbursement from you or whether
we are to look to Mssrs Hopkins and Patrick for payment."[9]
After paying the note, she still had $8000, enough for her New
York plan.

Crosby Noyes gave her letters of introduction to people at
the *Herald*, the *Standard* and the *Evening Mail*, and Albert Pike
contacted prominent New York Masons, asking their help in
finding a studio and getting commissions.[10] In mid-April, Vin-
nie opened a studio at 704 Broadway, where she displayed her
Sappho, *The Spirit of Carnival*, *The Butterfly*, *Morning Glory*
and *America*. She received commissions to do busts of Dr Charles
Deems of the Church of the Strangers and Theodore Tilton,
editor of the New York weeklies the *Independent* and the *Chris-
tian Union*. She succeeded in charming the press, members of
which invited her to parties and to concerts. One editor asked
her to attend all of his Tuesday night receptions, telling her that
the attendance varied each week and that he would "try to have
them advance your interests as an artist. I want very much that
you should meet Miss [Mary Louise] Booth, the editor of Harp-
ers Bazaar. So too I want you to meet Mr Reid, you have only
to meet your enemies to conquer."[11] This was a reference to

Whitelaw Reid, the managing editor of Greeley's *New York Tribune*, who was certainly an enemy, and remained so, despite what may have occurred at any Tuesday night reception.

Vinnie was meeting all the right people. J. Catlin, the U.S. District Attorney, promised her, "I can manage the Brooklyn press for you, at least two of the papers. This of course is sub rosa." He gave her the names of the editors of the *Brooklyn Union* and the *Brooklyn Daily Eagle*. [12] The help of Charles Van Buren, who had introduced Vinnie to the American consul in Florence, was also enlisted. Her shameless demands in pursuit of commissions are reflected in Van Buren's response: "I have, as you requested, distributed your card to wealthy friends and said many warm words in your behalf." She had asked Van Buren to place a copy of her bust of Lincoln at his club for sale by subscription, "but alas," he wrote her, "I have failed and, I fear, without any chance of success in the future. The difficulty is that so many subscriptions have been offered at the Club during the past two years. Then again, Reid of the Tribune has influence which he exerts against you." [13]

Favorable notices began to appear in New York papers. One reported: "Miss Vinnie Ream, the curly-headed sculptor, has been here about three weeks. In that time she has had 4000 callers, and orders have been declined, which if accepted, would have netted that pretty maiden about $60,000." This was the kind of publicity that Vinnie wanted: it was true that she had many callers—probably not 4000—but the $60,000 figure was pure fantasy. The reporter claimed his reward: "I have engaged a box at Central Park Gardens for Sunday's night concert. I will stop at your sanctum and be charmed to take you." [14]

Everything was going well, but then on June 19 a letter from Hiram Powers appeared on the front page of the *New York Evening Post*. "I suppose," Powers wrote, "that you, as well as other well wishers of art in our country, have been mortified, if not really disgusted, at the success of the Vinnie Ream statue of our glorious old Lincoln. An additional five thousand dollars

paid for this caricature! This last act of Congress in favor of a female lobby member, who has no more talent for art than the carver of tombstones, really fills the mind with despair."

Vinnie, not willing to settle for a defense against it by her friends, could not understand why this letter was printed. Friendly reporters tried to explain to her that any letter from Hiram Powers was news, that by printing it the *Evening Post* did not necessarily signal an endorsement of Powers' viewpoint. But Vinnie never understood the role of the art critic; to her, any critique was personal. She could take comfort only from Nathaniel Hawthorne's comment on Powers' penchant for denigrating rival artists: "He has said enough in my hearing to put him at swords' points with sculptors of every epoch and every degree . . . [believing that] no other man besides himself was worthy to touch marble."[15]

Actually this negative publicity had a bright side: the Boston Lyceum Bureau offered to arrange a cross-country lecture tour for her. Since, they said, Vinnie had so many friends and enemies, "you would make your success as a lecturer, at the best prices, assured." She toyed with this offer for several weeks, trying to get the Bureau to be more specific about money and what cities would be included. They told her they could not guarantee the money amount, but that a tour of that kind would certainly enhance her reputation.[16] In the end, she decided she could probably make more money and better enhance her reputation by staying in New York.

When Vinnie had been gone from Washington only a few weeks, she began to get letters from Crosby Noyes different in tone from the businesslike notes she had received from him when she still lived there. "No array of bouquets," he wrote now, "no smell of wildflowers, no light footstep on the stairway—no Vinnie." In another letter, he mentions visiting her parents so that he can enter her house "remembering the good nights." For the first time he addresses her as "Darling Vinnie" and begs for a long letter, "something more than the inch square you are

wont to dignify by the name of letter." Enclosing an editorial he
wrote defending her against Powers, he told her, "Powers' spleen
did not surprise me because I have known for years of the un-
happy state of his mind. He is in thorough jealousy of all who
get orders from the government." Noyes's editorial was, he said,
"impersonal" so that no one would consider him Vinnie's
"champion."[17]

Vinnie's friends in Washington began a campaign to con-
vince William Corcoran to purchase the *Spirit of Carnival*; Rob-
ert Ream sent Corcoran copies of Powers' diatribe. Corcoran
responded through his secretary: "You need give yourself no
uneasiness on the subject; the well known disposition of Mr
Powers to vilify all other artists will only serve to turn the poi-
soned shaft upon himself. Nothing he can say will lower Mr
Corcoran's opinion of your daughter's artistic excellence, and
he requests me to say so."[18] But Corcoran did not buy any of
Vinnie's work for his Washington gallery.

Robert Ream wanted more than pride in Vinnie's accom-
plishments. In July he wrote, "For weeks I have been to the
Druggist every day and sometimes two or three times a day and
with from one to three prescriptions. I had $60 the first of the
month and today I have 15 cents. On the 15th I will draw $50
on this month's pay and then at the 1st of August I will have
barely enough to meet the bills. But don't you send any more
money, what you sent is all gone." Fuller's affairs, he wrote,
were being straightened out and her sister was financially more
sound.[19]

Vinnie continued to bombard Ezra Cornell with letters urg-
ing him to buy her work for his university. She did not stop
with Cornell, but sent photographs and newspaper clippings to
Dr Andrew White, the president of Cornell. Thomas Rooker, a
minority stockholder in the *New York Tribune*, was a friend
and one-time business associate of Ezra Cornell, who often
stayed with Rooker when he visited New York. Rooker made
sure that Vinnie came to his house when Cornell was there.[20]

Early in 1871, when Cornell spent some time with Vinnie in Washington, his feelings toward her seem to have become paternal. He gave her advice. "Your numerous friends are like to absorb your time," he wrote, "and thus prevent study and labor at your cherished art, until through their great efforts they bankrupt you. You cannot depend on friends to avert such a calamity, they are thoughtless until the mischief is done. You must be your own judge of how you can best appropriate your time. . . . In my visit to the Capitol today I spent some time in studying your Lincoln, and I must confess the more I study it the better I like it. I will not say 'it is very well for a little girl.' I say it is a creditable work of art and compares favorably with any I find about the capitol. . . . Pardon me for my free method of writing, for I have almost fancied that I was writing to one of my own daughters." He tried to teach her telegraphy, but she was not able to master it. After some time, she confessed to him, "I know how to make an S, that is all."[21] Whenever Vinnie was in trouble she turned more and more to Cornell until his death in 1874.

She was doing quite well in New York, but Cornell wanted to help her do better. He, along with his friends Hamilton Fish and Columbus Delano, was on the Board of Regents of the annual American Institute Fair, which received several columns of notice each week in the *New York Times* and some less extensive coverage in papers throughout the country. It was arranged for Vinnie to set up a small studio in the fair where she would model several prominent people and reap the resultant positive publicity. In September the Board resolved: "That Miss Vinnie Ream is hereby requested to Exhibit in the Department of Fine Arts such of the processes of modeling in plaster and finishing in stone as may be practicable during such hours of the afternoon and evening as may best suit her convenience."[22] Cornell could not spare time to sit for her because of pressing business in Wisconsin, but he arranged for Peter Cooper, the founder of Cooper Union, to serve her as a model.

The Fortieth Exhibit of the American Institution opened at noon on September 7, 1871, with a prayer by Dr Charles Deems, after which Walt Whitman read his poem "After All, Not to Create Only." The fair occupied a building bounded by Second and Third Avenues and 63rd and 64th streets. Vinnie was given an alcove in the art galleries at the Third Avenue end. She enjoyed the excitement and had a good deal of time to walk through the rooms and mingle with the large, diverse crowds of farmers, housewives, elegant denizens of Madison and Fifth Avenues, schoolchildren and foreign visitors. In particular she was impressed with the grand hall filled with light from its immense crystal chandelier and long row of jets. The great arched trusses of the ceiling were wreathed with masses of bright bunting and the space between the spandrels was decorated with frescoes of the coats of arms of all the states. On each side of the outer edge of the promenade hung flags and signs of the exhibits. An orchestra played while crowds milled about the great fountains with their splashing waters and evergreen plants.

There was a soda-water fountain, too, built of white marble and decorated with glass lamps in the shape of pineapples, bunches of grapes and other fruits. Next to stands selling potted meats, polishing powders, candles, linens, boots, Indian moccasins, hunting shirts and skates, were agricultural implements and war materiel: swords, pistols, muskets and rifles inlaid with gold and silver, along with a shooting gallery. Then there was an electric railway with a little train running around a circular track. At the end of the hall a flour mill was set up. It had a glass front so that each step of the milling process was open to the viewer, from the deposit of wheat grains into the receptacle to its emergence as fine white flour, packed into bags or baked into bread to be distributed to the onlookers.

At Farnham's Tooth Lozenges, Vinnie could watch a beautiful young woman claiming that use of the lozenges would eliminate the need to clean one's teeth. And she could visit the Department of the Dwelling, to see displays of chandeliers, gas

fixtures, furniture, mirrors, mantelpieces, cabinets and toilet stands mounted with bronze medallions in low relief and expensive wood. The most technically advanced stove was the "May Morning," consisting of a grate, a coal magazine, a steam chest, an air chamber, a steam pipe, an escape pipe, an oven and a heat regulator. Then there was the Holmes Company electrical burglar alarm model house: wires were attached to the front door, the cellar and the parlor. In the bedroom upstairs was a small dial with signs representing various rooms of the house: if the front door was opened, the dial hand moved to the front-door sign and a bell went off.

Vinnie was fascinated by technical innovations like this, but out of necessity and probably preference, she would spend most of her time in the Department of Fine Arts, where her alcove was surrounded by alcoves displaying photographs by Alfred Bierstadt, Matthew Brady, Jeremiah Gurney and Alfred Fredricks; porcelain miniatures by William Kurtz, sculptures by John Rogers, Louis Maurer and Edward Kemeys, and designs in silver by Louis Tiffany. In the opening days of Vinnie's little studio, the crowds were so large that people pushed and shoved each other to get a better view, and policemen had to be posted to maintain order. As Cornell had foreseen, her exhibit was well covered by the papers, and each evening she cut out press notices and pasted them into her scrapbook.

At ten o'clock on the night of November 4, a gong warned that the fair was closing. The gas lights were extinguished and in a few minutes the building was deserted. The exhibition had been a great success, having drawn more than 600,000 people.[23]

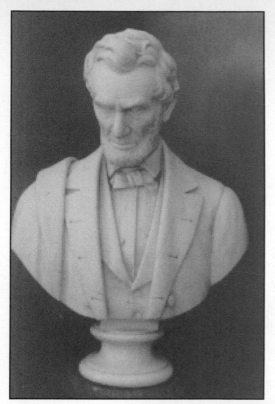

Lincoln bust
(Courtesy Cornell University Library. Photo by Edward S. Cooper)

Vinnie at a young age
(Courtesy Joint Collection, University of Missouri, Western Historical Manuscript Collection)

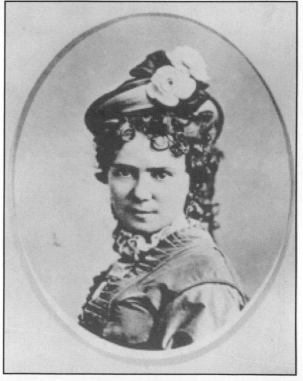

Albert Pike
(Courtesy Library of Congress)

Edmund G. Ross
(Courtesy Library of Congress)

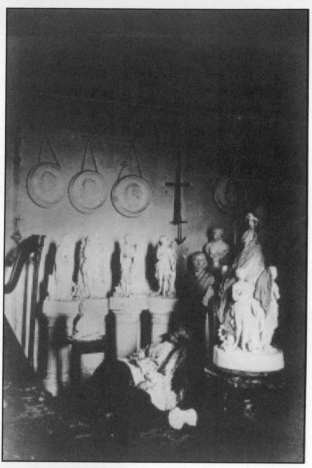

Vinnie asleep in
her studio, c. 1869
*(Courtesy Western
Historical Manuscript
Collection, 23 Ellis
Library, University of
Missouri-Columbia)*

Thaddeus Stevens, c. 1868
*(Courtesy Western Historical
Manuscript Collection, 23 Ellis
Library, University of Missouri-
Columbia)*

Voorhees
(Courtesy Western Historical Manuscript Collection, 23 Ellis Library, University of Missouri-Columbia)

Spartacus
(Western Historical Manuscript Collection, 23 Ellis Library, University of Missouri-Columbia)

Vinnie Ream in Italy
*(Courtesy Joint Collection,
University of Missouri,
Western Historical
Manuscript Collection)*

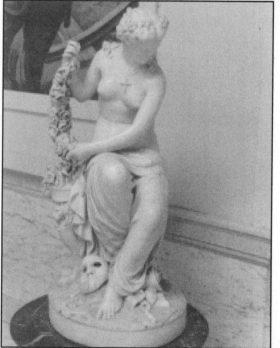

*Spirit of Carnival
(Courtesy Historical
Society of Wisconsin,
image 9736. Photo by
Edward S. Cooper)*

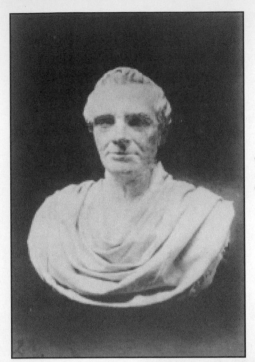

Cardinal Antonelli
(Georgetown University Collection)

Miriam
(Courtesy Western Historical Manuscript Collection, 23 Ellis Library, University of Missouri-Columbia)

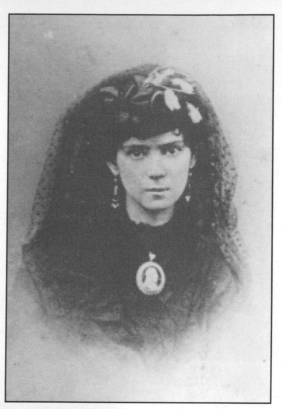

Vinnie wearing
medallion given by
Vatican, c. 1871
*(Courtesy Joint Collection,
University of Missouri,
Western Historical Manu-
script Collection)*

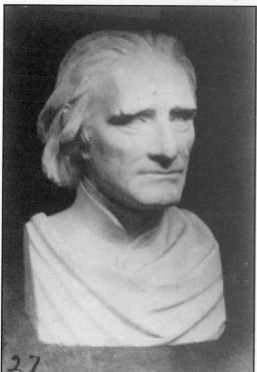

*Franz Liszt
(Courtesy Western Historical
Manuscript Collection, 23
Ellis Library, University of
Missouri-Columbia)*

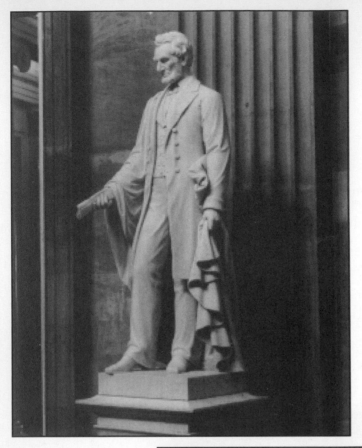

ABOVE: Lincoln by Vinnie , 1871 *(Courtesy Office of Capitol Architect)*

RIGHT: Portrait of Vinnie by G.P.A. Healy, c. 1870 *(Collection of the Smithsonian America Art Museum, Gift of Brigadier General Richard L. Hoxie. Photo by Edward S. Cooper)*

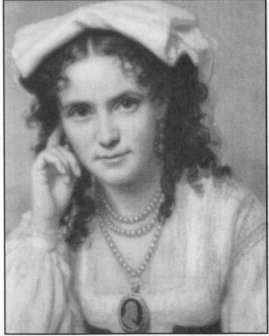

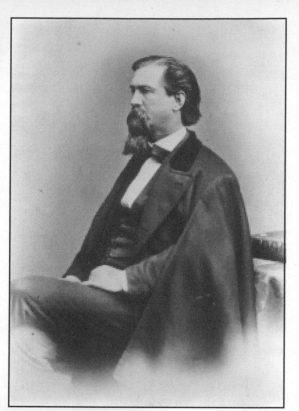

Daniel Voorhees
(Courtesy Library of Congress)

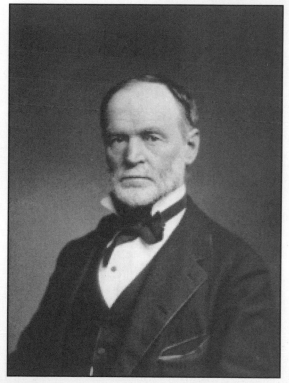

William Tecumseh Sherman, c. 1879
(Courtesy Library of Congress)

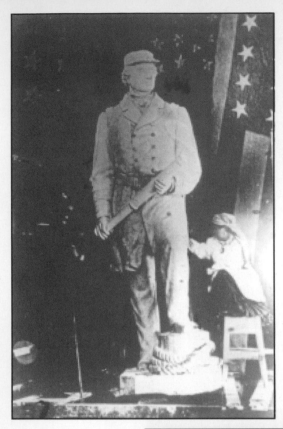

Vinnie working on
Farragut statue, c. 1875
*(Courtesy Joint Collection,
University of Missouri,
Western Historical Manu-
script Collection)*

*R.E. Lee
(Western Historical
Manuscript Collection, 23
Ellis Library, University
of Missouri-Columbia)*

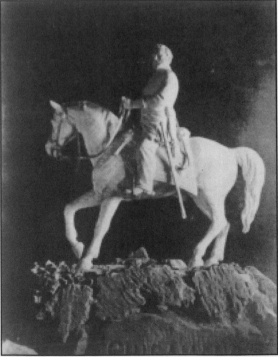

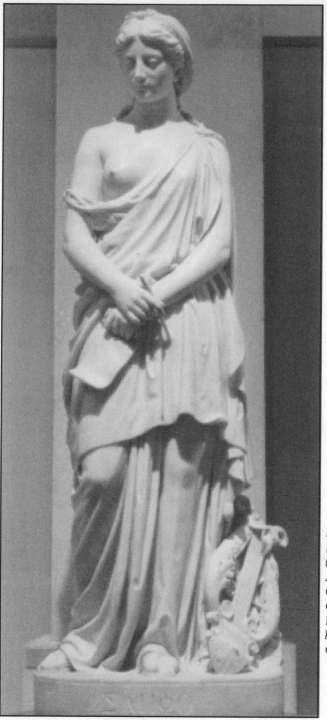

Sappho
(Collection of
the Smithsonian
Art Museum,
Gift of Brigadier
General Richard
L. Hoxie. Photo
by Edward S.
Cooper)

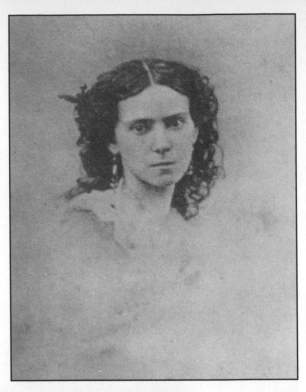

Vinnie Ream
(Courtesy Joint Collection, University of Missouri, Western Historical Manuscript Collection)

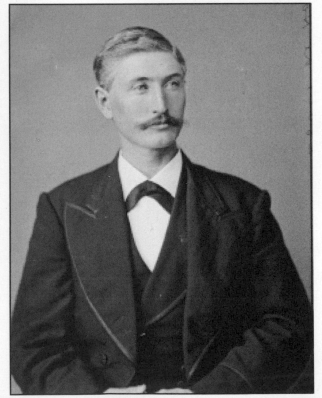

Richard Leveridge Hoxie
(Courtesy Library of Congress)

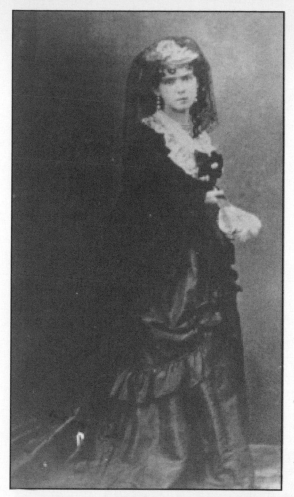

LEFT: Vinnie Ream
BELOW: Vinnie a bride,
c. 1878 *(Both photos
Courtesy Joint Collection,
University of Missouri,
Western Historical
Manuscript Collection)*

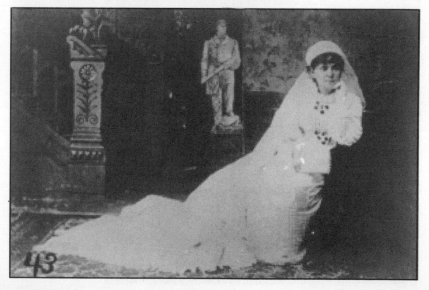

43

*Kirkwood
(Courtesy Office
of the Capitol
Architect. Photo
by Edward S.
Cooper)*

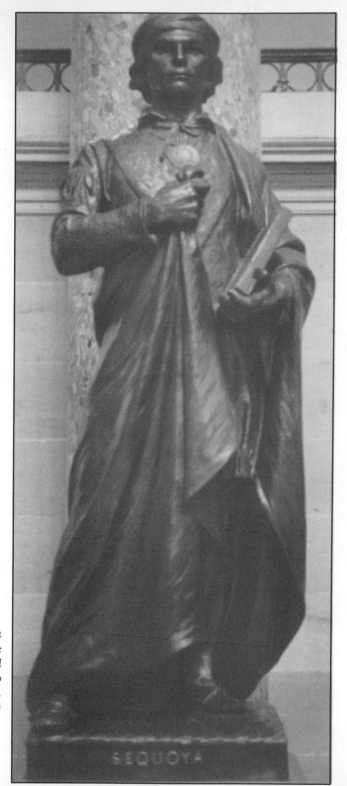

Sequoya
(Courtesy Office
of Capitol
Architect. Photo
by Edward S.
Cooper)

SEQUOYA

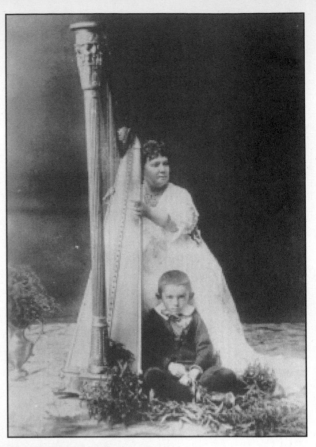

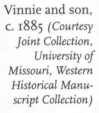

Vinnie and son,
c. 1885 *(Courtesy
Joint Collection,
University of
Missouri, Western
Historical Manu-
script Collection)*

Last photo of Vinnie,
c. 1900 *(Courtesy Joint
Collection, University of
Missouri, Western
Historical Manuscript
Collection)*

11
COMPETITIONS

*You may expect that when you hear from me and my
company, that the North Pole has been discovered.*
 —Captain Charles Hall

WHEN THE AMERICAN Institute Fair ended, Vinnie considered
that she had accomplished everything she could in New York.
Her reputation had certainly been enhanced. She had sold cop-
ies of *Miriam* and the *Indian Girl* and had completed busts of
Peter Cooper, Dr Charles Deems of the Church of Strangers,
and the prominent editor Theodore Tilton. She had expanded
her circle of influential friends and had collected excellent press
notices. It was time to return to Washington where she expected
to get important commissions.

She was now twenty-four years old and, deciding that she
needed her own house and studio, she bought a building at 235
Pennsylvania Avenue. It was not imposing, but the plaque read-
ing "Vinnie Ream's Studio" made it a major tourist attraction.
The studio was on the first floor; a reception room, living quar-
ters and a small work area were on the floor above. She spent a
considerable sum furnishing the reception area with lace cur-
tains, heavy maroon draperies, large mirrors and Turkey car-
pets, and hired a young black boy to answer the door and col-
lect calling cards. Her work she placed on pedestals, on the
mantelpiece and various tables around the room, and provided
a glass case for the study in marble of Jessie Benton Frémont's

hands. Against one wall were a piano, a harp and a guitar, each with piles of sheet music. Over the fireplace she hung her portrait by G. P. A. Healy.

She had been working hard and had new work in her studio. She had executed two busts of the nine-year-old twin daughters of Edward Clark, the Capitol architect who had tried to arrange the use of Truman Bartlett's Roman studio. One of the busts was called *The Lily*; the other, *The Butterfly*. She had finished or was working on four other busts—*Sensibility*, a young girl draped in an embroidered veil; one of a child entitled *Passion Flower*, and a bust of Admiral Farragut. In addition, she was working on two statues: one of Rip Van Winkle, and an equestrian statue of General Thomas.[1]

Despite these commissions, Vinnie had spent so much money on her new house, its renovation and furnishings, and on entertaining, that by the end of January, 1872, she was once again short of funds, and turned to Ezra Cornell, who was in Washington. He went over her expenses with her, including her expected income from the commissions and her mortgage payments. He told her she was not working hard enough and that she should not "allow professed friends to waste too much of your time until you see the homestead safe from the grasp of Shylock." He left to return to Ithaca, feeling that she had a relatively stable financial situation, and promising to "look around McGraw Hall to see if I can find suitable lodgings for Miss Sappho, and if I can't, I must try and find some kind soul to adopt her."[2] *Sappho* is a life-sized figure holding a stylus in its right hand and a partially unrolled scroll in its left. A loose tunic flows in folds from a pin on the left shoulder, slips from the right shoulder to expose a firm breast, and partially obscures the sandaled feet. The head is slightly bent and turned to the right. An intricately carved lyre decorates the base.

Two days after Cornell left Washington, Vinnie telegraphed him that her mortgage payment was due that day. Annoyed, he reminded her that she had told him that the payment was not

due for several months: "If you are liable to such errors in business matters, I fear it will lead to your financial ruin." But he felt compelled to help her: "I will take Lincoln at a thousand or something at equivalent price. Will send you seven hundred now and balance in time for next payment on homestead." He was sending $700 because "the payment was $500 and 6 months interest on $5000—which is $175, all $675—I send $700 which will make your payment and a small balance over."[3]

It is notable that Vinnie had been able to establish strong relationships with powerful men like Ezra Cornell, with politicians like Edmund Ross and Daniel Voorhees and with an intellectual like Georg Brandes. These were not sexual relationships, although they may have had sexual undertones; she certainly played the coquette and was strongly motivated by self-interest. But these men had to have been responding to a real warmth and charm and a genuine interest in their well-being.

She was not always able to establish long-lasting relationships. In the case of the Arctic explorer Charles Francis Hall, it was fate that intervened. Vinnie met Hall in early 1871 in Washington where he was outfitting the ship *Polaris* for a government expedition to the North Pole. Vinnie was attracted by his bear-like quality, and gave him a photograph of her recently unveiled *Lincoln*. On June 19, 1871, Hall sailed down the Potomac bound for a two-week layover at the Brooklyn Naval Yard. He knew that Vinnie was in New York setting up a studio and had dinner with her several times. He was often accompanied by the ship's doctor, Emil Bessels, a small man who spoke English with a heavy German accent. Hall enjoyed Vinnie's company, but Bessels became instantly infatuated with her. On June 28, he wrote her, "While thinking of you all the time and anticipating the pleasure of seeing you tomorrow we received very unexpectedly an order requiring us possibly to leave early tomorrow. I will never forget the happy hours, which kind fate allowed me to spend in your company before starting our perilous and uncertain voyage. Send by the reply vessel, which leaves

shortly, a few words to one who will cherish your memory, dear Vinnie, and who must now, however unwillingly, bid you a long farewell."⁴

Shortly after the *Polaris* sailed, Vinnie learned that the *Congress* was on the way to rendezvous with the *Polaris* at Upernavik in Greenland. Vinnie liked Hall and believed that he was destined for great things. She sent a bust of Lincoln and some other gifts to him and on August 21 he wrote her, "Your notes, flags, & other valuables all quickly and safely received by the US steamer 'Congress.' You should see my sweet little cabin. As you enter it our great, noble-hearted President strikes the eye while beneath it hangs the photograph you gave me of the statue of Lincoln. Today I resume my voyage—the Smith Sound remarkably open—never known to be more so. You may expect that when again you hear from me and my company, that the North Pole has been discovered. How true is your faith that we are going to conquer."⁵

But the *Polaris* never reached the North Pole. Wind and ice forced her back to Thank God Harbor in Greenland, where she sheltered under a giant iceberg. Hall died there suddenly. A Board of Inquiry into his death was held and Bessels was questioned by W. K. Barnes and J. Beale, Surgeons-General of the Army and Navy respectively. They concluded that "Captain Hall died from natural causes, viz, apoplexy; and that the treatment of the case by Dr Bessels was the best practicable under the circumstances." Hall was buried at Thank God Harbor. But in 1965, his body was exhumed and a post-mortem held. An analysis of the fingernails showed that Hall had ingested massive amounts of arsenic in the last two weeks of his life. Chauncey C. Loomis, Hall's biographer, writes that "[i]f Hall was murdered, Emil Bessels is the prime suspect."⁶

The death of Admiral David Glasgow Farragut occurred several months before Vinnie's return from Italy. He was a hero worthy of being immortalized, and Congress was soon receiving petitions for a monument from Farragut's widow, his staff and

from high-ranking Naval officers. Vinnie moved quickly to contact the widow, Virginia, and promise to work for legislation to commission a monument. Then she spoke to her friends in Congress about it. Congress was already favorably disposed to the project and on April 16, 1872, called for an artist to be selected by the Joint Committee on Public Buildings and Grounds from models submitted on or before January 1, 1873. Virginia Farragut, pleased with Vinnie's efforts on her behalf, was happy to give her all the information and photographs that she asked for.

Vinnie knew Farragut's public history. In the War of 1812, at the age of twelve, he had been assigned to the *Essex* under Captain David Porter, a mission that was so successful that Farragut was appointed prize master of a captured vessel. During the Civil War he conquered New Orleans. In his flagship *Hartford*, he had forced the surrender of the Confederate ironclad *Tennessee* and was the hero of the battles of Fort Morgan and Fort Gaines in Mobile Bay, Alabama. His words, "Damn the torpedoes, full speed ahead!" became the stuff of legend. In 1866, he was the first man in U.S. Naval history to achieve the rank of Admiral.

Vinnie wanted to know about the private man and to that end spent hours with Mrs Farragut, learning that the couple had met in Norfolk, Virginia, that she was the Admiral's second wife, that he had an explosive temper, and that their son Loyall was a graduate of West Point. Vinnie was particularly fascinated by stories about a speaking tour the Farraguts had made with Andrew Johnson in 1866, and about a trip to Europe on board the frigate *Franklin* when the Admiral and his wife were received by royalty wherever they went. Vinnie began to make sketches for the model, with advice and comments from Virginia Farragut and, when he was in Washington, from Loyall, who had resigned his army commission.

But progress with the design of the statue was impeded by family problems. Vinnie's brother Robert had surrendered to Union troops at New Orleans on May 6, 1865, was paroled the

following month, and had gone to live with Choctaw Indians. On May 13, 1872, he was indicted by an Arkansas grand jury at Fort Smith for larceny and for selling liquor to the Indians. U.S. Marshall Logan Roots rode out to the Choctaw Nation, arrested Robert and brought him back to Fort Smith on the 18th of June, receiving $69.94 for the ten-day round trip. A trial was held on the 22nd, and Robert was exonerated of the larceny charge, but was found guilty of selling liquor to the Indians. On the 27th he was fined $1000 and sentenced to six months in the penitentiary at Little Rock.[7] He hurried to Washington to ask Vinnie for help. She sent him back to Fort Smith with letters to friends asking that they sign a petition attesting to his character and requesting a presidential pardon.

Vinnie appealed to Senator Powell Clayton of Arkansas, who as Republican governor of Arkansas had placed ten counties under martial law in 1868, and by early 1869 had successfully destroyed the Ku Klux Klan in his territories. Clayton had taken his Senate seat on March 4, 1871, and within six weeks had written Vinnie that he had gone to her house "but found upon my arrival there, very much to my disappointment, that my little bird had flown." Vinnie wrote to him, "We are informed by one of the best lawyers that a request from you to the Atty Genl. and President, to pardon him would be more effective than all the petitions, and that they would do for you what they would not do for anyone else. Dear friend, will you come to my rescue in this matter, and place me under eternal obligation to you."

Clayton was happy to oblige and quickly produced an appeal. But there was no pardon. Not a request from Clayton and prominent citizens of Arkansas, nor the passage of time could soften the feelings of Grant nor his wife Julia toward Vinnie.[8]

Vinnie was careful to try to keep contact with admirers whom she had met only a few times, in case they might be of use to her. About six months after her stay in New York, in the

COMPETITIONS

163

midst of her problems with Robert, she received an angry letter
from one P. Randall asking her if she was returning to New
York "long enough to perhaps run some good looking philan-
thropist into the ground? I know you are daily getting new and
valuable friends who appreciate and like you. Everybody does
that, even Whitelaw Reid I think, as I read no more of those
unkind stories that were formerly in the Tribune."⁹

But Randall was certainly wrong about Reid. On July 26
the Tribune called the Lincoln a "scarecrow" and implored
Congress "for heaven's sake don't add the great Admiral to the
desecrated list." Ezra Cornell wrote to Vinnie immediately tell-
ing her not "to let such insane ravings disturb you, don't let
them divert you from the strict line of truth in marble. May the
only fault of your work be that it resembles the original."¹⁰

Vinnie's name was constantly in the newspapers. She had
only to be seen in public with a man to start the rumor mill
grinding. If the man could not be identified, the paper would
report, "Now they say Vinnie Ream is to marry a rich New
Yorker." But if his name were known, he would be mentioned
in the morning papers, as a representative from Georgia was:
"General Dudley M. Dubose is also a candidate for matrimony
with the beautiful and fascinating Vinnie Ream." Sometimes
the press, knowing the name of the man involved, would tease
readers, as in the Washington Letter: "There is a certain Colo-
nel here who represents the Cherokee Nation in the lobby. He
is certainly enamored with the fair Vinnie. Miss Sculp allow me
to present Mr Scalp. Vinnie cannot go into her milliner's to pur-
chase a whalebone for her corset but the red man is on her trail.
The day I saw the fair pale face a prayer went up from the dark
bosom of the Cherokee to the Great Spirit that he might incline
the heart of the white fawn toward him. It was too much for
me. I went out and indulged in some firewater."¹¹

The object—or victim—of this unattractive paragraph was
Elias Cornelius Boudinot, whose father, Galagina, was educated
in Connecticut at a mission school where he adopted the name

of his sponsor, Elias Boudinot (1740–1821), a member of the Continental Congress from Philadelphia who went on to become director of the U.S. Mint, and who was a devoted philanthropist, especially for Indians, whom he believed were the lost tribes of Israel. Galagina edited the *Cherokee Phoenix*, publishing articles in English and in the Cherokee language. His support of treaties in which the Cherokee surrendered their lands and were resettled in the Indian Territory—now Oklahoma—resulted in his murder on June 22, 1839, when his son Elias was not yet four years old.

At the outbreak of the Civil War, Elias was appointed lieutenant colonel in the Indian regiment led by Albert Pike at Pea Ridge. He and Vinnie had known each other since the mid-fifties when the Reams lived at Fort Smith near the Arkansas River. At that time Vinnie was thirteen and Boudinot was twenty-five. A noted lawyer and lecturer, he spent considerable time in Washington representing the Cherokee in land negotiations, and represented Vinnie in the sale of a copy of her *Indian Girl* and of her bust of Sequoya, the creator of the Cherokee alphabet. In 1871 he promoted the extension of the Atlantic & Pacific Railroad into the northeast corner of the Oklahoma Indian Territory, where he founded a town he called Vinita, in honor of Vinnie. This, along with the fact that he had volunteered to take over Perry Fuller's affairs and salvaged some money for Vinnie's sister Mary, may have prompted the marriage rumors. There is no hint of intimacy in their correspondence.

Mary's financial problems may have been alleviated, but Vinnie's continued. She called on Daniel Voorhees for help. He was in Terre Haute conducting the defense in a murder trial, but he still found time for her. Her *West* had been on display in the Speakers Room in the Capitol for months, but she had received no offers for it. She and Voorhees decided to raffle off *Spirit of Carnival* for $4000, Voorhees arranging with members of the Washington Club to conduct the raffle in which eighty tickets were to be sold at $50 each, for a statue of a young

woman, nude to the waist, with drapery over her legs, sitting on a bench supported by carved lions. Scattered around her feet are a lace-trimmed mask and other symbols of the carnival. Unfortunately, only twenty-four shares in the raffle were pledged by fifteen people. Vinnie would not sell at this price, and the money was refunded.[12]

In October, Cornell paid Vinnie the last $300 due for the Lincoln bust he had bought earlier in the year. But the bad news was that he was suffering business reverses and could not go ahead with the purchase of *Sappho*. Also in October, Vinnie was invited to set up a display at the King's County Industrial Fair in Brooklyn as she had the year before at the American Institute Fair. The King's County people wanted her to model Samuel S. Powell, the mayor of Brooklyn. She refused, citing the press of work, but when the fair offered her $50 a day, she changed her mind and received an advance payment of $100.[13]

Her display lasted from October 21 to November 9. In fliers listing the attractions—Concerts Every Afternoon, Printing Presses in Motion, Horticulture, Jewelry, Miniature Steam Engines in Motion, Agricultural Implements of All Kinds—Vinnie's presence was emphasized: "The Eminent Sculptor, Miss Vinnie Ream, At Work Modelling from Life, in clay, afternoons only, until Saturday, Nov. 9th." There was at least one positive press notice: "The increased attendance at the Exposition since Miss Vinnie Ream opened her studio shows the popular appreciation of a novelty which is alike interesting and instructive. To see the human form, the face and contour deftly molded from clay, and that by the hand of a lady, attracts an extraordinary amount of notice."[14]

Vinnie prevailed upon Ezra Cornell to sit for his bust at this fair. He had been too busy to sit for her at the American Institute Fair. When her work at the fair was completed on November 9, she signed the following receipt: "Received from the Industrial Fair Association of King's County, the sum, of Eight-Hundred and Fifty Dollars in full for services in modeling at the

Brooklyn Rink. I do hereby agree to finish in plaster before the 15th day of December next, the bust of the Hon. Powell, free of charge and in perfect order to the Express Company."[15]

A bitter presidential contest between Grant and Horace Greeley had been raging throughout the fall. Grant remained popular despite the corruption in his administration, but some liberal Republicans, Lyman Trumbull and George W. Julian among them, decided to set up a reform party calling for equality before the law, political amnesty, civil service reform, free trade and local self-government. A convention was held in Cincinnati, where the attendees included free traders, veterans of the anti-slavery movement, and many somewhat disgruntled politicians who had been turned out of office. After a good deal of behind-the-scenes maneuvering, Horace Greeley was nominated for president, with B. Gratz Brown, governor of Missouri, as his running mate. Because of Greeley's firm stand on protective tariffs, the free trade plank in the platform was dropped. The Democratic Party joined with this reform party, but many Democrats switched to the Republicans, and the black vote remained solidly behind Grant, at least partly because of distrust of the Democrats and Greeley's emphasis on amnesty and local self-government. The result was an overwhelming victory for Grant, who got the largest majority in any presidential election since 1836.

"I was the worst beaten man that ever ran for that high office," Greeley said. "And I have been assailed so bitterly that I hardly know whether I was running for president or the penitentiary."[22] He was a broken man, worn out by the campaign, horrified at the attacks upon him and, as a kind of last straw, devastated by the death of his wife just before election day. In his will he wrote, "I have done more harm and wrong than any man who ever saw the light of day. And yet I take God to witness that I never intended to injure or harm anyone. But this is no excuse." He died on November 29 and Whitelaw Reid took over the *New York Tribune*.[16]

After the Brooklyn fair ended, Vinnie hurried back to Washington to prepare for the January contest for the Farragut statue, and for an important meeting to be held in two weeks concerning a monument. General George H. Thomas, who had died in March of 1870, had served in both the Seminole and Mexican wars, but had achieved fame in the Civil War as head of the Army of the Cumberland, earning the soubriquet "The Rock of Chickamauga." In early 1872, the Society of the Army of the Cumberland announced that it would meet in November in Dayton, Ohio, to appoint a five-member committee to select a design for a statue of Thomas to be erected in Washington. Vinnie, while at work on the Farragut model, began modeling a bust of Thomas to submit to the committee.

Needing a photograph, she wrote to General Sterling Price, a comrade of Thomas, who had painted the general's portrait. She had never met Price, but she received a warm and helpful reply. "I have no photograph of Gen. Thomas," Price wrote, "but what Brady of your city can furnish you. If Gen. Davis does not furnish you with a chromo after my portrait of Gen. T. let me know and I will send you one. I do not know all of Gen. T.'s measurements. His weight was two hundred and twenty-four pounds, his height six feet one inch, face eight and one half inches in length." He suggested, in addition to General J. C. Davis, that she contact Secretary of War William Belknap for more information.[17] She followed his advice, but neither Davis nor Belknap answered her. She wrote to Thomas's widow, Frances Kellogg Thomas, asking her help and offering her a copy of the bust, but was rebuffed almost as curtly as she had been by Mary Todd Lincoln. A relative of Mrs Thomas, R. Kellogg, wrote to say that the bust was not wanted and no help would be forthcoming.[18] Vinnie, always persistent, found the general's tailor in Washington and got the exact measurements of his torso and limbs.

She asked Thomas Ewing what he knew about the men on the award committee. He had never served in the Army of the

Cumberland, he said, but Generals Edward M. McCook, Durbin Ward and Thomas J. Wood had, and they would be in Dayton. Ewing wanted to meet her in Dayton, but he was representing the defense in a trial, so the best he could do was give her letters of introduction.[19] She left for Dayton on November 19 and, in lieu of Ewing, arranged that James Rollins would introduce her to the generals. She had not seen Rollins for a long time and looked forward to seeing him again and talking about old times, about school in Columbia, Clark Mills's studio and her work in his congressional office. She was thus desolated when she arrived in Dayton to discover that Rollins was not there and had left no message. It was not until she returned to Washington that she found his letter saying that he had been ready to leave for Dayton when he read that the Brooklyn exhibit had been extended to the 25th and that Vinnie was going to remain there and model from life until the fair ended. "That being the case," he wrote, "you cannot be in Dayton tomorrow."[20]

Without Rollins to introduce her personally to the potential committee members, she had to rely on Ewing's letters of introduction, and of course on her personal charm, which worked with most men but emphatically not with General J. C. Davis, who was put off by her coquetry and her intense lobbying. He treated her brusquely. On November 21, 1872, Davis was appointed to the monument committee, along with Generals Sterling Price and Theodore Brown, Colonel Hunter Brooks and Captain H. M. Duffield. The committee called for models of an equestrian statue to be delivered to Pittsburgh the following year for judging. Vinnie found this a welcome challenge: Clark Mills was noted for his equestrian *Jackson*, and this would be an opportunity for her to enlarge her skills and improve her reputation. Believing that the committee, with the obvious exception of Davis, was favorably disposed toward her, she was optimistic about her prospects.

She returned to Washington with only a little over a month left to deliver the Farragut model to be judged by the commit-

tee. She completed the plaster model on time, but as it was being carried to the Capitol, it was dropped. The arms, legs and head separated from the torso and the base was shattered. Screens were set up in a corner of the Senate vestibule, a tub of plaster was delivered, and she set about repairing the model. Under the sardonic headline, "A Great Work of Art Ruined," the New York Times commented, "The sympathy of a crowd of spectators was freely extended to the unfortunate artist, who has one consolation, at least, in that the model, never having been seen, can safely be called a great work of art."[21]

A reporter for the Boston Journal, who had called the Lincoln a failure and criticized Congress for giving Vinnie the award, came to the vestibule one afternoon to find her "hard at work on her tragically shattered statue, using a handsome naval officer, dressed in Farragut's uniform, as a model, and with half a dozen officers lounging about, offering advice and suggestions." This was not a good working situation for Vinnie, who was suffering from a severe head cold; she probably did not need a model, but she could not turn away admirers. The reporter returned that evening to find the screens removed, the fires out and Vinnie, alone, hard at work standing on the cold marble floor. He asked her why she was still there so late. "I can't help it," she said. "I must work at night, for I can do next to nothing in the day."

"Yes," he said, "but you must rest in the day, for you must not make yourself ill."

"Then the committee would think I was idle," Vinnie said. "They are waiting for me and expect to see me on duty."

This episode won the reporter over completely, turning a harsh critic into a champion. The Boston Journal commented that Vinnie's "Farragut shall be an honor to the artist and the nation." The Richmond Weekly State Journal was also impressed with her dedication, calling her "the heroic young artist [who] without a complaining word, set herself up to repair the damage."[22]

Vinnie knew that men were captivated by her beauty; she knew too that they would accept her talent and admire her dedication if these were tempered by feminine helplessness and vulnerability. She wrote to the Joint Committee on Public Buildings and Grounds: "Although my model was so badly broken, I am not disheartened. I sometimes wonder what I am made of that I do not bow down before the many troubles that crowd my path. If industry will repair it, I will soon have it all right again, and I trust of course that you will see it." After she made the best repairs she could, she wrote the committee once more: "[A]lthough lacking the finish it had before being broken, and which it would take me many months to restore, I think you will be able to judge my idea of Admiral Farragut in form, feature and design." Never willing to leave things to chance, she asked that at their next meeting, the committee "give me an opportunity of making a short statement before you."[23]

Vinnie was not the only artist competing for the commission. There were models on display in the lower vestibule of the Senate chamber by Moses Ezekiel, James Wilson MacDonald, G. Turinni, Joseph Pickett, John Rogers, Olin Warner, Charles Hinkley Ostener, Theodore Mills and Theopolis Mills. Most critics disparaged all of these models, including Vinnie's. John Rogers' model was found to be full of life and energy, but lacking any resemblance to Farragut. Olin Warner's and several others did capture that resemblance but, one critic wrote, they looked "as if Farragut was standing for his photograph"— hardly a compliment in those days when subjects posing for photographs were stiff and unmoving. James Wilson MacDonald's Farragut lashed to a broken mast gave a cartoonish impression. There were models on display in various parts of the city by other artists, including Vinnie's old friend Horatio Stone.[24]

Vinnie had actually started her campaign to win the Farragut award before Congress was even seriously considering a monument. On February 24, 1871, during the debate over the

increased appropriation for the *Lincoln*, a letter from Dr Byron Sunderland was read into the record: "What had Congress given her? Ten thousand dollars. She is but a little thing, she ought to have more. I say it without the hope of favor, fee or reward; and give her another order for the grand old Admiral who rode through the demon fires at Mobile and New Orleans."[25]

Now she began lobbying the committee in earnest, collecting testimonials from people who had known Farragut personally and whom the committee would respect. Admiral David Porter, under whose father Farragut had served on the *Essex*, and who had himself served under Farragut in the Civil War, viewed the models and gave Vinnie a letter: "In my opinion the bust of Miss Vinnie Ream is the only likeness of the Admiral in the lot, and a very good one it is. In this opinion I agree with Mrs Farragut. I think the wife of the man, who is to be put on marble, should be the best judge whether or not the likeness is a good one. I think her voice in the matter should be attended to." There was a letter too from District Attorney J. Catlin: "I happen to know that the widow of the Admiral has seen Miss Ream's likeness of the Admiral, and have heard from her own lips the strongest expressions of satisfaction as to its resemblance to her husband."[26]

Vinnie sent these letters to the committee, determined to ensure that every member would be personally aware of her desire to obtain the award, of her confidence that she could execute the statue with skill, and of the gratitude she would feel toward those who voted for her.

Eli Perry, a committee member, having seen General Sherman looking at the models in the Capitol, wrote to him to ask his opinion of them. Sherman replied: "I would prefer not to be drawn into a controversy with artists whose feelings are unusually sensitive, yet as you ask me a plain question, I will give you a plain answer. In going to the Senate Chamber on two separate occasions lately I was attracted by the crowd to look at the various models of the Farragut statue. Of these, the plaster model

of Vinnie Ream struck me as decidedly the best likeness and recalled the memory of the Admiral's face and figure more perfectly than any of the models there on exhibition." A few days later, Sherman sent Vinnie copies of Perry's letter and his answer, and advised her to put her bust of Farragut next to her model "because it is eloquent in itself and will silence anyone that may attempt to argue that a small model cannot express a likeness as well as a large one."[27]

Vinnie took this advice and then increased her pressure on congressmen to the extent that Sherman felt compelled to warn her that she was overdoing it. "You are still a woman—you can't be easy—but must put notions in the breasts of men, and try to combat them." He told her that Senators Simon Cameron and Justin Morrill of the committee were against her, and despite his own warning about too much pressure, he asked his brother, Senator John Sherman, to speak to them for her.[28]

As the Congressional session began to wind down, it became apparent that the committee was deadlocked. Of the Senate committee, two members preferred Vinnie's model; two preferred MacDonald's and one liked Horatio Stone's. The House committee members favored Vinnie, but they knew that the senators would not agree. On March 3, 1873, the last day of the Congress, George Halsey of the Committee on Public Buildings and Grounds announced that all models had been submitted, but the members had been unable to reach agreement.[29] Vinnie was furious. She had no choice but to try to build an even stronger case in the next Congress, where the problem was that inevitably some friends and supporters would be gone. Her good friend Lyman Trumbull had decided not to seek reelection but to return to Chicago to practice law. He had broken with the Radicals over the impeachment and now he was in disagreement with Grant over Reconstruction and was disgusted with the administration's corruption. He, like Edmund Ross and others opposed to the impeachment, would eventually become a Democrat. In 1880 he ran unsuccessfully for governor of Illinois.

James Patterson, who had spoken at the unveiling and had signed the petition asking Grant for an appointment for Robert Ream, retired to become Regent of the Smithsonian Institution. Nathaniel Banks, who had spoken forcefully for her additional $5000, lost his bid for reelection, as did Matthew Carpenter, although Vinnie did not care much about Carpenter because she had given up hope that Wisconsin would ever place statues in the capitol's Statuary Hall. George Morgan, who had defended Vinnie against George Julian, also lost, but it was the loss of Daniel Voorhees that most upset Vinnie. They had been very close. She bade him a tearful farewell when he left for Terre Haute promising her that business would bring him frequently to Washington. She could not know, of course, that in November, 1877, Voorhees would return to the city as senator from Indiana.

12

GENERAL SHERMAN

Write me as often as you please and I will do the same. And you need not fear for I open all my own letters and commit the task to no one. And what you write me is sacred.

—General Sherman

THE DAY AFTER CONGRESS deadlocked on the Farragut award, the *New York Times* ran a story under the headline "A Narrow Escape," reporting that a Congressional committee had met to decide which of the models submitted to them by "the three sculptors, Ream, MacDonald and Stone, was least likely to outrage the memory of the departed Admiral. The friends of Miss Ream had reason to be particularly hopeful, inasmuch as that artist's model had been accidentally broken a few weeks previously, and had thus, in all probability, been rendered less glaringly unlike the human figure in general, and that of the late Admiral in particular, than it must have been before the occurrence of that fortunate accident. The admirers of Messrs. MacDonald and Stone, on the other hand, felt that however bad the models submitted by these gentlemen might be, the Ream model must be still more shocking to persons of delicate nerves. The nation ought to feel particularly gratified when it reflects upon its narrow escape from another of Miss Ream's eccentricities in bronze." The writer suggested that Farragut's nose had been broken off and Vinnie had replaced it upside down. It

was this feature, the *Times* said, that gave the model its originality.[1]

As could be expected, Vinnie was devastated by this article, even driven to wonder whether her hard work over the years was worthwhile if she were to be subjected to such ridicule. She did not understand why her many friends in Congress would not award her the Farragut commission: after all, it was she who had first suggested the idea. She always needed money and had not even been able to raffle off her *Sappho*. Deeply depressed, she wrote James Rollins that she was considering giving up sculpting. She admired and trusted Rollins more than she did her own father, who was always off surveying in Kansas, Missouri or Wisconsin. Rollins always had time for her. When he received her letter, he responded immediately, reminding her of the bleak days before she was hired at the post office, how he had taken her to Mills's studio, how much she had enjoyed sculpting, how many famous men had signed her petition for patronage, how hard she had studied and how successful her *Lincoln* was. He chided her for wanting to give up, pointing out that she was still very young, that she had sold many busts and medallions and that she was on the brink of another major success with Farragut.[2]

This letter revivified her. She decided to return to New York to see Virginia Farragut and enlist her support for the next Congress and the support of top Navy men. She wanted also to interest the city of Brooklyn in something more imposing than the plaster bust of Mayor Powell that she had modelled at the King's County Industrial Fair. And she wanted to confront the author of the "Narrow Escape" article in the *Times*. She asked General Sherman to give her letters of introduction to ranking Naval officers in New York. She had known the general casually for years through his brother Senator John Sherman, who had sat for her, and through Thomas Ewing. The general's father Charles, appointed a judge of the Ohio Supreme Court, had settled his family in Lancaster, Ohio, near the Ewing fam-

ily. Charles Sherman died in 1829, leaving his family of six boys and five girls in dire poverty. William Tecumseh, who was then nine years old, was taken in and adopted by Thomas Ewing, the father of Vinnie's friend Thomas Ewing, who had always helped Vinnie with small sums of money.[3]

The first letter from Sherman to Vinnie is dated February 14, 1873. A few days earlier, she had seen him looking at the Farragut models in the Capitol and had invited him to her house on a Friday evening. He accepted, but then wrote her, "When I saw you in the Capitol it had entirely escaped my memory that this Friday is our regular reception, when of course I must be at home. Can't you come?" Over the next few months, they conducted a friendly but rather formal correspondence, discussing lectures and gatherings they had attended at each other's houses. He gave her advice about the Farragut project and urged her to persevere in her art so that "the critics will be silenced who charge that your success is due to your pretty face and childish grace."[4]

He gave her a letter of introduction to Admiral Silas Horton Stringham in which he praised her talent, adding, "The fact that she is a bright girl seems to stand to her prejudice, for men fear that a preference expressed for the work of her hand will be charged as the natural admiration for her pretty face and luxuriant curls." In early April, she went off to New York with the busts of Farragut and Powell, and had been gone less than a week when she received this letter from Sherman:

Before the hurly burly of the day sets in I must answer your letter which is full of good things. I miss you more than I thought possible, and your little foolish ways. With all the admiration you express for heroic deeds, and heroic men, you possess within yourself a measure of talent and beauty that captivates and wins where hard words and hard blows would achieve nothing. Do not excite the envy of artists. Try and make them your friends.

Visit them and flatter their works, for the creation of an artist is the child. Is it not so, my foolish little pet?

Write me as often as you please and I will do the same. And you need not fear for I open all my own letters and commit the task to no one. And what you write me is sacred. The weather is now fine and Washington really looks beautiful. But of all the flowers the fairest is missing.

I destroy your letters. You must do the same of mine for in wrong hands suspicion would not stop short of wrong, which we must not even think of.[5]

The contract for a memorial to Farragut would be decided in the upcoming session of Congress. The Society of the Army of the Cumberland, at their last meeting in Dayton, postponed the decision for the General Thomas monument to their meeting in Pittsburgh later in the year. General of the Army Sherman was a valuable ally to have in these competitions.

Vinnie's trip to New York was short but successful. Mrs Farragut pledged her full support, Admiral Stringham, enchanted with Vinnie, endorsed the Farragut bust. In her meeting with Mayor Powell and the Brooklyn Council, it was agreed that marble was preferable to plaster. The mayor promised to draft a resolution for an appropriation and assured her that he would have a contract ready by November 1.[6] She could do nothing about the *New York Times*, but would have to accept the fact of bad reviews.

When she came back to Washington, she and Sherman spent a great deal of time together, apart from public entertainments like receptions in each other's homes. They took carriage rides together alone: sometimes Sherman himself drove, but at other times he mentioned "a driver and the back seat all to ourselves." Then there were sessions in Vinnie's studio where the two of them met, ostensibly to talk about the Thomas model. Sherman

and Thomas had been classmates at West Point and comrades throughout the war. Sherman often spoke of Thomas as his "best friend." He lent Vinnie one of his own saddles which, while not identical to Thomas's, was nevertheless the saddle of a Major General, and he praised the head and body of the model as true to life. Vinnie, he said, had caught the body because "Thomas was heavy and filled his saddle close." He gave her advice about Thomas's horse, which was always "fat, chunky, lazy and strong," and should be given "the strength of the Hunter, rather than the slender proportions of the race horse." Thomas, he told her, "was extremely averse to fast riding, and I never saw him gallop but once."[7]

Obviously Vinnie and Sherman were not discreet and it is not surprising that their relationship caught the attention of the press and Washington society. Emily Edson Briggs gave a sardonic description of them at a reception:

> [T]here comes into view the great warrior Tecumseh, sometimes called the Beau Brummel of fashionable life in Washington. Straight as one of those guns he carried so successfully to the sea, and about as useful at the present day, yet very dear to us, because he is the best paid for the least work of any man in the Union.
>
> And yet he was seen at the Burns Festival, as well as many other places, with Vinnie Ream on his arm, and who knows what the veteran warrior may have suffered? Vinnie is not large, neither is a Minnie ball, and yet if either one should hit the mark the most direful consequences might follow. When we compare Vinnie Ream to the great men who work in stone she grows beautifully less, but when we compare her with women she rises almost beyond feminine proportions. She is a very small man, but a very great woman. Go ahead, Vinnie! Bust Tecumseh, or somebody else will![8]

In 1850, Sherman had married Ellen Ewing, his foster sister, and when he began his affair with Vinnie in 1873, he was the father of six children, four girls and two boys. His eldest son, Willie, had died of typhoid fever in 1863. Ellen Sherman was a devoted wife, but a woman whose interests were limited to her children and her religion. The marriage was in many ways a success, but Sherman did not share his wife's devout Catholicism and he looked elsewhere for more fulfilling relationships. This tendency was a source of considerable gossip, especially as he grew older.[9]

Throughout the summer of 1873, Vinnie kept a hectic pace, meeting and ingratiating herself with new members of Congress, and working on *North*, *South* and *East*—companions to her *West*. Ezra Cornell, still working to help her in any way that he could, asked the curator of Cooper Union if the Union had a bust of Peter Cooper that they could lend to Cornell College. When the curator replied in the negative, as Cornell knew he would, Cornell told him that Vinnie had done an excellent plaster bust of Cooper that she would be happy to put into marble. This was a good development, as was a request from the Louisville Industrial Exhibition that she ship them her *West* "by Adams Express at our cost," so that they could display it.[10]

In September, before leaving for Pittsburgh to lobby for the Thomas contract at the Society of the Army of the Cumberland, Vinnie elicited a last-minute letter-writing campaign from her loyal friends. James Rollins wrote to John Hartranft, the governor of Pennsylvania; General Stewart Van Vliet wrote to General Philip Sheridan, president of the Cumberland Society; Charles C. Cox, Vinnie's physician, wrote to Dr J. H. Ranch, a Society member, and John H. Rice, former chairman of the Buildings and Grounds Committee, was resurrected to write to General John Negley, chairman of the Pittsburgh Executive Committee.[10]

Sherman, who planned for reasons of discretion to follow Vinnie to the meeting rather than to accompany her, gave her a

letter to the leading generals endorsing her model. He also told her what train to take to Pittsburgh to avoid excessive train changes and ensure the smoothest ride.[12] She arrived in the city on Saturday evening, September 13, and checked into the Monongahela House, the committee's headquarters. The next morning she worked on her formal proposal, in which she stressed that the model had been done in strict compliance with the committee's guidelines and that she had chosen the inscription on the pedestal—"Chickamauga and Thomas"—because it was at Chickamauga that Thomas had "fully established his fame. The instant of time typified is the evening of the second day of the Battle, when after having repulsed repeated assaults, and driven back the enemy, he stood calm, thoughtful and anxious to do all that man could do to discharge a high and solemn duty to his Country, his command, & himself." She had thoroughly researched Thomas's life, she said, and "I now submit my work with perfect confidence in your fairness but with an intense desire to succeed."[13]

She then went to find General Sterling Price, head of the Arts Committee. She and he had corresponded continuously since the Thomas award was announced; he had been helpful, giving her Thomas's measurements and suggesting designs for the statue's pedestal. They had had a cordial meeting at Dayton the previous November. But she had assumed that Price's cordiality reflected a stronger interest in her than he actually felt and this led her to a serious error in judgment. When he neglected for several months to answer one of her letters to him, she let him know that she was angry with him, and also that she disliked his friend General J. C. Davis, whom she had met in Dayton the year before. Price apologized for neglecting to respond to her, acknowledging that he knew he had "wounded your feelings to the very quick." But he added, "I hope you will find out some day that you have done Gen. Davis great injustice."[14] She had apparently assumed that Price, like so many others, was infatuated with her and would be intimidated by a display

of her displeasure. She tried very hard to insinuate herself again in his good graces, but from that time General Price was civil to her, but nothing more.

This was a disappointment, but there were other committee members to work on. She left notes for those she missed, inviting them to meet her in her room or in Library Hall. She was extremely busy, and so grateful for the help of a 33-degree Mason sent to her by Albert Pike that she promised Pike she would wear the Masonic jewel he had had especially designed for her by a New York company.[15]

On Monday she set out for Library Hall. The streets were taking on a festive air as workmen hung the buildings with flags and bunting in preparation for the big parade. The interior of Library Hall, where the committee members were gathered, had been decorated by Army personnel. The windows were darkened and gas jets provided the only light. Every inch of wall space was covered with sprigs of evergreen, flags both tattered and new, paintings, Army corps badges and mottoes. An old rusty Army tent, flying a worn corps flag, with a stack of arms at each side, had been set up on the stage against a backdrop of a painted forest. Over the stage hung a pennant reading "Welcome" in large letters and a huge oil painting of General Grant in uniform. Vinnie handed the committee members her proposal and the letter from Sherman, and gave a short talk before walking into the adjoining Art Galley, where her model had been placed, along with those by Adolph Bailey, G. Turinni, George Hess and James Wilson MacDonald.[16]

Sherman arrived on Tuesday and also checked into the Monongahela House. He had many public functions to fulfill, and how much he and Vinnie saw of each other is not known, but they saw enough of each other to generate considerable gossip. On Wednesday morning, Vinnie walked over to Library Hall to view the last two entries, one by Clark Mills's son Theodore, and the other by Olin Warner that was so badly damaged that she felt it offered no competition. Later in the day,

there was a parade through the center of town, ending at Library Hall where the committee was to announce the winning model. Excitedly, Vinnie took her seat. General Sheridan sat at the head table with Sherman on his right and an empty chair on his left draped in mourning for General Thomas.

Shortly after three o'clock, Sheridan called for order and announced that this was purely a business meeting that would not be very interesting except to those directly concerned. As a result, at least half the audience gathered their belongings and walked out. Vinnie stayed on while various committees gave their reports. When at last the arts committee was called upon, General Price rose to ask for an extension until Thursday morning. This was a bitter disappointment for Vinnie, who had been convinced that her model, with her many endorsements, would have carried the day. More committees gave their reports and then the audience called for Sherman and Sheridan and the rest of the afternoon was taken up with speeches. That evening there was a large banquet.[17]

On Thursday morning, Vinnie was in her seat when Sheridan called the session to order at a quarter to eleven. First, it was decided that the meeting the following year should be held in Columbus, Ohio, rather than St Paul, Minnesota, the other recommended site, and a speaker and officers for that meeting were chosen. Finally, General Price rose and gave a brief history of the arts committee's work of the year, explaining that a circular had been issued calling on artists to submit models and the artists had done so. Then, Price said, "We have carefully and conscientiously inspected their models, and while we conceded merit to all, yet we cannot recommend for adoption by the Society the work of any of the artists who have entered into competition, as completely embodying the ideas of our committee, as to the presentation of both horse and rider." The task, he said, was "sacred and should reflect credit on the Society." He ended with the recommendation "[t]hat the committee be empowered to employ some artist of known reputation and ce-

lebrity to construct the equestrian statue of General George H. Thomas, giving them power to enter into contract for the completion of such statue."[18]

Vinnie knew that when men spoke of "artists of reputation," women were not under consideration. She left the city in a rage, swearing never to return to Pittsburgh.[19] She was, of course, correct: the committee awarded the contract, without a competition, to J. Q. A. Ward. She was so angry that she chose to ignore the obvious problem she had with General Price, and with no real evidence, told Sherman that Philip Sheridan had turned the committee against her. She was not swayed by Sherman's vociferous defense of Sheridan. But in actual fact it was Sherman, and not Sheridan, whom she blamed for her defeat; she believed that he had not worked hard enough for her. It is not known whether she confronted him openly about what she considered his lack of vigor on her behalf. What is certain is that she began to formulate a plan to maneuver Sherman into personally awarding her the Farragut commission.

Every Wednesday evening, Vinnie held a salon from nine to midnight. The attending nucleus included General Sherman, Daniel Voorhees and Albert Pike, augmented by politicians, military men, businessmen and various others. As many as twenty to thirty people crowded her small rooms, many stopping by for an hour or two as they made their visiting rounds. If the visitor was new, Vinnie conducted a tour of her works, giving full background on each piece. At some point there was a musical entertainment, with songs by Vinnie or one of her guests, accompanied by harp or piano. Sometimes there was a discussion of interesting news, as for instance the trial in a French court of John Charles Frémont, accused of misrepresenting the bonds he had sold while he was in Paris. Frémont had defended himself in an open letter to the *New York Times* in which he claimed that he had not attached the word "Transcontinental" to his company's "stocks or bonds, nor upon its official papers, envelopes or signs."[20] Vinnie must have been amused to remem-

ber how often she had received notes from Frémont on the sta-
tionery of the Memphis, El Paso and Pacific Railroad under the
heading "Chemin de fer Transcontinental."

On occasion the Washington press would report on an event
in Vinnie's salon: "General Albert Pike, tonight in the parlors
of Miss Vinnie Ream, read an interesting and learned paper
upon 'Cremation.' His illustrations, drawn from ancient his-
tory, went to show the habit of burning bodies and preserving
the ashes in vases was founded upon practical sentiment and
prompted by affectionate impulses."[21] Some time in 1873, Pike
began a monumental philosophical autobiography that would
take him ten years to complete. Entitled *Essays to Vinnie*, it
consisted of 2,166 handwritten pages bound into five volumes,
each volume bearing the inscription "Vinnie. Pegni d'affecto"
on its cover.[22] In return for this affectionate dedication, Vinnie
came to his house to hear him read each essay as it was com-
pleted. As Pike grew older, she never failed to offer him her
wholehearted companionship.

The cost of all this entertaining was draining her cash. To
economize, she decided to give up her church pew. But Dr By-
ron Sunderland wrote her, "Please don't leave the pew—you
must not leave me—what can I do if you do not come to
church—I will fix it and you must not give up your pew."[23] In
the semi-autobiographical novel she had begun in Rome, an
American banker had come to the rescue of Leslie, the protago-
nist. Sunderland's letter is reminiscent of the later moment in
the novel when Leslie meets a "young Episcopal clergyman who
immediately fell in love with Leslie, as all tender-hearted men
were bound to. The sound of her musical voice, the glance from
her dark eyes, brought them to her feet."

This time her immediate financial problems were solved by
Brooklyn Mayor Samuel S. Powell, who had sat for her at the
King's County Fair in October, 1872. She visited him and the
fair council in the following summer to convince them that they
should buy the model and have it cast into marble. Her efforts

were successful. Just after Christmas, Powell wrote her that the council had voted $1000 for a portrait or a bust of him as a tribute to his three terms in office. He could choose whether "we shall look upon his features as represented on canvas or chiseled in marble."[24] He was also given the option of choosing the artist, and of course he chose Vinnie. Even after deducting the cost of the marble, she would realize a healthy profit.

The Forty-Second Congress adjourned without reaching a decision on the Farragut statue. Vinnie was determined to obtain action from the next Congress that convened on March 4, 1873, but it sat for only two weeks, and would not meet again until the first of December. Vinnie could no longer count on help from the Committee on Public Buildings and Grounds, since her supporter John H. Rice of Maine had retired. She decided to try to bypass the committee and have a special committee appointed, one that would favor her claim for the Farragut commission. Secretary of the Navy George Robeson would have to be a member, and if she could arrange the appointments of Sherman and Mrs Farragut, she would have a safe majority. Virginia Farragut was happy to oblige, and Sherman replied, "If your friends insist on my being on the Committee of course I will not object."[25] He and Vinnie both knew that without heavy lobbying, congressmen would not think of putting an Army general on a committee formed to select a statue to commemorate a Naval hero.

Vinnie began lobbying Congress on December 1, 1873. It did not take long for her friends to begin to draft a bill. Godlove Orth and Stephen Kellogg took the lead in the House, and Powell Clayton and John Sherman in the Senate. On March 6, 1874, after many strategy meetings and revisions of the wording, the bill to appoint Robeson, Sherman and Mrs Farragut to a statue committee was introduced in the House. An amendment introduced by Samuel Cox of New York, to include several painters on the committee, was defeated.[26]

Vinnie and her friends thought that they would be able to win in the Senate, but Vinnie dreaded the possibility that Charles Sumner would once again rise in the well of the chamber to denigrate her abilities. Then word came that on March 11, Sumner had died. He had not had an easy time since the debate over the Lincoln statue in July of 1866. A bachelor at fifty-five, he had made an unfortunate marriage in October of '66, and separated from his wife within a year. Then a falling-out with Grant resulted, to his great sorrow, in his loss of the chairmanship of the Foreign Relations Committee, and his support of Horace Greeley in the '72 elections destroyed his standing in the Republican party. In May of 1873 he had divorced his wife, claiming desertion.[27]

On June 20, 1874, Vinnie sat in the Senate gallery, awaiting the debate on her bill. There was a discussion of an appropriation to repair the recently recovered watch that had been presented to Lafayette by George Washington, and restore it to the Marquis' family. Then a bill was quickly passed to donate twenty condemned bronze cannon to be used for a statue of General George Gordon Meade. This pleased Vinnie, who saw it as a precedent for a similar donation of bronze to her own statue. When her bill came to the floor, an attempt was defeated to replace Sherman with the Admiral of the Navy, but Senator John Sherman defended the bill as it stood and it was passed. Two days later, Secretary of the Navy George Robeson was directed to confirm the sculptor chosen by majority vote of the new committee.[28]

Vinnie's friends inundated her with congratulatory letters and telegrams. But George Robeson was furious. He knew that Virginia Farragut felt indebted to Vinnie who had been instrumental in achieving legislation for the monument. He was also well aware that Sherman had been at Vinnie's house every week, that he had been in Pittsburgh with her, that he and she had taken those Sunday morning carriage rides together. The Secre-

tary knew he could not stop the award, but he could certainly delay it by simply not calling for a meeting of the committee. That is what he did, and Vinnie reacted with rage. She saw to it that his office was flooded with requests for action from Dan Voorhees, James Rollins, Reverdy Johnson, Godlove Orth, Powell Clayton and others from her army of admirers.[29]

One of the senators rallying to Vinnie's cause was John J. Ingalls of Kansas, who had just taken his seat in March of '73, having defeated Samuel Pomeroy by demonstrating conclusively that Pomeroy had accepted bribes. Vinnie had mixed feelings about Pomeroy's defeat: he had threatened her during the impeachment trial, but since that time had become her ardent admirer. Within three months of reaching Washington, Ingalls, forty years old, married and the father of two children, was arranging secret meetings in Vinnie's studio, with Vinnie's maid acting as go-between.[30] He knew he was being used, but apparently did not care. He had a sardonic sense of humor. One evening, after disagreeing with her over a design for a medal to memorialize shipwreck victims, he wrote, "I was wrong in objecting to the hovering angel above the tempestuous sea. Only I think instead of holding a laurel wreath in its hand, it should have in its right a steaming coffee pot and in its left a ham sandwich with plenty of mustard! Think of my suggestion. I charge nothing for it. It is a gratuitous contribution to the art of the period."[31]

On another occasion, he replied to an invitation to visit her by writing Vinnie that he had twice been told that she was too busy to see him, but that now, "It must be you want another appropriation."[32] Ingalls had a sharp tongue: he responded to criticism from Simon Cameron of Pennsylvania by saying that there had been only two great men from Pennsylvania: Albert Gallatin of Switzerland and Benjamin Franklin from Massachusetts.[33]

Although he agreed to put pressure on Robeson, Ingalls could not refrain from writing Vinnie a perceptive letter, laced with resentment disguised as joviality:

I will of course immediately address a note to that jolly old sea dog and gallant tar who presides over the naval destinies of the Republic, and who at the present time appears to exercise a malign influence over the fortunes of Farragut, so far as his immortality at your skilful hands and busy brain is concerned. I can imagine his consternation as he reads my epistle & files it away with those which he will receive from the rest of that troop of your captives whose scalps adorn your belt.

Vinnie, you are, as I have often told you, the biggest & most delightful fraud I ever met. Your methods are a most amusing study, and I have laughed a thousand times to see your ingenious tactics and manoeuvers, your wiles and stratagems to achieve your ends. And I have often smiled at your evident uneasiness for my departure when you had some fresh victim, of whose fealty you were not sure, in your parlor or studio, and my presence was not necessary to the full development of your schemes. And, you show a keen appreciation of human nature, in your evident preference for the 'old fellows'. Nothing tickles an old gray-haired rooster like the thought that he has not yet lost his power to make a conquest. To be sure it is the old chaps that have the power, the votes, & the influence.

The idea of deliberately sitting down to capture the Senate & House of Representatives, in the shadow of the Dome of the Capitol, is inspiring, and the best part of it all is that you succeed, and the general with them! Nobody eludes you but the laughing old sailor Robeson.

Well Vinnie, I wish you all the luck in the world. Your audacity deserves it. But I shant help you anymore if you count me as a dupe. You want allies & not slaves. And above all don't ever caution me again not to say that you requested me to do anything which I do in your

behalf. It is not flattering to my intelligence!

When do you come West? Not I suppose until this business is settled, and not till Sherman does I presume.[34]

As should have been expected, Vinnie was stung by this letter. She responded with what had always been her most effective weapon against these men: silence. Within the month, Ingalls had gotten the message. "Vinnie," he wrote, "Why don't you write to me? Did any of my nonsense vex or offend you? If so pray forget and forgive it. I think of you daily."[35] But his observations had hit too close to the bone. And to make matters worse, only two weeks after his vexing letter, on August 7, 1874, Ingalls was accused by the *Kansas City Star* of committing adultery with a Mrs Benedict. This, together with the fact that his penchant for sarcasm had alienated many senators, convinced Vinnie that it would be wise to avoid him. The next time he came to her studio, he was received coldly. He wrote to her intending to mend fences, but the tone that was natural to him could not have won her over: "You are a very troublesome creature, but it is such a pleasure to serve you that I can only wish the appropriations were larger and more numerous. But what have I ever done that subjects me to the indignity of being stigmatized as cousin to an Indian Agent? I reply with indignation and scorn the unworthy suggestion."[36]

That summer, with her congressional friends pressuring Robeson, was a good one for Vinnie. She convinced the Corcoran Gallery to display her *Sappho* for that season. The St Louis Exposition asked her to send for display *The West*, a five-foot female figure wearing windswept robes. It holds a surveyor's chain in its right hand and a compass in its left. Its symbols include also a star of empire on its forehead, a broken bow and arrow and a sheaf of wheat. It received good reviews; the Exposition judges gave it a First Premium award and paid the cost of freight. Vinnie was asked to send a life-sized sculpture to an-

other exhibition in Louisville, Kentucky, where she had sent *The West* the year before. This year she sent *Miriam*. The Hebrew prophetess is shown celebrating the passage over the Red Sea. Both arms are raised over her head, she holds a tambourine, a strand of pearls is woven into her hair, and a long scarf tied below her hips flows loosely upward over her right shoulder. Again Vinnie received good notices in the local papers, and the Louisville exhibition too paid the freight.[37]

Vinnie was so busy with all of this that she asked Sherman to review her correspondence. On one letter from a St Louis newspaper requesting Vinnie's picture, Sherman noted, "Strike while the iron is hot." On another letter asking for a biography, he wrote, "Comply with the request and blow your own trumpet."[38] That summer Elias Boudinot too was working on Vinnie's behalf, writing her about the growth of the town Vinita. From St Louis he wrote that he had just returned from the Cherokee Nation where he was trying to generate interest in another copy of her bust *Sequoya*, but he did not think he would be successful because his position on the allocation of tribal land was turning the Nation against him.[39]

This was certainly true: the *Cherokee Advocate* commented that the people of Washington had been misled about the character of the Indian people "and are led to believe the Cherokee Indian [who is] sometimes called Col. Boudinot represents the people of the Territory. It is time the public should know we have no use for a traitor to his own people, and a person who would assist to rob us of lands, destroy our governments, and open the door for border ruffians."[40] The wrath of the Nation was not to be taken lightly: Boudinot's father had been murdered in 1839 for supporting unpopular treaties.

In the midst of all this, there were signs of a backlash against Vinnie's methods and her handpicked committee. The *New York Times*, supporting an effort to create a committee of artists to consult with Congress on potential art grants, published an ar-

ticle, "Art in the Capitol" by the paper's art critic, who lambasted most of the work and the artists, and was heavily critical of Vinnie, complaining of "the appalling newness" of the *Lincoln,* Vinnie's "melancholy pasquinade in stone . . ."[41]

Meanwhile, serious difficulties had arisen between Sherman and William Belknap, the Secretary of War, who was encroaching on Sherman's authority, in particular on his responsibility to appoint sutlers—civilian provisioners to army posts—in the Territories. Eventually the point was reached where officers arriving in Washington did not know whether to report to Sherman or to Belknap. When Sherman complained to Grant, the president responded, "I have no doubt but that the relations between the Secretary and yourself can be made pleasant, and the duties of each be so clearly defined as to leave no doubt where the authority of one leaves off and the other commences." Sherman complained to his brother that Grant had often promised to "arrange and divide" the duties of Belknap and himself, but that he had done nothing, even though when he was a general, Grant had complained about similar problems between himself and Secretary of War Stanton.

Sherman suspected Belknap of making illegal decisions and told Grant that he did not want to be tainted by them and that if the matter were not settled, it "would surely result in driving me away." When Grant, embedded in his corrupt administration, did nothing, Sherman decided that he had to get out of Washington. He sold his house in I Street and in October moved his headquarters to St Louis, where he had lived when he was appointed commander of the Division of the Missouri after the war.[42]

This was a devastating blow to Vinnie. Their relationship was certainly sexual, but not only sexual—they had a pleasant friendship as well. Sherman told her amusing anecdotes: when he accidentally left her house with her handkerchief, he wrote her that he had once put a napkin in his pocket when dining out, and "[o]n leaving the hotel I had occasion to use a hand-

kerchief—pulled out the napkin, flourished it and staring in my face was the printed words, St Nicholas Hotel." Once they made a bet about which of them had correctly recalled a quotation from Walter Scott's *Lady of the Lake*. Sherman claimed victory, telling Vinnie what canto and stanza to look at. The terms of the wager are not known. Sherman did not stint on time spent for Vinnie: he delayed the delegation to Charles Sumner's funeral while he wrote to her to tell her that he had seen her at the theatre the night before.[43]

Vinnie found it difficult to understand why Sherman left the field; she believed the situation with Belknap could have been worked out. She admired Sherman's principled stand, but feared that with Sherman in St Louis and Virginia Farragut in New York, she was left vulnerable to Robeson's delaying tactics. Sherman certainly missed her: he had been gone only a short time when, apparently depressed on his birthday, he wrote her, "I often think of your studio and my precious moments there and wonder if you miss me, and who has the pleasure of toying with your long tresses and confronting your imaginary distresses. But I must heed the progress of time, for today I am 55 years old, and I must play the part of the Old Man the rest of my career."[44]

A few months later, he warned her, "Write me whenever you please, but be a little careful as Mrs S. looks at my letters, but she is not jealous of you, for she thinks you are wedded to your marble statues." His letters to Vinnie are filled with news about his children: Tom was at Yale, Lizzie in New York, Elly and Rachel at school in Cincinnati, and Minnie had moved into her own house. He described his travels and his opinions about the political situation. Vinnie's letters were not as long as his, but she talked about her studio, her family, various art works and—what Sherman enjoyed most of all—relayed Washington gossip.[45]

Becoming desperate about Robeson's refusal to act; she reminded Sherman that only two votes were necessary and sug-

gested that he and Virginia Farragut make the decision without Robeson, a thing that Sherman absolutely refused to do. He told Vinnie that he would not allow her to "commit Mrs F. and me to anything looking like an understanding beforehand."[46] Robeson had received his directive from Congress on June 22, 1874, the day before it adjourned. For the next five months he was under heavy pressure from congressmen writing him from their constituencies. Finally, with Congress due to convene for its second session on December 1, he decided he had to take some action or be subjected to greater pressure and possibly even congressional censure, so he arranged to meet Sherman and Mrs Farragut in Washington at noon on November 19.

Sherman immediately notified Vinnie that he was on his way and that he wanted to give her a letter from Virginia Farragut: "I first intended to hand it to you in person next Monday, but it is better that I should see Robeson first so as to say and say truly that I had not seen you on the subject. . . . I start this evening at 6:30 pm and will be in Washington as soon as this letter and will stop at my brother—will see Robeson same day, and then will see you."[47]

Robeson, Sherman and Mrs Farragut met at the Arlington Hotel where they arranged to look at works of art set up in the public grounds, to examine all the Farragut models in the city, and to meet the next day to make their final decision. They duly made their tour, stopping at Vinnie's studio and many other places. The next day they returned to the Arlington, where Robeson distributed the formal proposals of James Wilson MacDonald, Erastus Dow Palmer, H. K. Brown, Launt Thompson, Clark Mills, Horatio Stone, Franklin Simmons and, of course, Vinnie. Robeson asked them to consider also proposals from Thomas Ball, Adolph Bailey, Randolph Rogers, J. Q. A. Ward and William Wetmore Story. After Sherman and Mrs Farragut confirmed that they had received all the information and made all the necessary examinations, Virginia Farragut asked Robeson to name his first choice.

He named Launt Thompson, but added that he would be willing to vote for Franklin Simmons or H. K. Brown. Mrs Farragut announced that her first choice was Vinnie Ream, and her second choice was Launt Thompson. Sherman too chose Vinnie, but he said that if any other party was named, he also would prefer Thompson. Robeson suggested that since his first choice was the second choice of the others, they might perhaps agree on Thompson. As could be expected, this suggestion was rejected. A formal vote was taken and the majority ruled.

Robeson did not take this well. He asked Sherman and Mrs Farragut to draw up the formal award document, and he asked them also to submit letters giving the reasons for their vote. They drew up and signed the formal document, but Robeson refused to add his signature. Mrs Farragut presented a letter in which she said, "I give my vote for Miss Vinnie Ream, because of the few models presented for my careful inspection, I find hers best recalls the features, form and presence of my husband. . . . I feel no fear in intrusting the work to Miss Vinnie Ream, whose early and great zeal in the matter found no rest until Congress passed the bill that secured my husband the national compliment."[48]

Sherman refused to submit a paper of explanation for his vote. "I hardly deem it necessary," he wrote Robeson, "to explain why I voted for Miss Ream. I will state that of all the models presented to us, that of Miss Ream was the best. I now assert that I have not the remotest intention of changing my vote."[49] Robeson added his own reaction to the minutes of the meeting: "I dissent from the conclusion of my associates on this commission, and decline to concur with them in selecting Miss Ream." He commented that the model prepared by her had already been substantially rejected during the first selection process in March of 1873, and he assumed that under the new selection procedure, new models should have been provided. He added that he did not think that Vinnie had the experience to execute the task and that he felt sure that the Navy agreed with him.[50]

Nevertheless, Robeson had no choice; he had to sign a contract with Vinnie. But he determined to delay again as long as possible. Vinnie countered by complaining about him to every congressman she could buttonhole. Sherman, back in St Louis, heard about the furor she was raising, and wrote her, "I took it for granted that the contract had long since been made with you by the Secretary of the Navy. It is a fait accompli—and you can compel Robeson to make the contract if he has not done so already. I was expecting to hear from you whether you would have the bronze casting made in Munich or this country. You have got things in an awful mix since I left you."[51]

Finally, with Congress threatening action, Robeson signed the contract with Vinnie on January 28, 1875. Many senators were so angry with Robeson that they passed a resolution on February 3 requiring him to forward a copy of the contract with Vinnie "and any papers in relation thereto." Robeson submitted the minutes of the selection committee to the Senate. The contract called for a statue ten feet in height, of the best quality bronze, set on a granite pedestal of suitable height, both statue and pedestal to be finished to the reasonable satisfaction of the commissioners who had made the award. The price was to be $20,000, with $5000 to be paid as soon as possible, the second $5000 to be paid on completion of the plaster model and pedestal, and the remainder to be paid on completion of the whole. Vinnie now had her second major award.

The press reaction to this was somewhat more muted than to her Lincoln award. Nine years had passed, Vinnie had achieved some acceptance, and her government connections were impressive. The *New York Times*, however, did not deign to mention her name, reporting only that "A young lady of engaging manners and small experience in art got the contract to carve a statue of Farragut."[52]

Despite failing health and financial problems, Ezra Cornell did not ignore Vinnie. In September, Jay Cooke & Company, a financial firm, collapsed, thrusting the country into the Panic of

1873. On March 21, 1874, Cornell wrote her that he hoped
that "you have been successful with the Brooklyn job and the
honored Mayor has been immortalized by being marbelized."
He was trying, he wrote, to arrange a contract for her with
Cooper Union, but "[t]he influence of the panic increases my
labors, as it caught me with an hundred miles of unfinished
railroads on hand." On May 18, he wrote her that he had fi-
nally found a suitable place for the Lincoln bust he had bought
and wanted it sent to Ithaca. He was trying to set up dedication
ceremonies as she had asked him to do, but he could not under-
take to buy any more sculpture because "building Railroads
has made me poor for a time, and must wait to recuperate,
before I can do anything. There are several things in which I
should help you about [sic] if it was not for these RRs."

Vinnie sent him an ivory stylus along with the Lincoln bust,
explaining, "It is one that was used in olden times, and was
presented to me by the gentleman in charge of the Palace of the
Caesars. They were very kind to me when I went there to exam-
ine antique pens. I was at that time modeling my statue of 'Sap-
pho,' and wanted to see the ivory pens used by the Ancient
Greeks and Romans." She liked to give her male friends small
but significant gifts. She would certainly not have forgotten that
for years she had been trying to get Cornell to buy *Sappho*. She
also liked to collect the signatures of prominent men on repre-
sentative documents. She had Lincoln's signature on a copy of
the Emancipation Proclamation, and now she asked Cornell, "I
wish you would send me, in your own handwriting, the motto
of your Institution. I would prize it so much. I hope sometime
to see the Cornell College myself, and to have the pleasure of
knowing your family."[53] She was probably not unaware of the
flattery inherent in such a request.

In any case, Vinnie never visited Cornell College and never
met Ezra Cornell's family. The letter asking for the Lincoln bust
was the last she received from him. He died on December 9,
1874.

13

CENTENNIAL

Your victories are lasting and unlike mine are not pur-chased at the expense of the lifeblood of fellow crea-tures leaving sorrow, suffering and desolation in their track.

—*General George Armstrong Custer*

BECAUSE OF ITS SIZE, the Farragut statue presented engineering problems that Vinnie had not encountered before. Apart from the question of where to build it, there were problems of its weight and proper structural support and its design so that it could be cleanly cast. She drew upon her memories of the work done in Clark Mills's studio on the *Jackson*, considered an en-gineering marvel, with the entire statue balanced on the horse's hind legs. Mills was an engineer as well as an artist and crafts-man. At his studio, Vinnie had seen colossal statues in multiple sections awaiting casting. The secret was to divide the model into sections along unseen lines. Vinnie decided that she would build the Farragut in five pieces, separating the body just below the line of the coat collar, cutting the body laterally under the sword belt, and making separate pieces of a large telescope and each leg which would fit within the lower part of the coat skirts. When these parts were complete, the pieces would be cast by the foundry and welded together along invisible lines.[1]

Since she needed a large space so that she could gain the proper perspective on the work, Vinnie thought at first of remodeling her studio. Sherman argued against this, saying that remodeling would destroy "the space which now gives light to your studio." But what he was most concerned about was that the plan would destroy what he called "that auspicious sanctuary." He suggested that she have a studio and a separate residence, "like Powers in Florence, though not so large and extravagant." He knew she was always short of money, and asked, "Will the Secretary advance you anything on account? Can you raise the necessary funds on the faith of your contract? Have you other commissions?"[2] She decided to accept Sherman's advice and bought the house behind hers, building a connection between the two buildings, and removing part of the second story of the new house to create the necessary vertical space.

Sherman wrote Vinnie on a variety of topics, including politics. "I almost feel sorry for General Grant with a Democratic House," he told her, "but the Republicans have been so arrogant that they soon must fall. I confess I dont want to see persons come into power who look back on the war as something wrong. That War was sacred. And those who opposed it or were lukewarm ought not be entrusted with the future. I am perfectly willing to see our former enemies regain their property for good, but not to belittle the Event that raised our reputation as a Nation to a first rank among the World. If the Democrats now behave with moderation and wisdom it is well. But I fear their politicians are little better than those of the Republicans."[3]

Sherman's fellow-general Philip Sheridan created a considerable stir in January, 1875, when he was dispatched by Grant to put down violence in Louisiana, where Democrats opposed to the rights of freedmen tried to take control of the state legislature by physically seizing five disputed seats. Sheridan removed the five usurpers and asked Belknap to try members of the White League, the racist group behind these Democrats, before military tribunals. The country was in an uproar over this, even in

the North where defenders of the action like William Lloyd Garrison and Wendell Phillips were shouted down in public. Sherman commented to Vinnie: "P. Sheridan has stirred up a pretty fuss in the New Orleans. That is easy enough. But to get out gracefully is quite a different matter. I flatter myself that I am too old a soldier to be caught in such a scrape."⁴

Sherman finished writing his memoirs in January, 1875. When they were published in the summer, he told his publishers to send Vinnie a copy. Clearly she neglected to respond, because he wrote her, "I have not heard from you in a long while and feel uneasy. I ordered the Publishers to send you one of my memoirs, and thought you would acknowledge receipt and favor me with your honest criticism. . . . I have had a large amount of criticism, mostly by parties who thought I did not appreciate their full merits." He said he was going to Keokuk, Iowa, for the Fourth of July, and asked her to write to him on the 7th, which she did, and he replied, "I was glad to receive your letter of the 7th as it put me in possession of much that I wanted to know. . . . Mrs Sherman & children go soon to Geneva Lake for the summer, but I will stay near here. . . . I wish you could find some excuse to come out west."⁵

It is interesting that Vinnie's admirers seemed to value her opinions, or at least to invite them in response to their own discussions of events, current and otherwise. Lyman Trumbull told her that he had decided to give up his Senate seat because "the people seemed so indifferent to what was going on & so oblivious to the abuses of power and corruption of those in authority that it seemed useless to try and wake them up. The panic set them to thinking and now, I think, the days of the Grant dynasty are numbered. I do not mean that Gen. Grant is corrupt personally—I have no evidence of that, but the Republican organization has been rotten for years & Grant is its instrument."⁶ In this vein, Rollins, Voorhees, Ross and others also confided in Vinnie; their interest in her was not apparently limited to her sparkling eyes and dark curls.

On February 6, 1876, Reverdy Johnson died. It was Johnson, Maryland's senator from March, 1863 to July 1868, who had convinced Lincoln to sit for Vinnie, and who had signed her patronage petition and voted to grant her the *Lincoln* award. In the months before his death, he was trying to get her a commission from the Baltimore City Council for a statue of Johns Hopkins.[7] The council was inundated with letters from Johnson and other friends of Vinnie, often offering as proof of her abilities the fact that she had recently won the Farragut award despite "fierce competition on the part of the most distinguished sculptors." One friend, George Barry, wrote a council member, "I insist on your using your influence in Miss Ream's favor— she has been abused by critics who have never seen her work. She is perfectly willing to have the bust of Mr Hopkins she is now engaged on placed alongside of any and every other artist and would accept the inevitable verdict in her favor gracefully."[8]

All this pressure proved to be a waste of time because the council did not call for a competition.

Fifteen months after Sherman moved to St Louis, Secretary of War Belknap had become embroiled in a scandal involving the acceptance of kickbacks from the sutlers appointed to trade with soldiers at Fort Sill. Knowing an impeachment was imminent, Belknap burst into Grant's office at ten o'clock on the morning of March 2, 1876, to plead that he be allowed to resign. Grant immediately accepted his resignation, and at 6:15 that evening Belknap was impeached by the House. But he was acquitted by the Senate on the grounds that his resignation had removed him from its jurisdiction.[9]

Although Sherman had had his problems with Belknap, he wrote that the Secretary's "downfall was due to the vicious organization of Washington society and the ridiculous extravagance of the first social circles. Very few Cabinet officers are able to live within their means, none can begin to live within their salaries . . . Now Belknap got $8000 a year and no outside resources. His wife was fashionable and ambitious. . . ."[10] Sher-

man said he would not return to Washington unless orders to the various departments passed through him and him alone, a stipulation to which Alphonso Taft, the Secretary of War, agreed. Shortly thereafter Sherman moved back to Washington and was once more in regular attendance at Vinnie's Wednesday soirees.

Elias Boudinot, also an attendee, described one of these evenings:

> The studio is unique and characteristic. Like its mistress and ruling subject, it is small but crowded. Here are statues and busts, and statuettes, generals on horseback, and admirals not on ship-board, Indians and Indian trinkets, pictures and clay, and models, and paddles for moulding the clay. These small rooms are crowded to their utmost capacity, scarcely leaving room for the artist or the visitor to turn around. And she, the ruling spirit of so much confusion. Here mingle the wise and the unwise, the young and the old, the grave and gay, the titled of brief authority and the humble citizen who assists in giving their brief authority. Present were Generals Sherman and Custer; D. W. Voorhees, the tall sycamore of the Wabash; LaFayette Lane, member of congress from Oregon; Mr Karl of Germany; Miss Lillie Pike, the beautiful and accomplished daughter of the poet General Albert Pike; an inventor from Rochester, NY; and your own poor little lawyer from Kansas; and others whose names I did not get, as they were coming and going from nine to twelve o'clock in the evening. But central figure of all is Miss Vinnie herself. Small of stature, petite, lithe, sparkling,—now running over with wit, now a shade of sadness passing over her face as if some far-off thought or inspiration were working itself out to the surface, and yet never for a moment losing sight of the fact that she is entertaining friends.[11]

General George Armstrong Custer attended Vinnie's receptions; he had been ordered to Washington to testify before a military commission about his charges that high-ranking officers had taken bribes and that there was corruption in the Indian Bureau as well.[12] Vinnie had first admired the brash young major general when she saw him dashing down Pennsylvania Avenue in the Grand Review of 1865. When the army was reorganized after the war, Custer was made lieutenant colonel in command of the 7th Cavalry, a post he held until his death. He had distinguished himself during the war by his bravery and willingness, if not eagerness, to lead his devoted troops in the Michigan Brigade into battle. But after the Civil War, there were always questions about his methods and motives, and he often got in trouble with the Army. He and Vinnie became friends when he came to Washington in March, 1868, and signed the petition that helped her win the *Lincoln* contract. After that he stopped by her studio whenever he was in the capital.

In 1871 when Vinnie invited him to the *Lincoln* unveiling, he could not come because he was in New York seeking a lucrative career change after a year of routine duty at Fort Hays. He had been court martialed for leaving his command at Fort Wallace, Kansas, without permission. His penalty was a year of suspension without pay, but in September, 1868, after ten months he was reinstated, largely through the influence of General Sheridan, who admired him greatly. In November, two months after his reinstatement, he engaged in a massacre of Cheyenne at the battle of the Washita, and was accused of abandoning a small detachment of his men who were wiped out by the Indians.

His letter to Vinnie apologizing for his absence reflects his disillusionment with his military career, and certainly his bitterness at the accusations of inhumanity that had been leveled at him. "You are young," he wrote her, "and have obtained a foothold on the ladder of fame far in advance of your years. Go on dear friend, conquering and to conquer . . . Your victories are lasting and unlike mine are not purchased at the expense of the

lifeblood of fellow creatures leaving sorrow, suffering and desolation in their track."[13] He did not find the opportunities he sought in New York. In the Civil War, he had distinguished himself by his eagerness personally to lead his loyal troops into battle. In 1873 he served in the Dakota Territory, and in 1874 led an expedition to the Black Hills which aroused renewed hostilities with the Sioux. Custer was as rash politically as he was in the field. A Democrat, he enraged Grant by testifying against Belknap, and by accusing Grant's brother of being implicated in the Indian Bureau scandal.

Between appearances before the military commission, he had plenty of time for visits to Vinnie's studio where he sat for his bust and engaged in various antics that were typical of him. He took out his knife and tried to scratch his stars and emblem into the plaster model. They discussed her preparations for the upcoming Philadelphia Centennial celebration and his impending expedition against the Sioux who were defending lands reserved for them by an 1868 treaty. Custer's only surviving letter to Vinnie during this period was written after they apparently spent a late night together: "Pardon me for disturbing you at this early hour. Please have your servant examine the floor of your studio to see if my wallet was not dropped there last night. If so return it by bearer and, in any event, do not chide me, even mentally, for interfering with your much needed morning nap."[14]

Sherman commented that Custer was "young, very brave, even to rashness, a good trait in a calvary officer. I think he merits confirmation for a military service already rendered, and military qualities still needed—youth, health, energy, and extreme willingness to act and fight."[15] At Custer's last evening at Vinnie's, many of the guests were Indians, including Elias Boudinot, the Cherokee, and Pleasant Porter and David Hodge of the Creek nation.

Custer left Washington on May 1, wishing Vinnie luck at the Centennial. Before he joined his regiment, which had been detailed to the column under General Alfred Terry, he went to

New York to spend the day with some newspaper friends and reached Chicago on the 6th, where he was arrested for leaving Washington without orders. After Sherman intervened to obtain his release, he joined his 7th Cavalry regiment in mid-May at Fort Lincoln. In June, General Terry sent the 7th Cavalry to locate the enemy, and on June 25, Custer discovered an encampment of Sioux at the Little Big Horn. Apparently unaware that he was hopelessly outnumbered, he recklessly attacked, with the result that he and the 200 men he brought with him were massacred by Sitting Bull and Crazy Horse.[16]

The news about the Little Big Horn massacre spread everywhere; people gathered on street corners, talking about it in hushed voices. It was particularly painful coming as it did during the nation's centennial celebration. To Vinnie it must have come as a considerable shock, but not one that would prevent her from attending to business at the Centennial Exposition, where the thousands of exhibits were visited by ten million people.

When the exhibition was in the planning stage, a Woman's Centennial Committee had been set up to raise funds for a promised women's exhibition in the main building. But the promised space was turned over to' foreign countries. In less then four months, the women raised enough money to build a Woman's Pavilion, which housed collections of needlework and carpet weaving, among other things.[17] Vinnie was offered space to exhibit in this pavilion, but her attitude toward it was the same as that of Elizabeth Cady Stanton, Susan B. Anthony and Matilda Gage, who considered it an insult that women artists were segregated in a kind of ghetto and not given space in the Memorial Hall devoted to international sculptors. As we have said, Vinnie would have nothing to do with the woman's movement—apart from anything else, she could not afford to alienate the male committees that decided awards—but she was certainly aware that she lost commissions because she was a woman. She confided in James Rollins that centennial summer; he responded

that he felt "anxious" about her professional success and that some of her supporters loved her *"perhaps* a *little* too much."[18]

One supporter whose interest in Vinnie might have taken Rollins aback was Daniel Johnson Morrell, a wealthy and influential Pennsylvania businessman. He and Vinnie had met when he was in Congress from 1867 to 1871 and he had voted for her extra $5000 appropriation. It was Morrell who had introduced and won passage of the bill designating Philadelphia as the official centennial city. As chairman of the commission's executive committee, he had enormous power over the operation of the exhibition. He was in his mid-fifties, vain, and looking for sexual excitement.

Vinnie not only wanted to exhibit in Memorial Hall, she wanted to control the setting and lighting of her work, considerations she had learned about in Europe. Morrell was obviously the man to help her, and she knew how to play on his vanity and desires. In 1867, she had made a medallion of Senator Richard Yates to enlist his help at the Paris Exposition, and now she offered to produce a bust of Morrell to exhibit at the Centennial. This delighted him, and he readily agreed to have his profile photographed. Over the next several months before the opening of the exhibition, while he was tending to his business affairs in Johnstown and civic matters in Philadelphia, he wrote her, "I am happy to inform you that Mr [John] Sartain, the Chief of the Art Department, will see that you have a first rate opportunity to display your works of art. He had promised to see personally to it, and I know that he will keep his word with me."[19]

Morrell's price for exerting his influence was for more than a bust. He asked Vinnie to write him salacious letters, a thing she was perfectly willing to do. He told her that she should send business letters to his home in Johnstown but the other letters should be sent to a hotel in Philadelphia "in confidence, marked personal." On March 7, 1876, he wrote her, "Yours of yesterday was received by me at the Centennial Hotel this morning

and I have just had an interview with Mr Sartain in regard to your Exhibits. You need not fear but that full justice will be done you, as Mr Sartain is Chairman of the Committee on Selection, and will not permit other members of the Committee from jealousy or other improper feelings to influence him in regard to what shall be placed in Exhibition. Whatever you may present that will be creditable to you as an Artist, he will have placed on Exhibition and will personally see that you have a right to complain in respect to position, light, etc. He has promised me this, and you can depend upon him."[20]

She sent her work to Philadelphia in March and storage costs at the railroad station were mounting, so she asked Morrell to arrange free storage for her on the Centennial grounds. He instructed Sartain, the committee chairman, to make this arrangement personally. But Sartain—and possibly Morrell—could be pushed only so far. Vinnie decided she needed an attendant to look after her exhibit and asked Sartain to give the man a permanent pass to the exhibition grounds. Sartain replied, "As our janitors are employed to dust all the works of art in the Dept. it is not considered that the attendant is necessary."[21]

Vinnie made plans to meet Morrell in Philadelphia on May 5 to supervise the placement of her work and then to stay for the opening ceremonies on the 10th. But the prospect of spending a week with Morrell was not inviting, so she arrived on the 4th without telling him; among her correspondence is a telegram from Morrell complaining that he had spent the morning of the 5th waiting for her at the depot.[22] Vinnie went directly to the fairgrounds, and was impressed with Memorial Hall, a stone and brick Renaissance-style building with a glass-and-iron dome topped by a gigantic figure of Columbia standing on a huge ball. Figures representing the four quarters of the world adorned the sides of the dome, and each of four corner pavilions were surmounted by cast-iron eagles with outstretched wings. The main entrance to the hall consisted of three arched doorways,

each forty feet high and eighteen feet wide. The iron doors, decorated with bronze reliefs of the coats of arms of all the states and Territories, opened into the eighty-three-foot wide, eighty-foot-high central hall.[23]

Walking through the corridors, Vinnie could have seen Edmonia Lewis's *Death of Cleopatra* and a bust of Charles Sumner by Anne Whitney, which would have brought back fond memories of Rome. In Gallery B. in the Grand Central Hall, she found her *Spirit of Carnival, The West, Miriam*, and the bust of Morrell. Daniel Voorhees, unaware of course of her arrangement with Morrell, wrote that he hoped that she had had enough sittings with Morrell to finish the bust, and that he was sorry that he had to stay in Washington instead of "with the Queen who is temporarily sojourning in the City of Brotherly Love."[24] Vinnie saw little of Morrell that week in May because Sherman had arrived to participate in the opening ceremonies. In any case, now that she had accomplished her purpose, the obscene letters apparently abruptly ceased.[25]

On the morning of the 10th, she started for the Centennial grounds in the midst of a great stream of men, women and children coming on foot, in carriages, in streetcars, by steam railway, in milk wagons and beer vans, stagecoaches and common carts. By nine o'clock in the morning, a large crowd had gathered waiting to pay entrance fees. One hundred and eighty-six thousand, six hundred and seventy-two people entered the grounds that day. When the gates opened, there was a rush for Memorial Hall where the president and other dignitaries were to be ensconced. Shortly before ten, the women's committee filed in, followed by senators and House members. After that came the foreign commissioners and diplomatic personnel, to take seats on the platform marked by their national flags. The audience was greatly impressed by the foreign delegations, with their cocked hats and uniforms decorated with stars, crosses and cordons.

The president and Mrs Grant appeared to the strains of "Hail to the Chief." The opening speech, given by John Walsh, presi-

dent of the Board of Finance, was inaudible beyond the first few rows, as was the speech given next by Joseph Hawley, president of the Centennial Commission, presenting the exposition to the president. No one could hear Grant either, as he read from several legal-sized sheets that he took from his pocket, beginning, "It has been thought appropriate, upon this Centennial occasion . . ."[26] Vinnie saw, sitting behind Grant, her old enemy George Robeson, as well as Daniel Morrell. In the military section was her old enemy Phil Sheridan, with Sherman. She was so fascinated by the personages on the platform that she did not realize that Grant had stopped speaking until she heard the orchestra bursting into Handel's *Hallelujah Chorus*. After the ceremonies, Grant was conducted into Machinery Hall where he was to start up the gigantic 700-ton, forty-foot-high Corliss steam engine which could produce 1,400 horsepower, a mighty symbol of American technical progress. When the president pulled several levers, the giant arms of the machine began to move, slowly, and then at a speed that amazed the crowd, while a great sigh came from the immense iron chest, and belts and shafts moved in all directions.[27]

The sculpture exhibit consisted of 675 pieces from fourteen countries, the largest number—325—coming from Italy, and the smallest—one—from the Netherlands. There were 162 objects from the U.S. and seventy-three from France. Many prominent sculptors chose not to participate in the American exhibit, which lacked proper order and seemed to be composed of scattered odds and ends with a few worthwhile works. There were twenty-one judges, seven from the United States, who awarded forty-three prizes, of which sixteen went to Italy, twelve to France and five to the United States. The American winners were Erastus Dow Palmer, John Rogers, H. Roberts, Montague Hanley and Isabella Gifford.[28]

Once again Vinnie had failed to win a medal in an international competition, but she had at least achieved a place in Memorial Hall and avoided the Woman's Pavilion, a drab build-

ing in noticeable contrast to the imposing palaces dotting the fairgrounds. There was much talk about the Pavilion's women managers, who were criticized as disagreeable to reporters and officious to visitors.[29]

Vinnie returned from Philadelphia to find several rather frantic letters from George Caleb Bingham warning her about what he perceived to be a growing scandal involving the two of them. When Bingham, in Washington serving as adjutant general of Missouri, was introduced to Vinnie by his friend James Rollins, he immediately asked to paint her portrait, an undertaking different from his genre paintings of river life and political campaigns. She sat for him in her studio, and was her usual flirtatious self. Bingham, in his mid-sixties, called her his "little granddaughter," and they discussed problems Vinnie had encountered in sculpting. The finished portrait so impressed Daniel Voorhees that he had it elegantly framed at his expense, and in April when Bingham returned to Kansas City he presented the portrait to Mrs Bingham. Vinnie liked and respected the small, delicate artist so much that before she left for Philadelphia, she acted out of character and wrote several letters to Mrs Bingham praising him.

Neither Bingham nor Vinnie was aware that a representative from the Kansas City area named Benjamin J. Franklin, concerned for some reason that Bingham was going to run against him, had secretly sent a series of telegrams to the *Kansas City Star* that resulted in an article accusing Bingham of using taxpayers' money to gad about Washington and spend the bulk of his time in Vinnie's studio. Mrs Bingham sent the clipping to Bingham who was on a business trip to Jefferson City, and he forwarded it to Vinnie with a note: "I send you the enclosed to show you in what a scrape I have become involved in by falling in love with and painting the portrait of my little 'grand daughter.' It may yet lead to a tragedy."

He seemed convinced that he might have to fight a duel to defend his reputation and Vinnie's, writing her melodramati-

cally: "In the event that I shall be compelled to fight and lose my life in the conflict, you must not allow it to break your heart. In contemplating the possibility of such a sad termination of my mortal career, just console yourself, as I do, with the thought that 'we will meet again on that beautiful shore.'" When he discovered that Franklin was behind this attack, Bingham commented to Vinnie that he could not "believe him capable of a descent so low and have so stated to all others whose suspicions have attributed it to him." He was mainly concerned, he wrote, for his wife's health and for Vinnie's reputation; his wife did not believe any of these lies and she too was concerned for Vinnie's reputation. He said he had taken steps to correct the *Star* for their article in which her name "was discourteously and scandalously used in a wanton and malicious attack upon myself. I send you today several slips from papers of the State which my wife has forwarded to me. They will be sufficient to show you that no harm will result to you from this indelicate and cowardly use of your name."

Vinnie, afraid that he would do something rash, wrote him several long letters trying to calm him. She told him that she had often been the object of malicious newspaper gossip and that he should be motivated by love rather than hatred. Bingham heeded her advice to some extent, commenting that her letter showed her to be "a better philosopher than" he and praising her "wisdom" as a "surer guide" than any advice he could give her. He dropped talk of a duel and assured Vinnie that he would take every opportunity to help her advance her career.[30]

In September, Vinnie received a distraught letter from James Rollins, who had just learned that Robert Ream's name was on a list of government clerks who were to be fired, charged with disloyalty during the war. Rollins protested that he was familiar with Ream's opinions and that "[n]o man deprecated the War more than he did, or condemned stronger the succession [*sic*] movement, and no citizen was truer to the Flag and the honor of his country. He was always a true patriot." And Vin-

nie, too, he went on, made shoulder straps and epaulets for Union soldiers and was "a great favorite with President Lincoln." He told Vinnie to see General T. Williamson of the General Land Office who, he was certain, would "not permit an act of injustice to be done to so good a man as your father."[31] But Rollins had no reason to be upset. Vinnie, whose sources were at least as good as Rollins's, had already learned about the situation and had had her father's name stricken from the list.

Also in September, Bingham entered his portrait of Vinnie in the competition at the Kansas City Exposition, where it took first prize. He had painted her standing beside her bust of Lincoln, holding a sculptor's tool in her right hand, wearing her work clothes, a simple smock, and with her dark hair flowing over her shoulders. Mrs Bingham sent Vinnie a delayed response to the letters Vinnie had sent her before the *Kansas City Star* imbroglio:

> There is no surer way to my heart than by praising my husband and to the extent you love and admire him, be assured I will ever love and admire you. I have been his constant companion for twenty-six years and therefore know him too well to entertain for a moment, the suspicion, that any regard, however exalted which his appreciating nature prompts him to entertain for the gifted and lovely of my sex will ever alienate him from the wife of his bosom. . . . I gave him full liberty to allow you any place in his heart which you could be induced to occupy. . . . Your unfinished portrait, his valued gift to me I have received and am delighted with it.
>
> In contemplating the sketch and animated expression which radiates from every feature, I am not surprised he fell in love with its captivating original.[32]

Whatever emotions Mrs Bingham harbored, by October she had suffered a mental collapse and was taken to the State Luna-

tic Asylum, where she died on November 3, 1876. Bingham was of course devastated and wrote to thank Vinnie for her efforts "to console me and share with me my very great sorrow that its weight may not crush me to dust."[33] Mrs Bingham bequeathed the portrait to Vinnie's mother.

14

RICHARD LEVERIDGE HOXIE

Thank God I do not know that you are willing to be kissed by any other man as you are by me, or that you are willing any other arms should embrace you.

—*Albert Pike*

IN EARLY JANUARY, 1877, Vinnie finished her model of Farragut. Five thousand dollars was then due her under the terms of the contract, which also required that she obtain the approval of the "commissioners who made the award." She certainly had no problem getting the approval of General Sherman and Virginia Farragut, but Robeson was of course a different story. On February 2, she had a disastrous meeting with him. He had not forgotten that he had had to deal with a committee handpicked by Vinnie and that her friends had pressured him to the point where he had been ordered by Congress to give her the contract. At the meeting, it became clear to Vinnie that he was going to delay approving the model just as he had delayed giving her the contract. She left his office in a rage and went immediately to see Daniel Voorhees, who told her that he too had had an unpleasant experience with Robeson: "Just before the close of the last session, I applied to Robeson for a matter of right in behalf of Captain Law of the Navy, an old friend of mine. Robeson made repeated promises to me, all of which he broke, and I thereupon broke off all relations between us; and

in the course denounced him as a corrupt, lying scoundrel, as in fact he is."[1] Vinnie's friends agreed with her that since only a majority had been required to grant the contract, only a majority was needed to approve the model. On February 23, the House approved the $5000 appropriation with no debate.

The presidential election held the previous November was not yet resolved. The Democrat Samuel Tilden had won the popular vote over Republican Rutherford B. Hayes, but disputes in Louisiana, South Carolina and Florida prevented the allocation of the electoral vote. After a good deal of intrigue and maneuvering, a bargain was struck and Hayes was declared the winner and inaugurated in March. Vinnie was relieved that Grant was gone, and delighted when Hayes appointed John Sherman Secretary of the Treasury, and replaced Robeson with Richard W. Thompson as Secretary of the Navy.

She could now turn her attention to the casting of the statue. She invited Edward Clark, the Capitol architect, to one of her soirees, and asked him to recommend a foundry. General Sherman was interested in the choice of a foundry: he did not want her to go off for a long time to have the statue cast in Europe, so he told her about foundries in Massachusetts—one in Concord and two in Lexington—that he said "compare[d] favorably with any abroad." But she tended toward the Barbedienne foundry in Paris or the Royal Bronze in Munich. She wrote to Carl Ehrenberg, whom she had met in Rome, "I am very timid, and dread the idea of crossing the ocean, so though I have an excuse to go to Paris now, with my statue, I send it in care of other parties. We were in such a storm on our return from Europe that I shall never recover from the fear."[2]

But it occurred to her that the Navy had foundry facilities right there in Washington, and if it were handled properly she might convince them to let her use these facilities so that she could personally oversee the casting. She arranged a meeting with Secretary of the Navy Thompson and presented him with letters of introduction from James Rollins and a host of other

friends. Thompson was sympathetic to her desire to supervise the casting of the statue and her worries about the cost of shipping it to a foundry. He suggested that the statue be cast in the Dahlgren ordnance building in the Washington Navy yard. Nothing larger than a figurehead had ever been cast in that yard, but Thompson felt this was an opportunity to expand the workers' skills. Vinnie was happy to agree, and the statue was moved into a makeshift studio in the Dahlgren Building. Thompson assigned the chief of the bureau of steam engineering and the foundry foreman to perform the casting. They were accommodating and accepted Vinnie's request that the temporary pedestal should be the same height as the final pedestal. They built a platform around the model, movable by block and tackle so that she could make final alterations to it.[3]

Vinnie was still a celebrity. She was invited to model Chief Justice Morrison R. Waite at a charity fair in Washington, and the *New York Tribune* reporter commented on her "face . . . framed in curls and flowing ringlets."[4] When an Indian delegation of the five tribes came to Washington, they paid their respects to the president, the Secretary of the Interior, and Vinnie, in that order. In the *Cherokee Advocate*, Red Pine wrote that the delegation was "extremely gratified to find the distinguished, beautiful and intelligent lady, Miss Vinnie Ream, our friend, who, I am satisfied, will urge that justice and good faith of the government will be carried out with the Indians of the Territory. If we have such a lady to advocate our treaty stipulations, territorial bids cannot prevail against us"[5] It was a rare week that her name did not appear in the newspapers. When she attended the wedding of Major W. A. Dinwiddie and Ella Kilpatrick, a reporter noted "the petite Vinnie Ream was piquante in a pale silk with lace over-dress."[6] At a reception given by Mr and Mrs S. P. Brown of Mt. Pleasant, New York, Vinnie wore "garnet satin covered with rare Brussels lace. Her dark hair fell in loose ringlets at the back. A silver bandeau was worn across the head and a silver collar around the throat."[7]

She was deftly turning aside marriage proposals, including one from Carl Ehrenberg. "I am not unappreciative," she wrote him, "of the compliment you convey to me. You have a good and noble heart I am sure, but you must remain to me, a friend with a brotherly interest in my success and future. Love must not be mentioned between us. You must learn to think of me as your friend, who will always be anxious to hear of your safety, welfare and happiness. And now convince me that you will not reject my friendship by writing to me."[8]

Almost every day when she went to the Dahlgren Building to supervise the work, her studio would be filled with sailors from ships docked in Washington, and she would hear stories from those who had served with Farragut, about him, about the combat they had seen and the ports they had visited. She was given small gifts—a shell, a sailor's cap and other little souvenirs. And people flocked to her Wednesday night gatherings.

With the *Farragut* on the verge of completion, it was time to look about for the next major opportunity. Almost immediately after Robert E. Lee had died on October 12, 1870, a group of those who had served with him, led by General Jubal Early, had been carrying on a campaign to ensure he be remembered "correctly." They would brook no criticism of their hero, and brought enormous pressure to bear on authors and editors to bring their work into conformity with positions taken by the Southern Historical Society. There were divisions within this group, especially over a permanent resting place for Lee. One faction wanted his remains to be removed to Richmond, while another preferred that he be left in peace in Lexington. There were consequently two organizations: the Lee Monument Association for Richmond and the Lee Memorial Association for Lexington. The Richmond group had separate organizations for men and women. The two factions of the Monument Association held fund-raising drives throughout the South, but because of the impoverished state of the region and requests for funding from other memorial groups, it was seven years before

the Richmond association could gather the money they needed. Despite dissension between the Richmond and Lexington people, General Early decided to go ahead, and in early 1877 the Lee Monument Association put out a circular asking for models of an equestrian statue of Lee to be presented in Richmond in November.[9]

Vinnie did not pursue this contract with her usual vigor. She acquired endorsements, but not as many as for previous competitions, and she went to Richmond before the judging but stayed only a few days, although Albert Pike had warned her that a short stay would not be sufficient. She did manage to charm S. Bassett French, the secretary of the Monument Association, to the point that when she returned from Washington, she received an obscene letter from him. She could have responded as she had with Daniel Morrell, but she did not. She was offended. She showed the letter to Pike, who downplayed it as "only an awkward effort at gallantry" and advised her, "if you write to him, write kindly and with reserve: else he may really come to fancy, as other old geese have, that you love him."[10] She ignored the letter and maintained a proper professional relationship with French.

She worked halfheartedly on the Lee model during the summer of 1877, and spent little of her usual energy contacting the Lee family, trying to get his photographs or private possessions, and talking with soldiers who had served with him. She made some attempts to get the names of the judges who would award the contract, but when they did not respond, she did not follow up with her customary enthusiasm. When an influential association member from Richmond came to Washington, she did not seek him out for personal attention, but went about with him in the company of friends. She did produce, however, an elaborate model, with Lee on horseback, the bridle in his left hand, his slouch hat in his right, and his holsters resting on the saddle in front of him. At the foot is a female figure wrapped in a Confederate flag, with a wreath of magnolias on her shoul-

ders, and holding a pen with which she inscribes "Lee" on the side of the monument.

In early November, Vinnie took this model to Richmond, where there was pandemonium from the first day. All the models were set up in the senate chamber, which was crowded with onlookers from morning to night. To give an air of impartiality, the sculptors were not named and the models were identified only by numbers. But every day the sculptors stood before their models, ready to pounce on any influential visitor. A reporter for the *Richmond Daily Dispatch* commented, "As I entered the room I was at once surprised and diverted by the eager artists, each present to herald his own genius, and manifestly ready to resent the least approach to commendation of any specimen not his own . . ."

After several days of this, the entire Richmond group met, the men's and women's groups together, and disagreements surfaced immediately over where in Richmond the monument should be erected, over the number of foreign competitors to be invited, and whether any Northern sculptor should be considered. The wrangling went on for days, and finally the women's group walked out and took their $16,000 with them, leaving the men without the necessary funds for a contract. To make matters worse, the women announced that though their "funds were originally intended for an equestrian statue, yet we are by no means bound to limit ourselves to such a monument." General Early, issuing feeble excuses, announced that the competition would be delayed for one year.[11]

As if all this were not bad enough, Early sent Vinnie a seven-page letter criticizing her model: the "body of the figure is not long enough from the chest down and the legs are a little too long. The fetlocks of your horse are rather long and large, and the legs rather coarse for a fine blooded horse . . .Virginians prided themselves very much in the elegance of their blooded horses . . ." He added helpfully that the model's hat "is too low in the crown and has a shabby appearance."[12] But the model

was admired by James Proctor Knott, a Kentucky congressman and one of the judges for the Lee award. He wrote Vinnie that he had not met with her in Richmond because he wanted to avoid "the slightest semblance of partiality in case I shall decide in favor of your model . . . I will not say that your model is perfect . . . But I will say, that in my judgment, it is not only vastly superior to any other on exhibition but eminently worthy of your genius . . . Your symbolism is singularly beautiful and appropriate. The most conspicuous as well as the most touching feature of the late war was the devoted heroism of the Southern women. My friends are equally decided in favor of your model as I am myself."[13]

It was not until Vinnie returned from Richmond that she solicited an endorsement from George Caleb Bingham, a request she made probably because she was in regular correspondence with him anyway. She was still worried about his state of mind, and suggested he move to Washington where she could look after him. She offered him free use of her studio so that he could continue with his painting. He replied that her offer was a "temptation which I find it very hard to resist. But really my dear captivating friend would I not now be in some danger were I to venture within the sphere of your fascinating influence. While I was in Washington I discovered that grey headed Senators and Representatives could not muster sufficient self control to resist your charms and fear that were I now to place myself within the scope of your magnetic power I would quite as readily fall a victim to them."

He expressed the wish that he were twenty or thirty years younger so that he could court her "with all the earnestness which an impassioned lover could command, but alas, my three score years and the interdiction which says 'thou shalt not marry thy grandfather' chills the blood in my veins." He added that he had been unanimously elected to fill the Chair of Art at Missouri State University. Should he, he asked, accept the position and "spend the remnants of my days in teaching art to pupils

without talent, or remain simply the Missouri artist with liberty to go where I please, and paint pictures in accordance with my own untrammeled inclination?"[14] He took the position and wrote to her next on University of Missouri stationery.

Ezra Cornell was dead, but Vinnie remembered that he had promised to see if he could find a spot in McGraw Hall for *Sappho*. She wrote to Jennie McGraw Fiske asking her to purchase the statue for Cornell College. Mrs Fiske declined, and wrote to a friend, "I believe she has an exceedingly persuasive way especially to gentlemen. I shall endeavor never to fall in her grasp, as I don't fancy Sappho at all, & from all I have heard of Miss Vinnie, her indignation would be great that anything to her mind so beautiful shall not be so recognized."[15]

Vinnie's lack of enthusiasm for the Lee award and her annoyance at receiving French's salacious letter may be explained by the fact that she had met Richard Leveridge Hoxie in the fall of 1876 when he accompanied Loyall Farragut to her studio while Farragut was checking on the progress of his father's statue. Farragut and Hoxie had been classmates at West Point—Hoxie graduated third and Farragut fourth in a class of fifty-four—and both were commissioned second lieutenants in June of 1868. Farragut subsequently resigned his commission, but Hoxie in 1876 was a first lieutenant in the Corps of Engineers, stationed in Washington. He was an attractive man, six feet tall with wavy hair and broad shoulders, his face tanned from his work on construction in the sun with the engineers. He was also wealthy, having inherited his father's business and land holdings.

He was born on August 7, 1844, the eldest of three children. When he was seven years old, his family moved to Europe, where they lived for three years until his mother died in Pisa. His father sent the children to live with an aunt in Iowa City, and died a year later. On June 13, 1861, Hoxie enlisted as a private in Company F, First Iowa Cavalry, organized a month earlier, the first volunteer cavalry regiment with a three-year

term of service. At the end of September, the regiment was sent to Missouri, and assigned to duty as advance guards and scouts under General John Pope. For the next fifteen months the regiment crossed the length and breadth of Missouri, dispersing guerrilla bands and preventing armed men from joining the Confederacy. Hoxie sometimes spent eighteen hours in the saddle. Battles were few, but so were casualties. The most famous battle he encountered was the battle of Prairie Grove, Arkansas, in December of 1862, and even that was almost over by the time the Iowa cavalry arrived. He was released from the cavalry in May of 1864 when he arranged his appointment to West Point.[16]

It had been more than ten years since Vinnie had been awarded the Lincoln commission. Since that time her only major contract was the Farragut award. She had lost out on the George Thomas statue, and was not optimistic about the Lee commission that she expected to drag on as the Wisconsin and Johns Hopkins awards had done. She had not been able to sell any of her large ambitious pieces and she was nearly thirty years old. She still had dark flashing eyes and witty charm, but she was losing her fresh-faced appeal and her youthful figure. Her old friends and enemies—Richard Yates, Hiram Powers, Thaddeus Stevens, Charles Sumner, Cardinal Antonelli, Horace Greeley, George Custer and Ezra Cornell—were all dead. Edmund Ross, Samuel Marshall, John Rice, Matthew Carpenter, Orville Browning and Lyman Trumbull were no longer in office. The only good news was that Daniel Voorhees had been appointed to fill the Senate seat of Oliver Morton, who had died on November first.

Years earlier, a pompous young man had told Vinnie that she would "be subject to remark and even suspicion" if she chose to become an artist.[17] Basically she had proven him wrong: she counted congressmen, generals, diplomats and journalists among her friends, and was invited to their homes as a socially, morally and intellectually acceptable person. But she was very

tired. It would be good to rest, to be financially secure, before taking up her career once more. And Hoxie was charming, handsome, rich and persistent. She began to think of marriage.

From the spring through the fall of 1876, Albert Pike toured the West on his Masonic duties, going to Carson City, San Francisco, Lake Tahoe, Silver City, Portland, Walla Walla and down the Columbia River. He sent Vinnie detailed descriptions of the scenery, and also copies of his "Essays to Vinnie" as he completed each one. He was delighted when she replied that she valued the essays, and more than delighted when she told him to "think of and remember" her.[18] He makes no mention in any of his letters to her of his wife, Mary Anne, who died in Little Rock, Arkansas, on April 14, 1876. They had been married for forty-two years, but Mary Anne was never part of his life in Washington and never accompanied him on his travels.

Pike returned to Washington in December, 1876, in time to celebrate his sixty-seventh birthday. A year earlier, having neglected his law practice and incurred heavy expenses on his travels, he was forced to give up what he called "our cottage," and move into cheaper quarters in Alexandria, Virginia. Vinnie brought Hoxie there to introduce him to Pike, who immediately noticed a significant alteration in her manner, prompting him to write her that night, "I am always glad to see your friends but if your little hand cannot be placed in mine, nor you sit near me, nor like that I should kiss you even at parting, on their account, I am not anxious to see them with you any more." Hoxie had apparently made clear his disapproval of Vinnie's relationship with Pike. Vinnie attempted to soothe the older man, assuring him that she would never marry. Nevertheless he warned her, "I cannot fancy myself talking to Mrs Hoxie. And if you were to marry any one, you could not be 'Vinnie' any longer to me, and I think I should rather never see you."

However, Vinnie and Hoxie became constant companions and the Washington rumor mill operated at full speed with sto-

ries of her impending marriage, upsetting Pike, who told her
never to bring Hoxie to Alexandria again, and that he did not
want even to hear rumors about her from mutual friends. Vin-
nie reassured him again that, like Harriet Hosmer, she would
never marry, but he wrote her, "As I cannot sleep, I have re-
lighted my lamp, to write you this letter. Last night I was stupe-
fied and bewildered, and did not know what to say to you be-
cause I did not comprehend all. Now I see more clearly, and
know what I must do. I have already removed all your pictures
to other rooms, and laid the cross away among my jewels, no
longer feeling that I have a right to wear it." The cross, his most
prized possession, had been woven from Pike's and Vinnie's hair,
and was the subject of one of his poems to her in which he
speaks of her "soft, brown, precious hair" intertwined by her
"sweet consent" with "some gray threads" of his.

Pike's moods now shifted for several months between de-
pression and euphoria, responding to rumors of her impending
marriage and her constant denials. "Thank God," he wrote her,
"I do not know that you are willing to be kissed by any other
man as you are by me or that you are willing any other arms
should embrace you." He became angry and demanded that
she return books he had lent her, then apologized and vowed
his love for her while his loathing of Hoxie intensified. By spring,
1878, New York newspapers were reporting on Vinnie's prob-
able marriage. Pike, beginning to accept the idea, warned her
that the marriage would collapse because Hoxie would become
insanely jealous within six months.[19]

But Hoxie seemed to be sympathetic to her career. He did
not complain about her working on her *Farragut* in a building
filled with men, nor did he ask her to break off her friendship
with General Sherman, and he had said nothing about her trip
to Richmond to work for the Lee award. In April, 1878, she
accepted Hoxie's proposal of marriage. After the announcement
she received many congratulatory letters, and apparently did
not take seriously the writers' admonitions that her first duty

would now be to her husband, that she must put her artistic career second and that she should be satisfied with the bliss of a happy marriage.[20] The wedding was set for May 28, 1878, in the Church of the Ascension. She planned an impressive event and asked Sherman to give her away, perhaps because of the state of Robert Ream's health. The general agreed, on condition that he see her parents and be sure that they approved.[21] Her most inconsiderate gesture, however, was her choice of best man: despite everything he had had to endure, she asked Pike to stand beside Hoxie.

On May 28, guests began to arrive at 6:30 in the evening: they included Secretary of the Treasury John Sherman and his wife, Secretary of the Interior Carl Schurz and his daughters, Secretary of the Navy Richard W. Thompson and Mrs Thompson, the Postmaster General, the Attorney General, Daniel Voorhees and at least nine other senators, many representatives, heads of government departments, high-ranking military officers, and the Danish and Japanese ambassadors.[22] Among the gold and silver services given as gifts were a painting sent by Gustave Doré and a musical composition from Franz Liszt.

On one side of the chancel the letters "V.R.H." were spelled out in red roses, violets and orange blossoms, on the other was a floral sword and scabbard. Above the altar hung a five-foot marriage bell made up entirely of marguerites. As the bridesmaids and groom's men entered the church, the choir sang verses that Pike had composed for them, including the fifth stanza:

> Must we say "Goodbye!" Darling?
> Ah! word so hard to say!
> Must we, so long adoring
> Give you to him, today?"[23]

Pike at sixty-eight was still an impressive figure, as he and Hoxie walked to the altar to await the bride. The *Washington Star* commented, "General Pike is over six feet tall and of leo-

nine chest and mane, has a presence so stately as to make him conspicuous in any gathering."[24] Vinnie, radiant in white satin, approached the altar on the arm of Sherman, who was in full dress uniform. Braiding extended the full length of her gown, tulle drapery overlay the skirt and the two-yard train. One spray of lilies of the valley adorned her left shoulder; another crossed her skirt diagonally. Her tulle veil was embroidered with flowers and held in place by a cluster of orange blossoms over her left temple. She wore a spectacular diamond necklace and carried a point lace handkerchief and fan. Her hair was wound about her head in great loose bands; curls escaped on her forehead and on the back of her neck.[25]

She and Hoxie left that night on the nine o'clock train for a two-week honeymoon at his home in Iowa.

Vinnie's life had been centered in Washington, where her family and friends were, and where she was in the process of building the colossal *Farragut*. Now she was married to an army officer who could be ordered to a new post at any moment. This was something Vinnie could not accept; she had begun, even before the wedding, to work to ensure that Hoxie would be posted to Washington for the foreseeable future. Congress was tinkering with the municipal government of Washington, which had become the District of Columbia, a federal territory, in 1871. In 1874 the territorial status was revoked and an executive board of three commissioners was set up to govern the city under Congress. Two of the commissioners were civilian residents, and the third was an Army engineer above the rank of captain. The commissioners were appointed by the president with the consent of the Senate.

Vinnie wanted Hoxie to be appointed a military commissioner, but he could not be made captain because the postbellum Army was limited to one general, one lieutenant general, five major generals and ten brigadier generals.[26] The rest of the Civil War generals were now colonels or less, and the only opportunity for promotion, apart from another war, was the death of a

senior officer. Vinnie wanted the restriction on rank removed or lowered so that Hoxie could be appointed commissioner.

On her honeymoon, she kept abreast of congressional deliberations on the municipal government. On June 10, she heard from Senator John Morgan. "The Bill for the District government passed the Senate as you desired it. The House refused to concur in the Senate amendment relating to the rank of Engineer Commissioner and insisted on an Engineer above the rank of Captain. Our Conference Committee then proposed that the President should assign assistant commissioners, not more than two, to be engineers of the army. This was agreed to and becomes the only opening for Lieut. Hoxie."[27]

The next day Voorhees wrote her, "Your postal card from Crestline and your letter from Mount Joy have reached me. I have just mailed to Mr Hoxie a copy of the District Bill as it passed both Houses. It is not as we wished it but the amendment to Sec 5 will enable the President to appoint Mr Hoxie. Senator Ingalls did all in his power and so did we all but the House members of the Committee of Conference were very determined and our side yielded to my great disgust. I am writing this at my desk in an uproar in the Senate and you must pardon such a poor letter. Senator Dawes has just come to my seat to say that he will assist Mr Hoxie in any way in his power."[28]

Vinnie was not willing to settle for assistant commissioner. When she returned to Washington, she immediately contacted General Sherman and asked him to talk to President Hayes about vetoing the bill. For once Vinnie had gone too far, and Sherman bluntly told her that the president would not and should not veto a bill that involved larger interests, just to make her happy. But he said he would talk to Hayes that evening about appointing Hoxie one of the assistant commissioners, and when he did this, Hayes asked him for a written recommendation.

Over the next several days that it took Sherman to put the recommendation together and gather endorsements, Vinnie became frantic about the possibility that she might have to leave

Washington. "Cool down and take things easy," Sherman told her. "More than half our troubles are borrowed."[29] The president nominated Josiah Dent and S. L. Phelps to be civilian commissioners. They were approved by the Senate on June 19. Sherman met with Phelps on the 24th and after that with Secretary of War George McCrary, and both pledged their support. On June 28 Hayes appointed Major William T. Twining military commissioner, an appointment that did not require Senate consent, and on July 25th the president instructed Hoxie to report to Major Twining for duty as assistant commissioner.[30]

Although Vinnie had been careful to invite to her wedding practically everyone connected with the Lee award, she avoided the time-consuming persistent correspondence that had worked well for her in the past by allowing her to display her interest and her credentials. She wrote Jubal Early, attracted perhaps by his gruff frankness. He refused to come to the wedding or to her studio. "If I am compelled to visit Washington," he wrote, "I will certainly visit you at home, but hardly think I will ever be induced to go to that city voluntarily." When she made some changes to her model that she thought he had suggested in his earlier critique, he told her that if she knew more about horses and riding, she would know that he "took it for granted that you would understand that a stirrup of some sort was indispensable." When she planned an August trip to White Sulphur Springs near the Virginia border, she invited Early, who was not far away at Allegheny Springs, to visit her, but he said that he was too busy.[31]

S. Bassett French, Secretary of the Lee Monument Association, was still infatuated with Vinnie, and gave her some advice about winning the contract. "Judge Lay has the ear of Governor Holliday," he wrote her, "and I might say he has him by the ear and it would be a large advantage to you if you could get the Judge by the same member." She should, he suggested, win over Judge Lay by inviting him to her studio and flattering his vanity. The judge would then work on the governor, who dis-

liked her model. "Of course I will do all I can," French went on. "I have stopped at nothing yet and hardly will hesitate now."[32] Vinnie did not follow up on this: a few years earlier she would have considered it sound advice, if not a golden opportunity.

After the fiasco in Richmond the previous November, the Lee Monument Association asked the states of the old Confederacy to send judges to select the winner of the upcoming November, 1878, competition. Early warned Vinnie that the association, still lacking funds and involved in squabbling, was not in a position to award a contract. French, Early said, "was the greatest obstacle to future progress . . . [He was] objectionable to Southerners and especially to Virginians."[33]

The newspapers were predicting that the November meeting was an exercise in futility and should be called off before it inconvenienced the artists and judges and further embarrassed Virginia. Despite all this, Vinnie decided to compete and sent her model to Richmond. She could be sure of only two votes: Senator John Morgan and George Caleb Bingham. But the financial and political situation of the Lee Monument Association made these votes irrelevant. The generals, still trying to assign blame for the South's defeat, could not work harmoniously to create a statue of the personification of Southern pride. Beside Vinnie, only Moses Hezekiel, M. A. Harnish and D. R. Firth sent models. Prominent sculptors had been scared off. And the dire predictions proved justified. After a few contentious days, the association issued a statement: "Whereas the funds in hand for the completion of the monument are insufficient to insure the same, and whereas the models presented are but few: Resolved, that this commission is not now prepared to select an artist, and that such selection be postponed until such time as the Board of Managers may designate."[34]

It was not until 1887 that a newly formed monument association had enough funding to accept the entry of French sculp-

tor Jean Antonin Mercie. His statue of Lee was unveiled in Richmond on May 29, 1890, almost twenty years after the formation of the Lee Monument Association.

15
Elizabeth Custer

*I don't feel afraid to talk to you about money matters
for you know in what spirit I speak and you have braved
so much.*

—*Elizabeth Custer*

AT THE BEGINNING of July, 1876, Elizabeth Custer received the
news from Little Big Horn that shattered her world. She had
idolized her husband, whom she called "Autie," and with whom
she had shared many of the rigors of military life, traveling with
him from post to post. At the age of thirty-four, she had lost her
Army home, the press was attacking her husband as inept at
best, and she was reduced to living on a pension of $30 a month
and the proceeds of a small insurance policy. That fall, from
New York where she had found work at a charitable society
and as companion to an elderly lady, she wrote Vinnie, "I have
heard a number of times of the bust you have executed and
have longed to see it. If I could give you any suggestions I would
gladly do so. Can you have patience to wait for my coming?
You know there lies before me still an awful day of dread and
until it is ended it seems impossible for me to leave the seclusion
in which I have hidden myself in this great city."[1] The "day of
dread" was October 10, 1877, when Custer's remains, shipped
from the Dakotas, were buried with full military honors in the
cemetery at West Point.[2]

Mrs Custer's visit to Washington was delayed by the attempt
made by her and some friends to blame Major Marcus Reno for
the disaster at the Little Big Horn. Reno, they insisted, had gone
on the defensive too soon. If he had attacked the Indian encamp-
ment, Custer could have struck the Indian rear and won the battle.
They made their case through articles in the press, lectures, and a
biography by Frederick Whittaker—all intended to stimulate a
call for a congressional investigation. But Reno successfully pushed
for a military court of inquiry, which convened in January, 1879,
and found that Reno's conduct at Little Big Horn did not merit
censure. This was a severe blow to Custer's widow: it left the
onus on Custer, who, whatever his motivation, was held respon-
sible for the deaths of 225 men.[3]

In February, 1879, Elizabeth Custer came to Washington to
meet Vinnie and view the clay bust, which she declared fer-
vently had caught the essence of her husband. She thanked Vin-
nie "with all my heart for having presented by your genius such
a speaking face." The two women hit it off and spent a good
deal of time together: Elizabeth told Vinnie about her life with
Custer, and Vinnie told Elizabeth how she had met him, of his
sittings for the bust—omitting, of course, mention of late-night
sittings in the studio—and that she envied Elizabeth's life with
him. When the question arose of whether the bust should be
cast in marble or bronze, Vinnie quoted a price of $100 to $150
plus the casting work, although she customarily received five to
ten times that amount for a bust. But Mrs Custer could not
afford even this amount. She refused to accept the bust without
paying for it at once, and asked Vinnie to hold it until she could
gather the money.

Meanwhile, a group of Custer's friends had contracted for a
statue with J. Wilson MacDonald, and this was unveiled at West
Point in the summer of 1879. In September, the widow wrote Vinnie:

I do not dare trust myself to write but a few lines about
the statue at West Point. I was never consulted and did

not even know about it until it was done. The bitter
disappointment I feel is such a cross for me to bear. It
seems to me I cannot endure it. I shall not see the statue
until I can do something to counteract the effect that
such a face as MacDonald has modelled must surely pro-
duce. One day in Church I was praying for grace when a
thought came to me to comfort my soul. It was that I
might in time buy the bust that you have modelled and
put it in the library at West Point to let the world see
what General Custer's face and head really can be when
copied so truthfully from life as you have done. Let me
ask you to permit me to enter into this business arrange-
ment with you as soon as possible. I do not intend to
give the bust to West Point. I want to place it there for a
time until Providence points out a way for me to see a
better statue than the one that now disfigures the spot
he so loved. The face of the MacDonald statue is said to
be that of a man sixty years old, my friends are in de-
spair about it and agree with me that it is better for me
to remain away from West Point and not see what would
throw me into despair.[4]

This letter gave Vinnie the idea of creating a congressional
commission for a statue of Custer. But she would have to wait.
The first session of the 46th Congress had ended in July, and
the second session would not convene until December. She did
not mind this. She was happy. She had been married a little
more than a year, and everything was going as she had hoped.
Life was easy. She confined her professional efforts to writing a
few letters about the Lee award and tinkering with the Lee model
and supervising the work on *Farragut*. Hoxie grumbled from
time to time, but he did not ask her to give up her work. He
asked only that they build something larger and more impres-
sive than her house on Pennsylvania Avenue, and in a better
neighborhood. Vinnie chose a property at the corner of 17th

and K streets. One side of the lot bordered the open land that had been set aside for her Farragut monument. She looked forward to the day that she could see the statue from her window.

On the assumption that Congress would commission it, she set to work on the Custer model, consulting regularly with his widow, asking her for a photograph of him in his buckskin jacket which was how she intended to dress the statue. Elizabeth agreed to this, but ruled out the buckskin because Buffalo Bill Cody was making stage appearances and had just published his autobiography and she feared that people were starting to think of frontiersmen as showmen, and that Custer might look like the hero of a dime novel. Finally they settled on a semi-military costume with insignia of a major general, a blouse open at the throat and the broad collar that Custer had introduced when he began to wear navy blue shirts.[5]

At the beginning of the new congressional session, MacDonald's friends stole a march on Vinnie by introducing a bill directing the Secretary of War to contract for a duplicate of the West Point *Custer*. Vinnie disliked MacDonald. When she was in Europe, he had written her letters filled with malicious comments about other artists, and he sometimes won contracts by denigrating his competitors. Once he had offered to take down Harriet Hosmer's *Benton* at his own expense if he could be given a contract for its replacement. Now Vinnie was angry. She felt challenged and decided to respond by playing her trump card, the support of the widow, whom she asked to flood Congress with protests against a MacDonald award. Mrs Custer told her, "My blood boils at the thought of that wretched statue being repeated." She knew that she should come to Washington to help Vinnie's lobbying effort, but she was still furious at Reno's exoneration by the Court of Inquiry and the hurtful things being said and written about her beloved husband. She wrote Vinnie that "a wounded thing must hide and I *cannot* go to Washington and stay, as I should do, among General Custer's old friends."[6] But she wrote to Senators Morgan and Voorhees

and a long list of influential men Vinnie had given her, and gave Vinnie five extra copies of her letter to be distributed to anyone she had missed. Vinnie contacted the press, and the *New York Times* ran an item:

> It seems that the widow of Gen. Custer is not satisfied with the statue of her husband erected at the West Point Military Academy by Wilson MacDonald, and in a letter protesting against the passage of the bill now pending says that MacDonald did not consult her or any friends of her late husband. Mrs Custer does not object to the erection of a statue in Washington, but protests against employing MacDonald as the sculptor. Commenting on the Custer Monument at West Point, Mrs Custer says in a letter to Representative Daggett of Nevada: The statue could not be worse than it is. The face is of a man of 60, and the dress so unmilitary that his brother officers shudder in looking at it. He is presented with full-dress coat and top boots that only belong to undress uniform. The whole costume is incongruous and incorrect. Then, he is armed like a desperado, in both hands, while some of the General's best charges were made with no fire-arms about him. His friends in civic life, his comrades in the Army, and artists, all have but one story to tell—that the statue is a failure as a likeness, as the representation of a soldier and as a work of art. It seems as if I could not endure the thought of this wretched statue being repeated and I hope that your voice may influence those upon whom the decision rests.[7]

Vinnie followed up by meeting with James R. Waddill of Missouri and drafting a joint resolution authorizing the Secretary of War to contract with an artist chosen by Elizabeth Custer, along with a senator and one House member, for an amount not to exceed $20,000. This had worked with the Farragut

award, and Vinnie hoped it would be successful again. When
Elizabeth Custer heard of this, she was delighted, but at the
same time apprehensive at the thought of Congress being in-
volved with the statue. "Hope for any help for myself," she
wrote Vinnie, "has almost died." She told Vinnie that on March
12, 1880, Congress had postponed indefinitely a bill raising
Elizabeth's pension from $30 to $50 a month to which she was
entitled as the widow of a general.[8] To help her, Vinnie arranged
for her to meet with Sherman, evidently without telling him the
purpose of the meeting. Mrs Custer met with him, but could
not bring herself to bring up the subject of money. When she
returned to New York, she wrote him, telling him she was "deso-
late" and asking his help. A letter from one of her friends ap-
peared in the *New York Herald* on February 5, 1882, describ-
ing her financial difficulties. Two days later the *Herald* ran an
article on the subject. In July of that year, Congress passed a bill
awarding her the fifty-dollar monthly pension.[9]

The two women corresponded regularly. "When will I for-
get," Elizabeth Custer wrote, "the day I spent those hours with
you. I could not speak fast enough. I had so much to say to you,
and you a stranger. It never occurred to me until I returned
home and found that I had shared my heart." She asked if the
bust could be cast in marble as well as in bronze, and whether
she had to pay "the whole sum at once or in small installments."[10]
Vinnie did not object to installment payments. Elizabeth wanted
a marble bust for the library and a bronze one to place out-
doors near Custer's grave. She finally decided on bronze, telling
Vinnie, "I am so glad the day draws near for me to place the
bust in the cemetery to offset that wretched face and figure
MacDonald has dared to call General Custer."[11]

The bill Vinnie worked on with Waddill was introduced in
the House by Henry Bingham, and Elizabeth asked Vinnie if
there was "a shadow of hope that such a bill [would] pass. If it
does pass I still want the bust at West Point."[12] With the in-
crease in her pension, her financial distress was eased some-

what. "I have at last obtained a little home of my own," she wrote Vinnie, "and I am so grateful. And now if I could only have the bust of General Custer that you have so faithfully made from his features, I would think my home so blessed."[13]

But when Vinnie sent her the cost estimates from Clark Mills's foundry, Mrs Custer was horrified. "Your letter has just reached me and set my heart beating like a drum," she wrote. "You know how I earned the money for the memorial—sitting up entertaining a querulous old lady every evening after working all day at my Society desk. I don't know what to do or say. I can't see my way clear at all today. You are sure that I don't question your part of it. Your generosity is impossible for me to speak of. It is only the getting used to the part that is out of your hands. I wish I could afford to go to Washington as the memory of how the bust looked is getting dim. I don't feel afraid to talk to you about money matters for you know in what spirit I speak and you have braved so much."[14]

Vinnie had liked Elizabeth Custer from the first moment she met her, and her open-hearted letters had increased her affection for the poor widow. Vinnie understood that Elizabeth idolized Custer and that the bust had become an obsession with her. Marble and bronze were out of the question financially, but plaster was not. Without consulting Elizabeth, Vinnie ordered a plaster bust to be made from the clay. Knowing that Mrs Custer was too proud to accept charity, Vinnie told her that the foundry cost was $30, and Vinnie herself secretly paid the rest. Her labor she considered a friend's gift, and Elizabeth was overjoyed that she could have the bust in her house.[15]

But Hoxie was furious when he saw the $30. He demanded to know how Vinnie dared to take money from a struggling Army widow when it was not important to them and to take it was in fact demeaning. Vinnie tried to explain that women could be as proud as men and that pride needed to be respected. But he did not accept this and ordered Vinnie to return the money at once. Elizabeth returned it again, insisting that she could not

enjoy the bust unless she made a contribution toward it.[16] She
made a special trip to Washington to collect the bust and a rather
unpleasant scene resulted. Hoxie was present, and he insisted
once more that Elizabeth keep the money. She protested that
she wanted the gratification of paying, but he persisted, and
finally Elizabeth took the money to keep harmony between
Hoxie and Vinnie.[17] But there was no true harmony after this
incident. Hoxie was determined that Vinnie give up her work
after completion of the *Farragut*.

Elizabeth wrote to Vinnie from New York, "My little home
is indeed a home now owing to your kindness. Just above my
desk, that grand face looks up as if ready to face the future."[18]
The widow's financial situation was to improve dramatically
with the publication in 1885 of her autobiographical *Boots and
Saddles*. This book, dealing with army life at Fort Abraham
Lincoln, and the summer before the battle at Little Big Horn,
sold over 22,000 copies. She followed that with *Tenting on the
Plains*, a description of her life in Texas and Kansas, ending
with Custer's unauthorized visit to her that resulted in his court-
martial. Her third book, *Following the Guidon*, details a wife's
life in an Army camp. Her financial troubles were over, and she
lived comfortably until her death at the age of ninety-one in
1933, always fiercely protecting her husband's name. She was
buried next to Custer at West Point. After her death, revisionist
histories of Custer began to appear.

Even in her lifetime, she was not able to achieve federal sup-
port for a monument to the general, although over the years many
bills for one were introduced, to languish and die in committees.
But in June, 1907, the Michigan legislature appropriated $25,000
for an equestrian statue of Custer to be placed in the town of
Monroe, which was willing to donate a site for it. Vinnie, who was
attempting to revive her career at the time, wrote immediately to
Elizabeth to ask her to contact the monument committee and tell
them to give her the commission. No one, Vinnie wrote, could
reproduce the general in bronze "more faithfully" than she.

But the "warm hearted loving wife" who had been so en-
thusiastic about Vinnie's bust of Custer now became noncom-
mittal and remote: "so conventional, so unsympathetic, with
no kind word even or mention of my likeness of the brave Genl
Custer" that Vinnie was deeply hurt. Elizabeth threw her sup-
port to Edward Potter, who had done three admired equestrian
statues. The monument was unveiled on June 4, 1910, at an
impressive ceremony with President William Howard Taft in
attendance.[19]

When the Navy yard needed bronze and brass for the cast-
ing of *Farragut,* Vinnie remembered that in June, 1874, the Sen-
ate had approved the use of twenty condemned bronze cannon
for the casting of a statue of General George Meade. She ap-
plied for and was granted the use of obsolete Naval ordnance
and the propeller from Farragut's ship, the *Hartford.*[20] The cast-
ing then went smoothly until it became apparent that the ped-
estal she had designed was too low for the colossal statue. On
December 7, 1880, Samuel Kirkwood introduced a resolution
saying that the statue and pedestal had been executed accord-
ing to the contract entered into between Vinnie and the Gov-
ernment on June 22, 1874, but because the pedestal was "al-
leged to be wholly insufficient and inadequate in size for the
proper presentation of said statue," the Committee on Naval
Affairs should inquire "into the propriety and necessity of fur-
nishing material for constructing an additional pedestal for said
statue."[21] The resolution was agreed to unanimously. This was
the same Samuel Kirkwood who in July, 1866, had voted against
awarding Vinnie the Lincoln statue. As she had done so many
times with so many men, Vinnie had won Kirkwood's support.
 The work on the pedestal was going to be expensive and
she turned to her friends to draft a bill authorizing a $5000
appropriation for the increase in height. It easily passed the
House. When it reached the Senate where John J. Ingalls was
the presiding officer, Voorhees quickly sprang to his feet to say

that he "entirely" concurred "in the action of the House in propriety and necessity of this small appropriation." He hoped the Senate would pass it without referring it to committee because "the Committee on Naval Affairs have had the matter under consideration and are of the same mind as the House." Before anyone else could rise, Ingalls asked, "Is there objection to the suggestion made by the Senator from Indiana? The Chair hears none." The bill was read and quickly passed.[22]

Ingalls, pleased with himself, wrote Vinnie the same day, "I happened to be in the chair when it came over from the House, and Mr Voorhees called it up from the table, and between us it received three readings . . . and went to the Vice President quicker than greased lightning would pass a funeral."[23] Vinnie had not forgotten that Ingalls had insulted her by his analysis of her character when she had asked him to write to Secretary of the Navy George Robeson. She had broken off all communication with him then, but he had helped her get Hoxie his assignment to Washington and now was of help again with the pedestal appropriation. She forgave him, although they were never again close friends.

When the casting was completed in early January, 1881, and the statue was moved to Farragut Square, Vinnie notified Secretary of the Navy Nathan Goff that it was ready for inspection. The statue, eleven feet high, cast hollow, weighs about 3000 pounds. Farragut, wearing undress Navy uniform and a sword, holds a telescope and stands with his left foot resting on a block. The pedestal, which contains a box of Farragut documents, a copy of the Army and Navy Register, and a miniature model in bronze of the *Hartford's* propeller, is ten feet six inches in height. At each of the four corners of the unpolished Maine granite base is a four-inch mortar on a bronze carriage.[24]

Goff approved the work, and on January 14 sent a letter to the House recommending that the final $10,000 be appropriated. At last, after five years, it was time to plan the unveiling, an event that Vinnie wanted to be grander than the one she had

had for the *Lincoln*. This one was to take place outdoors, so she planned a parade with marching bands and regiments, with the main address to be given by the president. She and Admiral David Porter decided that the most fitting day would be April 25, the date in 1862 when Farragut had achieved the surrender of New Orleans. In the meantime the statue was covered with a sailcloth to protect it from the elements.[25]

The choice of April 25, 1881, proved to be propitious. It was a clear, warm day. Flags were everywhere along the parade route: on the portico of the White House, on houses fronting the park and Pennsylvania Avenue, and on the three large viewing stands erected for important personages on three sides of the monument. At noon, after the firing of a gun by Naval artillery, the procession, which had started forming near the Capitol an hour earlier, began to move in columns of companies down Pennsylvania Avenue. When the head of the column reached 15th Street, a gun was fired by the Naval saluting battery in Lafayette Square as a signal to the president and the Cabinet to proceed to the square. The Cadets and Naval Division massed on the west side, the Army Division on the north, and the Militia on the east. Long before the procession reached Farragut Square, the decorated stands were completely filled except for those reserved for the presidential party, the survivors of Farragut's battles and the members of the Grand Army of the Republic. At 12:35 President Garfield arrived on the arm of Secretary of the Navy William H. Hunt. Garfield's wife and children and his cabinet were with him. Virginia Farragut was seated on the president's right, and Vinnie, triumphant in these impressive ceremonies, on his left.

After the opening prayer, while the drums beat four rolls and the trumpets sounded four flourishes, the admiral's flag was unfurled. Quartermaster John H. Knowles, who had served under Farragut at Mobile Bay, was given the honor of unveiling the statue. Then an admiral's salute of seventeen guns was fired, the troops presenting arms at the first gun and coming to a

carry at the last. After receiving loud applause, the president, who had been introduced by Secretary Hunt, gave a flowery speech:

> Fellow-citizens: It is a singular province of art to break down the limitations which separate the generations of men from each other and allow those of past generations to be comrades and associates of those now living. Today we come to hail this hero who comes from the sea down from the shrouds of his flagship wreathed with the smoke and glory of victory, bringing sixty years of national life and honor to take his place as an honored compatriot and perpetual guardian of his nation's glory. In the name of the nation I accept this noble statue, and his country will guard it as he guarded his country.

Speeches were given by Horace Maynard, the former postmaster general, and by Senator Voorhees, after which the Marine band played "Hail to the Chief" and the troops fired another admiral's salute. The procession then formed again, the commands giving a marching salute as they passed the statue, and continued to the White House where Garfield reviewed the troops, who went on to New York Avenue where they were dismissed.[26] It was a great day for Vinnie. She had been twenty-three years old when the most important men in the nation had gathered for the unveiling of her *Lincoln*. Now, at thirty-three, she sat at the left hand of the president of the United States. She had known Garfield, who had been inaugurated a month earlier, since he was first elected to Congress in 1862. Four months later, on July 2, he was struck down by an assassin.

Voorhees wrote Vinnie, "It is a dreadful thing to be struck down in the prime of manhood by an assassin; it is dreadful to poor Mrs Garfield and her children, but more appalling than all these things combined is the thought of Arthur becoming President, and being ordered and controlled by the vindictive

malice of Conkling. The thought is frightful and almost suffo-
cates me."[27] Senator Roscoe Conkling was the undisputed boss
of the Republican machine in New York state. Grant had ap-
pointed Chester Arthur head of the Customs House at Conkling's
behest, a post that made it possible for him to give jobs to thou-
sands of Conkling's cronies. As Voorhees had foreseen, Arthur's
term was marked by corruption and incompetence.

Newspapers around the country gave front-page coverage
to the *Farragut* ceremonies. But this was Vinnie's last triumph.

16

THE CONVENTIONS OF MARRIAGE

Your duty is plain, to do all you can to produce the happiness of your husband.

—*Gen. Sherman*

BEFORE SHE MET HOXIE, Vinnie's career was gaining momentum. Few members of Congress could refuse her requests. She counted the powerful and famous among her friends, and she was the darling of the press. Men, young and old, wise and foolish, fell in love with her. She understood how to handle men, and she assumed that she could handle a husband. Hoxie was rich, handsome and charming. But he was also a man bound by the conventions of his age. He expected Vinnie to maintain his home, to be an efficient hostess to his fellow officers, to do everything she could to further his career and to eschew independent thoughts and actions, including a career of her own.

At first she simply ignored his wishes. She continued to pursue the Robert E. Lee award, worked to create momentum for a Custer memorial, and tried to interest the university in a bust of Ezra Cornell. She began, too, to work with Judge Alex Clayton of Mississippi on a monument "to the genius of the Confederate States, standing in despair, agony and unutterable woe, amid the ruins of a lost cause."[1] She considered going to New Orleans to meet Jefferson Davis; Clayton said he would go with her and "without difficulty, I think, be able to bring you into companionship with President Davis."[2] But nothing came of this.

Hoxie began to wear her down. He kept saying that by working for wages she was demeaning his status as head of the household. She was humiliating him by lobbying for contracts. Her style of dressing was flamboyant, undignified and unbecoming an officer's wife. He was angry when articles about her ran in the press; she did not realize, he said, that publicity was not helpful to his career. Working at all hours was not compatible with a wife's duties. When she turned in desperation to her friends for help, she met a unified chorus of support for Hoxie. Sherman's reply was typical, and the most direct: "Your duty is plain, to do all you can to produce the happiness of your husband."[3] This should not have surprised her. Sherman was a dedicated conservative with strong notions of a "well-ordered society" dominated by "principled men of substance" all of Anglo-Saxon descent.[4]

Finally, to gain some peace, she put aside her tools. But if she could not continue her work, she wanted at least to display her earlier accomplishments. She arranged with Jubal Early to exhibit at the exposition in New Orleans.[5] But Hoxie would not tolerate this either. He had complete control of all finances, and refused to pay any freight bills.

She became pregnant in the fall of 1882 and by the time Richard Ream Hoxie was born on June 6, 1883, she had given up all hope of continuing her career. She could only walk to the square to look at her statue of Farragut, or to the Capitol to see her *Lincoln*. She mentions the baby in her letters only when he is very ill. Her extensive and exciting correspondence shrank from hundreds of letters a year to ten or twelve relatively dull ones. Her only comfort seemed to come from being in Washington, the scene of her past glories.

But in the summer of 1884, Hoxie told her that they were to be transferred to Alabama. This could mean leaving Washington for good. She tried to convince her husband that the transfer was a negative comment on his work. Why else, she argued, would they transfer him in the middle of a project? She

was so upset that she became convinced that a conspiracy was afoot. General Sherman had retired several months before, and his replacement, Philip Sheridan, had never liked her. As leader of the Army of the Cumberland in September, 1873, in Pittsburgh, he had had a hand in the decision against awarding her the contract for a statue of General George Thomas. It was unfair, she told Hoxie, that she should have to give up her home, her friends, her family, and to leave the scene of her greatest triumphs. But her pleas and arguments fell on deaf ears. Hoxie considered the transfer a promotion, and would do nothing to alter his orders. He was to be placed in charge of all river and harbor improvements in Alabama and Georgia.

Desperate, she tried without Hoxie's knowledge to have the Army change his orders. Her circle of influential friends had shrunk considerably. There was still Sherman, but he told her, "I beg you to allow Hoxie to play his own game in life, for his brother officers, whose good will is all in all to him would be jealous if he was ordered back by reason of your personal efforts."[6] She then turned to Voorhees, asking him to intercede with Secretary of War William C. Endicott. Voorhees answered, "I have interviewed and re-interviewed the Secretary of War who appears to be as immovable as a rock out of one of the Massachusetts quarries, from which he comes."[7] There was still Crosby Noyes, who wrote a series of editorials in the *Washington Evening Star* calling for the retention of Hoxie as assistant commissioner. No action was taken. Since Hoxie wanted the transfer, Endicott would not interfere. Vinnie was only thirty-five years old, and she felt trapped by the conventions of marriage. She could not consider divorce or separation; she would not challenge the society she lived in. By September, 1884, she had moved to Montgomery, Alabama.[8]

Many people in Washington were saddened by Vinnie's departure, but no one was as unhappy about it as Albert Pike. He still loved her, but for the past several years had been content simply to spend time with her. And she had had more time for

him, having given up her career. Now, as his health was failing, she was forced to leave him. The letters he had filled with affirmations of his love for her now contained a litany of his physical infirmities. He had moved into his study at Masonic Hall where he became a recluse, staying in for months at a time, going out only to attend some Masonic function. He devoted himself to study of the *Rig Veda*, the ancient sacred Hindu scripture. His translation from the Sanskrit of more than 1000 hymns and 10,000 verses runs to over 2500 pages.

He found pleasure only in the fact that Vinnie, cut off from the world in Montgomery, not only replied to his letters, but poured out a stream of correspondence that challenged even his ability to respond. Trying to fill her empty days, Vinnie began to write poetry, which she sent him for editing. At first he was very supportive and had several of her poems published in the *Masonic Bulletin*. Her most interesting effort was called "Fort McRee."

A desolated beach—a ruined fort,
 Whose one great arch was standing grimly there.
Lashed by the furious waves in angry sport,
 A glorious ruin—fanned by sweet South air.
Its mighty battlements had washed away,
 Cumbering the white sand at its trembling feet;
The raving ocean thundered at its base,
 Like cannon when the deadly foeman meet.

A stretch of white beach glimmering in the sun—
 A sand-crane like a lonely sentry stood
Where sun and saber guarded once the wall,
 And men repelled assaults of fire and flood.

Hid in the ruined cistern owlets cried,
 Rendering with piteous moans the sultry air—
Where once the bugle's notes in clarion tones
 Gave warning that the enemy was there.

The eagle swept athwart the sullen sky,
 The lizard darted in and out the wood,
Which drifted, in the darkness and the gloom,
 From wrecks deep sunken in the angry flood.

No habitation marked the lonely spot,
 No living creature walked the snow-white sand,
The deep lagoon encroaching from the bay
 Had left old Fort McRee divorced from land.

The dark-green sea-weed, tossed upon the waves,
 Came drifting in like "night upon the plain."
The curlew cried from out the maddened foam,
 And dolphins sported in the seething main.

The sea-oats waved their graceful golden heads
 And sea-shells lay ungathered on the shore—
Dead soldiers' ghosts patrolled the walls at night
 And cursed the barren sand spit evermore.[9]

Apart from any merit this may have as a poem, the images reflect a rather dismal outlook. In any case, her heart was not in her attempts at poetry, probably because she knew she lacked the gift for it. Pike scolded her, telling her that poetry was as demanding as sculpture. Finally, when he was constrained to suggest that she take up prose instead, she embarked on a history of Lincoln and Farragut, but could not sustain interest in the project. She and Pike met once or twice a year when she visited Washington. The crosses made from their entwined locks of hair wore out, but their feeling for each other did not. Pike sent new locks of hair to be woven into fresh crosses.[10]

While Vinnie was in Alabama, there were many changes among her friends and relatives. Her father took a job in the 1880s in the office of the Surveyor General in Santa Fe, New Mexico, but bad health forced him to retire. His reminiscences of early Madison were published in Daniel S. Durrie's history of that city. Ream also dabbled in photography, writing to his

daughter Mary, "I wrote to Vinnie that I have taken up the picture business for fear that the artistic reputation of the family would go down after she left Washington and retired to domestic life."[11] The Reams celebrated their golden wedding anniversary on October 31, 1885, by remarrying at Mary's home in Washington. The whole family was there; even Vinnie's brother Robert came in from the Indian Territory to watch Dr Byron Sunderland perform the ceremony, which had unfortunately to be performed at Robert Ream's bedside, since he was very ill. He died three weeks later.[12]

Clark Mills died in 1883, and Vinnie's brother Robert in 1887. James Rollins and President Grant both died in 1888. In 1889, Hoxie was posted to Willets Point near New York City, close enough to Washington to allow Vinnie to visit Pike. Sherman had retired to New York in 1886 and, unlike Pike, was socially active, attending concerts, dinners and veterans' reunions. But he was feeling his age, and told Vinnie, "I would willingly exchange my honors and privileges for the lusty youth of one of the newsboys who clamor on the streets."[13] On February 14, 1891, several days after his seventy-first birthday, Sherman died. Vinnie went to his house on West 71st Street, and viewed him through the glass covering his coffin. The room was dimly lighted by the flickering flames of six candles in a great bronze candelabrum. Sherman wore his military uniform with the sash of the Legion of Honor.[14]

She had hardly had time to reconcile herself to Sherman's death when news reached her that Pike had died on April 2. He had been very ill, suffering from gout, boils, rheumatism, neuralgia and gastritis. In his last letter, dated March 25, 1891, he told Vinnie that doctors were inserting tubes into his throat every two days because "there is a stricture of the esophagus at the bottom. Have swallowed nothing since Saturday." He, who had spent a lifetime describing secret rituals, was given an appropriate funeral service at midnight on April 9 at the First

Congregational Church. The walls were covered with black cloth, and his casket was placed on a trestle near the center of the church. A heavy iron cross, painted black, stood at his head. At the sound of a trumpet, twenty-one knights entered and stood in a semicircle near him. Nine lighted candles in three triangles stood at east, west and south of the trestle. On the north, on a pillow surrounded by seven unlighted candles, was a human skull wreathed in ivy.[15]

Vinnie was deeply upset by these two deaths. Sherman and Pike were more than her friends and more than her lovers. They were the last main links to her youth, to her once bright career as a sculptor. They were gone; like her youth, they could not be brought back. And what about the fame she had achieved? She reread letters from Pike, recalling his erotic poetry, his jealousy, his "Essays to Vinnie." She looked again at hastily scribbled notes from Sherman, arranging private carriage rides and dinners, and at his request that she burn his letters. And among these missives from Sherman and Pike were letters from every important senator and representative, every notable Union general and most Confederate generals; letters from prominent sculptors and painters, from well-known businessmen and newspapermen.

She was only in her mid-forties. She wanted to resurrect what she had once had. She said in 1893 that sculpting "has never lost any of its charm, and I can not see a block of marble or the modelling clay without a quicker throb of the heart."[16] She remembered standing in Carrara among the blocks of marble and feeling that "in these unshapened blocks there was food for the imagination without end."[17] She wanted that feeling again. Her feelings of bitterness certainly surfaced when in 1909 she told the International Council of Women that "men often, perhaps from a feeling of chivalry, have not desired that women should find occupations in which they could earn their own living, denying them independence that they might be obliged to lean upon them."[18]

Vinnie decided to exhibit in Chicago at the World's Columbian Exposition, a celebration of the 400th anniversary of Columbus's discovery of America. A Board of Lady Managers had been authorized to deal with the work of women. Once again, as in 1876 at the Centennial Exposition in Philadelphia, the feminists did not want women segregated. Nevertheless, at their first meeting on November 18, 1890, the 117 Lady Managers elected Bertha Palmer as president, and decided to build a Woman's Building devoted to the work of women only. Both Anne Whitney and Harriet Hosmer, who had been commissioned to create a statue of Queen Isabella, refused to exhibit in such a building. Vinnie, as she had in 1876, agreed with them.[19]

Many states sponsored buildings open to artists of both sexes. Mary Eagle, a Lady Manager from Arkansas, offered to pay all costs if Vinnie would exhibit in the Arkansas building with male artists, but she declined. When Vinnie was younger, she had claimed to be a daughter of Arkansas or Missouri or Wisconsin—whatever state offered an opportunity. But now she considered herself a native of Washington, where *Farragut* and *Lincoln* were placed. She wanted to display in the District of Columbia building and in the Fine Arts Palace, the main building for artists from around the world. But she had lost her contacts. There was no Daniel J. Morrell, who had been chairman of the executive committee of the Centennial, to help this time. The few friends she still had in Congress had no authority over the Chicago fair. There was only Emily Briggs who, under her pen name "Olivia," had written about Vinnie and General Sherman, and who was now one of the Lady Managers. She kept Vinnie informed about what went on behind the scenes at meetings of the board.

Vinnie wrote to Mary Logan, Lady Manager from the District of Columbia, asking if the District would pay the costs of insurance and freight. Since she had been approached by the Lady Manager from Arkansas, Vinnie assumed that each Lady Manager was responsible for exhibits in the building sponsored

by her state. What Vinnie did not know was that there was no District of Columbia building. Mary Logan told Bertha Palmer about Vinnie's request and Mrs Palmer, already offended by Vinnie's refusal to exhibit in the Woman's Building, responded that even if there were a D.C. building, Vinnie would not be entitled to exhibit there because she had not lived in the District for years.[20]

Vinnie shipped *The West* to the National Jury of Selection of the Department of Fine Arts for consideration for exhibit in the Fine Arts Palace. Members of the jury for sculpture were Daniel French, Lorado Taft and Robert Bringhurst. Emily Briggs attempted to lobby Mrs Palmer on Vinnie's behalf. Her lobbying was apparently too forceful: the next time that Mrs Palmer was in Washington, in the winter of 1893, she refused to meet with Mrs Briggs, who wrote Vinnie, "The incomparable Mrs Potter Palmer came; wore her adorable diamond crown and other jewels; dashed before the bald heads of Congressional Committees, then went out like a huge meteor. I did not seek her at her hotel . . . but when she left I got her little card . . . which proved that, mite that I am, she did not forget me entirely . . . she did not get in the inner Social Circle though Mrs Senator [Calvin] Brice invited her to dinner; but she is one of the 'new ones,' her own social position not positively fixed, for money alone will not do it . . . The Vice President and the Cabinet kept aloof." She had to tell Vinnie that all her attempts to help had failed because there existed "an 'Art Ring' that is bound to keep out all that does not fall within its personal influence."[21]

Mrs Palmer's social position was a safe one, and her accomplishment in running the Board of Lady Managers with an iron hand was impressive. She filled the Woman's Building, which was designed by a woman architect, with exhibits from forty-seven nations, many of them obtained through her personal connections. She was a sophisticated admirer of modern art; her collection of French Impressionist paintings was an important contribution to the Art Institute of Chicago. In keeping

with this, she commissioned Mary Cassatt to provide a mural, "Modern Woman," for an end wall in the Woman Building's Hall of Honor. This did not go down well; it was a work too advanced for the taste of the time.[22]

Vinnie was unprepared for the heavy blow delivered to her in a letter dated March 10, 1893: "The National Jury of Selection for the Department of Fine Arts of The World's Columbian Exposition regrets to inform you that the works enumerated below did not receive a sufficient number of votes to secure acceptance for exhibition. It will be necessary to remove the above-mentioned works from the Art Institute Building without delay."[23] In desperation, she wrote to Vice President Adlai Stevenson asking for help and including photographs of her works. Less than a month before the fair was to open she received a polite but unhelpful response from Stevenson saying that he would show her any courtesy he could.[24] Two weeks after Vinnie received Stevenson's letter, her mother, Lavinia McDonald Ream, died.

While Vinnie was involved in funeral arrangements, Mary Eagle, eager to house the homeless, had her large marble statues—*The West, Miriam* and *America*—picked up from the Fine Arts Palace and, in an ironic twist, deposited in the Woman's Building. Vinnie had thought that they were going to the Arkansas Building, her last hope. She was so angry that she told an Arkansas newspaper that she was "very much displeased with Mrs Eagle" for not putting her works in the Arkansas Building. Mary Eagle tried to placate Vinnie by writing her that the statues showed to great advantage in the Woman's Building. But that relationship was ended.

Much of Vinnie's resolve and self-confidence had been eroded. She remained isolated at Willets Point where the years passed slowly for her. Hoxie was posted to Pittsburgh and then to Portland, Maine. She had dwindled into a wife. But the gods were

not finished playing with her. When her son was six years old, a playmate shot him with an air rifle and the pellet penetrated his skull, pressing on his brain. Surgeons said that only an operation to remove the pellet would save the child from mental retardation, but there was only one chance in a thousand that he would survive the operation. Vinnie refused to allow the operation, and the boy remained at a six-year-old mental level.[25]

In another attempt to secure a commission, she wrote to Sherman's son and daughter about a contract for a statue of their father, and invited the son, Tom, to Washington to look at a model she was working on. Tom replied that there was to be an open competition for a monument and that he hoped she would submit her model. He sent her a circular describing the conditions for the competition and on November 25, 1895, he told her that twenty sculptors were competing for the award. Vinnie had never won an open competition for a statue: through her friends in Congress, she had received the Lincoln award without a competition and she had won the Farragut competition with a stacked committee. She refused to submit her model in the open competition for the Sherman statue.[26] She approached the Masons of the House of the Temple in Washington to discuss a statue of Albert Pike. But they also intended to hold an open competition, and once again she declined to submit her model.[27] She wrote to Margaret Meade, an old friend, asking her help in obtaining a contract for a statue of Thaddeus Stevens; Margaret Meade spoke about it to the mayor of Lancaster, Pennsylvania, where Stevens had lived and practiced law, but no arrangement was made.[28]

The years passed in Portland. Occasionally Vinnie gave a talk on sculpture to a local school or woman's group. Then in 1899 Hoxie was posted back to Washington, where Vinnie could stand for hours before her *Lincoln* and *Farragut,* recalling the adulation and controversy she had inspired, the famous men she had known, the exciting events that had swirled around

her. But each day's newspaper seemed to report the death of another old friend: Daniel Voorhees, Harriet Hosmer, Thomas Ewing, Samuel Marshall, John Sherman—all gone.

At the turn of the century, retrospectives on nineteenth-century politics and art began to appear. In *Recollections of My Childhood and Youth*, Georg Brandes wrote about his moonlight ride with Vinnie over the Roman Campagna, their visits to the gardens of the Villa Borghese, the festivals, and their viewing of the Northern Lights.[29] Henry James published *William Wetmore Story and his Friends*, in which he called the group of expatriate women artists—Harriet Hosmer, Edmonia Lewis, Emma Stebbins and Vinnie—"the white marmorian flock." He described the help with the Lincoln's drapery that Story gave Vinnie, "the gifted child with the saucy curls."[30] Emily Briggs, in *The Olivia Letters*, described George Morgan's fight for Vinnie's extra $5000 appropriation, and gave a vivid picture of a reluctant congressman being dragged off to Vinnie's studio where "filmy lace curtains shrouded the tall gaunt windows.[31]

Edmund G. Ross's 1896 *History of the Impeachment of Andrew Johnson* included details of his walk with Thomas Ewing to the telegraph office from Vinnie's house the night before the impeachment vote.[32] Also in 1896, General Daniel Sickles gave a long interview to the *New York Sun,* in which he talked about the awkward early morning hours when he burst into Vinnie's house and insisted on seeing Ross.[33]

Not everything that was published was pleasant. Lorado Taft wrote in his *History of American Sculpture,* "It was the misfortune of Miss Vinnie Ream (now Mrs Hoxie) to receive from Congress, at the age of fifteen, and after a single year's study, an order for a marble statue of Lincoln. This she executed, and it stands today in the rotunda of the national Capitol, a monument to the gallantry of our statesmen. Not content with one such exhibition of its own ignorance, Congress ordered later, from the same untrained hands, a heroic statue of Farragut. With proper training and sufficient continuity of pur-

pose, she might have won something more substantial than notoriety." He softened this assessment by saying, "[t]he Lincoln is extraordinary work for a child, and really a far more dignified portrait than many of its neighbors in the National Hall of Statuary. It is neither grotesque in expression nor absurd in gesture. The bowed head gives it from a distance a serious and thoughtful air. Closer examination reveals an absence of body within the garments, but this oversight is concealed, from certain points of view, by an abundance of somewhat irrelevant drapery. One feels that the girl sculptor approached her subject with reverence, and although her work is quite devoid of strength, it has its own melancholy expressiveness."[34]

In October, 1900, Hoxie, now promoted to major, was posted, at his request, to St Paul, Minnesota. Vinnie developed acute inflammatory rheumatism in her hands. Finally, after two years in St Paul, Hoxie was permanently posted to Washington. By 1905 it was evident that Vinnie was ill—she apparently had a heart attack, along with serious kidney problems, and it was then, when he feared that her life was in danger, that Hoxie allowed her to resume her profession. For more than eighteen years, she had been cut off from the work that meant so much to her.

After the publication of *Reminiscences of My Childhood and Youth* in 1906, Vinnie wrote Brandes to thank him for his kind memories of her. In November of that year she wrote,

My life has been a romance, picturesque in every detail. After making the Lincoln and Farragut statues, both ordered by the U.S. Govt., I married and Col. Hoxie forbade my working. I laid aside my work for many years and occupied myself with my husband, child and home . . .

Three years ago I had a most serious attack of heart trouble and the army surgeons thought it was due to suppression of feeling—my wanting to work and not being allowed to do so. Col. Hoxie became very much frightened and begging me to "try and pull through" for

his sake, he told me again and again that if I wouldn't try and live I might resume my work. You see, I did live and my husband put me up a splendid studio opening into my home and I am making now a heroic sized statue of Ezra Cornell, founder of Cornell University, to be placed in bronze on the campus there . . .[35]

She would not enter competitions, but there was another way to gain a contract. Over thirty years earlier, in 1868, she had gone to Madison to arrange a contract with the state to fill the two niches allotted Wisconsin in Statuary Hall. This had not succeeded because the state did not have the money. Now she wrote to Elliot Woods, who had replaced Edward Clark as architect of the Capitol, to ask what states had what statues in Statuary Hall. She was particularly interested in Wisconsin and Iowa. Woods replied that Iowa had no statues and Wisconsin had one only, of Jacques Marquette.[36] Vinnie decided to try for Iowa, since Hoxie's roots were there.

On April 2, 1907, she received a contract: "Whereas, Vinnie Ream Hoxie proposed to the Thirty-first General Assembly of Iowa to model in clay and furnish to the State of Iowa the clay model of Samuel J. Kirkwood, former Governor of Iowa, without charge or expense to the State, provided the State would pay the cost and expense of casting the statue in bronze and placing the same in the Statuary Hall in the National Capitol at Washington, District of Columbia." The state appropriated $5000 "or as much as may be necessary" for the casting and shipping.[37] Vinnie worked on *Kirkwood* through most of 1910 and the statue was unveiled in 1913.

Forty years earlier, Vinnie had made a bust of Sequoya, the Indian leader who in 1821 had created the Cherokee alphabet. Through Elias Boudinot, Vinnie had developed many contacts in Oklahoma; now she approached that state in the same way that she had approached Iowa, and on April 29, 1912, signed a

contract with the state of Oklahoma to produce a statue of Sequoya for the sum of $5000 to cover casting and shipping.[38]

As they did every year, the Hoxies spent the summer in their house at 310 South Lucas Street in Iowa City. In early September, Richard was away and Vinnie was preparing for their return to Washington, when she collapsed suddenly. Believing that she would get better care in Washington than in Iowa, Richard chartered a special train and hired two nurses to tend to her on the journey east. She was suffering from chronic nephritis, and lingered for two months before she died of uremic poisoning on November 20, 1914. She was sixty-seven years old.[39]

She left *Sequoya* unfinished. It was completed by George J. Zolnay. Both *Sequoya* and *Kirkwood* stand in Statuary Hall in the Capitol.

Vinnie was buried in Arlington National Cemetery, on high ground overlooking the city she loved. The grave is marked by a bronze casting of her *Sappho*, with a medallion by Zolnay of Vinnie as she looked when Lincoln sat for her. The epitaph reads: "Words that would praise thee are impotent." Near the grave Richard placed a stone bench to symbolize, he said, her cordial and welcoming nature.[40]

For a brief time her flame had burned brightly when she was doing the work she loved. In her June 30, 1909, address to the International Council of Women, she said:

> In this field of sculpture disappointments will come, dark days of disappointment, nights of brooding and wakefulness, and we are never, never satisfied with the results of our efforts, but there is a glamor about it indescribable. It is a siren that leads us on; with a gentle voice she bids us on into the mystery of creation. God has been good to those who have heard that siren's voice and who have responded.

EPILOGUE

On April 30, 1917, Richard Hoxie, 72, married Ruth Norcross, 43, education editor for the *Philadelphia Record*, writer of a children's botany textbook, and book reviewer for a monthly magazine. It was a small wedding at the home of Norcross's brother in Washington. In that same year, Vinnie's sister Mary died.

Inevitably, Vinnie's works and possessions were donated to various museums. *The West* had been in the Wisconsin State Capitol building, possibly from the time it left the Woman's Building at the Columbian Exposition; it was certainly salvaged from the Wisconsin Capitol when that building burned down in 1906. In 1915, Richard had donated *Sappho* to what is now the Smithsonian American Art Museum, but was then called the National Gallery of Art. In early November, 1917, that museum received also the G.P.A. Healy portrait of Vinnie. One might assume that Ruth Hoxie may have found the portrait of her predecessor somewhat overwhelming, but it was not until 1929 that "Mrs Richard Hoxie" donated the George Caleb Bingham portrait of Vinnie to the State Historical Society of Missouri.

Basically, the Washington house and studio remained as Vinnie had left it until the late twenties, when Richard's advancing age and the changing neighborhood probably prompted the Hoxies to sell it and move to Miami, Florida. Obviously, the time had come for the dispersal of Vinnie's effects. *The Spirit of Carnival* and the marble bust *Passion Flower* were donated by the Hoxies to the Wisconsin State Historical Society at Madi-

son in 1929; Vinnie's modeling table and sculpting tools were donated by Ruth Hoxie to the same society in 1930, along with various documents and photographs.

Also in 1930, Ruth Hoxie donated plaster copies of the Lincoln bust to Ford's theatre in Washington.

The National League of American Pen Women owns the busts *Morning Glory* and *Violet* and enough miscellania to have prompted the dedication of a Vinnie Ream Room on their premises on September 29, 1979.The records are not clear on when they received *Morning Glory*, but Ruth Norcross Hoxie presented the League with *Violet* on April 11, 1954.

Jewels especially designed for Vinnie by Hoxie were given in 1937 to the Masonic Temple in D.C., and busts of Albert Pike were sent to the Scottish Rite Cathedrals in Seattle, Dallas, Williamsport, Pennsylvania, and McAlester, Oklahoma. The bust of Cardinal Antonelli went to Georgetown University in 1929; the *Kirkwood* to the University of Iowa.

Richard Hoxie died in Miami on April 30, 1930. His estate was valued at $250,000: Ruth inherited the Miami house and some money, and a provision was made for his and Vinnie's son Richard, who unfortunately died of cancer in 1936 at the Still-Hildreth Sanitorium in Macon, Missouri, where he had apparently lived for more than twenty years. Ruth Hoxie died on July 7, 1959 and was buried with Vinnie and Richard Hoxie in the family plot at Arlington National Cemetery.[1]

The quality of Vinnie's work is uneven. *Sappho* is excellent; *Lincoln*, *Kirkwood*, *Sequoya*, and *Spirit of Carnival* are competently done, while *Farragut*, *The West*, *Miriam* and others perhaps lack inspiration. Charles Sumner had declared during the Lincoln debate, "It is no small labor to set a man on his legs, with proper drapery and accessories."[2] *Spartacus*, in particular, falls short of this goal. It is true that Vinnie had no formal schooling, and it is also true that many women managed better to "set a man on his legs" without it. It is possible that it was not in her nature, if schooling had been available to her, to

pursue a serious and rigorous course of study. She put her faith in guidance from experienced artists, and in strenuous lobbying for commissions. She enjoyed perhaps too much the adulation of fans and the friendships of the mighty.

But she had a real talent for making busts. Most of her work in this area is excellent. Her busts of Lincoln, Thaddeus Stevens, Albert Pike, Daniel Voorhees and Cardinal Antonelli have life and show real sensitivity. Her busts of allegorical subjects are interesting, although not quite of the same quality as work she did when she had an emotional response to her subject.

In 1994, the *Davenport Art Reference and Price Guide* listed Vinnie's work as selling from around $500 to $1000. The 2003/ 2004 *Guide* shows prices doubling to $1000 to $2000. But Sotheby's records no sales for Vinnie Ream, doubtless because her work falls below the $5000 minimum value requirement set by Sotheby's for works in its nineteenth-century painting and sculpture auctions.

The gods did not play fair with Vinnie. They endowed her with talent, burning ambition, intelligence and striking beauty that made her the intimate of some of the most prominent American men of the time. But they cursed her with the misfortune of being born into an age that put social, economic, educational and legal obstacles in every woman's path. And what may finally have destroyed her was her decision to marry a man with rigid nineteenth-century attitudes toward the conventions of marriage.

NOTES

Unless otherwise noted, correspondence to and from Vinnie Ream [VR], along with material from her scrapbook and journals, are from the Papers of Vinnie Ream and Richard L. Hoxie [VRP] in the Library of Congress, Manuscript Division.
CG *Congressional Globe*
UMWMC Joint Collection, University of Missouri Western Manuscript Collection at Columbia, Mo.

CHAPTER 1: WASHINGTON

1. *New York Times*, April 25, May 1, 1861; William Roehrenbeck, *The Regiment That Saved the Capitol*, pp. 124–125; Margaret Leech, *Reveille in Washington*, p. 71.
2. WPA notes, University of Wisconsin State Library; Alice E. Smith, *History of Wisconsin*, p. 320; *Wisconsin State Journal*, Nov. 23, 1885.
3. Rollins to VR, June 27, 1863.
4. *A Christian College Chronicle*, Jan. 1900, p. 53, UMWMC.
5. Petition, Feb. 15, 1858, VRP; Lawrence Kennedy, ed., *Biographical Directory of the American Congress, 1774–1971*, p. 1629; Mrs Mark Hale, Christian College Historian to Frank Elliott, Mar. 22, 1953, UMWMC; Mary Ream to Frank Venerable, June 1, 1862.
6. Mary Ream to Frank Venerable, June 1, 1862.
7. Bruce Catton, *The Coming Fury*, pp. 470–471.
8. *New York Times*, July 24, July 26, 1861.
9. Rogers to VR, July 7, 1862.
10. Powell to VR, Aug, 26, 1861.
11. Ibid., Aug. 30, 1861.

12. VR to Gen. Curtis, Mar. 11, 1862.
13. Gen. Curtis to VR, Mar. 24, 1862.
14. Letter to VR, April 27, 1862, signature illegible.
15. Adj. Gen. F.G. Ainsworth to G.D. Carter, July 22, 1911.
16. Mary Ream to Frank Venerable, June 1, 1862; Gen. M. Jeff Thompson and Will Eller to VR, Nov. 21, 1863; Capt. G.J. Kelly to VR, Aug. 5, 1864.
17. Leech, *Reveille in Washington*, 1860–1865, p. 261.
18. *American Heritage*, Feb., 1976, Vol. 27, No. 2, p. 46.
19. Rollins to G.W. Anderson, Dec. 27, 1864.
20. CG, July 27, 1866, p. 4231; Lynes, *The Art Makers*, pp. 120–121, 124–125; *New York Times*, Mar. 16, 1861; *Encyclopedia Americana*, Vol. 8, p. 160; Leech, p. 15.
21. Circular and card in VR scrapbook.
22. Frank Bowen to VR, June 7, 1864.
23. *New York Times*, June 14, 1866.
24. Ibid., May 14, 1865.
25. Ibid., Mar. 6, Mar. 16, 1861; Rubenstein, *American Women Artists*, pp. 79–83.
26. *New York Times*, Mar. 6, 1864.
27. McHenry, ed., *Famous American Women*, p. 322.
28. Fine, *Women and Art*, p. 96.
29. Rubenstein, pp. 23–25.
30. Fine, p. 90.
31. G. L. Cramer to VR, June 4, 1864.
32. Hess and Baker, ed., *Art and Sexual Politics*, p. 28; Lynes, p. 124.
33. Rollins petition, Feb. 20, 1864, VRP.
34. Ibid.
35. VR in Mary Eagle, ed., *Congress of Women*, p. 604.
36. Ibid.
37. VR interview, Washington *Sunday Star*, Feb. 9, 1913.
38. Ibid.

CHAPTER 2: LINCOLN STATUE

1. VR to Stone, Horatio Stone Papers, Hist. Soc. of Pennsylvania; Wallace to VR, Jan. 29, 1865; Stone to VR, April 6, 1865, VRP.
2. Washington *Sunday Star*, Feb. 9, 1913, interview with VR.

3. *New York Times*, April 20, 1865.
4. Ibid, May 23, 24, 1865; Sherman, *Memoirs*, pp. 865–866; Grant, *Personal Memoirs*, pp 768–769; Lee Kennett, *Sherman*, pp. 221–282.
5. Wallace to VR, Jan. 29, 1865; John Sherman to VR, July 18, 1866.
6. Undated, unidentified newspaper clipping in VR scrapbook about Fuller's business; Kennedy, ed., *Biographical Directory of the American Congress*, p. 925; Chandler, "Story of Vinnie Ream," *Nat'l Republic*, Vol. 23, No. 11. p 6; Rogers to VR, June 29, 1865, giving wedding date.
7. Rollins Papers UMWMC.
8. Mary Eagle, ed., *Congress*, p. 605. Vinnie's speech gives details of help she received from Rice.
9. VR to John Rice, May 31, 1866.
10. J.F. Driggs to VR, July 2, 1866; Thaddeus Stevens to VR, July 20, 1866.
11. Ewing to VR, June 4, 1866.
12. Rollins to Smith, July 27, 1866.
13. Voorhees to VR, July 5, 1866.
14. Rollins to Voorhees, July 27, 1866.
15. Kennedy, ed., *Biographical Dictionary*, p. 185.
16. CG, July 26, 1866, p. 4182.
17. Haynes, *Charles Sumner*, p. 37; David Donald, *Charles Sumner and the Rights of Man*.
18. Ibid., July 17, 1866, p. 4225, 4230–4236.
19. Rubenstein, p. 83.

CHAPTER 3: LOBBYING AND CONTROVERSY

1. John Rice to VR, Feb. 21, 1867, VRP.
2. Bill paid by B.B. French, Commissioner of Public Bldgs, VRP.
3. Undated *Philadelphia Inquirer* clipping in VR scrapbook.
4. Rollins to Mary Todd Lincoln, Aug. 22, 1866.
5. McFeely, *Grant*, p. 211.
6. Mary Todd Lincoln to VR, Sept. 10, 1866.
7. Mary Todd Lincoln to Charles Sumner, Sept. 10, 1866.
8. Turner, *Mary Todd Lincoln*, p. 387.
9. Ibid., p. 418. See Bullard, *Lincoln in Marble and Bronze*.

10. *Washington Evening Star*, Aug. 28, 1866.

11. McHenry, *Famous American Women*, p. 248.

12. Unidentified, undated clipping in VR scrapbook.

13. Rubenstein, p. 88.

14. Henry Guerdon to VR, April 9, 1867.

15. Undated clipping in VR scrapbook.

16. *Liberty Tribune*, Sept. 14, 1866.

17. Unidentified, undated clipping in VR scrapbook.

18. Bowers, *The Tragic Era*, pp. 67, 76, 80–81. Eric Foner, *Reconstruction*, pp. 118, 230–234, 252–255, *passim*.

19. Stevens to VR, Dec. 10, 1867; Sandburg, *Lincoln*, p. 275.

20. John Sherman to VR, July 18, 1866, Oct. 14, 1867; Richard Yates to James Bowen, Mar. 28, 1867; Mo. Gov. to VR, May 23, 1867.

21. Weimann, pp. 162–163.

22. Bowers, p. 88.

23. Krenkel, *Richard Yates*, p. 125. See also Foner, pp. 232, 233, 278.

24. Yates to Bowen, Mar. 28, May 12, 1867.

25. Yates to VR, Dec. 3, 1867.

26. U.S. Official Report on Paris Universal Exposition, pp. 11, 34, 42.

27. Yates to VR, Sept. 14, 20, 28, 1867.

28. T. Bigelow Lawrence to Ross, Nov. 30, 1867.

29. Petition copy given to VR, May 14, 1867.

30. F.P. Blair to VR, May 29, 1867.

31. Voorhees to Johnson, May 13, 1867; Marshall to Johnson, July 24, 1867.

32. Marshall to VR, July 26, 1867.

33. Rice to VR, Feb. 21, 1867; Rice to Seward, Mar. 2, 1867.

34. Simon Mills to VR, Jan. 5, 1868.

35. Julian to Fairchild, Feb. 10, 1868.

36. Rice to Fairchild, Jan. 14, 1868; E.G. Ross to Wyman Spooner, Jan. 15, 1867; Wade to Fairchild, Feb. 11, 1868; Yates to Fairchild, Feb. 20, 1868.

37. Simon Mills to VR, Jan. 19, 1868.

38. UMWMC; Wisc. State Hist. Soc. WPA notes; *Philadelphia Telegraph*, Jan. 9, 1871; *Chicago Tribune*, Mar. 2, 3, 1868; *Wisconsin State Journal*, Mar. 4, 1868.

39. Bill from Vilas House, Madison, Wisc., Mar. 3, 1868, VRP

40. Ross to VR Feb. 21, 1868.

CHAPTER 4: IMPEACHMENT

1. See Hans L. Trefousse, *Johnson, a Biography.*
2. Foner, pp. 176–184; Michael Les Benedict, *The Impeachment and Trial of Andrew Johnson*, pp. 3–7.
3. *New York World*, Mar. 6, 1868.
4. *New York Times*, Mar. 6, 1866.
5. Lawrence Kennedy, ed., pp. 193–197.
6. *Philadelphia Inquirer*, Mar. 2, 1868.
7. Ibid., Mar. 14, 1868.
8. Ibid.; *New York Herald*, Mar. 14, 1868.
9. Undated, unidentified clipping in VR scrapbook.
10. Stevens to VR, Mar. 19, 28, 1868; John Sherman to VR, April 13, 1868.
11. *New York Times*, April 3, 1868. See also Foner, Benedict.
12. Pike quotes her letters to him in letters to her, April 2, 13, 1868.
13. *Philadelphia Inquirer*, April 13, 1868; *New York Times*, April 14, 1868; Thomas Frederick Woodley, *Thaddeus Stevens*, p. 338.
14. C.C. Warner to Butler, April 5, 1868.
15. Undated letter from Warner to Ross; Bowers, p. 192.
16. *CG*, May 29, 1868, pp. 2675–2676.
17. Lomask, *Andrew Johnson*, p. 327.
18. *New York Times*, May 16, 1868.
19. Ross, *The Impeachment Trial*, p. 4; telegram to Ross April 14, 1868 with Ross's reply; Ross to R. Hoxie, Nov. 21, 1896, VRP.
20. Foner, p. 209.
21. *New York Times*, Feb. 28, 1859. See Swanberg, *Sickles the Incredible.*
22. *New York Sun*, Oct. 25, 1896.
23. Ross to R. Hoxie, Nov. 21, 1896.

CHAPTER 5: THE VOTE

1. *New York Times*, May 17, 1868.
2. Edmund G. Ross, *The Impeachment Trial*, pp. 9–10.
3. Ibid.
4. *Philadelphia Inquirer*, May 28, 1868.
5. Foner, p. 336; Benedict, pp. 1818–183.

6. *Philadelphia Inquirer*, May 29, 1868.

7. Ibid.

8. Ordway to VR, May 19, 1868.

9. CG, May 29, 1868, pp. 26674–2675.

10. Ibid., May 3, 1868, p. 2706.

11. Ibid., pp. 2706–2707; June 1, 1868, 1868, p. 2751.

12. Mundy to VR, June 16, 1868.

13. MacDonald to VR, June 18, 1869.

14. Undated *New York Tribune* article in VR scrapbook.

15. Fisk Mills to VR, June 15, 1868.

16. VR to Stevens, June 15, 1868. Stevens's reply on bottom of note.

17. Stevens to VR, Mar. 28, 1868.

18. VR broadside, June 18, 1868.

19. *New York Tribune, Philadelphia Inquirer*, June 12, 1868; *Chicago Tribune*, June 25, July 10, 1868.

20. Thomas Frederick Woodley, *Thaddeus Stevens*, pp. 355–356.

21. CG, July 20, 1868, p. 4253.

22. Ibid.

23. Woodley, *op.cit.*

24. *New York World*, Mar. 6, 1868.

25. Hans L.Trefousse, *Thaddeus Stevens*, p. 241; *New York Times*, Aug. 15, 1868; *Philadelphia Inquirer*, Aug. 14. 15. 1868; Woodley, p. 413.

CHAPTER 6: PREPARATIONS

1. Lee Kennett, *Sherman*, p. 331.

2. VR's receiving book, VRP.

3. Fletcher to VR, May 23, 1867; Trumbull to VR, Sept. 8, 1868.

4. Rooker to VR, April 13, 1869; Cornell to VR, April 27, 1869.

5. Ewing to VR, Jan. 27, 1869.

6. Eleanor Flexner, *Century of Struggle*, p. 148; Ellen Carol Dubois, *Feminism and Suffrage*, pp. 163–164; Flexner, p. 144. *New York Times*, Jan. 20, 21, 1869.

7. Undated clipping from *Missouri Democrat* in VR scrapbook.

8. Ibid., Jan. 16, 1869.

9. Ewing to VR, Jan. 27, 1869; Browning to VR, Jan. 28. 1869; Browning to Wade, Jan. 30, 1869.

10. *CG*, Mar. 2, 1869, pp. 1782–1784.
11. Voorhees to VR, Sept. 21, 1868.
12. Pike to VR, April 2, 13; July 29; Sept. 9; Oct. 2, 1869.
13. Ray Baker Harris, ed., *Bibliography of the Writings of Albert Pike*, pp. 13, 15.
14. Pike to VR, April 9, 1869.
15. Rollins to Fish, Mar. 22, 1869.
16. Trumbull to VR, Feb. 4, 1869; Marshall to VR, Feb. 4, 1869.
17. McFeely, p. 287.
18. MacDonald to VR, Mar. 15, 1869; Brown to VR, Mar. 15, 1869.
19. Trumbull to VR, May 2, 1869.
20. Clark to VR, April 8, May 11, 1869; Rollins to Fish, Mar. 22, 1869; Sunderland to Gage, June 4, 1869; Van Buren to Graham, June 7, 1869; Corcoran to Powers, June 15, 1869.

CHAPTER 7: THE GRAND TOUR

1. Pike to VR, June 10, 1869.
2. *New York Times* passenger list, June 10, 1869.
3. VR, "Journals from Abroad."
4. Undated letter.
5. Kennedy, ed., p. 971.
6. Pike to VR, June 10, 1869; Aug. 21, 1869; Oct. 5, 1869; Aug. 15, 1870; April 1, 1870.
7. VR, "Journals from Abroad."
8. Ibid.
9. Bartlett to VR, Oct. 23, 1869.
10. James, pp. 257–258.
11. MacDonald to VR, Nov. 25, 1869.
12. Ibid.
13. James, p. 256.
14. VR to Mrs Nealy, Jan. 26, 1870.
15. Mary Eagle, ed., p. 607.
16. "Roman Carnival" by VR in *Washington Evening Star*, Feb. 18, 1871.

CHAPTER 8: HARD WORK AND LONG HOURS

1. "Journals from Abroad."
2. Gagliard to R.L. Ream, Feb. 28, 1870.
3. Carl Ehrenberg was a German tourist who wrote VR a letter dated Aug. 23, 1871.
4. First names of the journalists are not available.
5. Reprint of *Il Buonarroti* article translated in unidentified newspaper in VR scrapbook; *Evening Wisconsin,* June 4, 1870.
6. Ewing to VR, Mar. 31, 1870; Trumbull to VR, Feb. 8, 1870.
7. Patrick to VR, Feb. 2, 1870.
8. Fragments of novel, VRP.
9. Notes dated July 26, 1870.
10. John Jay to VR, Nov. 14, 1870.
11. Brandes, *Recollections*, pp. 316–318.
12. Ibid., pp 319–320.
13. Ibid., 321–323.
14. Ibid.

CHAPTER 9: THE UNVEILING

1. Noyes to VR, Dec. 27, 1870.
2. Leonard S. Kenworthy, *The Tall Sycamore,* p. 145.
3. Voorhees to VR, Jan. 7, 1871; Trumbull to VR, Jan. 10, 1871.
4. *Washington Evening Star*, Jan. 8, 1871.
5. Ibid.
6. All three newspapers, Jan. 8, 1871.
7. Article in the *Daily Gazette,* Feb. 21, 1871, responding to Ames *Independent* article. In VR scrapbook.
8. Undated articles in VR scrapbook.
9. Jan. 9, 1871.
10. Jan. 11, 1871.
11. Trumbull to VR, Jan. 10, 1871.
12. Fragment of letter, VRP.
13. Trumbull to VR, Jan. 19, 1871.
14. Morrill to VR, Jan. 23, 1871; Circular, "The Order of Arrangement for Unveiling the Statue of President Lincoln," in VR scrapbook.

15. Healy to VR, Dec. 17, 1870.
16. *New York Herald, New York Times,* Jan. 26, 1871.
17. Rooker to VR, Jan. 23, 1871.
18. Ewing to VR, Jan. 24, 1871.
19. MacDonald to VR, Jan. 31, 1871.
20. Custer to VR, Feb. 13, 1871.
21. Pike to VR, Feb. 2, 1871.
22. Undated clipping.
23. *Daily Chronicle,* Feb. 2, 1871.
24. Ibid., April 26, 1871.
25. Undated clipping.
26. Undated, unidentified clipping VR scrapbook.

CHAPTER 10: FINANCES AND FAIRS

1. Voorhees to VR, unreadable date, probably late January or early February, 1871.
2. *Washington Daily Chronicle,* Feb. 10, 1871.
3. CG, Feb. 24, 1871, pp. 1625–1627; Mar. 3, 1871, pp. 1997–1998.
4. Edward Bumgardner, *Life of Edmund G. Ross,* pp. 231–232; L. Kennedy, ed., p. 1634; Benedict, pp. 182–183.
5. John H. Krenkel, *Richard Yates,* p. 278.
6. Mar. 4, 1871.
7. Mar. 5, 1871.
8. Mary Clemmer Ames, *Ten Years in Washington,* pp. 111–112.
9. Drexel, Harjes & Co. to VR, April 8, 1871.
10. Pike to VR, Mar. 31, 1871; Noyes to VR, May 7, 1871; *New York Standard* description of VR's commissions, undated, VR scrapbook.
11. Undated letter appears to be from John F. Cleveland, Horace Greeley's brother-in-law. Probably written the first week of May, 1871.
12. Catlin to VR, May 9, 11, 1871.
13. Van Buren, June 17, 1871.
14. Clipping attached to letter to VR on stationery headed "Office of the Star," dated June 9, 1871. Signature is illegible.
15. Lynes, p. 145.
16. Boston Lyceum Bureau to VR, May 19, June 2, 1871.
17. Noyes to VR, May 7, July 19, Sept. 17, 1871.

18. Corcoran to RR, June 19, 1871.
19. RR to VR, July 10, 1871.
20. Rooker to VR, July 17, Aug. 16, 17, 1871; White to VR, April 24, 1871.
21. Cornell to VR, probably April, 1871; VR to Cornell. undated.
22. Sept. 11, 1871.
23. *New York Times*, Sept. 8, 20, 23; Oct. 7, 22; Nov. 3, 5, 1871.

CHAPTER 11: COMPETITIONS

1. Noyes to VR, Dec. 29, 1872; *Washington Sunday Chronicle*, Feb. 18, 1872; *Appleton's Journal*, June 15, 1872, pp. 663–664.
2. Cornell to VR, Jan. 27, 1872.
3. Ibid., Jan. 30, 31, 1872, telegram and letter.
4. Bessels to VR, June 28, 1871.
5. Hall to VR, Aug. 21, 1871.
6. Chauncy C. Loomis, *Weird and Tragic Shores*, pp. 329–330, 341.
7. Adj. Gen. F.G. Ainsworth to G.D. Carter, July 22, 1911, Nat'l Archives, Western Dist. of Arkansas, Ft. Smith Div., General Records, Common Law Record Bks, 1855–1910, Vol. 81-1-4 (Jan. 15, 1871–Nov. 25, 1874); Criminal Records, Defendant Criminal Jacket Files, 1866–1896, Jacket #160.
8. Clayton to VR, April 15, 1871; VR to Clayton, July 25, 1872; Clayton to VR, Aug. 9, 1872, enclosing letter to Grant and petition.
9. Randall to VR, May 18, 1872.
10. *New York Tribune*, July 16, 1872; Cornell to VR, July 28, 1872.
11. Unidentified, undated clippings in VR scrapbook.
12. Voorhees to Ingersoll, June 10, 1872; [Washington] *Catholic Mirror*, April 13, 1872.
13. Cornell to VR, Oct. 22, 1872; King's County Fair to VR, Oct. 13, 18, 1872.
14. Undated, unidentified clipping in VR scrapbook.
15. VRP.
16. William Harlan Hale, *Horace Greeley*, p. 351; Foner, 499–511.
17. Price to VR, June 25, 1872.
18. Kellogg to VR, Nov. 16, 1872.
19. Ewing to VR Nov, 13, 20, 1872.

20. Rollins to VR, Nov. 19, 1872.
21. *New York Times*, Nov. 22, 1872, Feb. 2, 1873.
22. *Boston Journal*, Feb. 4, 1873; *Richmond Weekly State Journal*, Feb. 12, 1873.
23. Feb., 1873.
24. *Boston Journal*, Feb. 4, 1873.
25. *CG*, Feb. 24, 1871, p. 1626.
26. Porter, Feb. 20, 1873; Catlin, Nov. 30, 1872.
27. Sherman to Perry, Feb. 18, 1873, to VR, Feb. 25, 1872.
28. To VR, Feb, 25, 1873.
29. *New York Times*, Mar. 4, 1873.

CHAPTER 12: GENERAL SHERMAN

1. Mar. 4, 1873.
2. Rollins to VR, Mar. 10, 1873.
3. Sherman, *Memoirs*, pp. 19–14. See Lee Kennett, *Sherman: A Soldier's Life*.
4. Sherman to VR, Feb. 20, 25, Mar. 22, 1873.
5. Sherman to Stringham, April 3, 1873; to VR, April 19, 1873.
6. Powell to VR, July 16, 1873.
7. Sherman to VR, Jan. 6, 1874.
8. Emily Edson Briggs, *The Olivia Letters*.
9. Kennett, pp. 52–61, 71–77, 332–333.
10. Cooper Union curator to Cornell, July 25, 1873; Louisville Industrial Exposition to VR, Sept. 13, 1873.
11. Rice to Negley, Sept. 4, 1873; Van Vliet to Sheridan, Sept. 17, 1873; Rollins to Hartranft, Sept. 9, 1873; Cox to Ranch, Sept. 12, 1873.
12. Sherman to VR, Sept. 3, 11, 1873.
13. Sept. 14, 1873.
14. Price to VR, June 30, 1873.
15. Samuel Harper to Pike, Sept. 20, 1873.
16. *Philadelphia Evening Telegram*, Sept. 17, 1873; *Pittsburgh Daily Post*, Sept. 17, 1873.
17. *Pittsburgh Daily Post*, Sept. 18. 1873.
18. Ibid., Sept. 19, 1873; *New York Times*, Sept. 19, 1873.
19. Thomson to VR, Sept. 20, 1873.

20. *New York Times*, Mar. 15, 1873.
21. *Mobile Register,* undated.
22. Walter Lee Brown, "Albert Pike," unpubl. thesis. There are 29 essays in the five volumes.
23. Sunderland to VR, Jan. 7, 1874.
24. *Brooklyn Daily Times*, Dec. 23, 1873; Powell to VR, Dec. 26, 1873.
25. Sherman to VR, Jan. 15, 1874.
26. CG, Mar. 6, 1874, pp. 2030–2031.
27. See David Donald, *Charles Sumner and the Rights of Man.*
28. CG, June 29, 1874, pp. 5251, 5255.
29. Orth to VR June 20, 1874; Rollins and Voorhees telegram to VR, June 23, 1874; Voorhees to VR, June 25, 1874; Sherman to VR, Sept. 11, 1874.
30. Ingalls to VR, June 3, 1874.
31. Ibid., undated.
32. Ibid.
33. *New York Herald*, Feb. 2, 1873.
34. Ingalls to VR, July 15, 1874.
35. Ibid., Aug. 25, 1874.
36. Ibid., Oct. 27, 1874.
37. Louisiville Industrial Fair to VR, Sept. 13, 1873; *Springfield [Il] State Journal,* June 25, 1874; *Philadelphia Presbyterian*, Aug. 5, 1873.
38. *Amerika* to VR, Aug. 23, 1874, and *Louisville Daily and Weekly Register* to VR, Sept. 4, 1874, both with Sherman's written comments.
39. Boudinot to VR, Oct. 21, 1874.
40. *Cherokee Advocate*, Feb. 2, 1878.
41. Mar. 18, 1874.
42. Sherman, *Memoirs*, pp. 934–936, 943; Kennett, pp. 288–289.
43. Sherman to Vinnie, July 1, 1874, April 4, 1874.
44. Ibid., Feb. 8, 1875.
45. Ibid., May 10, 1875.
46. Ibid., Sept. 24, 1874.
47. Ibid., Nov. 14, 1874.
48. Farragut to Robeson, Nov. 11, 1874.
49. Sherman to Robeson, Dec. 23, 1874.

50. Robeson to Wilson, 43rd Congress, 2nd Session, Senate, Ex. Doc, No 31, Feb. 22, 1875.
51. Sherman to VR, Jan. 29, 1875.
52. *New York Times*, Feb. 17, 1875.
53. Undated letter draft.

CHAPTER 13: CENTENNIAL

1. *Washington Evening Star*, April 20, 1878.
2. Sherman to VR, May 10, 1875.
3. Ibid, Feb. 25, 1875.
4. Foner, p. 554; Sherman to VR, Jan. 29, 1875.
5. Sherman to VR, June 30, July 12, 1875.
6. Trumbull to VR, Jan. 3, 1874.
7. Johnson to VR, Dec. 3, 10, 16, 1874, April 6, 1875.
8. Barton Able, George Barry to S. P. Thompson, Dec. 24, 1874.
9. William McFeely, *Grant, A Biography*, p. 433.
10. Sherman, *Memoirs*, pp. 944–945.
11. Boudinot, April 4, 1876.
12. *New York Times*, April 4, 1876.
13. Custer to VR, Feb. 13, 1871.
14. Jay Monaghan, *The Life of George Armstrong Custer*, p. 366.
15. Rachel Sherman Thorndike, *The Sherman Letters*, p. 289.
16. Jeffrey D. Wert, *Custer*, pp. 340–358.
17. Wisconsin Women's Commitee to VR, Mar. 20, 1876.
18. Rollins to VR, Aug. 8, 1876.
19. Morrell to VR, Jan. 21, 1876.
20. Ibid., Jan. 25, 1876.
21. Sartain to VR, June 21, 1876.
22. Morrell telegram to VR, May 5, 1876.
23. *New York Times,* May 7, 1876.
24. Voorhees to VR May 8, 1876.
25. Vinnie was careful to keep thousands of letters. Over the years Morrell sent her a few well wishes, but apparently nothing off-color.
26. *Philadelphia Inquirer,* May 11, 1876.
27. John D. Bergamini, *The Hundreth Year*, p. 15.
28. Francis A. Walker, ed., *U.S. Centennial*, p. 15.

29. *New York Times*, June 4, 1876.
30. Bingham to VR, May 5, 1876, May 10, 1876, May 11, 1876, June 4, 1876.
31. Rollins to VR, Sept. 12, 1876.
32. Mrs Bingham to VR, June 7, 1876.
33. Bingham to VR, Nov. 27, 1876.

CHAPTER 14: RICHARD HOXIE

1. Voorhees to VR, Feb. 3, 1877.
2. Sherman to VR, Feb. 1, June 30, 1877; VR to Ehrenberg, April 7, 1877.
3. Rollins to Thompson, June 21, 1877.
4. Feb. 28, 1877.
5. Feb. 2, 1877.
6. Undated *Chronicle* clipping.
7. *Washington Evening Star*, Feb. 21, 1877.
8. VR to Ehrenberg, April 7, 1877.
9 *Richmond Daily Dispatch*, Nov. 11, 1877.
10. Pike to VR, Sept. 13, 1877.
11. *Richmond Daily Dispatch*, Nov. 3, 18, 20, 21, 1877.
12. Early to VR, Nov. 28, 1877.
13. Knott to VR, Nov. 8, 1877.
14. Bingham to VR, June 13, Nov. 14, 1877.
15. Fiske to Boardman, May 15, 1878. Cornell University Libraries, Dep't of Mss and University Archives, Jennie McGraw Fiske Estate Papers, # 1622.
16 *First Regiment Iowa Volunteer Cavalry, Historical Sketch*, pp. 3ff.
17. J.L. Cramer to VR, June 4, 1864.
18. Pike to VR, July 18, 1876.
19. Ibid, Dec. 16, 1876, Jan. 4, Feb. 7, Mar. 7, 15, 23, April 11,1877; Ray Baker Harris, *Bibliography of the Writings of Albert Pike*, p. 16, 23; Brown, p. 835.
20. Stillson to VR, May 22, 1878.
21. Sherman to VR, April 23, 1878.
22. *Philadelphia Daily Evening Telegraph*, May 29, 1878.
23. *New York Times*, May 29, 1878; Albert Pike, "The Bridal."
24. *Washington Evening Star,* Mar. 28, 29, 1878.

25. *Philadelphia Daily Evening Telegraph*, May 29, 1878.
26. Sherman, *Memoirs*, p. 903.
27. Morgan to VR, June 10, 1878.
28. Voorhees to VR, June 11, 1878.
29. Sherman to VR, June 16, 24, 1878.
30. *New York Times,* July 27, 1878.
31. Early to VR, May 17, July 22, Aug. 13, 1878.
32. French to VR, Jan. 11, 1878.
33. Early to VR, Nov. 11, 1878.
34. *Richmond Daily Dispatch*, Nov. 28, 1878.

CHAPTER 15: ELIZABETH CUSTER

1. E. Custer to VR, undated but probably 1877, because it is addressed to "Miss Ream."
2. *New York Times,* Oct. 11, 1877.
3. Jay Monaghan, *Life of George Armstrong Custer*, p. 401; Jeffrey D. Wert, *Custer,* p. 357; Shirley A. Leckie, *Elizabeth Bacon Custer,* pp. 221–223.
4. E. Custer to VR, Feb. 22, 1879, Sept. 29, 1879.
5. Ibid., Mar. 10.
6. Ibid., Mar. 15, 1880.
7. *New York Times*, April 23, 1880.
8. E. Custer to VR, undated, but probably shortly after Mar. 12, 1880.
9. Monaghan, p. 403; Leckie, pp. 229–230.
10. E. Custer to VR, Nov. 13, no year.
11. Ibid., June 12, 1881.
12. Ibid., Dec. 29, no year.
13. Ibid., June 12, 1881.
14. Ibid., Sept. 15, no year.
15. Ibid., Nov. 13, no year.
16. Ibid., undated letter.
17. Ibid., Jan. 3, 1882.
18. Ibid.
19. Leckie, pp. 278–279, 282–288.
20. *New York Times*, April 26, 1881.
21. CG, Dec. 7, 1880, p. 16.
22. Ibid., Dec. 21, 1880, p. 292.

23. Ingalls to VR, Dec. 21, 1880.
24. *New York Times*, April 26, 1881.
25. Porter to VR, undated.
26. *New York Times*, April 26, 1881.
27. Voorhees to VR, July 7, 1881.

CHAPTER 16: THE CONVENTIONS OF MARRIAGE

1. Clayton to VR, Jan. 5.
2. Ibid., Feb. 5, 1879.
3. Sherman to VR, Nov, 21, 1884.
4. Kennett, pp. 105–106.
5. Early to VR, Sept. 1, 1884.
6. Sherman to VR, Nov. 11, 1884.
7. Voorhees to VR, May 9, 1885.
8. Sherman to VR, Nov. 21, 1884.
9. Undated clipping from the *Masonic Bulletin*, VRP.
10. Pike to VR, Feb. 11, Feb. 20, 1886.
11. Rbt. Ream to VR and to Mary, Oct. 31, 1884.
12. *Washington Evening Star*, Nov. 2, Nov. 21, 1885.
13. Sherman to VR, Nov. 27, 1887.
14. *New York Times*, Feb. 18, Feb. 20, 1891. Kennett, pp. 336–340.
15. Robert L. Duncan, *Reluctant General*, pp. 272–274.
16. VR speech at Columbian Exposition, May 15, 1893.
17. VR, "Journals From Abroad."
18. VR speech to International Council of Women, Toronto, June 30, 1909.
19. Weimann, *The Fair Women*, pp. 286–287.
20. Ibid., pp. 279–280.
21. Briggs to VR, Jan. 29, Feb. 24, 1893.
22. Weimann, 314–323.
23. Dep't of Fine Arts to VR, Mar. 10, 1893.
24. Stevenson to VR, Mar. 28, 1893.
25. Typed notes in VRP.
26. Tom Sherman to VR, Sept. 20, Nov. 25, 1895; Jan. 2, 1896; Minnie Sherman to VR, Dec. 27, 1895, Jan. 11, 1896.
27. House of the Temple to VR, Jan. 21, 1899.

28. Meade to VR, Oct. 27, 1900.
29. Brandes, pp. 316–323.
30. James, pp. 257–258.
31. Briggs, *The Olivia Letters*, pp. 86–87, 265–266.
32. Ross, *History of the Impeachment*, pp. 4–8.
33. *New York Sun*, Oct. 25, 1896.
34. Taft, p. 212.
35. VR to GB Doris Asmundsson, *Georg Brandes, Aristocratic Radical*, pp. 318–319. There is apparently no such statue on the Cornell campus.
36. VR to Edward Clark, no date; VR to Elliot Woods, July 17, 1900; Woods to VR, July 24, 1900.
37. Executive Council of the State of Iowa to VR, April 2, 1907; VR to Executive Council, May 1, 1914.
38. *Washington Sunday Star,* Oct. 7, 1917.
39. Gordon Langley Hall, *Vinnie Ream*, pp. 142–143.
40. Ibid., p. 143.

EPILOGUE

1. *Washington Evening Star*, July 8, 1959; *Washington Post*, May 31, 1917; *New York Times*, May 1, 27, 1930.
2. CG, July 27, 1866, p. 4234.

SOURCES

NEWSPAPERS

Boston Journal
Brooklyn Daily Eagle
Brooklyn Daily Times
Cherokee Advocate
Chicago Daily News
Chicago Tribune
Congressional Globe
[Lancaster] Daily Express
Daily Milwaukee News
Kansas City Star
Liberty [Missouri] Tribune
Missouri Statesman
Mobile Register
Newark Daily Advertiser
[Chicago] New Republic
New York Citizen
New York Daily Tribune
New York Evening Post
New York Herald

New York Sun
New York Times
New York World
Philadelphia Daily Evening
 Telegraph
Philadelphia Inquirer
Philadelphia Post
Pittsburgh Daily Post
Pittsburgh Weekly Post
Richmond Daily Dispatch
St Louis Daily Globe Democrat
St Louis News
Terre Haute Journal
Washington Evening Star
Washington Letter
Washington Sunday Star
[Richmond] Weekly State Journal
Wisconsin State Journal

ARTICLES

Chandler, Josephine C. "The Story of Vinnie Ream." *National Republic*, no. 11. (March, 1936).

Clifford, Roy A. "The Indian Regiments in the Battle of Pea Ridge." *Chronicles of Oklahoma* no. 4 (Winter 1947–48).

Cordato, Mary Francis. "Towards a New Century: Women and the Philadelphia Centennial Exhibition, 1876." *Pennsylvania Magazine*, no. 1 (Jan. 1983).

Griffin, Maude E. "Vinnie Ream: Portrait of a Sculptor." Missouri *Historical Review*, no. 3 (April 1962).

Haefner, Marie. "From Plastic Clay." *The Palimpsest,* no. 11 (Nov. 1930).

Kilham, Elizabeth. "Vinnie Ream at Home." *Appleton's Journal,* no. 168 (June, 1872).

Stat, Stephen W., and Lee Roderick. "Mallet, Chisel and Curls. "*American Heritage,* no. 2 (Feb. 1976).

UNPUBLISHED THESIS

Brown, Walter Lee. "Albert Pike." University of Texas, 1955.

BOOKS

Ames, Mary Clemmer. *Ten Years in Washington.* Hartford, 1873.

Andrews, Marietta M. *My Studio Window.* New York, 1928.

Andrews, Wayne, ed. *Autobiography of Carl Schurz, An Abridgement.* New York, 1961.

Asmundsson, Doris. *Georg Brandes: Aristocratic Radical.* New York, 1981.

Badeau, Adam. *Grant in Peace.* Hartford, 1887.

Beale, Howard K., ed. *Diary of Gideon Welles.* 3 vols. New York, 1960.

Benedict, Michael Les. *The Impeachment and Trial of Andrew Johnson.* Paperback. New York, 1973.

Bergamini, John D. *The Hundreth Year: The United States in 1876.* New York, 1976.

Bevan, Wilson L. *History of Delaware.* New York, 1929.

Bowers, Claude. *The Tragic Era.* Cambridge, 1929.

Brandes, Georg Morris Cohen. *Recollections of My Childhood and Youth.* London, 1906.

Briggs, Emily Edson. *The Olivia Letters.* New York, 1906.

Brodie, Fawn M. *Thaddeus Stevens: Scourge of the South.* New York, 1959.

Brooks, Noah. *Washington in Lincoln's Time.* New York, 1895.

Bullard, F. Lauriston. *Lincoln in Marble and Bronze.* New Brunswick, 1952.

Bumgardner, Edward. *The Life of Edmund G. Ross*. Kansas City, 1949.

Butler, Benjamin F. *Butler's Book*. Boston, 1892.

Butts, Porter. *Art in Wisconsin*. Madison, 1936.

Castel, Albert. *The Presidency of Andrew Johnson*. Lawrence, 1979.

Catton, Bruce. *Never Call Retreat*. New York, 1965.

———. *Terrible Swift Sword*. New York, 1963.

———. *The Coming Fury*. New York, 1961.

Cheetham, Nicolas. *Keeper of the Keys*. New York, 1982.

Coil, Henry Wilson. *Coil's Masonic Encyclopedia*. New York, 1961.

Connelley. William Elsey. *Ingalls of Kansas, A Character Study*. Topeka, 1909.

Connelly, Thomas L. *The Marble Man: Robert E. Lee and his Image in American Society*. New York, 1977.

Constant, Alberta Wilson. *Paintbox on the Frontier: The Life and Times of George Caleb Bingham*. New York, 1974.

Cooper, Jeremy. *Nineteenth Century Romantic Bronzes*. Boston, 1975.

Craven, Wayne. *Sculpture in America*. New York, 1968.

Croce, George C., and Daniel H. Wallace. *Dictionary of Artists in America*. New Haven, 1957.

Custer, Elizabeth Bacon. *Boots and Saddles or: Life in Dakota with General Custer*. Reprint. Norman, 1961.

DeWitt, David Miller. *The Impeachment and Trial of Andrew Johnson*. New York, 1903.

Donald, David. *Charles Sumner and the Rights of Man*. New York, 1970.

Dorf, Philip. *The Builder: A Biography of Ezra Cornell*. New York, 1952.

Downey, Fairfax. *Indian Wars of the U.S. Army , 1776–1865*. Garden City, 1963.

Dubois, Ellen Carol. *Feminism and Suffrage*. Ithaca, 1978.

Duncan, Robert L. *Reluctant General: The Life and Times of Albert Pike*. New York, 1961.

Eagle, Mary, ed. *The Congress of Women, World Columbian Exposition*. New York, 1894

Fielding, Mantle. *Dictionary of American Painters, Sculptors and Engravers*. Green Farms, 1975.

Fine, Elsa Honig. *Women and Art*. Montclair, 1978.

Flexner, Eleanor. *A Century of Struggle: The Women's Rights Movement in the United States*. Cambridge, 1966.

Foner, Eric. *Reconstruction: America's Unfinished Revolution, 1863–1877*. Paperback. New York, 1989.

Gara, Larry. *A Short History of Wisconsin*. Madison, 1962.

Goode, James M. *Outdoor Sculpture of Washington*. Washington, 1974.

Gordon, Thomas F. *Pennsylvania Gazetter*. Philadelphia, 1832.

Grant, Ulysses S. *Personal Memoirs of U.S. Grant*. Reprint. New York, 1990.

Griffith, Elisabeth. *In Her Own Right: The Life of Elizabeth Cady Stanton*. New York, 1984.

Hale, William Harlan. *Horace Greeley, Voice of the People*. New York, 1950.

Hall, Gordon Langley. *Vinnie Ream: The Story of the Girl Who Sculpted Lincoln*. New York, 1963.

Hamersley, Thomas, ed. *Regular Army Register, 1779 to 1879*. Washington, 1880.

Harris, Ray Baker, ed. *Bibliography of the Writings of Albert Pike*. Washington, 1957.

Hart, B.H. Liddell. *Sherman: Soldier, Realist, American*. New York, 1958.

Haynes, George H. *Sumner*. Philadelphia, 1906.

Hess, Thomas B., and Elizabeth Baker, eds., *Art and Sexual Politics*, New York, 1973.

Hesseltine, William Best. *Civil War Prisons*. Columbus, 1930.

Holzman, Robert S. *Stormy Ben Butler*. New York, 1954.

Hoxie, Richard Leveridge. *Vinnie Ream: Printed for Private Distribution Only and to preserve a Few Souvenirs of Artistic Life from 1865 to 1878*. Washington, 1915.

James, Edward T., ed. *Notable American Women, 1607–1950*. Cambridge, 1971.

James, Henry. *William Wetmore Story and His Friends*. Boston, 1903.

Jellison, Charles A. *Fessenden of Maine, Civil War Senator*. Syracuse, 1962.

Julian, George W. *Political Recollections*. Chicago, 1884.

Kennedy, Lawrence, ed. *Biographical Directory of the American Congress, 1774–1971*. Washington, 1971.

Kennett, Lee. *Sherman: A Soldier's Life*. New York, 2001.

Kenworthy, Leonard S. *The Tall Sycamore of the Wabash: Daniel Wolsey Voorhees*. Boston, 1936.

Kinsley, D.A. *Favor the Bold: Custer, the Indian Fighter*. New York, 1969

Krenkel, John H. *Richard Yates, Civil War Governor*. Tempe, 1966.

Krisman, Michael J., ed. *Register of Graduates of the United States Military Academy*. Chicago, 1970.

Krug, Mark M. *Lyman Trumbull, Conservative Radical*. New York, 1965.

Larkin, Lew: *Bingham, Fighting Artist*. Kansas City, 1954.

Leckie, Shirley A. *Elizabeth Bacon Custer and the Making of a Myth*. Norman, 1993.

Leech, Margaret. *Reveille in Washington, 1860–1865*. New York, 1941.

Lewis, Lloyd. *Sherman, Fighting Prophet*. New York, 1932.

Lockwood, Mary Smith. *Yesterdays in Washington*. Rosslyn, 1915.

Lomask, Milton. *Andrew Johnson: President on Trial*. New York, 1961.

Loomis, Chauncy C. *Weird and Tragic Shores: The Story of Charles Francis Hall*. New York, 1971.

Lynes, Russell. *The Art-Makers*. New York, 1970.

Macoy, Robert. *Cyclopedia and Dictionary of Freemasonry*. New York, 1872.

Martin, Christopher. *Damn the Torpedoes! The Story of America's First Admiral: David Glasgow Farragut*. New York, 1970.

McCabe, James D. *The Life and Public Services of General James A. Garfield*. Philadelphia, 1881.

———. *The Illustrated History of the Centennial Exhibition*. Philadelphia, 1876.

McDermott, John Francis. *George Caleb Bingham, River Portraitist*. Norman, 1959.

McFeely, William S. *Grant: A Biography*. New York, 1981.

McHenry, Robert, ed. *Famous American Women*. New York, 1931.

———. *Liberty's Women*. Springfield, 1980.

McKinney, Francis F. *The Life of George H. Thomas*. Detroit, 1961.

Means, Marianne. *The Woman in the White House*. New York, 1963.

Meredith, Roy. *Mathew Brady's Portrait of an Era*. New York, 1982.

Merington, Marguerite. *The Custer Story: The Life and Intimate Letters of General George A. Custer and his Wife Elizabeth.* New York, 1950.

Merrill, James M. *William Tecumseh Sherman.* Chicago, 1971.

Monaghan, Jay. *Custer: The Life of George Armstrong Custer.* Boston, 1959.

Mowat, Farley. *Ordeal by Fire.* Boston, 1960.

Nevins, Allan. *Frémont, Pathmarker of the West.* New York, 1939.

Nichols, David. *Lincoln and the Indians.* Columbia, 1978.

Nicolai, Richard R. *Centennial Philadelphia.* Bryn Mawr, 1976.

Oakley, Mary Ann B. *Elizabeth Cady Stanton.* New York, 1972.

Powell, William H., ed. *List of Officers of the Army of the United States from 1779 to 1900.* New York, 1900.

Randall, J.G., and David Donald, *The Civil War and Reconstruction.* Boston, 1961.

Roehrenbeck, William. *The Regiment that Saved the Capitol.* New York, 1961.

Roome, Lillian Pike. *General Albert Pike's Poems.* Little Rock. 1900.

Ross, Edmund G. *History of the Impeachment of Andrew Johnson.* Santa Fe, 1896.

Ross, Isabel. *The General's Wife: The Life of Mrs Ulysses S. Grant.* New York, 1959.

Rubenstein, Charlotte Streifer. *American Women Artists.* New York, 1982.

Sandburg, Carl. *Abraham Lincoln: The Prairie Years and The War Years.* New York, 1954.

Sherman, W.T. *Memoirs of General W. T. Sherman.* New York, 1891.

Singleton, William K. *The History of the Ancient and Accepted Scottish Rite.* New York, 1891.

Smith, Theodore Clark. *The Life and Letters of James Abram Garfield.* New Haven, 1925.

Stamp, Kenneth M. *The Era of Reconstruction, 1865–1877.* New York, 1965.

Stanton, Elizabeth Cady. *Eighty Years and More.* New York, 1898.

Story, Henry Wilson. *History of Cambria County, Pennsylvania.* New York, 1907.

Swanberg, W.A. *Sickles the Incredible.* New York, 1956.

Taft, Lorado. *The History of American Sculpture.* London, 1903.

Thomas, Benjamin P., and Harold M. Hyman. *Stanton: The Life and Times of Lincoln's Secretary of War*. New York, 1962.

Thorndike, Rachel Sherman, ed. *The Sherman Letters*. New York, 1894.

Trefousse, Hans L. *Andrew Johnson: A Biography*. Paperback. New York, 1997.

———. *Thaddeus Stevens: Nineteenth Century Egalitarian*. Chapel Hill, 1997.

Turner, Justin G., and Linda L. Turner. *Mary Todd Lincoln: Her Life and Letters*. New York, 1972.

Van Deusen, Glyndon G. *Horace Greeley*. New York, 1953.

Van Horn, Thomas B. *The Life of Major-General George H. Thomas*. New York, 1882.

Walker, Francis, ed. *U.S. Centennial International Exhibition 1876: Reports and Awards*. Vol. 7. Washington, 1880.

Weigley, Russel F., ed. *Philadelphia: A 300-Year History*. New York, 1879.

Weimann, Jeanne Madeline, and Anita Miller. *The Fair Women*. Chicago, 1981.

Wert, Jeffrey D. *Custer: The Controversial Life of George Armstrong Custer*. New York, 1996.

Wheeler, Richard. *We Knew William Tecumseh Sherman*. New York, 1977.

White, Horace. *The Life of Lyman Trumbull*. Boston, 1913.

Williams, Burton J. *Senator John James Ingalls: Kansas' Iridescent Republican*. Kansas City. 1972.

Williams, T. Harry. *Lincoln and his Generals*. New York, 1952.

Woodley, Thomas Frederick. *Thaddeus Stevens*. Harrisburg, 1934.

Woodward, C.V., ed. *Mary Chesnut's Civil War*. Binghampton, 1981.

Woodward, W.E. *Meet General Grant*. New York, 1928.

Wright, Dudley. *Women and Freemasonry*. Philadelphia, 1925.

INDEX